# STREET

Denim strutted ahead of Aubrey, Jo Jo and Sugar flanking him left and right.

"I'm a little surprised you want to join us after all this time. I'm glad you did." Denim's shoes thumped hollowly as they entered the stairwell. "You hadn't taken sides. That made you dangerous."

"I'm still dangerous."

Jo Jo looked at him speculatively. "We'll have a chance to find out how dangerous you are."

"You might as well believe in me," Aubrey said softly. "You're a little old to believe in fairies."

As they took the turn of the stairwell, Aubrey rammed the side of his foot into Jo Jo's knee. When his legs buckled, Aubrey hit him in the neck with a whiplash left hand, and Jo Jo dropped as if decapitated, tumbling down the stairs.

Denim shrank against the wall watching in horror. Then Aubrey was coming for him, and there was nowhere to go except back down the stairs. But even that option was no longer open, as a hand reached out, iron fingers lacing into the long black hair. Denim's head was pitilessly, inexorably, twisted back.

The last things he saw in this world were Aubrey's flaming black eyes....

# STEVEN BARNES

# STREETLETHAL

A TOM DOHERTY ASSOCIATES BOOK.

STREETLETHAL

A Tor Book
Published by Tom Doherty Associates, Inc.
49 West 24th Street
New York, N.Y. 10010

Cover art by Martin Andrews

ISBN: 0-812-51034-8

First Tor edition: January 1991

Printed in the United States of America

0  9  8  7  6  5  4  3  2  1

# Contents

| | | |
|---|---|---|
| 1. | Maxine | 1 |
| 2. | Aubry | 13 |
| 3. | Spare Parts | 33 |
| 4. | Therapy | 41 |
| 5. | Knight Takes Pawn | 56 |
| 6. | Cyloxibin | 75 |
| 7. | Luis | 96 |
| 8. | Deep Maze | 107 |
| 9. | The Dead Man | 115 |
| 10. | The Scavengers | 122 |
| 11. | "Love for Sale" | 142 |
| 12. | Out of Mind | 169 |
| 13. | Invitation to the Dance | 182 |
| 14. | The Hollow Woman | 204 |
| 15. | Dark Within the Earth | 217 |
| 16. | Warrior | 231 |
| 17. | Alpha-Alpha | 248 |
| 18. | Endgame | 262 |
| 19. | Old Friends | 274 |
| 20. | The Tribunal | 286 |
| | Epilogue | 306 |

Home is where I live inside
White powder dreams.
Home was once an empty vacuum
That's filled now with my silent screams.
Home is where the needle marks
Try to heal my broken heart
And it might not be such a bad idea
If I never went home again...

—Gil Scott-Heron
"Home Is Where the Hatred Is"

# 1

## Maxine

Naked and transparent, the woman's smooth white body undulated slowly, beckoning to the empty streets. The streets were still slick from the afternoon rain; the hologram reflected back from the wet asphalt, an erotic mirage.

Next to her, impossibly huge, a one-man waterbike revved noisily, churning out ethereal waves of foam. Closer to the deserted streetcorner a shoe the size of a human body moved up and down in its own rhythm, a rectangle above it flashing "Shoe Repair."

Maxine Black laughed at the holo display as she turned the corner. The rain had washed the air clean and she inhaled deeply, savoring the taste. She was a tall woman, broad-shouldered and firm-bodied, who walked with lithe self-assurance. Her eyes remained cool despite her smiling mouth.

As tall as she was, she was dwarfed by the man at her side. He moved as quietly as a shadow, and the arm that gripped her waist possessively was as solid as woven cable.

They passed a blood spectrograph machine. One slot for dollars, one for a Service Mark card. Maxine looked up at her companion playfully. "Ya want to check my B.S., Aubry?" Her voice was throaty and little-girlish at the same time.

His dark, scarred face crinkled in a rare smile. "You're clean, baby. We checked you two days ago—and you haven't had enough time to get into trouble." His arm tightened on her. "You better keep it that way."

She nuzzled up to him, kissing chin, tiptoeing to kiss lips

1

and run the edge of her tongue into his mouth. "Don't get scary, lover. I won't spider on you."

They walked through the marching shoe with only a slight flinch as the hologram came down on their heads. The phantom waves splashed by the waterbike brought a smile back to Aubry's face, as if a long-abandoned memory were stirring to life. She pretended to gather a handful of the "foam" and sling it at him. "You shouldn't waste water like that." He laughed, spinning her into his arms for a long, deep kiss. "You make me happy." He shook his massive head in wonder. "I don't know if I've ever said that to anybody." He rolled the words past his lips again, savoring. His eyes were very gentle. He took her hand as they walked through the naked body of the belly dancer. "I'm not used to good things."

"You'd better start, lover. Your life is headed for big changes." There was something in her voice that made him uneasy, and he squinted at her in puzzlement. She felt the tension in the air and dissolved it with a chuckle. "Good things. You're a contender now."

He nodded, satisfaction and pride replacing unease. "But I half-killed myself for that. Any idiot who can thump heads wants to ride the big rocket, do his thing up there in the clouds." He stopped, looking up in wonder. Barely a handful of stars shone through the overcast night sky. "Nullboxing. I still can't believe I made it."

"You made it because you're good."

"Because fighting is all I know, and they need dudes who don't mind killing each other for money. That's just guts. But you—" His eyes ravished her for the thousandth time: the maddening curves of her body, the face that seemed a master's collage of ovals and crescents.... "You're the only thing that doesn't fit. You just fell into my lap and turned everything around." His low, rough voice almost cracked, belying his twenty-eight years. "You're the best thing that ever happened to me, and you just fell out of nowhere."

Maxine ran her fingertips over his heavy eyebrows, the puffy rise of his cheeks, down to the fine wire stubble on his chin. She felt her throat constrict. "Let's not talk about it," she said huskily. "Let's just have the night."

She steered him further down the street, past the fluxing, beckoning projections that lined Pacific Coast Highway. Sound-loops triggered by their passing cajoled, promising the finest in services and goods, the ultimate in intimate experience. A

hungry taxi-drone paused on its eternal run down the central guidestrip, and Maxine waved it on.

"Come on," she said, pulling at Aubry. Then she pushed him away and started across the street without him. She made it a race, and he let her get halfway across before he moved. Without preparation of any kind he was moving fast, a fluid streak crossing the yellow pools of light.

Maxine shrieked, laughing, and wasted a moment finding the gate through the low fence that sealed off the beach. Aubry hurdled it effortlessly, slowing his pace as he neared her. He pretended to stumble, *whoofing*, but dove into a roll, springing up to snare her at the waist.

They wrestled for a moment and he went down, Maxine astride him, triumphant and panting in the moonlight. She beat her chest, growling. Gritting his teeth and snarling back, he staggered to his feet, her legs still wrapped around his waist. "Jesus, you're heavy. . . ." She smothered his words with a kiss and pressed her body to his, twining her legs and arms tightly.

When she pulled her face back, there was fire in her eyes, flames that flickered in a cold wind. She peeled herself off and stepped back, reaching out for his hand. "Come on, big man. Let's go bite some moonlight."

The arm he slung around her as they walked was gentler now, warmer. The night breeze was heavy with wet decay, but like true city-dwellers they shut that information away, concentrating instead on the echoing roar of the breakers.

The beach was almost totally theirs. Only one lone figure sat quietly in the sand, a dim outline in the pale light.

"I like his attitude," Aubry murmured. "Nothing can stop me from going where I want to go." He shrugged his big shoulders and swung his arms forcefully, then pointed to the rows of highrise office/apartments lining the beachfront. "Damned if I'd live like them. Sitting tight in their cubbyholes, hooking together over their facephones to make their bread. Won't even come out onto the beach except in gangs. Makes me sick."

He dropped his arm around her again as they walked towards the coiling, hissing breakers. The moonlight crested the waves with glittering silver patterns that shattered into darkness on the shore. "Are you cold?"

"Why?"

"I felt you shaking a little, that's all."

She moved closer to him. "Maybe."

"Well, it looks like our friend over there is sitting on a blanket. I bet if we asked him real polite, he'd let us borrow it."

"Aubry . . ."

He smiled evilly.

"You'd better not . . ." she snagged one of his hands, and he pulled her along behind him. She dug in her heels. "Aubry, don't be crazy."

Aubry was only three paces from the man now. The figure was still immobile, a slender dark silhouette against a silvered backdrop. With elaborate politeness, Aubry addressed the silent one. "Oh, excuse me—"

There was no sound or action, but suddenly something red and hungry was in the air, and Maxine stumbled back.

"Walker?" Aubry whispered. The seated man seemed to unscrew from the ground. Slowly, gracefully, he came to full height facing them. His hands were empty.

"Where is it, Knight?" Walker asked, his voice low and hollow. He was lanky, with arms that seemed disproportionately long. The sinuousness of his rise contradicted his clumsy build. His hair was cut squarely, without style, and in the darkness his eyes seemed wet smears.

Aubry scanned the beach uneasily. "Where's your sleeping buddy?"

"Don't need Diego for this, big man. Don't need nothing but little Loveless."

Aubry's voice shook with tension. "I got no hassle with you."

Walker's laugh was ugly. "That's not what Luis says." He turned his palms front and back, exposing their emptiness. "C'mon, Knight . . . where is it?" The thin man lunged forward. Aubry jumped back, his heel catching in the sand. Walker laughed nastily. "Maybe I didn't even bring little Loveless."

"You brought it." Aubry's eyes never left the hands of the man who approached him, step light as a dancer's. "But I don't get it. If Luis wants me, why like this?"

"He's a sportin' man, Aubry. You know that. He figures that if you're good enough to walk out on him, you're good enough to deserve a chance. Sportin'." Aubry's stomach grew heavy, then hot as the anger began to build. He forced his breathing to steady, and waited. Walker slid forward a meter, and suddenly his right foot hissed in a short arc.

Aubry pivoted right, and Walker's kick missed his left knee by a centimeter. With phenomenal lightness for so large a man, Aubry continued in a tight circle, spinning a rear thrust kick into Walker that could have broken the man in half.

But Walker was out of range. He snapped his right hand like a lounge magician performing a card trick, and it suddenly held a gleaming spike. A finger moved almost imperceptibly and the eight centimeter metal tube began to whine.

Aubry backed up again. Loveless chain-knife: a flexible razor strip whirred around its edge. It could slice effortlessly through bone. Walker thrust, and Aubry moved to the side, feinting lightly with a kick. There was a quick swirl of motion, and they were out of each other's range again.

"Loveless wants you," Walker said in a hypnotic monotone. The blade made whining crisscross patterns in the dark. "Ohh . . . don't be mean to Loveless. He just wants to kiss you."

Before the last syllable was out of his mouth, Walker moved. He seemed to take a single sliding step, but his reach of leg and arm combined to take him much too far into Aubry's defensive space. Aubry parried and dropped to the sand for a leg-sweep that failed, then scrambled back like a crab as Walker lunged. He rolled backwards and sprang to his feet.

Walker paused, grinning, then started in again. Aubry feinted with his left foot—and threw a handful of sand into Walker's eyes.

The thin man screamed, slashing the air in front of him as he retreated. Aubry was on him in an instant, spearing Walker's right knee with a kick. There was a grinding snap as the leg buckled. As Walker fell he backhanded with the knife. Aubry blocked with his right hand, and broke Walker's arm with his knee. As the knife fell from nerveless fingers, Aubry twined his fingers in Walker's hair, drawing the head up and back. His hand blurred, and the *shuto* knife edge slammed down into the exposed trachea. Walker's body slumped facedown in the sand.

Aubry panted, kneeling to check the body. "We'd better—" He jerked his head around, eyes narrowed. "Maxine?" There was nothing on the beach, no one, only the sound of the breakers rolling against the earth.

Alarmed now, Aubry jumped to his feet, eyes searching the empty beach. "Maxine!" Fear and uncertainty shook his voice. He ran in a half circle around Walker's prostrate body.

"Maxine!" Desperate now, he ran towards the highway,

towards the distant pools of yellow light.

He was a dark hurricane of movement, but long before he reached the fence he heard the whirring police skimmers. Their searchlights were glaring white ovals dancing on the sand. Desperate, he broke to the left, then right again in a zigzag that gained him only a few seconds. Then the skimmers bracketed him, pinioning him in their lights, and the grating-glass sound of their loudhailers wracked his ears.

"Do not MOVE. We are tracking you NOW. Any attempt to initiate hostilities will cause your death. Repeat. We are tracking you NOW." Aubry looked down at his chest and saw the tiny red dot of the targeting laser, and knew that its twin focused on his back. One sudden movement and a burst of hollow-point .22s would rip him into pieces. Numb with the sudden inescapability of it, he lay down on the sand and spread his arms.

Booted feet approached quietly; a knee pinned him to the ground. A strong arm jerked his own to the small of his back. His wrists were taped together, and he was hauled to his feet. His captors wore the standard dark-blue police armor and reflective face shields.

Aubry shut his eyes against the light, and a red roadmap of veins exploded into view. He tried to lower his head, but powerful fingers twined into his hair, pulling him erect.

A man's voice sounded, harsh against the hum of the skimmers. "Is this the man?"

Aubry wet his lips with the tip of his tongue. He growled and tried to shake off the hands, but they held fast. Through the bright wall of pain came the reply: "I couldn't forget a face like that."

Aubry sagged, only the hands at head and shoulders keeping him from sprawling to the ground. "All right, stow this garbage. Get someone downbeach to check the lady's friend. Miss—"

"Black. Maxine Black." Consciousness became a swirl of dark red; Aubry fought to think.

"Miss Black. You understand that the beach is off limits at night? There will be questions. . . ."

Two faceplated officers hauled Aubry to the waiting skimmer. As he got one foot up on it, he finally left the searchlight's cone of brilliance and could see the face of his accuser. Maxine gazed at him nervously, then looked away at the ground.

"You!" he screamed in a voice that would have carried at a whisper. "You set me up!" The hands on his back were

insistent, but he fought against them in a rage that verged on suicidal.

Their eyes locked. "I'll get you for this. I don't care what it takes. You . . . and Luis; but especially you, bitch. Do you hear me? DO YOU?"

Her chin lifted slightly, her face tightening. The hands forced him into the skimmer, but he didn't resist this time, keeping his eyes on her as the metallic tape on his wrists was magnetically locked to the restraint bar. He watched her as the skimmer rose whooping from the ground, until she was a tiny vulnerable figure surrounded by uniformed specks.

At the bottom of a tempered crystal flask were two insects. They were fat and pale, greenish-white, with a row of vestigial legs along their puffy underbellies. They writhed as Maxine burned them alive.

Her fingers shook as she waved the butane torch under the flask, and she licked her lips. Her tongue was rancid and slimy in her mouth. She watched the dying larvae with eyes that were bloodshot and scratchy. "Please, Aubry. Leave me alone. This time. Please. . . ."

She looked at the anesthetic-steeped tube that had held twelve of the insects—twelve larvae of the South American Coal Moth. Gone now, as these two would be in a moment.

With a barely audible pop, the first grub burst; and then the second. Vapor from their bodies filled the tube. Maxine clamped her mouth over the top, ignoring the heat, and sucked the mist into her lungs. It had a harsh, minty taste. Whimpering, she sank to the filthy rug of her one-room apartment and held her breath.

Eyes tightly closed, she could see the light begin to glow in her chest. It crept outward through her bloodstream, penetrating her muscles, her bones.

She exhaled in an extended whistle, and let the light spread, the weight of her body and mind lost, driven far away by the drug.

She began to laugh. Just a giggle at first, then hiccuping hysteria. "All gone. Everything's gone. . . ."

*Your account will be credited* . . . Luis Ortega had told her on the phone, his voice and face so calculatingly pleasant that a sneer would have seemed friendly in comparison.

His face swelled, grew solid and warm, bobbing in the whirlpool of images that filled her mind.

Luis. What a handsome, handsome man—Latino and Chinese, with a full sensuous mouth and a voice to match. A body that sent chills up her spine. She could use a body like that right now. Now, with the heat and light coiling around her like a nest of snakes.

Then Luis wavered, snarled, darkened, and became Aubry Knight.

Knight: his face flayed of all human emotion as the judge pronounced sentence: fifteen years at hard labor.

His eyes had been a light chocolate brown when she first met him. At the moment of sentencing, through some trick of the light, they seemed the deepest, coldest black that any eyes could be, and they held a vast and certain promise. *We will meet again,* they said, *and when we do* . . .

And for the first time during the trial, for the first time since that terrible night on the beach, Aubry had smiled. It was a tight little smile, meant for her and her alone. Then, unresisting, he was led from the courtroom.

Maxine Black sweated and whimpered in her grub dreams, praying for release.

There were many johns, a melange, a morass of flesh in which Maxine tried to drown herself. But every body became Aubry's body, every voice Aubry's voice, and after long months, the time came when even the grubs gave no release.

She was filthy most of the time, and always ill-fed. The men she rented her body to were as tired and worn as she: laborers and salvage miners, piecework bodyguards, and low-level drug traffickers. When the weather turned cold and rainy, and the streets of Los Angeles filled with holiday cheer, Maxine stayed indoors during the day, deeply into grub toxicosis. She pissed blood in the mornings and was driven to her bed by wracking headaches that shattered her vision into mirrored slivers and magnified distant snoring into the crashing roar of a *tsunami.* Her gut rejected complex proteins and saturated fats. Her diet was confined to rice gruel and predigested egg whites.

It was on one of those terrible, fever-clouded days when the serpent beneath southern California awoke. It stretched from slumber, shedding its skin, the screams of its wrath heard in the shriek of tortured steel, of splintering wood and concrete.

Maxine was torn from her slumber by the moans of the dying and the awful sound of her ramshackle apartment shifting on its foundations. "Earthquake!" She pulled herself from the

bed, stumbled from her building into the street, and watched the lurching structures and snapping powerlines, the buckling sidewalks and exploding water mains, as a seismic debt long outstanding came due.

The days and weeks that followed were filled with hunger and confusion and ache for the grubs she needed. Everywhere, everywhere, was the smell of smoke as central Los Angeles burned.

There was no call for her services: too many desperate amateurs stalked the same streets, giving anything for food, water, and shelter. Maxine stumbled in darkness, alone with her pain, a growing hollowness inside her. . . .

. . . Maxine wandered along the Alvarado Street barricade, where barbed wire marked off what was left of south-central Los Angeles. There was nothing for her there, no customers, no shelter—just the twisted, blackened remnants of the Firestorm, rising from the wreckage beyond the fence like the shadows of a demon forest.

Emaciated, nerve-dead in the left side of her body, her vision obscured by burst blood vessels, she was unable to attract even the grimiest fungus farmer. Men walked around her, looking the other way as she hissed her siren call, desperately gyrating her once generous hips.

By lowering her price to virtually nothing, she finally managed to attract a customer, a piecework bodyguard with filthy teeth and a great chunk carved out of his nose. After he left her she realized that she hadn't demanded a blood spectrograph.

She fled screaming to the nearest machine and thrust her hand into it, fumbling in her purse for her charge card. She punched it in—and nothing happened. Sobbing, she punched it in again, watching the "insufficient funds" light flash in monotonous rhythm.

She sagged to the sidewalk, hearing only her own breathing and not the firm, soft footsteps that approached the corner where she lay propped against the machine. But she noticed when the footsteps stopped.

She looked up and saw a tall slender figure, its face lost in darkness. Maxine curled her body tighter against the spectrograph vender, and whimpered.

The stranger bent down. Within the shadow Maxine caught sparkles of light, a dancing crackle of rainbow electricity, then nothing. Reflections. Or the beginning of grub withdrawal. A

slender hand reached out and cupped Maxine's chin, raising
her face with gentle strength. Focusing her eyes, Maxine could
see that the shadows were created by a dark brown cowl.

The hand released her, and she sagged back to the ground.

A cool, carefully modulated voice said: "Grubs?"

Maxine looked up hopefully, stretching out a hand.

"I owe someone a favor," the voice, a woman's voice, said.
"You and I can make a trade. Do you want to live?"

It sounded as if the voice was calling from the depths of a
swirling wind, all but lost in the roar. But Maxine, groping for
life, for any understanding or hope, nodded with the last strength
in her body.

"Then you'll do." The woman bent down and slipped an
arm under Maxine's, wrapped it around her back, and helped
her to her feet. The cowl slipped a centimeter or two, and
Maxine saw the outline of an oval, full-lipped face. Then the
woman sighed, a sound that contrasted with the almost metallic
tones of her voice, and the left side of her face glowed like a
rainbow reflected in shattered ice. Maxine collapsed again as
her already numb mind overloaded.

She felt herself pulled to the curb, and heard the woman
punch a Mark card into a cab box. Within moments an armored
taxi-drone hovered in for a landing. The door opened auto-
matically and sealed behind them. The readout screen flickered
its query: DESTINATION? in crawling yellow dots of light,
simultaneously speaking the word in politely androgynous tones.

"Emergency Detox." The readout was silent and dark for
an instant, then simultaneously read and said, "TWO POINT
SEVEN-EIGHT MARKS. FORTY-SEVEN DOLLARS."
While they watched, the display faded, then brightened again.
"EXCUSE ME. ADJUSTMENT IN EXCHANGE RATE.
FORTY-NINE DOLLARS."

"Are you sure you're finished?" The taxi was silent. The
readout remained the same, and the woman chuckled darkly.
"Fine. I'll pay in Marks, thank you." The taxi rose, coasting
them to their destination.

The woman pulled back her cowl. In Maxine's wavering
vision it seemed that she had never seen a woman so beautiful
and yet so distant. Her eyes were almond-shaped and shifted
colors from brown to gold as she turned her head. Her hair
was a spray of dark brown, only slightly ruffled by the cowl,
and came down on her forehead in a very slight widow's peak.

Her forehead was high and smooth. Her skin was a darker chocolate than Maxine's own, and seemed somehow unreal.

"Who . . . are you?"

The woman looked at her, a brief flash of hostility giving way to a smile. "Santa Claus." Then she leaned back into the seat and watched the crumbled, patchwork buildings of the Maze whip by, the few denizens who traveled by night looking up to wonder who had business here in the crumbled core of Los Angeles.

Maxine awoke with a start, aware only of being carried from the taxi pod, of voices buzzing softly around her. She lost consciousness again and awoke stretched out on a couch in a clean, almost sterile room. There were a few flat-frame pictures decorating the plain yellow walls, and several sprays of flowers. There were three other couches in the room, but they were empty.

The woman in the cowl was standing to one side, talking to a tall, moon-faced oriental man with slender fingers.

"She'll stick," the woman was saying. "She's got nowhere else to go."

The man's mouth curled in a tolerant smile. "Promise, how can you be sure of that? How long have you known her?"

"Half an hour, Cecil. Trust me, all right?"

"Trust *you?* A piranha maybe, but not you."

Maxine expected a flash of anger, but instead there was laughter; the woman laid her hand on his shoulder. They seemed about the same height. "Look. I know that if she doesn't stick you're just going to bug me until I bring you someone who will. Believe me—I know her type." For the first time, there was genuine softness in her voice. "I was there, remember?"

"Never that far, Promise." Cecil sighed and looked at Maxine casually. He scratched an ear and looked back at the tall woman. "Will you come and see her? We've got some new techniques— some grub antagonists that I've been asked to try out. Catacholamine drugs, very experimental and *very* powerful. Pretty wild stuff, Promise. She's going to need a friend."

She glared at him, then at Maxine. There was a flash of light in her face, one swiftly dimmed. "If she'll have me—" Her voice grew fierce. "But this is it, all right, Cecil? Debts paid. In full?"

"Sometimes I forget—you have more important things to

do with your time, don't you?" She stiffened at that, but Cecil's bare trace of a smile softened the words.

"All right." Promise walked slowly over to the couch on which Maxine lay curled. She knelt down. "All right, mouse. We don't know who you are and we don't care. This is Dr. Kato, and he's a crazy man. He got some of the federal emergency funds coming into L.A., and he's got this psychotic need to do good deeds. He'll get you out of the woods, if you let him." Maxine tried to speak, to protest or complain, but could find no strength. "Give it a chance, mouse. It's better than the Farms."

Maxine closed her eyes, knowing the words to be true, no matter what she was headed for. Promise ruffled her hair affectionately, then stood and slapped Cecil lightly on the cheek. "She'll do."

"I think maybe you're right. Check back next week, would you?"

"Doctor's orders?"

"Friend's request."

She patted his cheek again, nodding. "Oh, one more thing. Better give her a blood spectrograph. She might have a spider."

"Have you brought me some more trouble, Promise?"

"I do my level best." Promise turned and walked to the door and the waiting taxi pod.

Maxine found her voice finally, raising it above the level of a whisper. "Promise?"

The tall woman turned. "That's it."

"Maxine. My name is Maxine." She paused, gulped air. Then: "Thank you."

Promise smiled then, and the left side of her face exploded into light, as if every nerve and muscle were connected to a tiny Christmas bulb. "I'll be back." Then the lights were gone. A moment later, so was Promise.

# 2

## Aubry

Jackson, the copilot of State Penal Transport Skimmer 101, felt his stomach drop as his pilot and friend, Art Rollins, swooped down low over California's Inyo mountains to begin weaving his way towards Death Valley.

Too close below them, the landscape whizzed by in a crazy quilt of packed sand, rock, and scrub brush.

He looked back over his shoulder at the walled-off compartment holding their cargo. Despite the sliversling in his holster and the ceramic plastic wall with a tested strength of better than a thousand kilos per square centimeter, he felt profoundly uncomfortable. Judging by Rollins's erratic flying, the feeling was mutual.

They cleared the last rise of mountains and slowed, beginning their descent to the floor of Death Valley, eighty-six meters below sea level. There, just a pale glitter in the morning sunlight, was the faceted dome of Death Valley Maximum Security Penitentiary—the future home of their cargo.

"This is Penal Transport 101. Transmitting identification code of the day, please respond." Rollins slowed the VTOL to almost zero, hovering twenty meters over the desert sand like some impossible insect, a roughly triangular mirage of belly fans and lift jets. Rollins turned to Jackson and smiled weakly. His hands were sweating. "Light me a cigarette, would you?"

"You got it." Jackson lit up a low-tar for him and pushed it into his mouth. Rollins inhaled gratefully.

"Thanks, Jacks." His fingers drummed on the controls as

he waited for the clearance light to flash an acceptance. "Come on. . . ." He sighed heavily. "You know something, I've flown just about everything in my time. Explosives, nuclear waste, toxic gas. . . . Hell, I ferried food right into the middle of L.A. after last year's little shakedown." Rollins raised one hand from the controls, watching it tremble. "This gets to me worse than anything else. I gotta get *out* of this work, Jacks. The old nerves just can't handle it."

With a beep, the clearance light popped on, and Rollins throttled the skimmer ahead into the security zone surrounding the prison.

"Nerves my ass, Rollins," Jackson said, feeding their landing coordinates into the guidance system. "Nerve gas doesn't *try* to get out and poison somebody. Radioactive waste doesn't *want* to fry you, for Chrissakes. These poor bastards we run out here got nothing to lose."

Rollins clouded the cabin air with smoke. "Forget the rest of them. Did you *hear* what this bastard did to those two guards at New Q? Right through their armor." He shook his head. "Damned nullboxers are freaks, man. Sport ought to be outlawed."

"I'll write my congressman tomorrow." Jackson took the controls. They glided in to the concrete landing square a hundred meters north of the greenhouse bubble. The bubble was the only section of Death Valley Maximum Security Penitentiary that lay above ground. "Right now, let's just get shed of this package, then we can go someplace and get drunk."

"Sounds too good to be true. All right, Jacks. Two degrees left—"

Charteris, the assistant warden of D.V.M.S.P., ran a finger under his collar. *Plastic fibers don't absorb worth a damn*, he cursed silently. It was cool in his office, but he perspired heavily. Perhaps it was the knowledge that the sun outside would burn the moisture from an unprotected man in hours.

On the other hand, maybe it was the man who sat quietly in a calculatedly uncomfortable chair opposite. The metal tape around his wrists held him securely to the magnetic pads of the chair arms.

With an effort, Charteris pulled his mind back to the routine speech he was trying to make. "You can do two kinds of time here, Knight," he continued. "Hard, or killer. You gave up

your other options when you attacked those two guards at New Quentin."

He waited for words, anything from denial to explanations to threats, and got silence. Aubry Knight's body was a statue carved in obsidian. His black prison fatigues stretched tight across his chest and thighs. His huge hands were relaxed, loosely curled on the chair arms. His black eyes watched Charteris casually. "I've heard about you," the assistant warden went on. "You think you're a real tough guy. A hard case. Professional nullboxer? Well, even if four years at New Quentin didn't knock the spunk out of you, things are different here at Death. Tough guys don't last here. Just do your time, shut up, and listen when you're talked to. And don't . . . *don't* make the mistake of touching one of our guards. Even if they do decide to discipline you. This isn't New Quentin—this is the end of the line, and we let our guards deal with problems like you in whatever way they see fit. There isn't anywhere lower than this to send you. In a manner of speaking, the Buck stops here." Charteris smirked. "I didn't expect you to understand that, Knight. That's all right. I'm not here to entertain you— in fact, I'm not here to reform you, either." Charteris overcame his discomfort and came closer to Aubry, stooping to look in his face. "I'm just here to keep you off the street for twelve more years. If you reform, so much the better for you."

He backed up again, startled to discover that his breathing stopped when he came close to Knight. There was no mistaking the silent message in those eyes. *I could kill you*, they said, *even now, bound as I am. You can talk and play the big man, but we both know the truth.*

"This is an experimental facility. The security apparatus necessary to keep the prisoners under control is expensive. We cannot force you to work, but we *can* key your diet to your caloric output. If you don't work, you will receive a subsistence diet, enough to keep an inactive man of your height and bone structure alive. The harder you work, the more you eat. You can also earn other privileges, but the main point to remember is that a decent diet is a privilege here—not a right. I hope you understand." Aubry didn't move. "Good. Security!" The office door clicked open and a burly guard entered. He wore five-mil flexarmor, and carried a slender shock prod. "Take Mr. Knight to his caseworker." The guard unlocked Aubry and escorted him out.

Charteris pulled a bottle of Scotch from his bottom desk drawer and poured himself a splash.

Aubry Knight. Professional fighter. Former enforcer for the Ortegas. The *Ortegas,* for Christ's sake. There was little question but that he had been set up, but there was nothing anyone could do about it. A man like Aubry Knight needed to be locked up anyway.

Charteris took a sip and closed his eyes as the heat spread down his throat. "Screen on," he called. "Transplant requests."

A shallow holo window appeared over his desk, and a quick list of kidneys, eyes, and legs rolled past. Legs and arms. Knight looked good for an arm and a leg. He was tough, though. Give him a year down in Hell. Let him see what twelve of them would be like. Then offer him a reduction in sentence if he would repay society for his misdeeds. . . .

Yes, maybe a year. And then—at least a kidney.

Aubry lay on his bunk, hands folded behind his head, staring at the ceiling. The transparent plate that sealed his cell was open for the first time since his arrival six weeks before. Each cell was soundproofed and formed an effective solitary confinement. The only noise was a steady whisper from the arm-size ventilation hole as it pumped dry, lukewarm air into his cell. Three levels beneath the surface of the sand, the ventilation system was life itself.

Rumor had it that during the riots of '08 the ventilation ducts had been shut off. Twenty-eight prisoners had died of suffocation.

Today Aubry would be allowed to take his meals communally, to use the showers rather than merely wipe his body with a wet towel. Then he would be assigned a job—digging out a new level in the bedrock beneath the prison, perhaps. There were six underground levels now, but overcrowding was always a problem. With a job he could earn money tokens, exchangeable for candy, cigarettes, or time in the gym.

The first two were of no interest, but the thought of a gym made his muscles twitch hungrily.

He was still lost in thought when he heard the sound of crepe soles stopping in his doorway. Aubry looked at their owner with idle curiosity.

The man was large, almost as big as Aubry. His face was a flattened moon, his skin color some indistinguishable blend of Black and Hispanic. The two men behind him were smaller,

but carried themselves as if all the death in the world were at their disposal. Weapons. Without thinking about it, he knew that they carried weapons: homemade knives, sand-filled socks, wire garrotes, perhaps an acid bag. Something. One of them was blind in his right eye, a dull plastic replica staring from the emptied socket.

"The name's Jo Jo. I'm from Denim." The big man's voice was ragged, gravelly. Aubry wondered how many times he had been hit in the throat. "Denim's the power here. He gets what he wants, understand? You're good to him, play straight, you get what you need, understand?" Jo Jo took a step into Aubry's cell, looking around. "This is home for you now. Maybe the rest of your life. Forget about what outside was like, and this won't seem too bad."

His manner changed, became tighter. "I hear talk. I hear you're a real tough boy. Well, in here, ain't nobody tough but me. You work for Denim, or you play with me, understand?"

"Get out."

Jo Jo snorted. "You know something? I don't think you're really all that tough. You're big, all right, but I'll bet you're a pussy, ready to put out for the first stud who flashes a stick of gum at you. What do you . . ." As the words left his mouth Aubry's gaze locked on him. The eyes were insanely black and seemed to peel away his skin to drill into the back of his skull. He backed up, startled.

"Mister," Aubry said coldly, "I think that you're about to find out more than you want to know." Then he closed his eyes.

For a moment there was silence. "Big man," Jo Jo said finally, forcing a laugh into his voice. Aubry heard the three pairs of feet retreat. Listening carefully, he could hear that one walked with poor balance. One bad leg, one bad eye. Weird.

Aubry lay still and listened to his breathing, trying to relax.

For a moment there was peace. Then there was a quick thought, a flash of a pretty brown face, a lying voice, and Aubry thought: *Maxine*. Then the face became a name, a printed name stenciled on a plain granite tombstone. As an afterthought he added a second stone, labelled *Luis*.

Aubry relaxed again, a contemplative smile on his face.

Three echoing tones sounded in the cell before Aubry opened his eyes. He could hear footsteps down the hall: only a few minutes until roll call.

The guard on the morning shift appeared as the door became translucent. He said, "Knight," into a handheld transmitter, then moved on.

Aubry slipped on shirt and pants and walked to the door, waiting for the mess line to form. He felt numb, only vaguely curious as to what the day might bring. There was nothing to be excited about—today would be all too similar to thousands of days to come. Best relax.

He took his place, feeling the eyes on him, noting with satisfaction that he was the largest man in the line. Less likely that some idiot would start something, try to rank him.

They moved along the narrow corridor, down a slanting concrete tunnel and into the mess hall. It was large enough for two hundred men, tables and serving stations arranged economically. He guessed that there had to be twenty small mess halls serving food on three shifts to feed the prison population. More separation meant greater control and security. There was an upper tier to the cafeteria, walled with the same unbreakable ceramic that formed the cell doors. The surface was dark, but he knew that behind it guards watched and waited.

His line moved up to the food counter. He took a tray, allowing a trustee to add a dollop of fruit mush, some eggs, grits, and a chunk of some kind of textured soy. He sniffed: it smelled vaguely like ham.

The thin, quick-eyed man who dropped a tin of black coffee on Aubry's tray avoided looking into his face. Aubry suddenly realized that no one in his immediate vicinity was speaking, although an undercurrent of whispers rippled through the air. He took his tray and sat at one of the long, plain tables that filled the room.

The food was tasteless and grainy. The eggs weren't eggs. The coffee tasted real, but was thick enough to fork into his mouth.

There was an empty seat in front of him, and an albino sat down. Except for his deathly pale skin and the sunglasses that shaded his eyes, the man seemed very healthy, muscles straining under his tight workshirt. He smiled without warmth. In addition to the glop on his tray, there was a small orange. The albino placed it carefully on Aubry's side of the table. "From a friend," he said quietly.

Aubry pushed the orange back across the table with his fingertips. "I don't have any friends in here."

"Oh, but you're wrong. Denim wants to be your friend."

"Why?"

"He can use you. He likes what he sees." The man put a mouthful of food away and watched Aubry.

"What sees? I never met the man."

"He knows all about *you*. He wants a talk."

"He knows where to find me."

"No. You come to him."

One dark eyebrow rose and something like a smile twisted Aubry's face. "Now that's not very friendly."

The albino drank a swig of the "coffee." Aubry watched his reaction carefully, then followed suit.

"Listen, Knight. Denim is going to talk to you. You just hope he talks nice." Their eyes locked. The rhythm of Aubry's chewing remained monotonously steady. The albino dropped his eyes to his plate. He lifted another forkful and pretended to have broken contact voluntarily.

The rest of the meal was eaten in silence. The messenger hurried through his food. Finally he stood, gathered up his tray, and smiled. "Just remember, Knight, you can be spare parts." And he left.

Spare parts. Aubry watched the man go. Aside from the pale skin, there seemed to be nothing else unusual about him.

Aubry glanced at the man immediately to his right. He was wiry, with fixed, logy eyes and two day's growth of beard blueing a pale chin. His sleeve was rolled up to the biceps. His left forearm seemed thinner than his right. There was a long rectangle of scar tissue beneath a shriveled tattoo. Two tables away sat an inmate in a wheelchair.

Aubry grunted and finished his meal.

Denim found him during the recreation period. The rec yard was two levels under the surface, a room almost seventy meters square, with a five-meter ceiling. The upper third of the rec room was covered in ceramic.

There were two racks of weights, two ping-pong tables, and mats for calisthenics. Card tables and racks of magazines dominated the remainder. In one corner of the room was a set of uneven parallel bars, and on them a man with painfully thin legs was working vigorously.

Around the outer edge of the room there was a running track. Aubry grinned.

He stripped down and spread out his legs, feeling the bunching quadriceps atop his thighs quiet as he relaxed into the

stretch. He did a half dozen more, and when his skin was covered with a light sheen of perspiration, he walked to a water fountain and filled his mouth, holding it as he moved onto the track.

He started running around the edge of the wall, pulling air down to the bottom of his lungs, matching his strides to his breathing cycle. For the first time in months he felt the kinks work out of his muscles. The weight of the water in his mouth caused slight pressure on his jaw, and he tightened down.

There were a few others jogging or running along the .2-kilometer track, so he took little notice when a small, slender oriental man moved up and ran alongside him. The man spoke in a low voice. "Denim wants to talk to you."

Aubry looked down directly at the man's bald spot, grunted incuriously, and picked up his stride. The little man matched him, pumping his short, skinny legs faster. This time when he spoke it was between gasps. "He's over there." He jerked a thumb toward the weight racks. "Come on. Don't hurt to be polite."

From where they were, Aubry could see that two men were at the racks. One was Jo Jo, the other the large albino from breakfast. Both of them had stripped to the waist and both were monstrously muscular. He said nothing and increased his speed.

The small man gasped alongside. "Wait. . . ." Red-faced and gushing out his words from a slack mouth, he kept up.

Clearly, the idiot was going to keep running until he keeled over. Curiosity caught at last, Aubry trotted to a halt. The little man stumbled up to him, sucking air like a drowning swimmer. Finally he motioned Aubry along, and the two of them walked between rows of tables and chairs, the short man leading the way.

The two muscle boys stopped pumping iron, standing as he approached. A third man sat leaning against one of the racks. He was Caucasian, tall, and slender as a coathanger. Aubry typed him as a former pimp, and smiled at the image of the two muscle boys as Denim's "women."

Denim wore his fatigues with lazy elegance, as if they had been tailored for him. His hair was longer than regulation, and he wore it tied in a knot, ponytailing down the back of his head. His mouth was an ugly slash.

"You're Knight?" Aubry nodded silently. "Good. I've heard a lot about you. You did good work, before you got stupid." He watched Aubry's eyes, looking for emotion that wasn't

there. "You know," he continued, "there are some people who are very angry with you, and you're lucky . . . I'm supposed to give you a chance to make it up." He moved a step closer. "The Ortegas can forgive, if you play your hand right."

Aubry raised an eyebrow.

"Muscle. You're supposed to be the best—" The albino tensed. Denim laid a restraining hand on the pasty shoulder. "Cool off, Sugar." He turned back to Aubry. "All the tough boys have their places here, and they're *very* jealous of their ranking. Now, you can go through the mill, maybe get knifed in the shower, or you can throw in with us and start at the top." He spread his arms. "I expect you know about Federal Statute 874–BB. No? It allows federal prisoners to donate limbs and organs to the Federal Transplant Bureau. In exchange, a prisoner can earn money or a reduction in his sentence.

"Sometimes an order comes down the pike for a kidney, or an eardrum, or an eye . . . and someone has to find an obliging con who wants more than anything else in the world to be a Good Samaritan and help a stranger in need." He smiled wolfishly. "Needless to say, there are kickbacks . . . I'm sorry, *honoraria*, for any assistance we can offer. I have an excellent arrangement with the assistant warden."

Aubry said nothing, his gaze floating from one bodyguard to the other. They had edged marginally closer.

Denim seemed annoyed that no answer had been made. "What's wrong? Doesn't suit your skills? All right, how's this. Sometimes one of our brothers has an accident—falls down a flight of stairs or slips in the shower. Afterwards we discover that he had signed a Total Donate Card and that he can be— ah, *disassembled*, and used as might best benefit medical science." His eyes sparkled as Aubry's lips curled into a smile, then grew tight as the big man started to turn away.

Sugar's hand shot out and grasped Aubry's shoulder. Aubry turned with the pull and looked him in the eye, then pursed his lips. He lowered his head and spat out the mouthful of water—a well-aimed stream that splashed into a grilled drain at the albino's feet.

Sugar bared his teeth. Denim shook his head urgently.

Aubry spoke very softly, very distinctly. "Stay away from me, and I'll stay away from you. Good luck with your 'business.'" And he walked away.

Denim watched him thoughtfully. "Let him go. He won't be trouble." He laughed as if at a secret joke. "He thinks we're

finished with him. When he learns different, he'll come around."
He jerked his head back toward the weights, and the two body-
guards took their places again. Denim watched with a practiced
eye as they performed their daily exercise.

The weeks melted together, an endless muddied stream of
inconsequential events. Aubry was assigned to the digging crew,
clearing away the debris left by blast and jackhammer in the
lower level. He was given no heavy tools that might have served
as weapons. Thick gloves protected his hands, while his back
and arm muscles levered the rocks into the trolleys. The air
was close, the lighting bad, and the ceiling insufficiently
shored; but he grew used to it, came to look forward to the
ache it gave his body.

He ate ravenously and slept deeply, dreaming of tomb-
stones.

He said little to anyone, and after the first few months people
stopped trying to converse with him.

There was one exception, the slender blond who pushed the
library cart past the cells after dinner. Every day he tried to
rouse Aubry from his cocoon, but failed. Until the day that
Aubry was jerked out of his reverie by a magazine slapping
down on his belly. He grabbed it and automatically rolled it
into a club, ready to swat the gently bemused figure in the
doorway. Something in the young man's face made him pause,
and he unrolled the magazine and looked at the cover.

On it, amidst a blaze of stars and a crescent moon, in a
golden bubble of light, were the words: *Sphere, the Magazine
of NullBoxing*.

Aubry looked up, but the librarian was already gone. He
opened the *Sphere* and browsed. He ignored the unfathomable
columns of print, his eyes fixed on the photos, the illustrations
of weightless wrestling and kickboxing technique, the color
studies of orbital mayhem.

Aubry wiped moist palms on his trousers and devoured the
magazine hungrily.

The next day when the blond passed, Aubry said, "Hey—"

With a grin, the man brought the cart back, and Aubry saw
that he was barely out of his teens and wore thick glasses under
a square-cut thatch of pale hair. His chest poked bonily through
his T-shirt. "Yeah?"

"Got any more *Sphere?*"

"Nope, but I will in a week. I knew you'd like that."

Aubry rubbed a thick knuckle under his nose. "Yeah, well, I did. Thanks."

"No sweat. It's my job, you know. Everybody's gotta have something to do, you know?"

"I know. What're you called?"

The young man grinned again. "The legal's Billy Mack, but you can call me Mother."

Aubry laughed, and it felt good. "All right, Mother. You keep me posted about those magazines, you hear?"

Mother nodded, backing toward the door. He paused there, suddenly seeming even younger. "Uh—is it true what they say about nullboxers? I mean, about your reflexes?"

"Depends on what you've heard."

The young man swallowed hard. "What I heard was something about having to be faster than any normal human being. Something about being fast enough to accelerate your opponent's chin or ribs to the breaking point before the rest of the body can overcome its inertia and bounce away."

Aubry laughed. "I don't know what the hell inertia is, but . . ." He flipped the copy of *Sphere* to a page of advertisements, checked the other side, then ripped it free. "Watch." He tossed it up in the air, his eyes never leaving Mother's face. As the paper fluttered down, Aubry's hand flickered out, and there was a sharp popping sound. Apparently undisturbed, the paper continued its path to the floor. Aubry picked it up and held it out.

It was pierced by three neatly punched fingerholes.

Mother's eyes widened. "Can I . . . can I have that, Aubry? Can I call you Aubry?"

"Go to town."

He took the paper, gazing at the holes in wonderment. Again he flashed that broad, honest grin, then left.

Aubry shook his head as he leafed through his magazine for the twentieth time, lingering over the color plates of stars and the long, gradual curve of Earth. In the midst of the gentle blues and tans, the speckled white of clouds, two powerful men were locked in desperate struggle.

That night he dreamed of clouds and weightlessness, and awoke refreshed.

At lunch the next day, Mother brought his tray over to Aubry's table and sat across from him. With him was another man, older, heavier, with a suspicious look in his eyes.

"Aubry," Mother said lightly, "this is my—friend, Carl."
Aubry nodded without speaking. He felt Carl's nervousness
but couldn't quite place it. "I've been telling him about you."

"Don't listen to too much of that," Aubry growled. "I never
got a real match. Just some basic training in a Shuttle tank."

"Doesn't matter," Mother said hastily. "He's a big null-
boxing fan. Aren't you, Carl?"

Carl's dark face creased, bringing a thin white knife scar
to light. It ran in a diagonal from left eye to right corner of
the mouth, with a healthy nick taken out of the right nostril.
"Yeah, that's right." His eyes flickered from Aubry to Mother,
and suddenly Aubry had the missing information.

"How long have you two been together?"

Mother answered shyly, "Four years?"

"Four *years?* How old *are* you, Mother?"

"Twenty-three."

"What'd they pinch you for? Smuggling cigarettes in your
diapers?"

Mother laughed. "Close. Selling grubs. Damn. I had a grub
farm in my apartment, and my landlady phoned me in. Ten
years. I hope she gets a spider."

"And four years with Carl. Congratulations."

Mother excused himself to get more water and Aubry felt
the tension expanding in the air again. He lowered his voice
and said, "Don't even think about it, Carl. I'm not in the
market, and I'm not interested in your boy, all right?"

Carl traced the scar on his face with a forefinger. "I got this
fighting for him. I'd do it again."

"True love," Aubry said without mockery. "What do you
do here?"

"Film room. Took me a long time to get that gig, too."

"Flatfilm?"

"You don't think Death would be set up for holo, do you?"
Mother returned to the table and discreetly touched the back
of Carl's hand.

"Go ahead. Tell him about the movie."

Carl shrugged and blinked.

"Next Thursday is movie day for your level."

"What's the flick?"

"Got a detective movie and a sports reel."

Mother's grin tipped Aubry off. "What sport?" He tried to
keep the eagerness out of his voice.

"Well, it seems we have coverage of the Welles-Mustapha title match."

*"Welles?"* Aubry's fingers were gripping the table savagely; his heart trip-hammered. *"I* was supposed to fight Welles. Holy—and now he's fighting for the *title?"*

"Everybody says he's too old to do it. . . ." Aubry glared at Carl. "Anyway, Mother is crazy about it, and begged me to get it in. It took some time, but . . ."

Welles-Mustapha. A classic match-up for sure. The thought of seeing it lit Aubry's face. He stood up from the table. "Thank you." He tried to smile, and found that it was difficult to keep it shallow—that for the first time in months he was feeling expectant, eager. Emotions he had sworn to stay away from. He had to leave the table. "Thank you both."

He got up, tray in hand, trying to deny the excitement that coursed through him, but failing. He dumped the garbage from his tray and sat at the edge of the room, waiting for the signal to leave.

His hands were shaking.

When the prison auditorium filled with eager viewers, and the lights went down, Aubry could feel his heart thundering in his chest. His body canted forward on his seat, the saliva furballing in his mouth.

The newsreel music played. Hissing and catcalls filled the room until Carl turned the sound down. Then there was anticipatory applause and a few whistles.

The legend *Welles-Mustapha* blazed across the screen, and a rough chorus of approval sounded in the room. An announcer's voice called the fight card, and from a clear black screen the flatfilm dissolved to an image of pinpoint stars and a long blue curve of Earth, atmospheric haze obscuring the shape of the continent below.

"Station Four," the voice said, "two thousand miles above the surface of the Earth." Station Four was a cluster of huge gray cylinders anchored at a central globe.

"Here, in a regulation ten-meter plastic bubble, two giants of the sphere will meet in combat. . . ." The camera moved up on one of the oblong shapes and seemed to dissolve through its surface to the interior, where the bubble was blown and anchored, cameras ready to catch the action and a few hundred seats set up for the fortunate few who could afford to fly up

to witness the ultimate in contact sports.

An over-brassed arrangement of *Also Sprach Zarathustra* rang over the speakers as two shuttles approached the "stadium," each carrying one of the gladiators. They docked at opposite ends, and the camera went back inside for the disembarking.

The two men, John Welles and Mustapha, entered the cylinder to the cheers of their partisans. Aubry watched with unblinking eyes as the referee briefed them on the rules: "Let's have a clean match. No blows to groin, eyes, or joints. Chokes can be held until your man is unconscious. If you get him in a hold or lock, you've gotta give him a chance to surrender. If he doesn't tap out, you may continue until the joint is broken, unless it would result in a fatality. Protect yourselves at all times. Touch gloves and come out fighting."

The men shook hands and doffed their robes, revealing oiled and chiseled torsos. They swam along the safety lines and entered at opposite ends of the bubble. The referee was a small chunky man who bounced from one side of the bubble to the other, testing its resiliency, then braced himself out of the way as the two men floated cautiously toward each other.

Welles flipped in midair and kicked out, pushing off from Mustapha. The two flew in opposite directions, and Welles rebounded off the clear plastic wall, tucked into a ball, and shot back toward his opponent. The referee scrambled hurriedly out of the way as the challenger, Mustapha, caromed around the sphere doing flip-flops: hands, feet, hands. . . .

They clashed, and suddenly there was a knot of straining bodies. A sudden movement, and they flew apart, rebounding together again, each seeking the advantage.

Punch and kick blended into lock, suddenly broken and converted to counterkick at such a speed that no one in the auditorium but Aubry saw exactly how it was done. There was the incredible midsection strength that could torque the body without the assistance of gravity. There was the coordination that combined gymnastics, wrestling, and kickboxing into a totality that was much more than the sum of its parts.

The audience screamed with every blow, cheered and clapped until the room rocked with the thunder of their approval. Aubry felt his teeth sink cruelly into his lower lip. As the two null-boxers performed their weightless arabesques, broke apart and reformed into straining knots of tortured sinew, as their grunts

echoed on the soundtrack and their sweat droplets drifted in the air within the bubble, he fought a losing battle with his control.

After the first three minutes the two men broke and went to opposite sides of the bubble, rinsing their mouths out from nipples in the sides of the sphere. Tiny mechanized arms sprang to life, tending their cuts by remote control, while whispering speakers laid out strategy for the next round. The camera cut to a view outside the shuttle tank. The statistics of the two athletes: so many kilos, so many centimeters of reach, so many wins and losses, paraded across the blue curve of Earth.

Aubry didn't watch the stats. His eyes were riveted on the motionless clouds, the unwinking stars. He heard his voice as a faraway roar, murmuring, "Oh my God . . ." as he looked down on a patch of impossibly blue ocean edged with a gauzy haze.

He blinked, but was unable to keep his vision from blurring. There was a hot, salty taste in his mouth, and his breath was coming in gasps as he fought to retain control. He finally stood, pushing his way out of the aisle as the other prisoners glared silently at him. One of the guards laid the tip of a shock prod against his chest, a nervous finger on the switch. "Where do you think you're going?"

Aubry managed to strangle out his reply. "The can, man." The guard, uncertain, let him pass. Behind Aubry, the crowd burst into cheers as the combat resumed.

By the time he reached the little enclosed urinal at the back of the theater, tears were hot on his face. He rubbed them away in shame.

There was a sound behind him. He half-turned, and saw that it was Mother. He hardly recognized his own voice. "Get out of here."

Mother stood, quietly.

Aubry turned now, too angry to care about the tears streaming down his face. "Get out, you faggot son of a bitch!" Then he turned back to the wall, fighting his way back to control.

A hand touched him on the shoulder, and there was a hand-kerchief in it. "I'm sorry, Aubry. I really am. I didn't realize." There was infinite regret in the voice, and somehow Aubry overcame his impulse to strike out, to nullify his shame by destroying its witness.

He wiped his face with the handkerchief, his breathing fi-

nally returning to normal. He swallowed salt and wiped his
eyes again, handing the handkerchief back to Mother without
looking at him.

"Man, I thought I told you to get out."

"It was my fault. I did it to you. I just wanted you to
know . . . I'm sorry. I care."

Aubry still couldn't look at him. "All right, man, all right.
I hear you. Now go on, get out." Mother started to leave, and
Knight added: "Mother, if it had been anybody but you—"

"I know."

Aubry turned again. "And if you tell *anyone* . . ."

Mother crossed his heart and left.

Aubry washed his face, staring into the mirror at a stranger.
The stranger had the same square-boned face, the same flat-
tened nose, but Aubry saw something that hadn't been there
for a long time: vulnerability. And that could be fatal.

"Aubry, I can't help you if you won't cooperate."

"I didn't ask for your help," Knight said calmly. He stared
across the desk at Cotter, the overloaded caseworker who, once
a month, attempted to establish a "meaningful dialogue" with
him.

"Tell me," Cotter said, drumming his fat, sunburned fingers
on the desk, "why did you refuse Denim's offer?" Cotter's face
was neutral, as clear as glass. Aubry felt a millipede of disgust
inching up his spine. He leaned forward.

"Just what the hell is this? Are you shilling for him too?"

The plump caseworker shook his head in an emphatic no.
"Right now all I care about is you. Your rehabilitation. Your
emotional health. You had an opportunity to make things easier
on yourself and didn't take it. I would like to know why."

"Because it *sucked*. What kind of a monster do you think
I am?"

"Aubry, Aubry. You have a long and colorful record. Theft,
manslaughter, drugs . . ."

Aubry's teeth gleamed deadly white against the darkness of
his face. "That was a frame. I never dealt. Never. Never took
drugs, never sold them."

Cotter's fleshy lips curled into a stifled frown. "No drugs?
Might I ask why that one enterprise offends your moral sense?"

Aubry was silent.

"All right. But we'll talk again. You'll talk to me. If not

this month, next. Or the next. You're going to need someone to talk to...."

Aubry's voice was sudden and harsh as the crack of a whip. "I don't need anybody, do you understand me?" His shoulder muscles had bunched with tension under the black prison fatigues, and one tape-bounded hand tensed to point an accusing finger. Although sitting halfway across the room, the caseworker felt as though something were constricting his breathing. His mouth suddenly went dry. Aubry almost shimmered with anger. "I don't need *anybody*."

Cotter jabbed twice before he found the intercom button on his desk. "Remove Mr. Knight, please. We've finished our talk."

In the months that followed, Mother tried again and again to start conversations with Aubry, receiving only grunts in reply. He took the magazines that the librarian left and read them in the solitude of his cell.

He worked. The digging in the lower level was finished, and he had been transferred to the shop, where he made furniture for government buildings. The work was less physical; he no longer felt worn out by the end of the day.

From a distance, Aubry listened to Denim's shoes click as he strutted the halls in his tailored fatigues, flanked by Sugar and Jo Jo. Aubry smelled the fear hanging in the air like coils of smoke. He saw himself mirrored in the glassy, staring eyes of the other prisoners. When the pills and grubs changed hands he turned away, tempted by their promise of relief for the first time in his life.

He compensated in the gym, seeking in exhaustion the peace he could not find in sleep or drugs. But here, for the first time, his body betrayed him, revealing only further stores of vitality. The harder he pushed, the more of his humanity sloughed away to reveal a tireless machine that mocked his greatest efforts.

The other prisoners grew to fear him, especially when he stood in the showers, the enormous musculature of his buttocks and legs a fact for all to see. Eyes closed, lost in a world of sensation, he rubbed the coarse soap harshly into his body, as if trying to remove the skin. Lather ran in rivulets along the corded stomach muscles, down along ridges of thigh and calf, to the strong, thick-nailed toes.

As the months passed and the black eyes grew more and

more remote, retreating behind a film of hatred and despair, it
became clear to all who cared to notice that what humanity
remained to Aubry Knight was being flensed from him day by
day. Until, someone said, there was nothing alive within that
incredible body. No soul, no feelings. That a ghost named
Aubry Knight walked the corridors of Death Valley Maximum
Security Penitentiary.

Mother slid his cart by Aubry's cubicle and fiddled with the
top of the stack. Aubry lay on his back in the cell, staring at
the ceiling, waiting for the inevitable quip or joke or harmless
innuendo. He would snarl, or remain silent, and Mother would
laugh, ignoring him, and trundle off down the hall, hawking
his wares.

But today there was no conversation, just the sound of two
magazines slapping down on the edge of the basin, one after
the other. Then the cart moved on, its wheels squeaking. That
in itself was off; Mother usually greased them before every
day's work.

Aubry looked up, sitting up slightly, and started to say
something, then saw Mother's face. The thin blond hair hung
lifelessly. The boy's mouth was closed, lips stretched hyster-
ically thin. He stared straight ahead, and his skin, always pale,
was pasty white. He walked stiffly.

At first Aubry thought he would remain silent, but the words
forced their way out as if they had a life of their own. "Hey,
Mother—no talk today?" His tone was gruff.

Mother turned to look at him, and there was nothing in the
blue eyes, no life at all. His mouth opened and he tried to say
something. Aubry could tell by the intensity of the battle that
the words were important. So important that Mother couldn't
make his mouth work to get them out. He turned back to his
cart and pushed it along its daily path to the next cell.

Aubry swung his feet down to the floor and stuck his head
out the door, watching Mother retreat down the hall. Mother's
body moved like a puppet's, as if no longer guided by an
organic consciousness.

*Well, if you don't want to talk about it . . .*

On the other hand, why should Mother have thought that
Aubry would give a damn?

Knight shook his head. No, that was right. He didn't care.
He couldn't. All that mattered was surviving his time in this
place, and getting out to kill Luis and Maxine. That was all

that mattered. He focused on the thought of the two of them broken and dead at his feet, and mentally kicked their bodies until ribs shattered and blood came to the lips of corpses.

He struggled to keep that image, even as the dust-pale face of Mother came back to him, again and again.

Just before lockup, Aubry had a visitor. It was Carl—big, gentle, slow-moving Carl—who stood outside the cell like a commoner paying court. "Aubry? Can I come in?"

Aubry's eyes opened slowly and fixed on him. Carl's lantern jaw worked nervously, and his face was almost as pale as Mother's. Aubry nodded and sat up on the bed, making a place for him.

"All right. What is it?" Aubry was disgusted with the ice in his voice. It had no place there. This man and Mother had been the only inmates to extend anything even remotely resembling the hand of friendship. But Carl, like everybody else, probably wanted something.

"It's Mother," he said, his voice dropped so low it was barely decipherable.

"What about him?"

"Spare parts, Aubry. He's going to be spare parts."

Aubry thought of the limping, one-eyed, flesh-stripped damned roaming Death Valley, and barely kept the revulsion from his face.

"Senator's kid. High on grubs—some kind of accident on the National City CompWay. He's in critical condition; they did a quick match-scan for donors, and came up with Mother." He laughed bitterly. "A hundred thousand to one, but those are the kind of odds Mother beats."

"So what happens now?"

"So the assistant warden gets an order from on high, and he passes it on to Denim. Denim puts the squeeze on Mother. Mother can either volunteer for the surgery, or there'll be an 'accident,' and they'll take what's needed from his corpse."

There was a sick, sour taste building up in Aubry's mouth, but he fought it back. "What do they need?"

"A kidney, a retina, an eardrum, and a few feet of skin."

Aubry heard the blood rushing in his ears. The room began to slew sideways. "Why are you telling *me* this?"

Carl licked his dry lips. There was stark desperation in his face. "You're the only one who might be able to stop it."

"Me?"

"Denim wants you. He'd lay off Mother if you asked him to."

Aubry's nostrils flared. He stood up, grabbed Carl by the collar, and whirled him into the wall, pinning him brutally. "So that's what you want. You'd have me sell my soul to that Spider? I should burn your ass, do you know that? I should pull your head clean off."

Carl swallowed two gasping breaths and tried to struggle against Aubry's arms, to absolutely no avail. Then the fight went out of him and he lowered his head, sobbing.

Disgusted and embarrassed, Aubry let him go.

"I shouldn'ta—couldn'ta asked you for myself. Only for Mother, only for him. It'll kill him, I know it, but . . . I should have known there wasn't any way out. I love him." Carl looked up, the tears streaming freely. "I love him, and he's the most beautiful thing that ever happened to me. This will just . . . kill him." His voice was dull now, no fire at all left in it. "I shouldn't have expected you to be any stronger than the rest of us. I'm sorry."

Carl wiped his face and left the cell.

Feeling tired and old beyond his years, Aubry walked slowly back to his bed, staring at the wall as he sat. The warning bell chimed and, some three minutes later, chimed again. The cell door slid shut. The night guard walked the aisle checking faces, and after he was finished the door clouded into darkness.

Silently, Aubry slipped off his shoes and lay back on his bed, back in the warm hollow his body had worn in the blanket and mattress, and he stared at the light. When it went off, he stared unblinking into the gloom, desperate to find a single thread of sanity in a tangled web of doubt and fear.

# 3

## Spare Parts

By the next morning, the cold, impersonal hostility of Death Valley had solidified into a wall, surrounding and encapsulating Aubry Knight as if he were a pocket of diseased tissue.

Too much time was spent just lying in his bunk, staring into the ceiling, listening to his body. *You're going to grow old here*, it seemed to say. *You'll never be anything. To anyone. Your life has meant nothing, and neither will your death.*

The walls of his cell were covered with pictures of space: the scarred disk of the moon; the hazy globes of the outer planets; the stars, blazing white-hot, pinholes in the fabric of time. One by one, the pictures came down, until the bare walls were all that met his eyes.

Aubry tried to focus on the image of tombstones, but they shimmered in his mind like heat mirages, refusing to solidify.

He lay there, mind wandering, listening to the bookcart wheeling down the corridor. The footsteps behind the cart seemed strange, and Aubry looked up. It wasn't Mother pushing the cart. It was a dark little man with narrow teeth and hair that had receded far up onto his forehead, leaving only a few wisps behind.

"Magazines?"

"Where's Mother?" Aubry asked, ignoring the question. "Who are you?"

"Name's Stitch," the little man said, picking at one of his teeth with a long fingernail. "Magazine?"

"Where's Mother?"

33

Stitch shrugged. "The hospital, man. Like the rest of us been."

"You?"

Stitch hitched up his left pantleg. The limb beneath was much too thin. Suddenly Aubry remembered where he had seen Stitch before: working the uneven parallel bars in the gym. "Muscle tissue." Stitch laughed hollowly. "Part of me is playing in the Super Bowl this year. Ain't it a bitch? Come on, now. Ain't got all day. Magazines?"

A shake of the head was the only answer Aubry could muster.

Carl came by the cell later, saying nothing, merely peering in with a face as emotionless as a bare skull. His hands tensed and relaxed in hypnotic rhythm, almost as if they had lives of their own. He stared not so much at Aubry as at Aubry's body, as if it belonged to another man; dark visions danced in his eyes.

Then, wordlessly, he turned and left.

Aubry slept uneasily that night, waking up every few minutes to stare into the darkness. Staring into the ceiling, his imagination painted the Earth, its clouds and seas, its untouchable beauties all coming to life in his mind. Dreams were fragments of memories and fantasies woven together into a nightmare tapestry, a maze of past and future where every decision was fatal.

Three days later Mother was brought back to the prison. Aubry waited until recreation hours and walked down two levels. He rapped knuckles against the frame of the cell door before looking in. "Hello?" There was no answer. Mother sat on the edge of his bunk, head down in crossed arms. There was a bandage over his left eye, and one across the left ear. He wore a plain white shirt, and it looked to Aubry as if there were dressings of some kind under it. Mother turned and looked at him dully, his one remaining eye unfocused.

Aubry's world grew a little darker.

Mother didn't come down for dinner. Carl came in late, escorted by a guard. His face said everything. He walked stiff-legged up to the food line, got his plate of slop, and came back to the tables. His eyes were wide and staring, his mouth tightly pursed. As Carl approached Denim's table, there was silence for a moment.

Denim took a sip of his coffee, meeting Carl's eyes without

a tremor. "Tastes like spit." Carl's mouth worked without producing words. "Do you want something?"

"He killed himself," Carl said quietly.

Denim's expression never changed, but there was a tangible aura of tension in the air as his bodyguards hunched forward. "That's too bad. Who are we discussing?"

Carl dropped his tray. "You son of a bitch—"

"Strong words, little man." Denim said it in a whisper of a voice, his eyes straying to his fingernails. Sugar and Jo Jo began to rise from their seats.

A huge hand gripped Carl's shoulder firmly. Carl swung around, fists balled.

Aubry shook his head, black eyes hooded in silent warning. Carl coiled to throw the punch. In that instant there was no sound in the room, not even breathing.

A spotlight hit them as the ceiling lights dimmed. A metallic voice rasped through the mess hall speaker. "Prisoners. You will return to your seats *immediately.*"

Carl's eyes blazed, and he tried to turn, but Aubry's hand tightened implacably. A growl broke in Carl's throat, threatening to become a sob. He picked his tray up and left to sit by himself on the far side of the room.

Slowly, sound returned to the room, and the lights began to come back up. Denim looked at Aubry with faint curiosity. Aubry returned the look without comment, then went back to his seat with a movement somehow reminiscent of water swirling down a drain.

Denim lifted a forkful of algae steak to his mouth, eyes resting on Carl's back casually. His two bodyguards had gone off point, but were not yet eating. They sat patiently, thick fingers folded before them on the table.

At last Denim turned to Jo Jo, and his eyes flickered toward Carl. Jo Jo's eyebrows lifted questioningly. Denim nodded. Jo Jo smiled and went back to his meal.

Aubry's stomach was tying itself into knots of acid. He retired before lockup, trying to sleep. He tried slowing his breathing until his head buzzed. He tried chanting "Coca Cola" a hundred times a minute while consciously relaxing every muscle in his body. Still, Carl's straining face danced before his eyes.

At last he swung his feet down to the floor and stepped into

his shoes. He slipped on his shirt and wiped his fingers on the rough fabric, leaving damp blotches.

He walked down the hall, down the two spiral staircases to Carl's level. He wasn't sure what he would say or do, didn't even totally understand the impulse that drove him out of his cell and down the corridor. He just knew that he ought to say something, anything at all.

He had reached the sixth level when he heard the pattering echo of running feet and saw two men, heads covered in plastic garbage bags, running the other way.

There was a sound, a low, grating bubble of a moan that swelled into a crescendo of agony, then burst wetly at the top of the note. A scratching, scrabbling sound came from halfway down the cell block.

Without conscious volition, Aubry broke into a run. The faster he moved, the slower things seemed to happen, until he felt as if he were running through a sea of jelly.

A human shape appeared at one of the cell doors and staggered into the hall. Aubry came to a stop, his eyes widening.

What stood there had once been Carl. There were stab wounds in his face and neck, spurting blood as he clamped his hands to them. More slashes scored his chest and abdomen.

Carl took a staggering step. Then, as if he had lost his way or forgotten where he wanted to go, he spun around. His trousers were down around his knees; with a blood-smeared hand he fought to keep them up. His face held a bewildered, childish expression. Carl saw Aubry and took a step toward him, a scarecrow of wet red straw.

Legs already trembling gave out, and he collapsed to the ground. His mouth was working, trying to find a way to force something out. Aubry stood, unable to move. One of Carl's hands was outstretched, a blood-smeared claw that trembled as his body heaved in a final spasm. The breath leaked out of him in a great sigh.

Aubry looked up and caught a brief glimpse of sick-white faces staring from their cells. The faces disappeared as a sudden pattering of feet filled the hallway. Aubry was pushed aside as the guards went to Carl.

Two of them examined the body, while a third, faceplate dropped, waved Aubry away with the tip of his shock prod. "All right. Back to your block."

Aubry didn't move. "Don't you want to question me?"

"No." The faceplate curved and distorted Aubry's reflection

into a funhouse mirage. The guard's voice was flat. "We saw everything."

"Then you've got them?"

Now a touch of irritation came into the voice. "This is our business. We'll handle it. Now get back to your cell, Knight."

"Did you catch them?" Aubry stayed where he was, even when the guard thumbed his prod to humming life.

"I said to get back to your cell."

"You won't catch them, will you?"

"Knight—"

"You don't give a damn about this, do you?" The prod whined, Aubry twisted to the side as the guard moved. He slapped the guard's insulated glove away with his right hand, and his left blurred out instantly, stopping a bare centimeter from the mirrored faceplate.

The guard twisted his hand free, gasping.

Aubry stepped back, muscles locked painfully tight. "Don't ever touch me," he hissed.

The voice behind his own reflection was shaking. "G-get back to your cell, Knight. We'll deal with you later."

Aubry took one last look at Carl's body, now an inert shape covered by a sheet. Red splotches seeped through at face and chest. The shock prod nudged forward again, and Aubry moved away, back toward the staircase, back up to his cell, one last glimpse of the still shape accompanying him into the night.

Aubry was quiet as he joined the line to the cafeteria. The guards gave him no more than cursory glances, but he felt keenly observed. The other prisoners around him, limping and wheeling in their various states of dismemberment, were quick to turn away if their eyes met his.

He received his tray and trundled it into the line, waiting for his turn to receive a generous dollop of soya grits, flavored, today, to taste like roast beef hash. The coffee was black and bitter, but he filled his mug to the brim and sipped as his eyes roamed the cafeteria.

He spotted the man he sought and moved toward him. He set his tray down in the space between Jo Jo and Sugar, across the table from Denim. Denim ate his food without acknowledging that Aubry was present.

Aubry ate a spoonful or two of the grits, then looked up. "I want a talk."

Denim took his time meeting Aubry's eyes. When he did

it was with a lazily triumphant smile. "So, talk."

"You know what I have to say. I'm ready to work." There was no encouragement from across the table. "So where do we go from here?"

Denim chewed slowly. "You wait. When dinner is over, we talk."

There was no more conversation at the table as they finished. When the chimes sounded the end of the meal Aubry rose. With Denim and his men, he filed back up to the cells.

The lines thinned as they went. Denim purposely lagged behind. Finally they walked along the corridor as a group of four, only the unblinking SCAN cameras watching.

"So you want in now, do you, Knight?"

"Is that so unusual?"

Denim strutted ahead of him, Jo Jo and Sugar flanking left and right respectively. The boss looked back over his shoulder. "No, not really. I guess I'm just a little surprised that you'd come in after all this time. I hoped you would."

Aubry grunted. Denim's shoes thumped hollowly as they entered the stairwell. "You're known in here, but you hadn't taken sides. That made you dangerous."

"I'm still dangerous."

Jo Jo looked at him speculatively. "We'll have a chance to find out how dangerous you are. I'm not so sure I believe in you."

"You might as well believe in me," Aubry said softly. "You're a little old to believe in fairies anymore."

As they took the turn of the stairwell, Aubry rammed the side of his foot into Jo Jo's knee. When the Italian buckled, Aubry hit him in the neck with a whiplash left hand, and Jo Jo dropped as if decapitated, tumbling down the stairs.

Before either of the others had a chance to move, Aubry had taken the step forward that he needed to grab Denim's chin from behind, place a foot in the small of his back, and drop into a *tomoenage* stomach throw, performed from the rear. Screaming, Denim wheeled through the air and smashed Sugar into the wall.

Sugar scrambled up and dropped a knife out of his sleeve. He limped back in, teeth bared. Aubry faked a punch and faded back as Sugar lunged. The injured leg slowed Sugar for a fraction of a second, all that Aubry needed to deflect the knife with his right hand, and ram the ball of his foot into the exposed armpit.

Denim shrank back against the wall, watching in horror as Aubry and Sugar joined in the dim light. There was a sudden shift of mass, and then a sharp crack that preceded Sugar's boneless slide to the ground.

Then Aubry was coming for him, and there was nowhere to go except back down the stairs. But even that option was no longer open, as a hand reached out, iron fingers lacing into the long black hair. Denim's head was pitilessly, inexorably, twisted back. The last things he saw in this world were Aubry Knight's flaming black eyes and the hissing downward chop that broke his neck.

Aubry lay in his cell, waiting for the guards to come for him. He was at peace, the pain and anger cleansed from his system in a single purifying act of violence.

The light in his cell snapped on, and the door slid back. Three guards, with shock prods whining at "kill," stood outside, motioning him away from the cot and over to the wall. Slowly, he complied, and as the door opened two of them advanced to shackle his hands and feet. He offered no resistance. At prod-point they hustled him along the hall and down the stairs.

He was led from the main block down through corridors he had never seen. The air grew colder, the oppressive sensation of muggy air scraping at his calm.

In a cell lined with yellow plastic he was magnetically shackled to a chair. He sat there in the middle of the room for hours—how many he wasn't sure, because there were no clocks in the room. He fell asleep and woke up twice before the door opened. Charteris walked in.

The assistant warden looked as if he hadn't slept for days, and in his eyes there was a curious mixture of hatred and respect. "Knight. I knew I'd be seeing you again."

"Just what is it I'm supposed to have done?"

"Let's cut the crap. You killed Denim and one of his boys, 'Sugar' Markum."

One of Aubry's heavy eyebrows inched up. "And the other one?"

Charteris looked disgusted. "In a coma. The doctor said it looked like he'd been hit by a car. Broken knee, broken neck, concussion, and skull fracture."

"Too bad. He seemed to be a nice guy."

"So, you tried to kill him?"

"Not me. Denim said that lots of accidents happen around here."

The pudgy man came closer, and for an instant Aubry thought he was going to be backhanded. "There is only one reason why you are still alive. One reason we don't send your black ass to the meat shop right now."

"And what's that?"

"The same reason that Denim wanted you. You can be useful. You could replace Denim."

"As what?"

"My go-between. Officially there is no meat shop here. We just have an unusual number of prisoners who volunteer to donate or sell body parts. Nothing illegal about that. And they do earn reductions in their sentences if they prove that they can support themselves on the outside."

"And what do you get from this?"

The assistant warden smiled toothily. "The satisfaction of a job well done."

"Charteris, you make me want to vomit."

"Don't get holy with me. Why else did you kill Denim? You wanted his position. Well, I'm offering it to you."

Charteris lit a cigarette, leaned back against the wall and studied Aubry carefully. "It's not up to you, Knight. We have evaluated you carefully. Do you know something?" He leaned forward, smoke trickling in streams from his nostrils. "You're a very sick man. Hate is the only emotion you're comfortable with. That's just not healthy, and we've decided to help you."

He straightened and walked back to the door. He stopped without turning and said, "Just a little something you've needed for a long time."

Then the door slid open, and he left.

# 4

## Therapy

"We are going to show you some films," the doctor said, slipping headphones over Aubry's ears, fastening the strap under his chin. "If you close your eyes, you will be punished—like this." He stepped back from the bound man and triggered a button on his watch. Aubry sat up violently in his seat, grunting with sudden pain. "That shock is—ah—very uncomfortable, but not fatal. I suggest that you watch the screen.

"To begin, we will give you a mild dose of apomorphine. . . ." One of the male nurses took Aubry's arm and injected him smoothly. The airgun barely stung his skin. Aubry tried to yank the arm away, jerking to the end of his restraints. "Nothing dangerous, Knight. A little disorienting. You may feel a bit queasy. We will help that feeling along with this."

He tapped the headphones.

"At intervals that we shall determine, you will receive varying levels of a special sound-signal, ranging from twenty-five to thirty-five kilohertz in intensity. It will complete what the drug has started."

Aubry began to breathe heavily; he shook his head as the dizziness took hold. The lights dimmed in the room and the wall lit up brightly. He recognized the film: it was the null-boxing footage that had been shown in the theater months before.

He saw Welles catch Mustapha in the neck lock, and the screen went into slow motion as Mustapha strained, muscles bursting from his arms and neck. Despite his attempt to remain

41

distant from the action, Aubry strained against his bonds, leaning forward, breath hissing from between clenched teeth.

A shrill whine started in the earphones, built to an agonizing intensity, then oscillated. Light burst behind tightly squeezed eyelids, and his stomach spasmed. He fought against the pressure, pressed his lips together, and attempted to swallow as sour fluid splashed into his throat.

Then the signal stopped and his world righted again, his stomach calming. He took a deep breath and tried to concentrate on the screen.

Welles struggled desperately to free himself from a leg scissors. . . .

And the signal tore into Aubry's brain, acid boiling in his guts, foaming up, stopping just before the point of release. He screamed in humiliation as his sphincters relaxed.

And in the darkened room the doctor and his assistant nodded quietly to each other and prepared to trigger the button again. And again.

On and on into the night.

An eternity later he was carried back to his cell, dragged past the shocked, disbelieving eyes of his blockmates. He was dumped unceremoniously on his bunk, half-conscious and filthy, with the cell door open for all to see.

He had no idea how long he lay there, only that eventually the work boss came and he was taken to the laundry.

Still dazed, he pulled loads of wet, steaming fatigues out of the enormous washing machines and ferried them to the driers. The other men watched, but didn't speak.

Although he managed to stay on his feet, by the end of the shift he was aching with the need to turn off his mind and sleep.

But just before the end of the shift they came for him, taking him back once again to that small, plastic-lined cell. There, movies played ceaselessly on the walls and Aubry seethed with chemicals and wrenching sound.

Again and again the urge to vomit rose, only to be squelched. He tried to look away, and was shocked again. Back in his cell he tried to rest, to clean himself, only to be awakened and dragged back for more. He tried to work in the laundry and to ignore the nasty, whispered jokes and disparaging grins. He fought to hold on. To anything. To the image of tombstones, the names now lost in fog.

Mealtime provided a contrast to the reception he received on the job. Places were made for him at the tables. When he stumbled groggily, sympathetic hands propped him up. There were no nasty asides or jokes, only a growing sense of acceptance. *Finally,* the eyes said eloquently, *finally, you are one of us, and you understand. . . .*

Two days later they came for him again. This time he thought he would die. He could not turn away from the screen, from the scenes of violence in a thousand forms, without receiving a smashing shock in the chest. He could not watch the screen without becoming ill. He went beyond consciousness into a trance induced by pain and nausea. There was a kind of synesthesia, when sound became a rainbow of hue, and color an army of lice driving him mad with itch. And emotion was scent, a sickly wisp of scent that brought him a welcome moment of relief, allowing him to empty his stomach. Even the humiliation and the wet were a cheap price to pay. Aubry cried, delirious with relief.

At the end of the session, Charteris came to call, wrinkling his nose at the smell.

"You really are taking the hard road, Knight. We'll break you if you don't work for us. You won't even know where your brain went. We can just scramble you. What do you think about that?"

Aubry raised his head, panting. His eyes seemed sunken far back in their sockets; a week's growth of beard was caked with drool. He growled at Charteris, puckered, and spat.

It hit the assistant warden in his open mouth. He gagged, backing away, and wiped his lips with the back of his hand. "All right, asshole. We've made it easy for you so far. Fight on or give in, you're going to be our boy. Think about it."

Then he was gone from the room. Aubry twisted in his seat, trying to get his head out of the phones that were strapped down so tightly. He shook and foamed with rage and frustration, the frustration transmuted into fear as the earphones hummed anew. The lights went down, and Aubry Knight howled his misery in a roomful of shadow plays, dancing at death in color and stereo sound.

Aubry lay in his cell. He hurt everywhere: his wrists where they rubbed against the restraints; his stomach from the spasming; his ears. He seemed to have banged his head at some point, and it ached abominably. A patch of skin over his left ribs was

swollen—he had no idea when that might have happened, but it itched as if an insect had laid eggs there.

He had trouble remembering who he was or what day it was. His muscles felt slack and unresponsive.

Something was gone—he could feel it. A whole range of emotional responses went foggy when he tried to summon them. He was glad to be in his cell, especially when the door closed and locked, and he was no longer under the scrutiny of the other inmates. He could curl up on his cot and stare into the darkness.

Dreams were strange and fearsome places, where for the first time in his memory the creatures that haunted them rose up and tore, and his limbs were weighted with chains.

He woke up in the middle of the night, staring, panting, and knew he was losing the battle for his mind.

Stitch, the new librarian, came to sit with him in the mess hall the next day. His eyes darted furtively from his own tray to Aubry, to the observation windows to his tray again.

He spoke quietly. "We know what'cha going through. And why." He didn't say anything else until the end of the meal, when he added, "Help's coming."

Aubry watched him as he gulped down the rest of his coffee and opened his mouth to speak. Before he could, a gloved hand dropped on his shoulder. "Time, Knight."

Aubry felt for the place in his head where anger used to flare, and felt the spark die under a flood of nausea. He rose docilely and followed the two guards from the room, back to the hated conditioning chamber. The other prisoners watched wordlessly.

Months. It had to be months later when Aubry kicked to the surface of the filthy pond he was drowning in. The one with the Kraken whose arms sucked at him and pulled him down into darkness, where time lost its meaning and the only reality was pain.

It had to have been months. It had to take that long to twist a man's head off at the shoulders and turn it inside out. Even with the sound and the lights and the drugs that turned his senses against him. It just had to.

Aubry opened his eyes, seeing the ceiling of his cell, not knowing where he was. He tried to make a sound, but a thin mewling noise was all that emerged.

There was a creak at the doorway, and Aubry moved his head too quickly, the pain shooting up his neck. "Mother?"

It was Stitch. He examined Aubry soberly and tossed a book to him from the brimming cart. "Return this one personally," he said, "say, an hour from now." His eyes said more, but he wheeled the cart on. Aubry watched, numb. He leafed through the book nervously, wondering what in the world they could want. A distant relative of the automatic disdain and haughtiness surfaced, but at the first flash of annoyance or anger, a wave of nausea immobilized him. He stabilized his breathing and waited.

There were two men in the library with Stitch. Both of them were missing body parts: one of them an eye, one a leg. Stitch leaned on a cane.

Stitch was nervous, and rings of perspiration stood out under his bony arms. "We know that you killed Denim."

Aubry started to protest, then gave it up as useless. "So what?"

"Now they're going to kill you, unless you start up where he left off. We can help you."

"How?"

The thin man looked around the room carefully. "Escape."

Aubry's laugh was ghastly to hear. "You're crazy. No one has ever escaped from Death."

"True, but it's still possible. For one or two men, if they're strong, and they time it right."

"What are you talking about?"

"A distraction. What you need is to buy yourself enough time to make it to the mountains before they know you are missing."

"I don't . . . how do I do that? How can I get that time?"

"Riot," Stitch said softly. "A food riot would do it, but there are a lot of men who know the assistant warden's been getting rich from selling us. It's been building up for years. But with Denim on the inside, and the Ortegas on the outside—"

Aubry's eyes cleared as he locked on the name. "Who?"

"The Ortegas. They broker the organs, and grease the chute. Didn't you know?"

He thought, trying to pull together a cohesive picture from the swirling chaos in his mind; failing.

"Anyway, that's how the lid has stayed on. With Denim dead, things can be pushed a little. If you're in the right place when things begin to heat up, you can make your move."

Aubry looked at the three of them, hope dulling to suspicion in his eyes. "Why would you do this for me?"

"Denim," they said with a single voice. "You did what we should have done a long time ago. Things may be bad again; they may get worse. But for right now, Charteris's ramrod is dead, and we're going to kick some ass."

Aubry raised his eyebrows at that. "Just what are you talking about?"

"You'll see. I'm surprised you haven't smelled it yet."

The empty, silent faces, the eyes burning deep in their sockets, the low murmuring at dinner, had he really been so lost in his own world that he hadn't realized?

Stitch was watching him carefully. "Well?"

"Who's showing me the way?"

The thin man tapped himself on the chest. His eyes were eager.

"All right," Aubry said finally. "I'll try anything."

In the middle of his work shift three days later, it happened. The air in the laundry room was rank with steam and sweat. The men around seemed quiet and expectant.

Things happened in a rush. One minute he was burning his hands on a load of pants and underwear, the next there was a flurry of movement as two of the inmates, in coordinated action, attacked two of the guards in the room.

One of the two prisoners gripped his man from behind in a savage headlock, sitting him on the floor and bending over him from behind. "Hold the stun!" he screamed. "If I go out, I'll fall forward and take his neck with me."

There was no answer from the barricaded guard stations, but the eight men in the room were tense. Then a low, triumphant voice spoke over the intercom: "All right, you assholes. We've got 'em. Wire these guards and let's get moving."

Only the two who had knocked out the guards seemed to know exactly what was going on. They stood, eyes flashing. "Who's with us?" One screamed defiantly. "We're going to get some reporters in here and talk about Charteris's little racket."

There were cries of agreement, and laundry was thrown to the floor. The other man spoke. "We can't get out of here, but by now we've got almost ten hostages, and control of our sector. We can hold it long enough to see some action."

"But they'll turn off the air conditioning!" someone yelled. "We'll suffocate!"

"We'll take worse if we don't get our story out. Who's with me?"

Hesitantly at first, then with increasing enthusiasm, hands were raised into the air. "All right!" the initiator yelled. "Everyone to the cell block!" There was a roar, and a tide of prisoners swept out of the room. Aubry started forward, but there was a restraining pressure on his shoulder.

"No," Stitch said softly. "Don't go with the others. Everything we need is right here."

"But is—?" Aubry paused, thoughts stuttering. "What do I do?"

Stitch's voice was urgent. "It's all taken care of. Just trust me."

Aubry looked uncertainly at the beckoning door. "All right."

Stitch did a little hop in place and motioned for Aubry to follow him. Aubry heard screaming and the muffled sound of an explosion. There was a growing whine in the air. He felt the vibration of a distant alarm trembling in the floor.

Then came a sudden stillness of air that was unmistakable and ominous. The warden had cut the pumps in the affected areas. The atmosphere would go bad within hours.

Stitch hurried him to a corner of the laundry room. The unattended washers and driers, great hulks of chrome and steel, still sighed steam and settled with metallic creaks. Warm water condensed on the ceiling and dripped down into the recycler ducts.

He chose one of the ventilation pipes and ripped into it with a homemade knife, peeling aside the paint and plaster to get at a flexible layer of metallic sheeting. He tore loose a huge square of it and folded it into a bulky package, jamming it into a makeshift knapsack.

"Here," Stitch said, handing Aubry the pack. His tiny eyes flashed nervously. "We have to get this grille loose."

"Grille?" Aubry asked vaguely. Despite his confusion, he found a laundry cart with a leg that wobbled and set to dismantling it. One foot went alongside the thick wire mesh of the basket. The other planted firmly on the ground as he fought with the leg, tearing it free with a snap.

"Why this one?" he asked, slipping one corner of the bar into the side. He tried a levering motion, then grunted. "Get me something to support this—anything solid and about twice the size of my fist."

Stitch scampered away in search, bringing back a hunk of

machinery. He held it in place while Aubry set his bar against
it and under the grille. He heaved, and it began to give way.

"It's the largest ventilator duct on this level," Stitch said,
keeping an eye on the door. "The only one large enough to
hold a man."

Aubry grunted, relaxing his muscles in preparation for an-
other heave. "Why hasn't anyone done this before?"

"Because of the ventilator fan. We'll have to rip it out of
the shaft to get by. If you tried to do that with the ventilation
system going, you'd be electrocuted or chopped to bits. And
any interference with the system would show up immediately
on the system computer. Only when the ventilator is shut down—
during a riot—can it be done. As soon as they find out what's
happened, they'll correct the system."

With a final pop and a shower of plaster of dust, the worried
half of the grille gave way completely. Aubry put the lever
down, grabbed the grille in his hands, and twisted, exhaling
sharply, the veins in his forehead standing out in branching
patterns. The grille came loose with a final shudder of metal
and plaster, and Aubry threw it aside.

"Hurry up!" Stitch whispered, crawling into the hole.

It was pitch-dark within. As Stitch disappeared up the shaft,
Aubry looked down, trying to gauge its depth. There seemed
no way to tell. Shrugging, he forced his way in. Anything was
better than another session in the little room.

Above him, Stitch moved up shallow handholds with eerie
agility for a man partially disabled. The shaft may have been
large enough for an average man, but it was too narrow for
Aubry's liking. He lost skin from both of his shoulders, and
trying to find leverage to hoist his bulk another meter seemed
impossible at first.

Twice he almost lost his grip, sliding down the tube, until
his fingers could dig in and stop him. From the darkness above
he heard Stitch hiss, "Are you all right?"

Aubry panted, "Yeah."

At last they reached a horizontal branch. Stitch moved into
it, motioning Aubry to follow. They crept along the narrow
tube until they reached one of the great fans that pumped cool
air down the pipes. Its blades were still. A faint light from
beyond outlined the edges with ghostly luminescence.

"This is it," Stitch whispered. "You've got to get beyond
this, but when you have it you're almost clear." They switched

positions in the tube, the air growing warmer and staler with each breath.

He crawled up to the fan and drew out his pry bar, working at one of the blades. It started to bend, then the pry bar snapped, banging Aubry's hands against the walls of the shaft. Anger flared, followed almost immediately by a wave of nausea. Alarmed, he fought the anger down, trying desperately to change it to another emotion. The only one that came at all easily was fear, a crawling snake of claustrophobia.

Normally, he would have cursed the fear away, but now it was the only option open to him, so he used it. He grasped the edge of the fan blade, feeling it revolve gently, smoothly on its bearings. He breathed deeply and let his fear explode out of him, into his shoulders, into his arms and hands. His fingers bit into the metal like grapnels. His whole body was locked in unyielding contraction, until he knew that either the fan would give—or his spine.

His lungs ached and his head swam as he pulled. He heard no sound except his own thundering heartbeat, and then suddenly all sound and all dim light faded to black.

There was a hand shaking his shoulder. Stitch was there over him. Even in the faint light, the awe in Stitch's eyes was obvious. Aubry struggled upright and realized that he had ripped the fan half out of its moorings.

Together, they pulled it aside and crawled past. Above him was another stretch of vertical shaft.

He inched up, mindless of the pain in his shoulders, of the skin being flayed from palms and elbows. There was a chance at freedom ahead, and that was worth any sacrifice. At last they came to a concrete blister. Aubry set his weight, wedging his feet and ankles into the sides of the shaft. He inhaled deeply and heaved, pushing until the heavy grate began to lift. He gave another grunt and pushed it out. It fell to the ground outside with a dull thump.

At first he froze, expecting to hear running feet and the whine of a shock prod on kill. Nothing. He cautiously raised his head out of the blister, eyes widening slightly at the sight of the abandoned hothouse.

They were at the surface of the desert, in an area domed with thousands of square meters of shatterproof glass and plastic. In it, along with the algae tanks that provided part of the food for the prison, was a garden laced with cactus and fruit.

Smaller bubbles within the larger housed orchids and other tropical flowers. The scent of citrus and lilac were sweet in the air, and the hanging ferns made the huge room look green and lush.

"All clear?" Stitch whispered.

Aubry gave no direct answer, just climbed slowly out of the blister, dropping to the ground without a sound. He helped Stitch out. The little man bent to pick up a corner of the grille, straining without effect. "Come on," he whispered urgently, "we've got to get this back on."

Aubry wrenched his gaze away from the sunlight streaming through the translucent panels. His breathing was ragged, his scarred fists knotted convulsively. He turned back to the blister, bent his knees, and fastened his hands into a section of the grille. He straightened his legs slowly and dragged it clear of the ground, sliding it up the slanting concrete side and fitting it into place. Stitch watched, silent.

After the grille clicked down, Stitch pulled Aubry towards a toolshed. "Come on. We have to wait until it's darker, and I have some instructions for you." Aubry trembled with frustration, but followed.

When the six o'clock buzzer sounded, the two of them crept out of the shed and across the forest of miniature fruit and shade trees to the outer edge of the dome.

Stitch pressed against the material experimentally. "Plastic," he said softly, watching it give slightly under his fingertips. "Supposed to be unbreakable. So we're not going to break it."

"How do we get through?"

"We'll split it along the seam. The glue they used to seal the plastic to the metal frame is even stronger than the plastic— but both of them are stronger than the metal frame. *That* is where the weakness is."

Aubry looked at the little man with new respect. "I don't understand—how do you know so much about the prison?"

"No time for questions." Stitch's hand searched the seams. "It's here," he said scanning each panel in turn. "Everybody knew that Denim worked for Charteris. Did you ever wonder what he got out of it?"

"Money? Drugs?"

"That—and more. Women, when he wanted them. And, if need be—an escape hatch."

Aubry's eyes lit. "Where?" He slammed his palms against the framework of the bubble. Hollow booming sounds vibrated

down the length of the wall, but there was no give.

"Not here, where anyone walking by might test it. Higher up—the next level of panels."

Three meters from the ground was the next row of squares. It was dark outside, and they were dim. "Drag that table over here," Stitch said. "We don't have much time."

Savagely, Aubry swept his arm across the top of one of the heavy wood-grain tables, sending plants and potting soil spraying into the air. The legs were screwed down, but the screws were there for stability, not security, and were no match for his desperate surge of strength. He dragged it across the room to the side of the bubble and stood atop it, testing the panels.

"Damn!" he screamed in the darkening room. "They're still sealed!"

"Of course it *feels* that way. But the frame is weaker there."

"What the hell kind of tool was he going to use? Never mind. I can do it." He shoved, but the dirt on the tabletop slid under his straining feet and he made no headway. He gasped, looking around wildly. *So close* . . .

"Get me one of the shovels."

Stitch's footsteps were pinpoints of sound in the dusk as he ran to the toolshed and returned. He handed a slender shovel up to Aubry. Knight set the tang in the tiny gap between plastic and frame, and heaved. Slowly, the sheet began to move. The half-centimeter of unbreakable plastic that stood between him and freedom edged out of place as the metal groove splintered. His eyes narrowed and he set his feet again, hissing, prying, and there was a popping sound as half of the sheet came loose from its slot. Aubry stuck his head out, smelled the air, and fought to keep himself from trembling.

"Good," Stitch said urgently. "Now—I have to get out of here. The guards will have the riot broken soon."

"Aren't you coming?"

"With these legs? I'd never make it across the desert." He shook his head. "Don't even think it. You can't carry me. They'd get us both."

Aubry climbed back down and dusted off his hands. "How long do I have?"

"Until the first head count."

"Then, I'd better move it." They returned to the blister, and Aubry levered the grate out again. Stitch popped into it, pausing only to say, "Good luck."

"Stitch—" Aubry said, trying desperately to call up his

feelings. Gratitude, suspicion, anything at all. All were over-whelmed by the burning need to escape, to leave this place that had taken so much from him.

Lamely, he held out his hand. The words felt thick in his mouth. "Thank you."

Stitch shook it, smiling in a way that made him feel vaguely uncomfortable. "Good luck," the little man said. "You're going to need it." Then he was gone, scuffling back down the vent pipe.

Aubry ran back to the pried panel. He shouldered the crude rucksack and set his hands in the open space, levering himself up and through.

Dangling on the outside, he closed the panel as best he could, then dropped to the ground.

The sand rustled as he bent to one knee, trying to get his bearings. There was a faint red glow from behind a rise of mountains. "West," he muttered.

Death Valley Maximum Security Penitentiary was in the middle of Mesquite Flat. He had to cover close to thirty kilometers to Cottonwood Mountains, northeast of the prison.

His thin-soled prison shoes slid on the sand as he ran, and the cold air cut into his lungs. As the light dwindled to virtually nothing, his imagination went berserk, seeing sidewinders in every hollow, crevasses beneath every step. A thin edge of frigid wind whistled from behind him, lifting a curtain of sand into the air, snaking in front of him, stinging his nose.

His legs pumped smoothly, eating distance at a killing pace, until they burned with fatigue and his lungs screamed their protest. He turned his ankle in the sand and slid, rolling, down the side of a shallow embankment. Aubry lay there for a moment, breathing heavily until his ears caught the sound of a patrol skimmer.

Frantically now, he opened his pack and pulled out the sheet of insulating material Stitch had stripped from the steam pipes in the laundry. Damning himself for leaving the shovel behind, he dug with his hands, listening for the sound of the criss-crossing skimmer. Darkness would not hide him from their infrared scopes. The heat of his body would betray him as surely as a magnesium flare.

The skimmer's hum faded out, then slowly rose again as Aubry lay down in the shallow trench he had made. Carefully, he laid the heat-reflective material over his feet, covering it with sand. Unrolling it towards his head a few more centi-

meters, covering, unrolling, covering. . . .

The hum was coming straight for him. He fought to keep control. At last only his face and arms were left, and he lay the material over his head, smoothed sand over it, and wiggled his arms under.

The skimmer passed directly overhead, its whine like an angry insect's, fading quickly into the distance. He waited patiently for about ten minutes and was rewarded by the gradual whine of a slower approach. A more thorough sweep. It stopped and hovered not thirty meters away, then took off to another grid of the search pattern, the sound fading to the east.

How much longer he lay there, breathing sand and his own fear, he didn't know. But finally he peeled the cover back, peeking out timidly. There was nothing. He grinned, triumphant.

He oriented himself and headed off again. The twisted corpses of mesquite trees rose up like specters from the past, the thin hissing wind giving them voice. He dared not rest or even slow down. The pain of the run slowly crept up his calves to his thighs to his back and chest.

There is nothing harder to run on than sand. It presents no traction, false traction, then, suddenly, with a stretch of packed grains, the traction to sprint forward. He stumbled over a gnarled root in the dark, sprawling, and heard something slither away into shadow.

Tired. Tired. He hauled himself to his feet, ignoring the pain in his joints, the ache in shoulders and skinned palms. Far behind him came the angry whine of a skimmer continuing its ceaseless hunt.

Ahead of him rose conical heads, hair spraying in all directions, eyes. . . .

He shook his head. Fatigue. The wind chilled his forehead as it dried his sweat. His nose ran, salting his mouth as he realized that he had reached the Devil's Cornfield, shocks of arrowweed thriving in one of the few areas with accessible goundwater.

Breath scalding, leg muscles burning with every step, he ran on into the night, towards the gradually expanding vista of the Cottonwood Mountains.

It was almost dawn, the first orange light appearing in the east, giving depth to the black cutouts of the Grapevine Mountains to the east.

He stumbled up a hill at the foot of the Cottonwoods, his feet swollen and blistered, rubbed and torn by the run. Where was it? He hadn't been able to find the cross-shaped cairn of rock that marked his next stop. He burned from fatigue and hunger and encroaching despair.

Where . . . ? He missed his footing and fell, sliding down rock, grabbing at plants as he went. "Ouch . . . damn!" he yelled as his head struck something hard. He reached out and felt something pitted and metallic.

Aubry stood, trying to see where the ancient mining-car tracks led. Light was just beginning to reach his little valley, and he shoved his hurts and fatigue into a distant corner of his mind and followed the tracks uphill. "Please . . ." he gasped, wheezing out the single syllable. The tracks were eaten by wind and weather, and half-buried in sand, but they led him up the mountainside to the gaping slash of a mine opening, and Aubry yelled, running now.

There were boards covering the entrance, but there was light enough to see that they had been recently disturbed. He wrenched them loose and crawled in, grateful beyond words. He lay there, numb and shuddering, as the dawn came up outside. A thin stream of light cast a wedge of dusty silver into the cave. He looked around, spying a rectangular wooden box.

He crawled over to it and pried a slat loose, knocking it cautiously with the side of his hand. When there was no answering hiss or rattle, he fished around inside, pulling out a handful of slender cartons.

He laughed delightedly, the sound emerging from his throat as a croak. They were concentrated food bars, and he set them aside and dug deeper into the box. He found a flashlight, a compass, a knife. . . .

He lifted the box up and found that it was sitting on a twenty-liter jerrycan of water.

It was cold and quenching. He tried to drown himself in it, washing away the dust in his throat with deep, satisfying gulps.

He lay back, peeling one of the food bars with his teeth. Some amateur prospector was going to be mighty surprised and disappointed when he came back to claim his cache, Aubry decided. He ate another bar and curled onto his side, fatigue eroding his iron endurance at last. His eyes closed drowsily, his fingers curled around the hilt of the knife. He would hide and rest. And then he would set out for Los Angeles to complete

some unfinished business. At the moment, though, he was so tired that it was difficult to remember exactly what that business was.

He did know, however, that it had something to do with tombstones.

# 5

## Knight Takes Pawn

Promise thumbprinted the front door and waited a half-second before pushing it open. She dropped her purse by the door, her variheels in the hall, and her thermal wrap on her living room's pile carpeting.

The inside of the apartment was lined with mirrors that reflected the morning sunlight and gave off a soft silvery glow of their own. Promise edged up close to one and took a careful look at the dark crescents beneath her eyes. "That face needs a retread, lady." She slipped off the rest of her clothes and turned, evaluating her body in the mirror. *A few more side bends . . .*

She looked closely at the thin line where her real flesh met the plastiskin that covered the left side of her body. It was clear now, a transparent layer of artificial skin that showed the warm red muscle pulsing beneath. She clicked her molars twice, triggering the microprocessor implanted in her jawbone. It analyzed the input from the sensors buried in the plastic and turned the skin dark brown. Only a close observer could tell that there was anything abnormal. This was a new, and potentially useful, trick. If she couldn't have the stuff removed, maybe she could make it hide itself.

The touch of a button programmed a five-minute shower. A handful of liquid peppermint soap foamed into cooling lather, numbing the pain.

She watched the water bead on her limbs, watched her hands play on the warm, smooth surface of the plastiskin, and tried to sing. Her voice rose for a few moments in a tuneless ditty

that she couldn't remember learning, then died away. She gave up and leaned into the spray, feeling the water drizzle down her face.

Remember Osato. His hotel room had been opulent, his champagne crisp perfection. He treated her with the utmost respect, discussing his pharmaceutical firm with sober enthusiasm. She danced for him, making her plastiskin burst into a concert of pulsing colors, Osato clapping along with childish glee. But there had been nothing childish about his appetites after the drinks had been downed and the dancing and polite conversation ended. As always, there had only been the brutal softness of his bed, the driving urgency of his body, and whispered endearments as false as the diamonds on her wrap.

He had been easy—a steady customer, with his preferences and needs on file in her date log. Only with a regular like Osato could she dare to schedule another man later in the evening.

A man named Cushing. The Grand High Immortal Ghoulmaster of some alphabits lodge or other. Convention business. Instinct had warned her to turn the assignment down, but the hotel manager had done Promise many a good turn. Last night the debt had been paid in full.

Cushing met her at the door of his room, dressed in a tight robe and a light sweat. An iced tumbler was in hand, and judging by his eyes and spotty coordination, it had already been filled several times that evening. He joked about how pretty her mouth was before he took her to the bedroom. Then he told her again how pretty it was. So did the two friends who waited there.

She felt sick now, and tired. As she stood leaning against the wall, she watched the suds swirling down the drain, wondering idly how water feels as it floats out to sea.

The shower dribbled to a stop. She stepped out and walked through the drying screen, feeling her skin tingle as the water evaporated. She ran a comb through her hair and pulled it back into a puff of fine wire, half black and half transparent filament. She clicked her teeth and watched an arc of light flex through it.

She wrapped a towel around herself and walked out into the living room, pulling the curtains back to look out at the morning. The smog was no more than a light haze, only about half of the L.A. basin totally obscured.

Exhausted, but too tense to sleep, she rolled herself a joint

from the humidor by the wall video, wetting it with her lips and plopping down into a chair. She inhaled deeply and felt the sweet smoke warming away her tension. The anticipated high smoothed the lines out of her face. She sprawled in the chair, her eyes closed, deliciously limp. She opened one bleary eye.

"Playback, please," she said sharply, and the screen cleared. There was a momentary hum, and Osato's moon face filled the wall. His clipped accent hissed from the four corners of the room.

"Miss Promise," he began, composing himself, "I am very grateful for the evening's entertainment. I regret that I must leave your country tomorrow evening, but I am planning to be back in a month. If it would be possible to see you on the first of March, I would appreciate it greatly. If this is to your satisfaction and convenience, please leave your response on my exchange. Thank you." Promise sighed as his image faded to black. Pleasant enough man, very wealthy. Of course she'd see him again, give him another taste of flesh and fantasy in exchange for some of his nice solid Service Marks.

The screen blipped clear again, and Victor Gibbs's face appeared. His face was thin—too thin for his generous mouth. His perpetual smile lines softened the severity lurking just behind the bland green eyes. He had all of the clothes and cars and protection that a smooth-running pimp agency could afford. "Promise, Darling, listen." He grinned broadly, his reconstructed teeth lighting up his face with megawatts of concern. "I hope you got my note. I was just wondering why you haven't called?"

She remembered the note. It had arrived with a bouquet of butterfly orchids and mimosa. The note had been burned unopened: She already knew what it would say.

"We both know you're going to come back to me eventually, so why fight it? I knew you when, sweetheart. We go *back*. You and I both know that you need somebody. You can't make it alone. You need a man, and you know it. Liven up, Honey. I can get you work on Orbit II. Service Marks, not dollars. You could be making two or three times what you're earning now, and with protection. You can trust me. I knew you back when Jamie—"

"Cut it!" Promise snarled. She took a nervous drag on the joint. "You blew it again, Vickie. Should have left Vegas out of it."

The screen cleared again. The face was unfamiliar. "If I am speaking to a Miss Promise, I have a message for you. My name is Doctor Patricks." The face was rather nondescript, an oval topped with wavy brown hair, a tight mouth with a ghost of a friendly smile playing on it, and pale blue eyes. "It concerns Maxine Black."

The smoke gushed out of Promise's mouth in a cloud and she canted forward in her chair. Patricks continued, "She wanted me to get in touch with you. I'm afraid that she has had an accident. Her condition is stable at this time, but there are . . . complications. She is in the security ward at County General. The ward will be open to receive visitors between noon and three. We would appreciate it if you could come in to help us resolve this matter. Thank you." His face faded out and Promise sat alone in the room, deathly still, then stubbed out her cigarette.

Promise glanced at the digital clock pacing off the minutes at the upper corner of her wall video. "God. It's eleven already." She closed her eyes and saw red-tinged darkness, felt the swelling in her lids. "Oh, Mouse—couldn't you have waited a few hours?" Still in darkness, she sighed, then stood and headed for her closet.

When you can count your friends on the thumbs of one hand, there are some things more important than sleep.

Promise took the tube to County General. She watched the crowd at the tube station warily. There were always gangs. Sometimes Spiders snuck out of the Maze. They called themselves Spiders because of the facial tattoo that warned others of Thai-VI, the lethal, incurable venereal disease they carried. Instead of huddling in their hovels or in the isolation camps, they wore their tattoos as badges of honor, running the streets until the police force, or the disease, brought them down.

Spiders took a particular delight in rape, passing the disease on in a bizarre game of tag.

Promise was dressed simply, a knit shift with pale leather boots, her hair flared out in its natural puffball, her face unmade. In a back corner of her mind a tiny bit of consciousness kept the plastiskin flesh-colored and camouflaged. None of the women on the tube looked at her twice. Many of the men did more than glance, taking in the gentle swell of her calves, the rise of her breasts, the noncommital quiet of her expression. A couple of them sidled up to her and tried to start conver-

sations, but she warned them off or cut them dead with a look, and soon they left her alone. Silent, she watched the city whiz by as the tubecar sped along the rise of Baldwin Hills east to the central connection, then north to the old downtown area.

It was easy to remember when there had been skyscrapers here. The Great Quake, and the even more ruinous firestorm that followed, had razed the city, sending business fleeing to the valleys and peripheral areas. Already decaying by the turn of the century, no one cared about central L.A. anymore. The slums remaining in the area were simply referred to as The Maze, and only the hopeless made it their home.

The tube dropped around a long curve and slid to a halt at the side of the hospital.

County General had stood in this area for over a hundred years. Federal emergency funds helped rebuild and repair it after the Quake, a token effort soon abandoned in an avalanche of federal tax reforms. But it was all that the Maze had, and at least it was something.

Promise steadied her breathing, patted a nonexistent hair into place, and walked in.

The receptionist at the front desk was a white-haired Latina whose face was grooved with age. "Excuse me," Promise asked quietly, "could you tell me where the security ward is?"

The woman looked at Promise with polite disinterest. "And whom do you wish to see?"

"Maxine Black, please."

The woman's gaze lasted an irritating moment too long. "I'll have the attending doctor come down for you. Take a seat over there, please." She pointed the way, and Promise found herself taking pleasure in the dowager fat hanging from the woman's arm like flesh-colored cottage cheese.

She sat watching the stream of people feeding through the doors into the waiting room: mothers with children, old people, the broken limbs and contusions, and those who looked as if they just needed a good meal. A Chinese lady fixing a zipper on her little boy's pants smiled at her, and Promise nodded in return. A man in the opposite corner...

That's odd, she thought. He had been looking at her— and not with the kind of look she usually got from men, either. As if she knew him, or he knew her, or something. He was a large, Black man, perhaps thirty-five, with inexpensive but neat clothing covering what looked like one hell of a body. Now his gaze was back on her again, almost casually, except

that contact with those dark, expressionless orbs was somehow frightening. She was glad when a hand fell on her shoulder.

"Miss Promise?" The voice was friendly. The face was Dr. Patricks's familiar bland oval.

She nodded, rising to shake his hand.

"Please come this way. We'll need to get a picture of you before we can let you into the prison ward." He shunted her into a side room where she stood briefly in the focus of a simple holo setup. The light brightened momentarily, and Patricks stepped back toward her. "That will be ready in a moment. Is that a first or last name?"

"It's what I'm called." Her face was expressionless. "My parents were too busy fighting to name me. When the nurse asked them to make up their minds for the birth certificate, they 'promised' that they'd get around to it."

He frowned. "You expect me to believe that?"

"No. But then I didn't expect you to ask the question, either."

"Oh." He seemed unsure of himself. He cleared his throat to try again when the timer rang. He pulled her badge from the ID machine and pinned it to her blouse.

"There you go, young lady." His eyes lingered on the swellings beneath his hand.

"Why, thank you, doctor. I certainly couldn't have managed that by myself." He laughed uncomfortably, and they left the room. He led her to a battery of elevators.

"Until recently," he began, "I headed County's detoxification program. As you know, Miss Black was an inpatient of that program about two years ago. We thought she was doing well, until this." The elevator door opened, then closed behind them. He continued as the car began to move. "Naturally, I became interested in her case."

Promise shook her head. "I still don't know exactly what happened."

He ran a hand over his thinning hair, slicking beads of perspiration into a sheen that reflected light more evenly. He faced her with his thin lips drawn into a line. "Apparently she entered into some kind of drug deal with one of the therapists in the Rehab program, a Larry Ornstein." He looked at her questioningly. When there was no reaction, he went on. "This is a very unpleasant business. Much of it is conjecture, but the authorities seem to be satisfied with it. The two of them were evidently sampling the—ah—drug...."

Promise winced and bit her lip before asking, "Are you talking about grub-toasting?"

He nodded expressionlessly. "I'm afraid so. We found over a thousand Marks worth of grubs on the premises." He watched her grimace and continued, licking his lips with the tip of a pink tongue. "Well, the way—" The elevator stopped, and the door slid open. "Follow me, please. We figure that they were both high on grubs and got into some kind of argument. They fought. She killed Ornstein and panicked. She tried to escape, forgetting all about the grubs that had started the argument."

"Forgot?"

"Yes. She also evidently forgot that the glass doors on the patio were closed. She ran right through them, fell down the embankment, and slid about twenty meters before landing in somebody's backyard. The neighbors called the paramedics, who brought her here. The police investigated, and they found her dead lover and the grubs, some of them thawed out and crawling."

Her studiedly calm face became contemplative. "I knew Mouse was in trouble, but I had no idea."

"It's worse. She seems to be suffering from amnesia." As they turned a corner, a guard stopped them and passed a small monitor over her badge, waving them on when it beeped.

When they were out of earshot, Promise whispered, "What do you mean?"

"She doesn't seem to remember much that has happened to her in the past few days."

"And you think I can help?"

He looked at her and shrugged. "Can't hurt. She's in trouble either way."

They had reached room 1732, a plain blue door with a small white card set at eye level: "Maxine Black." Under the card, attached to a metal clip, hung a clipboard with scribbles of words and numbers covering it. Patricks thumbed it open. "Go right in," he said. "You'll have ten minutes." The room was small, made smaller by the wire-grid windows and the security camera in the corner. Patricks preceded her to the bedside.

Within a collage of bandages and plastic was what had once been a very pretty girl. Patricks gazed at Maxine for a long time, then sighed, moving closer to the bed. "Maxine?" he called softly. "Can you hear me?" Most of Maxine's long, soft hair had been shorn, the bare scalp stitched together like a quilt. One eye opened, and the head nodded. "This is Promise.

You asked to see her, and she's here. She's going to talk to you for awhile, then she has to go." He looked at Promise significantly. "Okay. Ten minutes." He left the room and shut the door behind him.

Promise looked around the room. The ceiling radiated a pale light. There was a single chair near the bed. Promise moved it close to the head and sat. She looked at the swollen face of the girl she had befriended. "Oh, Mouse. . . ." she said finally, just to break the silence. Maxine's hand stirred from under the covers and rose a fraction. Promise took it, hand in cool hand, and they stayed that way for a time.

"Did you do it?"

There was no response. Promise felt worse than useless. She tried again. "Is your name Maxine?" There was a slight pressure against her hand. "Is *my* name Maxine?" She could have sworn there was a smile tugging at the bandages on that ravaged face. There were two squeezes.

"Did you do it?"

Maxine squeezed twice, and there was a very faint sound: "No."

Promise's heart leaped. "Do you know who did?"

Maxine's eyes grew frantic as she struggled to speak. "Drug," she said, the word a painful effort. "Find drug."

Promise nodded soberly. "Yes. They found the grubs. My God, how could you go back to burning those things after we fought for so long to get you clean?"

Weakly, Maxine shook her head. She coughed, and her voice grew a little stronger. "No . . . grubs. Different. Better. Much better, but . . ." She closed her eyes, gathering strength. "Love drug. Needs two. Worth . . . God, I don't know how much."

"Better than grubs?" Promise tried to keep the skepticism out of her voice. "Who has it?"

Maxine's good eye looked around the room frantically. "I did . . . we. Larry and me. You have. Don't let anyone find out. Take it. Try it with . . . with someone you could love. Grow print . . ."

Promise nudged her gently. "Where is it?"

"Fright wig . . . oh, Christ. I hurt. Listen. Don't trust . . . *anybody*. We got it here. The leak was . . . here." She tried to sit up in the bed, but the attempt was both futile and painful to watch. "I couldn't have killed Larry. Couldn't. You try it. You'll know. . . ." Her voice was slipping away into delirium

again. "It would have been so good. It would have . . ." Her voice drifted again. Promise was tempted to shake her gently, then thought better of it and let her lie. She rose from her chair and watched quietly. Maxine's smooth dark skin was ashen with weakness, the muscles in her face slack and lifeless.

Promise hadn't heard the door open, but suddenly Patricks was in the room. "Time," he said quietly.

"What did she say?" he asked as they walked back to the elevator.

"Nothing, really. There isn't a whole lot working in her head yet. She just mumbled a lot."

Patricks nodded thoughtfully. "Well, thank you for coming down, anyway." He paused. "You're sure she didn't say anything important?"

Promise looked at him levelly. "Absolutely. But if I think of anything that might help you, I'll be in touch."

"Thank you. I'll need that badge back."

She plucked it off her blouse and bent the corner back, ripping off her holo. "I don't like the picture," she said, handing it back to him.

She stepped into the elevator, the door shutting silently behind her. Patricks looked at the closed door, frowning. Then he turned and walked away, her torn ID badge in his hand.

It took about forty minutes for Promise to get back to her apartment. She walked in slowly, feeling the emptiness of the rooms, eyes fixed on the vidcube on her mantel. She adjusted its position, frowning absently. It played a continuous tapeloop of her with Maxine. Both were laughing, both dancing in their Saturday-night finery—two dark pretty women without a care in the world. Good times. Party people.

She went into the kitchen and punched out a meal. The white enamel dispenser hummed, and a thin stream of rich nutrient broth trickled into her cup. She drank, but her mind was far away.

What was it that Max had said about another drug? Something stronger than grubs? Impossible. Promise squelched a shiver of revulsion as she remembered the days, thankfully years in the past, when she had been a slave to that addiction. She remembered spending her last dollars, earned by theft or the renting of her body. How long ago was that? Eight years? Nine? How old had she been, twenty?

But the price of chemical ecstasy was a dear one, paid in

flesh and spirit. At last, desperate, she turned herself in to Dr. Cecil Kato's detoxification clinic. After three months of searing agony she found real freedom at last.

And now Max, who had been there herself, who had struggled through the same process for the better part of a year, said that there was something better.

Impossible. She had gone back to the grubs, that was all.

Still, something in Promise that was frighteningly strong and hungry, even after a decade, wondered. . . .

*Fright wig?* Promise had loaned Max one of her old wigs three weeks before. Max had returned it, laughing, calling it a "fright wig."

Promise dropped her cup of broth and ran into her bedroom, to the closet. She threw the door open, gasping as a severed head glared down at her from the shelf. She shook the image out of her mind and took the styrofoam dummy down, peeling off the shaggy afro wig. There was nothing on the dummy, so she turned the wig inside out.

And there it was. A small, dark bottle and a glassine envelope with a slip of paper inside. She opened it and unfolded the letter. It was a note, which read simply:

"Promise. It's the best I've got, and the least I can do. Max."

At the bottom of the paper was a dark watermark or an emblem of some kind. It was circular and looked rather like a ribbed doughnut, with a blank spot in the center. An inkblot? She rubbed her fingertip across it thoughtfully, vaguely surprised when the mark smeared. She folded the paper and replaced it in the envelope.

She examined the bottle next. It was opaque, so she shook it, listening to the contents rattle. Something in there, all right.

A hand fell roughly on her shoulder and Promise gasped in surprise as she was swung around. Automatically, her knee came up for a groin blow, but a calloused hand brushed it easily aside, and the back of the same hand landed brutally across her face.

She spun back and fell to the carpet, looking up in shock.

There stood two men. Neither was dressed like a cop. One was a Latino, heavy with muscle and only a slight swell of paunch detracting from the image of a massive man in extremely good condition. He wore an elasticized stretchsuit that fit snugly into every crevice and around every bulge. He grinned at her as he picked up the bottle and twisted it open.

"You don't know nothin', huh?" he sneered. The other man was perhaps in his early forties. His twisted little face was deeply lined. It showed Oriental, Black, and hard, fast living. He was shorter than the Latino, but seemed in better condition. In his right hand he carried a gun, the bore of its needle-projector trained directly between her eyes. "Well, lookee here, Chango. The lady who didn't know nothin' about nothin' has some nice little tablets."

The little man seemed skittish, maybe high on something. "Think there's more, Devon?"

"Ain't paid to think." He held the bottle up to the light.

Devon looked at her, his smile a thing of gentle menace. "No rush. I think we better take her back to the Palisades. Luis will want a word with her before she goes."

Promise found her voice. "Just what the hell are you doing in my apartment?"

The smaller man regarded her evenly, bringing the gun closer to her face. "The time you're living isn't even borrowed, Sweetmeat. It's trespassed on. I'd quiet up if I was you."

Devon hauled her roughly to her feet. As he raised her she rode the pull in and jabbed for his eyes. Devon twisted out of the way so that she only scored shallowly along the side of his face. He grinned, backhanding her a shot that brought fresh blood to her mouth and new pain to an already throbbing head.

They dragged her to the door and Chango went out into the hall first, gun hidden under his coat. Devon threw her purse in her face and then dragged her out and into the elevator. It sank to the parking level.

It was cool in the basement, and quiet. Most of the cars were hooked up to the charging posts that sat at the head of every space, current trickling into the batteries powering the electric engines. One dark blue sedan stood against the far wall unattached to any post. Promise knew that it was her destination.

She tried again to twist free, but Devon anticipated her. His grip sank brutally into her arm. Conscious only of her pain and fear, Promise could hardly recognize the bubbling sounds that rose in her throat as her own.

Chango moved forward to the car and pressed the tip of his index finger against the photocell on the door handle. It opened. Fast.

The door slammed into Chango's body, and he was thrown back, the needle gun spinning from his hand and clattering

across the floor of the garage. Out of the car exploded a dark figure that rammed a shoulder into Chango so that the man stumbled and fell, skidding on his butt, face slack with shock. Devon tossed Promise out of the way like a plastic puppet, and charged the new man. They ran directly at each other for a few steps, then the stranger hit the ground and spun, cutting Devon's feet out from under him.

The stranger stumbled getting back to his feet, and his next inhalation was painfully choked. Promise saw something like sick alarm clouding his face. He gulped air and wrapped thick arms around his midsection.

Chango got to his feet and said, "Aubry?" shaking his head before charging in.

Sweat had broken out on the stranger's face, as if he were fighting with weighted limbs. As Chango came in, the stranger spun, his left heel burying itself in Chango's chest with a terrible crunching sound. Chango smashed back into the wall.

The stranger was wracked with spasms now, and he bent over the hood of the car, retching.

Devon staggered to his hands and knees, eyes on the attacker. He reached into his pocket for a knife, and never saw Promise pick up the gun and turn, face twisted with hate. He heard the hiss of the projector an instant after the expanding needle ripped into his chest. He was dead in less than two seconds.

She swung to cover the stranger, clenching her teeth to keep them from chattering. He wiped his mouth and walked unsteadily to Chango.

He knelt down and spat on the concrete floor. "Where is he?" His voice was ragged.

Chango shook his head slowly and coughed, a bubble of blood sliding from his lips. The stranger bent nearer. "Where's Luis? You're dying, but I can make it harder for you." He reached out a shaking arm and placed the ball of his thumb on Chango's right eyelid.

The wounded man gurgled and swallowed, whispering, "No."

The big dark man stood, staring at Chango almost vacantly. Softly, he said, "You're a better man than he deserves."

A smile flickered on Chango's lips for a second, and he tried to say something. Then his body stiffened in a convulsion and he died.

The victor turned, to look directly into the barrel of the needle gun. Promise's hands shook. "Wh-who are you?"

He was still breathing hard, perspiration spattering on the floor as he shook his head. "Give me that."

She took a step backwards. "Just who the hell are you? What is all this about? Who were they? Who the hell is Luis?" Her eyes swept the carnage in the garage, and she shuddered.

He wavered, stumbled to catch his balance.

She winced empathetically. "What's wrong with you?"

His mouth opened and he collapsed towards her. As he did his arm snaked out impossibly fast to pluck the gun from her hand. In the same instant, he regained his balance. Promise stood unmoving, shocked speechless.

"Listen." He was still fighting for breath. "Would you rather talk or survive?"

The gun wasn't pointing at her. She breathed a sigh of relief. "What do you mean?"

"Luis knows who you are and where you live. He might even have a picture of you. You're in deep shit, lady."

She dug her fingernails into her palms, fighting for control. "But why? What did I do?"

He staggered to the car, fitting his massive body behind the wheel. "You coming?"

"Do I have an option?"

"Sure, baby. Live or die. That's it."

He was regaining control of himself quickly. *He could make me come, but he isn't playing it that way.* She ran the variables through her mind as quickly as she could, filed the unknowns for later reference, and made her decision.

She looked into his expressionless black eyes. When she spoke, her voice was a careful mixture of caution and vulnerability. "I can't trust you . . ." She let a touch of desperation onto her face. "Can I?"

"You have to decide that for yourself."

Her glance moved from him back to the elevator, then to the inert bodies on the floor. This man was lethal—there was no question about that. But he was also sick in some way that she didn't understand. She clamped down on the thought— another variable for later.

"All right," she said. "But only until I have a chance to think." She walked over to Devon and dug in his pockets until she found the letter and the vial, and slipped them into her purse.

He looked at her curiously. "Is that what this is all about?"

Promise narrowed her eyes. "You mean you didn't *know?* Why the hell did you buy in?"

He offered no explanation, merely leaning over to unlock the passenger door. She ran around and hopped in. With an electric hum, the car lifted on its springs and glided out of the garage.

She sat, huddled in her corner, dazed, watching the awesome man with the scarred hands smoothly pilot the car out of the garage and into traffic. "Who *are* you?" she whispered, fighting to retain balance.

He turned to face her, the weakness washing out of his face with each new breath. "My name is Knight," he said. "With a K."

He swung onto the CompWay, switching the car to automatic. He dialed southeast, into town. "I bought in because Ortega wants you. If you're valuable to him, you're valuable to me. And because you know Maxine."

"Mouse? What has she got to do with you?"

Despite the autopilot, his hands were heavy on the wheel. "Because of her, I did five years in stir." His eyes flamed, then clouded. "She set me up for Ortega, and I'm going to—" He had to swallow to get the words out: "—kill h 'r."

Promise was silent. She looked out of her window at the other cars on the La Brea CompWay, at the climbing glass spires and dancing holobillboards she saw so often and paid so little attention to. Then she took the bottle out of her purse and held it, shook it, and heard the pills rattle, and felt hatred for them. Such small things, but important enough to kill for. She studied Knight's face, finally recognizing him from the hospital waiting room. "Did you follow me to my house?"

"No, I followed Chango and his friend. They were at the hospital, although they didn't see me. When you went upstairs, they left. They looked like they knew where they were going."

"You knew his name."

"We used to work for the same man."

Silent again, she watched the approach to Washington Boulevard, with its office towers and business people walking to their jobs and appointments. For most of them, the day was near to ending. They would go home to their tridees and chilled martinis. There would be love in their lives, and stability, and safety. Some would be planning vacations to Paris, or the Bahamas or Orbit II, and maybe a few would go to the Arcade

to drown their troubles in sound and light and direct induction.

Maybe she could tell Knight to stop the car, and she could get out and just blend into the crowd. . . .

But the weight of the bottle in her hand brought her back to reality, and she sat back stonily into her seat.

She didn't know where she was or where she was going, but her only hope was to remain as calm as possible and play out the hand she had been dealt.

Aubry watched her out of the corner of his eye. Promise glanced at him quickly, then turned away, showing nothing but a flash of fear and an exceptionally full profile.

The car came to a gliding halt. The buildings around them were old but colorful, and there was sound in the streets, strange music that blended a dozen cultural rhythms into a pulsing melody. There were sharp, rich smells—tomatoes and pork and chicken and spices of innumerable kinds blending from a hundred windows, and she realized how empty her stomach was. Aubry jerked his head towards a peel-painted four-story building. "It's where I stay. Do you want to come in, or . . . ?"

"I don't have anywhere else to go." Her eyes fixed on the street ahead. "What do your friends call you?" She asked hesitantly.

"I don't have any friends."

"Maybe you just made one."

He grunted without speaking and swung his door open. He paused outside the car and stuck his head back down. "Aubry'll do."

"I'm Promise," she said, trying to find the right amount of warmth for her voice. She followed him from the car, so lost in a tangle of worry that she almost walked into a drone taxi. Its radar picked her up in time to shimmy to a halt. It squealed at her.

"Watch yourself," Aubry said disgustedly, and led the way across the street.

There was a tattered rooms-for-rent shingle projecting from the building, faded and weatherworn, creaking on its hinges in the wind. The building looked as if it had been cobbled together out of scrap pieces of wood and plastic and steel: riveted, glued, bolted, wired, dovetailed, and prayed into place.

The front door looked like a metal security door salvaged from a fairly classy old hotel. Inside it was dusty but not filthy,

and Promise gave thanks for the lack of crawling things.

The halls were lit with low-wattage gloplates and a series of burnished metal mirrors that relayed light down from the roof. The air didn't flow evenly through the building; it seemed to pool and eddy, collecting in stale pockets here, there distributed by a gust of wind whistling through the inadequate paneling. Behind some of the doors Promise could hear radios blaring the latest fusion of classical and Indo-Chinese music, or heartbeat-adjusted synthesizer jazz.

Aubry led her up a set of stairs and opened a splintered wooden door for her. "Ain't much," he said flatly.

And he was right. There was a rickety bed, a couple of straightbacked chairs, a little microwave oven with its solar panel flagging forlornly out the window, a dresser, and a dingy white refrigerator. An aged compactor toilet squatted in the corner. The room looked like a hundred cheap hotel rooms whose ceilings she could describe from memory.

Promise sat down on the edge of the bed and watched as Aubry went over to the refrigerator. He pulled out a crudely made sandwich and held it up to her.

She met his eyes squarely. "I want to know what's going on."

He shrugged and shut the door, sat on a chair facing her and started to eat.

She waited patiently, using the time to absorb as much about him as possible, distracting herself from the fear chewing at her nerves. She noted the scars that creased faint lines into his face, the strength of his blunt fingers, the compact massiveness of his body. An image of the garage fight flashed in her mind, its spectacular beginning and strange end.

And on the tail of that image, Maxine, swathed in bandages.

"What did Max do to you?" she asked, unable to hold the question any longer.

Aubry shook his head. "This is *my* game. What about you and the Ortegas?"

"*The* Ortegas? Everybody hears talk, but I've never dealt with them, thank God."

"Then tell me about you and Maxine."

"I helped her. I used her to pay a debt."

"What kind of debt?"

Promise carefully dropped her control over her plastiskin. It lost its dark brown hue and began to pulse with color. Aubry's

jaw fell open. "Damn! What the hell *are* you?"

Promise glanced quickly at her left hand, and turned it brown again. "What's the matter? Never seen an Exotic before?"

"Yeah. I guess so." He nodded slowly. "I been away a while. You forget a lot."

"I guess so." She paused thoughtfully. "I used to be addicted to grubs. A very good man got me off of them. He only asked that I pass the favor on, help someone else get free. She was my third try, the only one that worked."

"When was this?"

"About three years ago. After she got clean I helped her . . . get work. Gibbs Agency. Party people."

"That figures. Luis parties through them. He may even own 'em. You sure you never made one of his parties?"

"He sounds like someone I'd remember. Anyway, she didn't trick too much. She had a steady old man—this guy Ornstein. She was trying to straighten out her act, as far as I can see."

"Do you still work for Gibbs?"

"No. I free-lance."

"How'd you know Maxine was in the hospital?"

"Dr. Patricks. I couldn't make much sense out of what Max told me when I got there. Something about some drug more powerful than Coal-Moth larvae. Told me where to find a sample. I came home—"

"Did you tell anyone what she said?"

"Hell, no. I came home, found the bottle, and got snatched. That's where you came in, and that's all I know." Her hands were trembling, and she interlocked her fingers to disguise it. "What about you?"

"I used to work for Luis Ortega, until I made the mistake of thinking I wasn't a slave. I don't feel like going into it. All you need to know is that he set me up, and he used your little friend to do it."

"W-won't you tell me about it?"

"No."

She wiped her hands on her dress. "So, you want Ortega?"

"And your precious Maxine. I was tracing down a lead on her when I found out she'd put it to another boyfriend but got caught with her fingers in the cookie jar. I figured to hang around the hospital to see who came to visit her, and *you* showed up. Two of Luis's boys left as soon as you arrived. I followed them back and waited. Lucky you."

"What happens now?"

"Not sure. Max ain't going nowhere for a while, so I guess I start with Luis."

In a voice so small that she could barely hear it herself, Promise said, "I think Max was set up."

Aubry's laughter was loud and harsh. "Do you, now? What a joke. I suppose you think Ortega did it."

"I don't know. From what Maxine said, five years ago she was just another junkie, just like I was. And I know that I would have done anything, any damn thing, to get another fix. That's why I quit. That's why Max quit. But she's not a junkie now; and I just don't believe she'd kill her boyfriend. I don't know what to do, but I've got to help her to help myself."

Aubry grinned nastily. "And how are you going to do that? Ortega's people know who you are now. They might even have pictures."

Promise thought frantically. *He's right. Not much time. I can run though, and keep running until they catch me.*

"If you're going to do something," he said, "it had better be soon. You'd better get on the job. The door's over there."

*Or I can fight back, if I have the right weapon....*

After a long moment, Promise lifted her head and smeared her face dry on a sleeve. "You. You could help me. You're strong. And you know what I'm up against."

"Not me, lady. As far as I'm concerned, your friend can be diced up for spare parts. Or stand trial and find out how she likes the sisterhood in the state pen." His voice got even colder. "Or come back onto the street, where I can get my hands on her." He grinned nastily. "I don't know if you're telling me the truth. I'm not sure I care. It'll be hard enough working by myself. Why should I drag you around with me?"

Promise met his eyes. After a moment, he turned and studied the floor. She stood, taking the three steps between them as carefully as she had ever walked in her life.

"You bastard," she said evenly. "You'd just throw me out on the street, knowing what's going to happen? Just what are you? What did they do to you up at that prison? I don't know what you went in as, but you didn't come out a man."

His eyes flared, and she came just a step closer, until he could smell the perfume in her hair. "I'll bet they took your balls, didn't they? I'll bet that all you can get hard is your muscles—"

His hand moved before she saw it, the palm slapping across her face. She rolled with it, but the shock still whiplashed her.

Aubry started to turn away, and she saw the sickness in his eyes. Instinct told her that she had only a moment before he went over the edge.

She grabbed his arm and pulled him around, making a spitting sound into his face. He grabbed her shoulders and pulled her to him, staring. She could *feel* it, the surge of emotional alchemy that was changing his anger into something quite different.

With a flip of his wrist he tossed her onto the bed and stood over her, face a mask of warring emotions. She curled onto her side, watching him, and sneered. "What's the matter, big man—don't you remember what to do?"

Promise melted the hardness of her face, her lips curving into a practiced smile. The tip of her tongue moistened them, made them glistening wet invitations. The burnt umber on the left side of her body faded, and in its place there was a pool of clustered lights, moving and changing hue to a heartbeat rhythm. "How long has it been, Aubry?"

He moved like a man with rust in his joints, his big rough hands taking her by the shoulders to press her down. With surprising strength, she resisted. "First," she said, chin lifted to him, breath moist and warm on his face, "will you help me?"

Aubry's fingers gripped savagely. "I can *take* it, woman."

"Of course you can. And you can make me do whatever you want. But do you want *me*, Aubry?" Her voice was strong now, stronger as she felt his body tremble. "Do you want *me?*"

He bent to kiss her and she turned her face to the side so that his lips brushed the glowing plastiskin. He pulled back and said, "As long as you don't stand between me and Maxine, I'll take you with me."

"Do you swear?" Her skin pulsed in a slow rhythm, reflected in his eyes.

His eyes were direct and honest when he answered. She knew he spoke the truth. "I'll do it." She closed her eyes and ran her hands along the undersides of his arms, feeling the hard muscle.

"All right then," she said at last. Her eyes opened, and they seemed to be bottomless dark pools, but there was no scream of protest as he was engulfed in their depths.

# 6

## Cyloxibin

Aubry Knight sank back in the seat of the blue coupe, the dim light fading him to a shallow, massive shadow. He watched the street: the few cars sliding quickly by, the tight multiracial knots of youths on their way to whatever the night might bring. The distant sound of breaking glass rang in the air, and the smell of unburnt garbage was a pungent perfume. Across the street from the coupe was a door covered in broken, concentric rectangles. A raucously dressed pair of women strode up to the door and knocked. Their fluorescent makeup flared as a square panel slid back. There was a conversation full of harshly accented words, and the door opened to admit them.

"Real classy place there."

Promise said nothing, her eyes darting from the closed door to a group of strangers approaching from behind the car. On each face crouched the Thai-VI Spider, a silent scream in black and red. Their slight loss of coordination was concealed with a measured stride. As they approached, the sidewalk cleared of pedestrians.

"Spiders," she said nervously.

"Roll up your window."

She nodded, complying. The gang stopped as it passed and looked at her, laughing. A huge Black woman with most of her upper teeth rotted away pressed her face against the window. The glistening wet rings of advanced Thai-VI left circular slicks when she pulled away. She noticed Promise's shiver of disgust and laughed, a nasty hollow sound as the Spiders continued on their way. The last of them to pass the car kicked at

the window, jarring the vehicle on its shocks without damaging the clear plastic.

Aubry watched them disappear around the corner. "This is the fourth dive we've been to tonight. I'm getting a little tired of this."

"Think of it as a wilderness excursion. A broadening of your horizons." Promise squeezed his arm and then reached for her door handle. "Let's go."

Aubry tch'd and got out of the car, all senses alert for violence or its seeds. Promise felt the hair at the back of her neck tickle as soon as she closed the door behind her, and walked swiftly around the car to take Aubry's arm. *I don't know what's wrong with you, big man, but you're still my best bet, and I'm sticking close.*

Promise rapped at the door, and a panel slid back at head level. A vast flat expanse of face met them, eyes dull but not disinterested. "Marks or dollars?" the guard said, his voice growling up from deep in his throat.

"Marks," she answered quickly. Technically, an establishment was obliged to accept dollars for goods and services. In reality, US currency was often refused in favor of the more stable Service Marks circulated by the multinational unions and trade guilds. The man grunted, glanced at Aubry, and opened the door.

The guard startled them. He was both an Exotic and a NewMan, one of the supermen genetically engineered from XYY ova in the Male Separatist camps of New Mexico and Arizona. Hormonally enhanced and, some said, conceived and brought to term totally *in vitro*, they were barely human, towering hulks of sharply defined muscle and abnormally thick bone. Aubry and the NewMan regarded each other carefully as he entered. The NewMan wore makeup horns and hooves which, along with his physique, suggested a Minotaur without further elaboration.

The NewMan sniffed hopefully. "You brother?"

The mistake was a natural one, given Aubry's size. "Null-boxer," Aubry said. The friendly expression on the guard's face died, replaced by envy and grudging respect. NewMen were denied athletic competition with normal humans.

He stepped aside and let them pass. The interior of the bar was blue with smoke. Aubry could smell grubs in the air, a minty mixture of citrus and burnt blood that tickled at his nose

seductively. The chairs and tables were laid out like the twisting walls of a maze, the partitions of each booth linking to form corners, dead ends, and corridors. The Mark-size dance floor was the lowest ring in the Maze, and from the highest tier it was possible to survey the entire club.

The two of them were seated, and Promise ordered an iced liqueur to Aubry's beer. She sipped at it gingerly, peering through the haze.

The distortion beam flickered over the dance floor, and couples began to gravitate toward it. Once under the light their bodies were twisted into impossible funny-mirror freakshows, all with light and color and the visual effects of a brain-busting hallucinogen. He watched as a fat woman flattened into a ribbon of flesh that stretched to the ceiling. Her partner, a tall, un-healthily pale man made taller by platform heels, widened into a disk. Aubry sighed with disgust.

Promise pointed to a darkened corner on the far side of the room. "There he is."

"Now, that's more like it. Let's go."

"Not us, just me. Let me talk to him."

A trickle of suspicion ran its course, and he nodded. Aubry crossed his legs and watched her walk away, liking the way her body moved under the tight shift. He had never seen a woman move like that. It wasn't as if she was moving her body to make it attractive to men—it was more than that: totally, utterly feminine, and totally under control. The combination made him feel uncomfortably warm, and he withdrew, looking around the room with cautious eyes. It felt strange to be in a roomful of happy people, even people pretending to be happy. In the middle of the Maze he had little to worry about from police, but it was still impossible to keep his eyes from roving, his back from knotting reflexively, if someone passed too closely behind him.

Promise crossed to the other side of the room. He saw her approach a table which seated two large men, one of whom was clearly Oriental. That would be Cecil Kato. Promise hugged him.

Aubry growled. *Keep your hands*— He caught himself just in time to stave off a sour stomach.

The two of them finally rose and came to Aubry's table. Kato was dark for a Japanese, and Aubry wondered if there might be some Filipino mixed in. He seemed amiable enough,

and slightly drunk. His body was very soft, as if it had never been subjected to the torture of exercise or honest work. He extended a broad, plump hand, and Aubry took it.

"Cecil Kato."

"Aubry."

"Understand you folks have a problem."

"Seems that way. Buy you a drink?"

"Hell, yes." Kato crooked his finger at a passing waiter. "Tequila Mockingbird." He plopped his elbows down on the table and propped his cheeks up on the balls of his fists. His small, dark eyes scanned Aubry's face carefully.

Knight pulled back into himself until he felt he had given up as much of his space as he could, until he felt like a compressed rubber ball ready to spring. The instant before it happened, Kato relaxed, a satisfied smile on his face. The waiter returned with a tumbler. The doctor drank, peering over the edge of the glass at Promise and Aubry with an expression that combined humorous curiosity with private knowledge. He put his drink down. "Cuervo and Thunderbird wine," he said. Promise rolled her eyes and made a gagging sound. "No sense of adventure, that's your problem."

Promise reached out an expensively manicured hand and laid it on Cecil's arm. Her voice was low and sincere. "This could be serious trouble, Cecil. Are you sure you want to help?"

Cecil took another sip, then put the drink down, screwing his face at Aubry in a little-boy mask of disgust. "Friend, you buy terrible drinks. So terrible, in fact, that I can't think of any reason for staying to finish it. Can you? I thought not. Do you have a car? Good. I'll meet you at the clinic in, say, half an hour."

He stood away from the table, winking solemnly at Promise. He started to turn, then a thought caught him and he bent back down. "By the way, how's our friend Maxine?"

Promise said nothing, but for an instant she lost control of the left side of her face and a flash of light peeped out. She lowered her head. Kato's smile went dead. "I think we had better make that twenty minutes," he said, and disappeared into the crowd.

Although obscene graffiti speckled the ruined and ramshackle buildings of the Maze, there were surprisingly few superfluous markings on the exterior of the two-story building labeled "Inner Los Angeles Drug Clinic." There was a con-

spicuous lack of trash in the area. Parking his car behind the building, Aubry had the impression of neutral territory in the midst of a war zone.

Promise struck up a cigarette, the momentary flare painting her face in shadow and white light. A muscle on the side of Aubry's jaw bunched as he fought the urge to touch her. Not now. Later—on his terms. "What is it with Kato? His clinic is the only clean thing on the block."

"In the Maze."

"Whatever. Does he walk on water, or what?"

She blinked slowly and blew a mouthful of smoke out the window. "He's a crazy man, I guess, and he's been fired from more hospital staffs than he can count. But this is one of the few places people can come to get help. Most of them don't stay helped, but they know that Kato cares—he's proved it too many times."

Kato's little double-seater wheeled silently up next to them. He eased himself out almost before it had come to a complete stop. Aubry whistled in silent amazement, wondering how the man had managed to wedge his bulk into so tiny a space. "A wild drug, you say?" he muttered, thumbing the rear door of the building. A rectangular block of reinforced steel and plastic, it hummed open. They followed him into the dark.

"Where did you get that stuff?"

The bottle bounced up and down in Promise's hand. "Max left it for me. Her letter implied that she'd been taking it and that it was like nothing else in the world."

He looked back over his shoulder at her as he flicked the lights on. The hall was bare and thin-carpeted, but Aubry felt comfortable in the building, safer than he had in recent memory. "Do you believe that kind of story? Wonder drugs usually turn out to be somebody's kitchen-sink concoction, slapped with a fancy name and sold to any hype with veins big enough to swallow it. Well, let's take a look."

Kato took a left turn into a sparsely furnished lab. There were a host of things that Aubry didn't recognize, a pressure inoculator which he did, and a rack of sealed plastic bottles, tubes, and slides. He flicked on the light and then a machine that looked like a tiny aluminum oven. "All right, let's have it, gorgeous." Promise handed it to him, and he shook it. "Hmm. Four of them. Any idea what the effective dosage is?" Promise shrugged. "Well, let's find out what it is, and then we can take a guess."

He tweezered one of the tablets out, sniffed it, and crushed it into a tiny ceramic holder. Then he opened the door of the "oven" and dropped the holder into a rack, screwing a metal cap on it. He closed the door and pushed a button. A shushed pumping sound thrummed through the floor. "Take a few seconds to evacuate the air, then we can analyze this mother. Come on over."

The metal-frame swivel chair in front of his computer screen received his bulk with a squeak, and he hummed as the screen cleared and started its program run. "Any idea where she got this?"

Promise sat on the edge of his desk and peered over his shoulder. "Max said something . . ." She chewed at the inside of her lip. "She might have been saying that she and her boyfriend Ornstein—"

"Larry Ornstein?"

"That's the one. She said it came from County General. Does that make any sense?"

"It might. This is a standard sample bottle. We'll see." The screen began filling with abstracts, geometrical symbols, and numbers. "We're getting something. Now we'll see."

Promise looked over at Aubry, the lines of her face drawn together in tension. He nodded silently, standing back near the analyzing device. He touched it with the tip of his finger, drawing his hand back quickly. It was hot.

The screen's abstract shapes gave way to formulas, and Cecil leaned his face up close to it. "Phew. Will you look at this mess?"

"What is it, Cece?"

"You tell me. It's a *looong* organic chain. Look at this." His finger traced a line on the screen. "$CH_2$, $CH_2$, Nitrogen, Carbon, Carbon, Oxygen. Holy . . . what in the world? Will you *look* at that carbon chain?"

His face was a mask of frustration mixed with delight, like a small boy who's found a butterfly that doesn't match any of the pictures in the book. "Wait a minute. I want to query something." He typed for a minute, and the screen cleared, then swiftly printed a reply in white script. "This looks like a synthetic organic to me. Part of it reminds me of a *Psilocybe*, or a mescaline." He turned around in his chair and grinned at them both. "You know, this *does* look cobbled together, but it was no kitchen-sink job. We've got eight, maybe ten separate tryptamine derivatives. Must be psychoactive as hell." He threw

up his hands. "I don't know *what* it is, but I bet I know who does."

"Who?"

"The central computer at County General. Maxine . . . Larry . . . the sample bottle . . . this analysis . . . I'll lay you odds that this is one of the antagonist drugs we experimented with before they clamped down. Ornstein had access."

Promise pulled in close to him. "Can you get into their bank?"

"I can damned well try. I've been feeding the results of my work into them for the past four years. They change their codes, but in a *remarkably* unimaginative manner. Let me try." His fingers flew over the keyboard.

Aubry felt lost, and it wasn't a comfortable feeling. He scratched an ear and tried to think of an intelligent question. "What's this antagonist crap?"

Cecil chuckled. His fingers were a blur. "Grubs are cross-tolerant. Self-limiting. If you take too many in too short a time, the effects drop off and you have to take a *humongous* dose to get high. Well, the search started for a substance that produced a mild set of grub responses, but blocked the cravings and rendered the drug itself ineffective."

"Tall order." Promise watched the computer blink: RE-STRICTED ACCESS. Cecil cursed and started over again. "Did you have any success?"

"Sure. What we wanted was something we could use as a skin implant, that would disperse its drug over a period of— oh, say six months. That would give us time to do a little head-rewiring. I mean, why bring someone back into the real world unless you're going to give them the emotional tools to survive, eh? What did Patricks *do* to this program?" Inspiration spread across Cecil's face like a wind-whipped brushfire. "Wait a minute. Once, when I was in Dr. Patricks's office, I caught the first three elements of his wall-safe combination—it was an arithmetical progression of his own name. I'm going to try that."

The screen cleared, then he typed:
PATRICKS
QBUSJDLT
RCVTKEMU
And the screen read: ACCESS DRUG REHAB PATRICKS EYES ONLY QUERY?
GRUB ANTAG RESULTS FINAL PROGRAM?

Promise kissed him on top of the head, and he beamed like
a fourteen-year-old science fair medalist.

ANALYSIS.

"Look at this. Except for binding agents, we've got a match."

PHYSIOLOGICAL.

The screen filled with figures, and he scrolled them as quickly
as he could absorb them. "Fairly standard here. A lot like the
popular hallucinogens. Pupil dilation, heartrate increase.
Breathing fast and shallow, digestion inhibited, sweat in-
creased, skin blood vessels constricted. Let's see—we have
some other adrenal activity inhibition. . . ."

"Wouldn't that be less of a turn-on?" Promise asked.

Cecil grinned lasciviously. "Naw. Adrenalectomy often gives
ladies the hots. Hmm. Here's a curious error. Seems it was
given to a patient on MAO inhibiters—"

"It keeps them from mewing?"

"Just shut up, Promise. Monoamine oxidase. It's a cellular
enzyme, found in most tissues. It catalyzes oxidation of ad-
renaline."

"That's clear as custard."

"Back to school, sweetheart. Anyway, the lady *stayed high*.
Just didn't come down. They had to give her a shot of chlor-
promazine to cut her trip short." He scratched at his chin un-
comfortably. "Strange mistake to make."

His fingers flew again.

PSYCHOLOGICAL?

"Feels good. Nothing spectacular, though."

TOXICITY?

"Low. As low as psilocybin."

ABSORPTION MODEL?

"I want to see this on the Stage." He switched the display
over to the holographic projector next to the flat screen and sat
back as it lit up, a disembodied human brain bobbing in midair.

START SEQUENCE.

At first there was no change, then a swirl of red climbed
up the pinkish stem of the floating sponge, migrating directly
to the center.

"I'll be damned. Straight for the hypothalamus. Specifically,
the areas above the anterior and medial hypothalamus. A high
concentration in the lateral geniculate suggests that it's con-
nected to the catecholinergic tracts." There was a conspicuous
silence in the room. Promise and Aubry were staring, openly
dumbfounded. "This is just a guess, but I'd bet that someone

under the influence of this drug would have massively exaggerated response to all stimuli."

"Maxine said that it was like nothing in the world."

"Strange. All of the patients state that the drug is very pleasant. That's about as far as it goes." The corners of Cecil's mouth fought to keep from curling into a frustrated grimace. "Well, *damn*. Are you *sure* she didn't say anything about dosage? Maybe you were supposed to take all four of the tablets?"

Promise stood, eyes closed, trying to remember the scene. Maxine's gauze-swathed face, the broken whisper of her voice, and her injunction, "'Take it with someone you could love.' That's what she said, Cecil."

"So this was supposed to be enough for two people. Maxine, who has been around enough to know, said that it was totally beyond anything she had ever experienced. And this gang—"

"The Ortegas," Aubry snapped.

Cecil's brows drew together. "I've heard that name somewhere. . . ." He shook his head. "Anyway, all right, the Ortegas. They're willing to kill to get hold of it." He kicked his feet up on the desk and thought. "I have to try to come up with something that makes sense—a conceivable event sequence. Let's say that the drug is synergistic in nature. Maybe when it's taken in combination with another drug, or within a specialized situational framework, it goes crazy in your head. Somehow the Ortegas got wind of it—"

"Patricks," Promise said grimly.

"What makes you say that?"

"The questions at the hospital, the thugs that followed me home. He's tied up in this."

"I really don't like to think about that, but let's imagine that it's true. Patricks develops the drug, then discovers that in some set of circumstances yet unknown it becomes exponentially more powerful than these reports indicate."

"Those reports could be faked," Aubry said sullenly.

"Eh? Why fake reports and then put them under security?"

"*You* got into them, didn't you? It's a big mistake to think that you're the only one smart enough to do a trick." There was a calm matter-of-factness in Aubry's words that cut through any irritation that Cecil felt.

"Point well taken. All right, Patricks knew he had something worth protecting . . . stealing for, killing for. . . ." His voice broke a little when he said that, then strengthened again. "So, he made contact with this Ortega, someone who knew how to

handle drugs, and made a deal. And part of the deal..." He steepled his fingers meditatively and closed his eyes, thinking, that slight smile curling his lips. He looked for all the world like a dark-stained stone Buddha.

"Part of the deal," Aubry finished for him, "was to clean up the tracks. No one gets to know where the shit came from."

Promise looked at him with curiosity and respect warring in her face. "So, Ornstein dies, and Maxine gets chewed up. And the reports in the computer are faked?"

"Maybe not *faked*," Cecil said softly. "You forget, several of those tests took place at my clinic. I *knew* some of those people—Maxine, for instance. *I* submitted some of the reports on the drug's action. So, let's say that something has been omitted from the report. Something that Patricks learned later. That Ornstein and Maxine discovered...."

Promise's memory rolled back over the previous weeks. "Maxine had been seeing this Ornstein pretty steadily. Could...? No." She shook her head. "That's pretty ridiculous. Drugs don't act like that."

Cecil sighed in irritation. "This isn't an ordinary drug. Go ahead and say it."

"Well, it..." she glanced at Aubry, who was sitting on the edge of a counter, his arms folded, the tendons in his forearms crawling slowly. "Maxine seemed really gone over this Ornstein. I mean, no holds barred. First blush of springtime, you know? I saw them together a couple of times, and she just couldn't keep her hands off him. It was kind of strange, really."

"Maxine was pretty far gone when you brought her in," Cecil said. "It's not uncommon for emotional attachments to form between patients and nurses, doctors, therapists...." He shrugged his broad shoulders. "That's one of the reasons it's considered a violation of trust for any such liaison to develop. Ornstein was breaking strict clinic rules with Maxine."

"She had her ways," Aubry hissed. "She got what she wanted—" He started to say more, but suddenly that sick expression came back to his face and he wobbled on the edge of the desk. His head sank and he swallowed hard. Promise jumped into the conversational breech.

"And she wanted Ornstein. So maybe, just maybe, the drug worked differently if you took it with someone you loved."

Cecil tore his gaze away from Aubry's struggle. "Maybe if you take it with your sexual hormones pumping full tilt...?"

Cecil's gaze was distant, and he seemed frustrated. "I'm sorry, Promise. I'm not going to try to draw any conclusions from data as scanty as this. I'm out of my depth."

"It's OK, Cecil. You did what you could."

"What now?" the doctor asked, glancing from Promise to Aubry.

"We're going to get out of here," she said. "We've involved you enough. But I can't go back to the hospital, not until this mess is cleared up. Is there any way we can use your hospital link to peek in on Maxine? I'd just like to make sure she's all right."

Aubry jumped off of the desk as though it had bit him and staggered out of the room.

"When did he get out of prison?" Cecil asked softly.

"How did you—?"

"Come on, now, Promise. The way he keeps looking over his shoulder, the way he responds to invasion of his personal space—he's a time bomb, darling. We talked about reprogramming earlier. Well, somebody did a little of that to our friend Aubry. Aversive conditioning. Pretty strong job, to look at it. Complicated, delicate, and expensive. He must be very dangerous, and very valuable, to somebody."

"He's all I've got right now." Promise smiled weakly. "I'm out of my depth too."

Cecil's fingers clicked out a pattern on the terminal. The display cleared and clouded again. "Did you say she's in the security ward?" He spelled out MAXINE BLACK and waited for her chart to rise to the screen. "I can't get you visual, but I can tap into the diagnostic bank. Then—aha—here it is."

A multicolored diagram of sliding bars appeared. Under the diagram was the legend: MAXINE BLACK 0800 HOURS.

"This doesn't look to have been updated since this morning," Cecil said, frowning. The greens and reds of the graph reflected from his face, painting it grotesquely, a Halloween mask of concern.

"I don't understand what any of that means," Promise said carefully. "Is everything all right?"

"I don't know." There was a shadowy question hidden in Cecil's voice. "I've seen thousands of addicts in various stages of withdrawal, addiction, active high, and everything in between. This stinks of grubs. How long would you say she's been without them?"

"Since she left your clinic."

"She's had them more recently than that. Hours, maybe. I want an update on this woman."

Promise paced from one side of the room to the other as Cecil quizzed the diagnostic computer for the information they needed. "Got it!" he cried triumphantly. "I don't like being on this line, though. They can trace me back—" His face went slack, and his eyes widened in horror. "Shit-*fire*. Will you *look* at this?" There was a slightly different set of bars on the screen now. Even as Promise watched, some of them crept slowly upwards while others fell.

"*Look* at it. Blood pressure—up. Heartbeat—up. Respiration—up, Temperature—*way* up. Liver and kidney function breaking down—this woman is going into some kind of toxic shock, and the monitor alarm *isn't triggering!*" He gulped for air, beads of sweat glistening on his forehead like jewels. "She's *dying!*"

"Well, what is it?" Aubry came back in from the hall, curiosity easing his dizziness.

"I don't know—wait, yes I do. It's similar to a grub overdose, only . . . no. It's grubs plus another drug. Some kind of stimulant."

"Well, *what?*"

"I don't know. It could be any one of a dozen drugs that they might be prescribing for her. It's not the drug that's killing her, it's the combined action of the drug and the grubs."

"But where could she have gotten the grubs?" Promise stopped in the middle of her thought, and she whispered the next word. "Patricks. He's murdering her. He'll say that *I* brought her the drug during my visit." She was beginning to lose control, and the reflected lights of the lethal sliding bars of the video display mixed with the awakening light and color of the plastic that covered the left side of her body.

"You're right. Oh, God . . ."

"Why can't you stop it? The damned computer is pumping that crap into her veins *now*. Can't you?"

Cecil was sweating. "Stop it? No—drug's already been administered. Counteract? Not without knowing exactly what they gave her." He was talking rapidly, just voicing thoughts aloud, lost in a world of frantic speculation. "Could just as easily kill her. . . ."

"Why doesn't someone in the hospital stop it? Do they all

want her dead? Doesn't anyone care?"

"Of course they do. But it's three in the morning. They've got a skeleton staff monitoring hundreds of patients. They have to trust the computer to alert them to something like this, and it's *not triggering the alarm.*"

"Patricks," she said, her face radiating light with an intensity almost too bright to watch. Her fingers knotted in the fabric of Cecil's shirt until, with a cracking sound, two of her perfect fingernails broke right down to the quick. Blood seeped out the tips and into the fabric. She looked up at Aubry.

An expression close to sick alarm was creeping into his broad features, and his mouth framed foul words without speaking them.

Maxine's blood pressure reading had begun to flash red.

"I can try treating the symptoms. I can try to trigger the alarm from here. . . ." He looked up at them. "I'm telling you, though. I've been on this line too long already. If Patricks is in on this, he's sure as hell got the smarts to put a tracer on his files. He'll know."

"He'll know you broke into his files?"

He nodded. "And he'll know what it means."

"Cecil, they killed Ornstein. They were going to kill me. You can't risk yourself like this—"

"What do you want me to do?" He was working feverishly at the console, his fingers a blur. His head snapped up. "What if it were you, Promise? I can't stand back and watch her die." His eyes were wide, moist. His voice broke to a whisper. "I just *can't.*"

Promise looked at Aubry. The big man was stunned to silence, uncertain of what to feel. "Aubry, his mind is made up. We've got to know *now* whether Patricks is in this."

"And if he is?"

She met his eyes squarely. "Then, we get whatever information we need out of him. And then—"

He nodded tightly. "I know how to find him. Let's move. Kato—" Cecil looked up, his face locked with strain. "I don't think much of your target, but I like your aim."

Promise squeezed Cecil's shoulder and ran after Aubry, whose footsteps were already disappearing down the hall.

Kato glanced after them, then bent back to the monitor, trying with all of his skill to save a woman who was dying, alone, ten kilometers away.

* * *

"You drive," Aubry said. "I may have to duck back. It's harder getting out of the Maze than into it." Promise nodded silently and slid into the car.

"How do we find Patricks?" she said. "I could hardly ask Cecil to set up his boss."

Aubry snorted. "No problem. If he has dealings with Luis, then all of Luis's car-guidance systems will have his address encoded. Punch him up and let's get on the way."

The sedan responded positively to her inquiry and began to nose its way out of the parking lot into the street. Promise looked back at the clinic, its solitary light glowing, and shuddered. "Poor Cecil."

Aubry watched the streets. "He made his choice," he said simply.

Their vehicle was intimidatingly expensive, so they had no trouble getting through the checkpoint. In fact, they received no challenge until they reached the outskirts of Griffith Acres, the exclusive residence community their autopilot guided them to. It still maintained some of the spaciousness of the city park it had been before auction and subdivision. Even from the wrong side of the gate they could see that Patricks lived the good life.

At the gate a tiny video camera snaked out to peer through their window. "Your vehicle has conditional clearance. Your business?"

Promise put on her softest smile, hoping that she was talking to a man and not a computer-synthesized voice. "A little company, dear. A gift for Dr. Patricks from his friends."

"Having a regular party up there tonight," the disembodied voice said wistfully. "All right. Have a good time." The gate swung open, and as Promise slipped the car into gear and let it drive through, Aubry sat up from the back seat and frowned. "A 'regular party'?"

The car picked its way through curving streets, past fenced and secluded estates. Aubry checked the car clock. The guidance blinker armed as they pulled up to the gate of a cubical red brick house with sunscreened windows. "Will you look at this? This guy's been calling both sides of the coin for a *long* time."

"Light's on up there." Aubry jerked a hard thumb over to the side of the lane. "Let's pull over and wait a while—see if his guests are gonna stay all night." She nodded and put the

car on manual, pulling it over to the side of the road.

They watched, sharing the dark and the quiet. Promise dug into her purse. "Mind if I smoke?" she asked reflexively, striking the cigarette against the dashboard.

Aubry plucked it out of her hand. "Not if you do it outside, no."

She glared at him. "I didn't know you were a boy scout."

"I've just got this agreement with my lungs—wait," he said suddenly, peering up at the house. "One of the lights went out."

"So somebody finished using the can." Promise shut up as the sound of an opening door floated across the dead night air. "I think you're right."

"In that case, I'm worried." His breathing had stilled, eyes fixed on shapes moving beyond the grilled fence, beyond the strip of lawn, on the crescent drive serving the front door. Three men exited the house, closing the door behind them. They crossed to a wheelless sedan. "Is one of them Patricks?"

"Can't be sure from here, but I don't think so." The low purr of the sedan lifting itself and turning 180 degrees on a six-inch cushion of air grew louder as it coasted toward the gate.

"Pull up," Aubry said urgently. "We don't want them to recognize this car." She nodded and eased their coupe forward just as Patricks's gate opened and the aircar slid out.

Aubry was out of the car and moving before Promise had killed the motor. Cursing under her breath, she followed him. He disappeared around the corner, and she heard the whine of gears grinding. She caught up in time to see him holding the gate open, the closing arm groaning in protest. "Hurry up," he whispered. He released the gate as she slipped past, and with a whimper of relief it closed. He pulled her over to the side of the drive.

"All right," he said. "I don't have any idea what kind of defense set-up he has, so we'll play it like I laid it out."

His grip on her arm was too tight. She shook it off. "I can handle it, all right? Have a little faith."

She walked up the middle of the drive while Aubry traced her in the shadows, trying to keep bushes between him and the house.

When Promise rang the front doorbell, there was no answer. She shivered, pulling her arms close around her chest, and looked around nervously. She tried it again, heard the chimes

echoing in the house, stepped back to look up at the brooding two-story structure, its windows dark and curtained. Where was Aubry? She looked around trying to find him, but couldn't.

The reception screen blinked on, and a plain flat-image of Patricks came on the line. "I'm sorry," it said, "But I am busy for a few moments. The autobutler is paging me now, and I should be with you shortly. If you would state your business, please?" He was seated at a desk, a polite bland-faced man with nothing of force or intrigue in his manner.

"Uhh . . ." Promise looked around again. *Where was Aubry?* She felt as if crosshairs were stenciled on her back. "Dr. Patricks," she said finally, repeating the words that she had decided on, "when I talked to you in the hospital, you said to get in touch with you if there were any developments. There have been—urgent ones—and I didn't dare speak over a public-access line. It's an emergency. Please."

She waited for almost a full minute, then pressed the doorbell again. The reception image cycled back. "I'm sorry, but I am busy for a few moments. . . ."

Aubry emerged from the bushes next to her so suddenly that she almost screamed. "It's no good. I've checked all around the edge of the house—doesn't seem to be anyone here."

"Well then, why does he have the short-term message on?"

"Forget to switch?" She hunched her shoulders, and he went on. "Maybe he was taking an unexpected trip." He grinned suddenly as a cheerfully larcenous thought struck him. "In that case, maybe he forgot to arm his alarms, too."

"Aubry," she said urgently, "how in the world can we be sure they aren't armed?"

"We *can't.* Have a little faith." He crept around the side of the building, and after a swift and acrimonious discussion with her common sense, Promise followed.

It wasn't that Aubry moved silently, it was that the sounds he made seemed integral parts of the night, background noises, nothing to draw the attention. He moved in spurts, covering ten or fifteen meters in a crouched run, then paused, listening.

At last he spied an unlatched upper window. He gestured her near. "See?" he whispered. "Get around the back door. I'll let you in there." Then he was gone, his strong fingers finding purchase where her eyes saw none, scrambling up and up like a meld of monkey and black spider.

The night seemed infinitely deep and hostile as she watched him disappear into the house with a screech of resisting hinges.

When his feet disappeared into the open rectangle, Promise took her bearings, inhaled and held her breath, then ran to the rear of the house.

He was at the back door before she was, holding it open a crack. "Come on," he said quietly. "I don't think there's anyone here."

"Let's hope it stays that way."

"Chicken?"

"Don't want my feathers ruffled, if that's what you mean." She crouched close to him. "Where do we start?"

"We start by looking for Patricks's bedroom. Upstairs? Downstairs? What do you say?"

"I'm not sure. You've had more experience at break-and-entry."

"Yeah, but I'll bet you can sniff out a bedroom at eighty meters."

"Fair enough. Upstairs."

The house was well furnished, but not extravagantly so. The stairway was a spiral in the center of the cubical house, coiling on itself one-and-a-half times before reaching the second floor. "Which way?" Promise said when they reached the top, examining an empty frame hanging on the wall. She probed a button at the base of the frame, and a holographic sculpture of a bisected human body appeared there, blood pumping as they watched. She turned it off. Aubry had already moved down the left branch of the hall. There were three doors, two on one side and one on the opposite wall. Aubry eased one of them open with his fingertips, saw that it was dark, found the light strip, and ran his finger a third of the way up. By the dim light it was clear that it was a work room, with a small library attached. There were papers strewn on the floor. Books had been pulled out, tapes and data cubes and holo plates ripped and broken on the desk, electronic instruments shattered on the floor.

Aubry whistled low.

He crossed to the next door and opened it a crack, then opened it wider. He jerked his head, motioning for Promise to follow.

It was a bedroom, and judging by the wealth of electronics and comfort accessories, almost certainly Patricks's own.

There was a refrigerator and microrange built into the nightstand. The bed was diamond-shaped, and the blankets were some gossamer-thin material that glowed in the dim light.

Promise sighed. "This bastard lives just too damn good."

"I'll try to do something about that. You must have stretched out a few toppers. Where did they keep their candy?"

"I'm not sure he'd have any, Aubry. 'Them that deal don't do,' and all that."

"He didn't deal it, he cooked it up. And even if he isn't a junkie, he still might have a personal stash."

"Try the medicine cabinet."

"Cute." There was an adjoining door. Aubry nudged it open, flicking the lights up halfway. "Well," he said in disgust, "I think we can stop looking for Patricks."

Part of Promise knew what he was saying even as she moved to follow him, but another part hung back, pretending that there could be more than one interpretation of the words. By the time she crossed the threshold of the bathroom, she knew that she was lying to herself.

A sunken tub had been installed in the bathroom, surrounded by white synthetic fur carpeting. Promise hoped it was synthetic. She doubted if that much blood would ever wash out of natural fabric.

It was splotched and puddled, gumming brown, at least a liter of it in the fur. There was more on the white ceramic of the tub itself, and even more running in cracked rivulets on the twisted and ruined body of Dr. Patricks.

Aubry tried to look at the thing in the tub but couldn't, suddenly dizzy. He turned and staggered, catching himself on the washbasin with both hands. Promise shut the wet sounds out of her mind as she examined the corpse.

He was stark naked, hands and feet bound with wire and fastened to either end of the tub. There didn't seem to be a centimeter of his body that was not bruised, burnt, or torn. A gooseneck lamp had been twisted down to shine directly into his eyes. There was a half-melted bucket of ice cubes sitting at the head of the tub. Patricks's lidless blue eyes stared sightlessly into the ceiling, and beneath his gaping mouth was a second, lipless red maw that stretched from ear to ear.

It was repellent and fascinating at the same time. She was horrified to hear a small voice in the back of her mind say, *That evens it for Maxine. . . .*

Aubry staggered out of the room, and she followed. As she stood, the barriers she had erected in her mind, that had kept her going for the past thirty-six hours without sleep crumbled

with the abruptness of a rotten bridge giving way underfoot. The events of the past day hit her a sledgehammer blow and she felt her vision blur, her guts twist like a rubber band. There was a flash of light and then blackness. When she opened her eyes, Aubry was crouching over her.

"I think," Aubry muttered, "that they got what they wanted out of him."

"Why?" she said dizzily. *Odd . . . a moment ago I could look at Patricks as if it were all make-up and cherry jell-o. Now, even bringing the image to mind makes me want to puke.*

Aubry steadied himself. "The throat. They cut his throat when they were done. A reward."

*"Reward?"*

"If you were Patricks, believe me, by the time they delivered that cut you'd be grateful."

"All right, all right. A reward for what?"

"What do you think they wanted? He talked. He told them what they wanted to know."

"All right. Do you know what it was he told them, Sherlock?"

"What?"

"Sherlock. Holmes. Don't you read?" There was a moment of strained silence, and then she sighed. "Right. He was a big detective."

His voice was steadier, but she could detect a tremor when his eyes flickered to the open bathroom door. "He probably told them about the drug. Everything they wanted. Formula, source, whatever it was." He wiped his finger on the carpet. "One more thing. Maybe they killed him because he didn't give them any other choice, got too greedy. Or maybe they're still tidying up after themselves."

A horrible thought was forming just below the horizon of conscious thought. "Let's say that's what they're doing. That they're killing everyone connected with it. Ornstein. Maxine. Patricks." She paused hesitantly, "There's still me. They want the drug. But maybe if I can get it back to them . . ."

Aubry shook his head. "I think it's too late for that. Just hope it's not too late for your friend at the clinic."

Promise paled and spun on her heel. "Oh, no . . . Cecil. . . ."

Aubry carefully wiped the doorknobs clean behind them and followed her out, his mind filled with new questions. Behind him, Patricks stared sightless in the tub, beyond all thought.

* * *

It was near dawn by the time they got back to the clinic. There were no lights on anywhere in the building.

"Maybe he's gone home?" Promise said hopefully. Aubry shook his head as they pulled back behind it, pointing out Kato's two-seater. The back door was unlocked, and Aubry entered it sideways, flattening himself against the wall. There was a sound from the far end of the hall, the sound of clinking bottles and harsh breathing. Aubry ran lightly down the hall, almost making it to the end before a face poked out and squeaked. Promise was close behind him, but what happened next was much too fast for her to see clearly. Aubry reached out and grabbed a handful of hair faster than the figure could vanish back into the room. With a savage yank, he pulled the man—hardly a man; stick-thin, he could barely have been out of his teens—off his feet and hurled him across the hall with a movement so reflexive he hardly broke his stride. The youngster somersaulted into the wall shoulders-first, sliding to the ground in a heap.

There was trash everywhere, and broken glass. The examination rooms had been stripped almost bare. Promise nudged open the door of Cecil's office with her toe. There, in the middle of the floor was a single huddled shape.

Moving slowly, she sat on the floor next to Cecil, lifting his head into her lap, keening to his inert body, the light from her face washing over him in gentle waves.

She didn't hear Aubry move up behind her. She felt him there, and turned with wet streaks lining her face.

"He was the only one, Knight—the only man who ever gave me anything without wanting my body in return. The only one worth a damn. And I killed him." She paused, then added, "*We* killed him."

"Don't lay that on me, lady. You brought us here. My hands are clean."

She flared murderously, the light from her plastiskin so bright that for a moment it hurt his eyes and he had to look away. The effort exhausted her. She slumped down, folding herself over Cecil's head. Her body moved, but she made no sound.

Aubry left the room and looked out into the hall. It was empty, the one remaining assailant gone into the night. He grunted with a mixture of anger and relief.

"Aubry," Promise called. She was still holding Cecil's head,

but the tears on her face had dried. "What now, Aubry? What do we do?"

"Only one thing left," he said.

There was total silence in the room for a few heartbeats, and Promise bit her lip, examining Aubry carefully. "I know they did something to you in prison, Aubry." Her voice held no mockery, no taunt. "Are you sure?"

"The day I can't fight back is the day I'll lay down and die," he said. His voice was steady, but she saw the perspiration on his forehead, and wondered.

"All right, then," she said, lowering Cecil's head gently to the ground. He helped her up with a steady hand. "Truce. No bullshit. No play."

He took her hand and shook it, hard. "All right, then," he said, taking a last look at the figure on the floor. "Let's get it done."

# 7

## Luis

Promise drew her wrap tighter around her shoulders as the aircab drew near *Casa Ortega*.

The enormous two-story structure sat perched on a bluff overlooking the Pacific, its foundations jutting out from the cliff, supported by beams sunk into the rock below. The setting sun painted the water molten, and Promise could not erase the image of a primordial god squatting on the lip of a volcano, demanding sacrifice.

The car swooped down in an arc. Promise inhaled deeply, bringing all of her skill to bear on the single task of maintaining control. As they dropped in closer, she could see the individual cars parked in the area beyond the fence, and the people streaming out to join the festivities.

One half of the roof was steeply slanted, joining with a level sundeck. An airpad took up half of the space, and a sheltered jacuzzi the other. Guests had already doffed their clothes to enter the swirling water. On another night she might have looked forward to it herself.

Her cab locked into a holding pattern above the guest pad, waiting for two other vehicles to land and disgorge their passengers. She watched them emerge, doll-like, her cab's rotors growling patiently. The pad was set between two electrified fences surrounding the estate, set back half a kilometer from the main road.

*Security. That's the motto, Promise.* Aubry had repeated it to her over and over again. *Too damn much of it. Can't even get close to it with any metal, or any kind of chemical bomb.*

96

*I know—I did security detail there sometimes. But they have
a weak spot, and together we can break it. Luis. Every Friday
night he's got to have his party. Can't believe he's still so
predictable, but that's Luis. You'll know him when you see
him. Tall. Built like a dancer, but the man isn't human. Does
all the drugs in the world. Drinks like an alky, burns the sheets
every night with a different woman, and still manages to take
care of business.*

*His little brother Tomaso is different, dangerous. It's easy
to forget that he's even there. Round, soft little man. Doesn't
party, doesn't drink. Doesn't like women or men. Talk is that
he doesn't have any balls at all. Doesn't care about anything
but the Family, and taking care of big brother. Watch him.
He's the danger....*

One of the host/bodyguards came to meet her aircar as it
settled, opening her door before the steam ceased gushing from
under the rubber flange. *Showtime*, she said to herself, taking
a moment to adjust her wrap and carefully shoulder her braided
hemp handbag. It held extra makeup, a few salves and oint-
ments for the adventurous, and a couple of props, all non-
metallic and nonthreatening.

"Gibbs?" Rhetorical question. He took her hand and helped
her down, keeping an eye on the metal detector on his wrist.
His eyebrow rose in surprise. "Less than ten grams?" He was
almost as tall as Aubry, but slender and white.

She smiled, showing rows of perfect teeth. "Right here."
She ran her tongue over them smoothly. His shoulders squared,
back straightened, stomach tautened. Male preening. He was
hooked, his mind pulled off business.

The left side of her body flared with light for a moment.
The burst seemed to crawl upwards from her feet, finally coiling
out through her hair. The stream of partyers paused in their
forward motion. Men studied her speculatively, their female
companions analyzed the competition with practiced caution.

She squeezed the host's hand as he helped her past the still-
warm landing coils. "I hope you won't have to search me,"
she said so softly that he had to strain to hear her. "I'm sure
you wouldn't find anything you'd like."

If a depth charge had gone off in his pants, the reaction
could have been no more obvious. He grinned broadly. "My
name's Brad," he said. "And I'll definitely see you later." He

escorted her past the first checkpoint, and she had an opportunity to check out the other guests.

She recognized the mayor of a southern California municipality, and a congressman from Nevada. There was a businessman she recognized—from her business, not his. A few women she knew professionally. The rest were just faces, hungry faces. She knew the type. They would be here every Friday night. Currying favor, enjoying the sex and drugs, seeking an opportunity to observe Luis's guests with their guards down and libidos up.

The guests were individually scanned a second time, but Promise's was cursory, the man on her arm a quick pass through the checkpoint. She sighed in relief as the whining scan-field remained stable, no change in color or pitch.

There were at least twenty guards, perhaps more. Some were uniformed, but most were dressed as guests, only the constant movement of their eyes a giveaway. They strolled through the checkpoints over and over without concern. "Brad," she said quietly, "I heard that this place was *tight*. Why are all of those people just walking through the gates?"

"Guards."

"They're not wearing uniforms. How can you tell?"

He laughed. "Security Central knows. Little implant under the arm. Talks to the computer every time they pass a scan. If the code doesn't match, well . . . you wouldn't want to see it."

"What might I *like* to see?"

They reached the front door before Brad formulated an answer. She grinned. "Like you said. I'll see you later." She walked through the final checkpoint alone.

The light inside the house was a soft gold, radiating from the carpets and walls of a hall that seemed to stretch to the horizon. She blinked. Some kind of visual illusion field, certainly. Her wrap and purse were taken at the door, and she wandered down the hall.

After a few steps she turned and looked behind her. It looked as if she had walked a mile, the front door a distant and tiny rectangle disgorging midgets.

The first door to her left was a dining room, and she entered, mingling with the guests. They were gathered around a low table, a slow, continuous conveyer belt circling buffet dishes in never-ending abundance.

The smell was maddening, and she took a plate. There was slivered and glazed roast duck, turkey in wine sauce, to be

plucked out with chop sticks; Cornish hens stuffed with spiced mutton; fish served whole, halved, diced, sliced, souped, bouil-labaissed, jellied, dried, and pounded raw. Bowls of raw and cooked vegetables made the rounds, platters of fruits, trays of fresh hot breads and jugs of every conceivable beverage. And of course, the desserts, hot and cold, sweetened and natural, in any quantity or variety desired.

She chose sparingly and circulated through the crowd, keeping an eye open for Luis. There was no one who fit the description, although she did finally see Tomaso.

He *was* soft-looking. Studiedly so, and something about his fleshy chin, his skin—unusually pale for a Latino—the brutally short hair and poorly cut suit, told her that it was a deliberately shaped image. His movements were reserved and tentative. When she walked backward through the crowd to get closer to him, she could hear his voice as he spoke to a striking blond woman. "...Chyrmin, I suppose he's down in the Grotto." She heard a carefully timed pause. "He always ends up there. Maybe he started early this evening."

Promise engaged in conversation with one of the male guests, and maneuvered him around enough to get a closer look at Tomaso. Their eyes met for an instant, and he looked away in disinterest.

Check that—*apparent* disinterest. There was something there that made her suddenly, massively uncomfortable. His face was so flat, he made Osato's look downright convex.

She found a mirror along one wall and stared into it until she found Tomaso, noting that he glanced at her twice before returning to his polite conversation. A moment later he left the room. Her spine crawled. She put her plate down, her stomach too knotted even to look at food.

The guard at the front door seemed happy to see her again. "My purse, please. I'm going downstairs in a few minutes." He glanced in it, saw the collection of oils and glazes, and handed it to her with naked envy on his face.

"Don't look so sad," she said. "Don't you get your fun later?"

"Yeah...much later. Everything good's used up."

"I'm never used up," she said, meeting his eyes so directly that he had to look away.

She found her way to the rear of the house and pushed at the doors until she found the bathroom. It was a miracle of glittering tile and chrome, two sunken bathtubs and a bubble-

shower, massage table, and tanning lights. The bathroom had a dual-pipe system: fresh water for bathing and cleansing, salt for flushing. At the rear of the room was a window that looked down on the ocean. She opened it as far as it would go, looking out. The sun had set completely, only the slightest fringe of red brushing the horizon. The kiss of sea air helped to unknot her stomach, and she inhaled deeply.

*Hold on. Just hold on. It's too late for Cecil, but Maxine still needs you.* Steadied, she dumped her purse out into a hamper, turned it inside out, and felt along the bottom for the knot. When her fingers found it, she breathed a sigh of relief, and started to work it loose.

The Grotto. It was a cavern sculpted in the rock beneath *Casa Ortega* at a cost she couldn't imagine. Artificial stalactites crowned huge bathing pools, colored lights flickering in their depths. The water was filled with nude couples absorbed in slow-motion lovemaking. The scent of hashish, opium, grubs, and sex was heavy in the air. The sound of a tropical lagoon played over hidden speakers, augmented by an excited heartbeat rhythm.

Promise wore her nudity like armor, knowing that no one who saw her, male or female, could sink their mind past the perfect muscles in her legs and stomach, the fluid swivel of her hips.

She danced as she walked, every step a touch more lyrical than the last, until she was a swirl of movement, seemingly stoned out of her mind, slowly weaving through the sprouting forest of groping hands and beckoning voices.

Then she stopped, vibrating in one place, and the dance truly began, totally arhythmic, or perhaps following a tune that she alone could hear. The revelry stopped. Lovers parted in midstroke as every eye in the room was drawn to Promise. Slowly, she let the light play through her body in time with the movements. She strobed, she isolated patches of color and intensity. She moved her legs to one beat and her arms to another, her hips to a third in an impossible counterpoint that defied logic. She worked up a sweat, churning until her scent penetrated even the haze of blue smoke hanging in the air.

Slowly, the clapping began. Automatic, compulsive, men and women alike fascinated by this glowing, writhing wraith who seemed to balance on some uneasy edge between humanity

and illusion. The clapping grew until it rocked the room, was complemented by simultaneous exhalations and footstamping.

Promise was gone, lost in a world of her own where no fear or plotting existed. No *Casa Ortega*, no Aubry Knight, no time or space. Lost in feeling, just raw feeling, and the glory of riding the rhythm in her mind.

Then she saw him, moving through the crowd like a king brushing aside his subjects. He was tall and beautiful, his olive body a Renaissance sculpture come to life. His eyes radiated heat, swirled with golden flecks among the brown. His full, sensuous lips were moist, his nostrils flared.

His hair was long and straight, his face thin but not angular. Every movement spoke of perfect control, and Promise was startled to notice how naturally her body responded to him, how quickly her dance became something for him and him alone.

Luis.

He did not clap, but his hands clenched rhythmically as he watched her. She knew from his breathing, from the fixation of his eyes and the size of his erection that he was fascinated.

A woman had followed him over to the crowd, and in her eyes there was loathing. Her skin was tawny gold, except for her breasts and stomach, which were flushed red. She was naked except for a silver necklace which spelled out "Nadine." Even in the midst of her dance, Promise took mental note, recognizing one of the most perfect meldings of face and form she had ever seen. Luis's woman.

A chant started, a sound somewhere between a forceful exhalation and a hushed yes carried on every tongue, eyes still transfixed by her, even though nearly blinded by the light. The left side of her body turned nearly transparent, her bones seeming to show through the glare. Mouths were hanging open with naked lust.

She felt a grip on her arm, and with startling swiftness, she stopped. Just stopped, her body bent into an arc, as if she were a doe suddenly afraid and ready to flee.

Luis took a step closer to her, and drew her the rest of the way. She trembled in his hands, melted for an instant, coming near enough to brush his lips with hers—then turned, wrenching herself away, and ran up the steps out of the Grotto.

The revelers cheered shatteringly as Luis pursued her.

He followed her out into the hall, and she was there, smiling.

He stared at her body, overwhelmed by an urge to touch and knead, to make her scream for mercy like a thousand women before her.

Her face was turned half away from him, and she leaned against the wall, watching. He saw her light reflecting on the wall and took a step toward her, another step, reached out. She moved away with a dancer's grace, slipped away from his hand as if he had tried to grasp a handful of mercury, and disappeared into his study.

He followed her into the darkness, into the quiet, groping for the lights. A soft, cool hand touched his. "We don't need that," she said, her voice a current of warmth that slid down his spine, going straight for the groin.

"Who are you?" he asked. Her light twinkling, wavering with soft color, pierced the darkness and washed over him. He followed her further into the room, reaching for her hand. He caught it and lost it, caught and lost, all the while her smile and laugh leading him on and on. "Who are you?" he asked again, feeling the tension building up and up, becoming something that tore at his head, made his tongue thick and his feet blocks of lead.

The light came up in the room, the single block of plastic hanging from the nine-foot ceiling glowed white. Luis looked up at it, confused. There was a strange smell in the air, something musty and sour that he didn't recognize. A voice behind him said quietly: "She's Death, you crawling shit."

He turned, eyes wide and puzzled by the huge, dark figure by the door. He heard the slight, scuffling footsteps of the woman circling behind him to join the man.

Luis licked his lips, confused for a moment. "What—?" The shape moved out of the shadow into the light, and the intoxication sloughed off Luis Ortega like an ill-fitting cloak. In his eyes was a disorienting mixture of fear and awe and outrage. "You?" The anger began to boil up. "How . . . ? How in the hell did you get in here?"

"Never mind, Luis." Aubry stepped towards him, and with that step he seemed like a barely checked avalanche, a terrible force of nature held on the slightest of tethers.

"You . . ." He moved away from Aubry, toward the raised dais in the center of the room, and he began to search desperately for a way out. "You know you can't get out of here alive."

"Doesn't matter," Aubry said calmly, slowly closing the distance between them. "It doesn't matter at all. You've already

killed me. There's nothing left to my life, and you know it. The only thing that matters is taking you with me."

Aubry stepped up on the platform, and the two men stared at each other. Promise held her breath, seeing the anger in Aubry's stance, waiting for the spasms that had racked him before. She wiped at her nose. *That smell? Where was it?*

Luis tried to cover his nakedness, paralyzed in the most dreadfully vulnerable moment of his life. "Wait...we can deal."

Aubry nodded. "Yes. Yes, we can. The deal is this: You always thought that you could take me. I know it. So come on, Luis, take your shot. That's your deal, and it's the only one you get." He clenched his teeth, and his dark eyes opened wide, and fixed unblinkingly on Luis. "Come *on*, big man." Luis looked frantically around the room, saw Promise, saw the cold expression on her face as she weighed him and found him wanting, discarding him along with the other garbage she had known. And somehow that disdain did what Aubry's challenge could not, and made his mind calm, his muscles taut.

He faced Aubry on the dais. Promise moved to the control chair and looked through the collection of cartridges until she found one that interested her. It was labeled "Aubry Knight: Beach." She slipped it into the projector.

All around them swirled color as Aubry Knight faced Walker on the beach. Promise watched, and watched Aubry watch. Knight was a little younger then, a little slimmer, but it was the same deadly man, the same unearthly quick movement, and the same brutal techniques that spiraled to the same inevitable conclusion.

Walker's pain superimposed itself on Luis's face.

"You *taped* it?" Aubry's voice was staggered under a load of hatred and disbelief. "You set me up and *taped* it?" There were two Aubrys there—one moving swiftly, only a synchronized camera keeping him in range and in focus; the other a man who looked about him in amazement, an eye of calm in the center of a cyclone.

"Listen—" Luis said, then kicked, as hard and as fast as he could, at Aubry's groin. Aubry didn't seem to move, but somehow the kick missed its target, hit the inside of his thigh with a crack that resounded in the room. The big dark man didn't flinch. Aghast, Luis followed with a punch. Aubry caught the fist with his right elbow. Promise flinched away from the sound of splintering bone.

Luis sagged to his knees on the dais, looking up at his executioner with eyes glazed with pain and shock. Aubry's fingers spread as he stepped foreward, twitching with the hunger of a junkie for his grubs. "And now—"

Promise looked away, squinted her eyes shut.

After a while, the screams died away, the cracking thumps stopped, and she heard Aubry walk away from the dais. She looked up, saw the shapeless dead thing that had once been Luis Ortega, and shuddered. In the back of her mind, she registered a tinny whirring sound, and the sour smell dissipated.

Aubry turned and looked back at the huddled shape, and right in front of her eyes, something went out of him. The strength and power just *evaporated*, replaced by a fear and a gnawing weakness. He collapsed on the floor.

She rushed to him. "Aubry! My God are you—" She turned her head as another spasm ripped through him, but she held onto his shoulders until it passed.

"All right," she said slowly, gulping air. "How do we—?"

The door exploded open. "Don't move!" a man screamed, his voice almost hysterically high. The sounds of partying beyond the door were still audible, but dying slowly. Promise froze. Behind her, the holo projector clicked off.

Aubry got unsteadily to his feet. Two guards had guns on him; a third went to check the body on the dais. Tomaso walked past Promise, stopped five meters away from Aubry. "Aubry Knight," he said venomously.

"Hello, Tomaso." Aubry's eyes darted side to side, saw nothing that would be any use or help, and became resigned.

"He's dead, sir."

"Are you sure?" Tomaso's gun never wavered from Aubry's head.

There was a choking sound from the guard. "Neck, spine, arm—God only knows what else. I'm sorry, sir."

Tomaso faced his brother's killer, a nervous tic pulling at the corner of his mouth. Aubry filled the silence. "What are you waiting for?"

Tomaso jerked his head at Promise. "Bring her over," he said. One of the guards grabbed her by the arm, dragging her. He didn't notice that her breathing had become fast and shallow, that as he released her she sucked in a huge lungful and held it down, that when she exhaled she pulled down another, even deeper, and followed it with sharp, short hiccuping inhalations.

"Marty," Tomaso said to the guard behind him. "Get the guests out of here."

There was no time for any of them, including Aubry, to shield his eyes. The glow started as a slow wash of color and became pure white, then grew in intensity like the burst of a flare-grenade. In three quarters of a second Promise's plastiskin went from dormant to full-output. Every eye turned away as she broke through the pain barrier and pumped more and more mental effort into the light burst. Then she fainted.

But in the instant that the light filled the room, Aubry Knight moved. His body tensed like a coiling spring, and he leaped into the air with a savage scream of triumph, his foot lashing out and up and through the light fixture above their heads. The sound of the shattering glass and plastic seemed to snap Tomaso out of his momentary paralysis. "Kill him!"

The words were unnecessary, the guns of the three body-guards already swinging up, firing at Aubry's last position. In the darkness they could not see him, but they heard a thump and a scream of pain. There was a rolling, scuffling sound, then more shots, and suddenly there were a hundred screams in the air, panic and confusion, and Tomaso was brushed aside by something that felt like a tumbling tree trunk.

There was the sound of shattering glass from the hallway and more screams and shots, and still no lights at all. *Damn!* Tomaso swore silently, *the bastard must have crippled the lights on the way in!*

"Lights!" he screamed. He was buffeted by guests streaming for the door. He fired his pistol into the ceiling. "Wait, dammit! Get control of yourselves, or—"

It was no use, no damned use at all. An oval of light floated down the hall towards him, and he grabbed the light band off of the guard's wrist, flashing it back into the rec room. There were two men getting up from the floor, neither of them Aubry. "Damn!" he snarled. "Get through to the perimeter guards. Don't let anyone out!" He saw blood spots on the floor, trailing towards the doorway. He followed their trail to the bottom of the stairs, then cursed again. "The roof! Luis's aircar. Hurry!" There were guards at the door, trying to organize an orderly exit, and more of them clustering around Tomaso, awaiting instructions. He gestured to six of them and started up to the roof. It brought fierce satisfaction to his heart to see the blood stains wetting the rug. "—got *one* of you, at least...."

He remembered the brief image of Aubry's kick, of the enormous body virtually *levitating*, for Christ's sake, just straight up like a freaking *bird!* And hoped fervently that it was the nullboxer who had been hit. Preferably somewhere vital.

They hadn't gotten more than halfway up the stairs when he heard the howl from the roof and knew that they were too late. "Mark!" he screamed. "Fernando! Get to the garage. There's a class-one scooter there—get after them. Get on to the police department; tell them what happened and have them get their butts in *gear!*"

He charged up the rest of the way, grateful beyond words to find the lights at the top level functioning, the blood droplets more clearly visible.

He followed them to the third story, the roof. The wind whipped at his hair as he strode angrily over to the circular launch pad, its surface still warm from the backwash of the takeoff. On the horizon, skimming away to the south, was the two-seater aircar, brother Luis's pride and joy, carrying his killers to safety.

"The hell it is," Tomaso snarled. He ran back down the stairs to the communications complex. He could trace them, by damn, and would. Both of them. Aubry Knight *and* the woman Promise would be dead by morning.

# 8

## Deep Maze

Even with its superb stabilization system, the aircar was more difficult to drive than a standard automobile. There were three dimensions to worry about to a groundcar's two, and the sight of trees and shrubs whizzing beneath them in a breakneck mosaic made Aubry hold his breath.

He hated to do it; it went against his every instinct and claim to better judgement, but he put the car on autopilot, selected the only destination he could think of, and bent to inspect Promise's wounds.

The steel sliver seemed to have pierced the muscle of her upper right thigh cleanly. The bleeding had slowed to a trickle, but Promise's face was ashen.

She had barely opened her eyes since the escape, and her breathing was shallow, irregular. She didn't seem to be aware of her surroundings, and when her eyes fluttered open, the pupils were huge and shiny. "Where . . . are we?"

"Just try to relax. I'll get us out of this if I can." He checked the snugness of her seatbelt, tilted the backrest for her, and returned to the controls.

He had only flown an aircar a couple of times, years ago, and was happy that this one did most of the thinking for him. It was bubbled with clear plastic and barely large enough for two. Its fans roared as he skimmed down the coast, keeping his eyes open. The waves beneath him glistened silver and blue-black. To the other side, the early-morning lights were crusting the tinker-toy outlines with diamond.

When the aircar reached Santa Monica it took the eastern flight path, curving away from the ocean, speeding through the ovals and spirals of southern California's wealthiest business district, heading inland to the Maze.

Promise was almost unconscious, and for the first time Aubry saw the little girl in her face, the weakness she hid so well, and he set his teeth grimly. She had done her part, damn it, and he had just about fallen to pieces. Why? Why so suddenly? For a few moments everything had been perfect, everything had been like the old days, and then . . .

But now he was a helpless passenger, ferried by the brain of a machine that knew its way better than he did.

He found himself touching the controls, imagining that he was guiding the car, just to have something to do. It was almost peaceful up here, above the city. It was almost possible to forget the violence ahead and behind, the violence all around, the churning red carpet which crept into every crack and crevice of his life.

He was so deeply immersed in his thoughts that he didn't even realize when the first ship began to follow him.

It was a police glider, larger and faster than his own craft, a more sophisticated version of the hovercraft that had captured him on the beach. His communicator bleeped red, but he didn't bother to turn it on: It was too easy to imagine what they might have to say to him.

The glider was joined by a second, and then by an older craft, a helicopter.

Aubry put the little two-man craft on manual, trying to feel his way into the controls. Maybe he could handle it. The right-hand toggle controlled vertical movement, the left horizontal?

Ahead of them, the twisted skeletons of the Maze arose.

Perhaps there was refuge—for a time.

Aubry pulled his aircar around the edge of one of the burnt-out skyscrapers, taking it in a tight spiral. The ground whizzed by at insane speed, now only ten meters below. He dipped down into a street—at least must have been a street, once. It was hard to tell, with the accumulated layer of trash and debris, shattered fragments of buildings, and the gut-punched wreckage of a bus, stripped of rubber and glass and most of its metal, only a framework of rust remaining.

He looked up behind him and saw the helicopter coming in. Slower than aircars, the old prop-driven craft were still

more maneuverable. Where were the aircars, if they were sending the helicopter in along the street?

It was a narrow corridor Aubry traversed, and he looked desperately to either side to find a place to hide. The wreckage was incredible, as if an orgy of wholesale looting and vandalism had destroyed what little was left by the natural disasters of earthquake and fire.

The other aircar appeared behind him. It was more of a one-man sled, really, barely room for the weapons bristling from its nose. He clapped the headphones over one ear and tried to find their hailing frequency. Nothing. "Guess they don't want to talk anymore," he muttered. There was a crack and a sharp whistle, and Aubry banked sharply as something screamed by his right flank, exploding in the rubble of a building beyond.

Now the headphone spoke. "We have you in our sights *now*—" A long-lost memory, the memory of a dreadful night on the beach when betrayal had stolen away dreams and love, came boiling up out of his past with shocking clarity. "No," he said, deadly calm. "I'm not going back." He waited until the last second and made a ninety-degree turn, staying inside the cleared zone, as low to the ground as he dared. The police airsled made the turn effortlessly, the helicopter just as easily.

Aubry banked right, then left, and made another turn, into an alley. The sled was still on his tail, the helicopter rising above the buildings to track.

The scarred and pockmarked walls of the alley became a blur as Aubry went for the far end. It was still dark, dawn at least an hour away, and it took all of his alertness to insure that he didn't smash into one of the walls. If he could just find one maneuver his car could do that the sled couldn't . . .

Then there was a whistle. Aubry looked in the rearview mirror to see a streak of light and smoke gaining on him. There was no room to swing sideways, and he was already too low. The sled fired a third shot, a line of smoke that crossed the only exit Aubry had, and in that instant he thought he was dead.

Something, certainly not any manifestation of conscious thought, took over then, and reality slowed to the speed of a child's flipbook. The flashing lights on the board before him, the blur of the brick walls he passed, the mirror image of the two rockets clicked by in slow motion, everything locked into the same torpid dance of death. Aubry, trapped in the same

syrupy motion, extrapolated lines of intersection, relative speeds
and movement options, as if he were engaged in a far more
personal form of combat.

And even before he found the correct answers, his hands
were moving on the controls. He was climbing, banking, and
one of the rockets passed within a meter of the aircar's belly.
There was a flash and a jar as the second rocket nicked the
bumper of his vehicle and rebounded to the wall before ex-
ploding, fire and shards of brick raining down, the wall col-
lapsing even as he sped towards the mouth of the alley. In his
mirror he saw the police airsled collide with the shower of
brick, and there was an explosion that brought him scant com-
fort: his own car was out of control.

He fought desperately to stabilize, but he just didn't have
the skill, the intuitive understanding of the car that might have
enabled him to neutralize the killing vibrations, the shock of
the flying bricks, and keep going smoothly. He was spinning
sideways now, directly into the wall of the alley. The plastic
bubble exploded as it struck.

He screamed in rage and frustration, and the nausea re-
turned, choking him, shattering his thought and filling his stom-
ach with knotted flame. There was nothing left to throw up,
but the pain of the attempt drove him over the edge. With his
last thought he threw himself over the unconscious Promise.
Smoke pouring from the front and rear of the car, it rebounded
out of the mouth of the alley, skimmed across the street like
a misshot hockey puck, and smashed through a boarded-up
storefront church.

The shock of the crash was monstrous, but the car had
enough momentum left to plunge on into the wall at the rear
of the church before stopping. Aubry felt it but didn't hear it.
There was a jolt that felt like a kick in the temple, and then
darkness.

*I don't want to move, dammit. I don't want to . . .*

His body was cut and bruised and possibly broken. Surely
his leg was twisted against the crumpled firewall of the aircar.
Every breath hurt more than the last. All he wanted was sleep,
or death, whichever would come more easily. But there was
the sound of a helicopter somewhere overhead, and the sound
of a rumbling explosion, and his mind commanded his body
to *move!*

Aubry told Aubry to go to hell.

Beneath him, Promise lay motionless. The plastiskin was a dull milky color. She looked dead, blood coating her leg, head laying back with terrible limpness. He looked through the shattered bubble and saw the light of the burning airsled. There was no sense of satisfaction, only more of the devouring illness that sapped his little remaining strength.

Holding his breath, he levered himself up out of the cockpit, shaking some of the pain out of his leg. He examined his surroundings. The inside of the building was incredibly musty, as though it had been twenty years since fresh air last leaked through the door. The walls were marked with wetrot and dryrot and agerot, and had been stripped bare long ago. The pale outline of a crucifix marked the wall-paper.

The car had smashed through into the next building, and that was the only way they could go.

He limped around to the other side of the car, trying to shut the pain and nausea away in his mind. (Giddily, a crazy image formed of a giftwrapped box marked, "Open me first at Christmas," something dark and dirty-nailed scrabbling away at the cardboard on the inside of the box. *Open me now*, scratch, scratch, *open me right now . . .*)

He kept that lid on tight, God, so tight that if he squeezed it any harder the box would burst and everything would come apart right there in his head. He leaned on the side of the aircar, shaking his head and then wincing with the pain that ate through him when he did it. He bent over and worked his arms under Promise's limp body, saying, *Shut up!* to the part of him that told him to leave her. *Go ahead, leave her. . . . She'd leave you, you dumb asshole. You owe her nothing. She owes you nothing. Leave her. Maybe you've got a chance without her. . . .*

He straightened up, pain shooting through his back, another wave of dizziness and nausea hitting him as he took the strain of her weight.

She was awake, just a little, just enough to lock her arms around his neck, making it easier to carry her. "Come on, lady," he whispered fiercely. "We're *both* getting out of this." Eyes closed, barely conscious, she nodded shallowly and mumbled something he couldn't hear, her cheek collapsing against his chest.

The air was unbelievably foul as he staggered through into the next building.

This one hadn't been completely stripped. There were a few rust-eaten steel lockers bolted to the walls and floor. For a moment, Aubry considered the possibility of hiding. Resting.

He staggered on, carrying Promise in arms too tired to feel anything but cold. Vision blurred and spun, and his back crashed against one of the lockers, the sound reverberating through the dark cavern of the deserted warehouse. There was an answering sound, something that wasn't the *thucka-thucka-thucka* of the helicopter hovering above.

He froze, listening. Had they found him already? How long had he been unconscious? It seemed like moments, but . . . he had to push on, get out of the large open area, into hallways, stairways, anywhere he could hide.

The sound again. Feet. There were people here. What *kind* of people? Aubry looked within himself and found nothing but exhaustion and the beginnings of fear.

There was a quick shuffle and a face popped out of the nearest corridor, stared at him for a second, then disappeared. He blinked, not wanting to believe what he had seen. It was a face out of a nightmare, one eye socket completely hollow. The skin was stretched tight over the skull, almost luminously pasty. The lips had been eaten away, and in the dim light it was difficult to see the crouching black spider that was tattooed in blacks and bloody reds from jaw to brow.

A wave of weakness swept over him, his spirit buckling under the latest blow. Where do the Terminals go? Where do the Spiders go when it's time to die, and don't want the camps to isolate and sterilize and cremate them when they're too weak to protest?

Deep Maze.

More shuffles now, in rhythm, and a moaning that grew louder, deeper. It was a sound of frustration, of hunger, of anger and outrage that two members of the hated society beyond had come here—even *here*. . . .

Promise's eyes fluttered open. "Where—where are we?"

"Don't ask." Aubry scanned the room desperately, looking for another exit, saw a boarded-up door on the far side of the room. Finding new strength, he ran, the burden in his arms growing lighter as consciousness returned. She looked back over his shoulder, and he felt her body tighten.

"Spiders!" They boiled out of the shadows, out of the corridor behind him, hobbling with the shuddering gait of the

spastic and crippled, their nervous systems and muscles eaten away by the disease.

They wore bits of rags or nothing at all; their voices sounded like air bubbling up through oily, stagnant water, moist and abrupt, the product of weak, ruptured lung tissue.

Aubry tripped on a broken floorboard and they went down. He rolled, protecting Promise with his own body. He came up to his knees panting, and in his eyes she saw fear and panic clawing at his restraint. Promise tried to get to her feet but couldn't, the effort draining her tiny reservoir of endurance.

Aubry lunged twice against the boarded-up door. It splintered and cracked, but didn't give. He looked back at the creeping army of Spiders, and his face tightened with resolve. He gathered her up into his arms and drove against the door again, using their combined weight.

It gave, and he staggered into the room. The floor was wooden and creaked beneath his feet. There was a little morning light leaking through from the far end of the warehouse. He could see by it that the room had no exit, no window low enough to escape through.

Lowering Promise to the ground, he took a fighting stance, balancing himself, keeping his right side, his strong side, forward. He couldn't fight them all. The tremors in his legs told him that he had almost nothing left. But if he could just manage to hurt one of them, maybe the rest would cut and run. He bared his teeth and made the closest thing to a snarling sound he could manage.

"Keep the hell away from me," he said through his teeth as the legion of Thai-VI Spiders reached the door, crowding, watching. There must have been a dozen of them, brandishing makeshift weapons, hunger in their eyes, the smell of their bodies and breath a terrible, rotting wind even at a distance of six meters. His vision swam, and he felt the room tilt. "Stay..." He wiped his brow. "...away...." They weren't coming in after him. *By God!* They weren't coming in! They were afraid! Afraid of one man who was almost dead on his feet. Crazy laughter tickled his brain. He fought to keep it back, fought as the room spun and the groaning sound in his ears built to a grinding roar.

A sudden sound of splintering wood ripped him brutally out of his fantasies. Aubry and Promise fell in an avalanche of splinters and dust, into utter darkness.

He braced himself for the impact, twisting in midair to try to land as cleanly as possible. There was a sudden cold shock, and a voice in the back of his mind whispered, *Water!* as he plunged beneath the surface.

Filthy liquid filled his nose and mouth as he gave into shock and pain and fatigue. Unconsciousness was a blissfully enveloping cloud. His last thought was that death was good and that he had been a fool to fear it so long and so deeply.

# 9

## The Dead Man

First, there was pain.

Pain was a sign of life, something that pierced the dark of his unconsciousness and guided him towards the light.

It existed in pockets on his arms and legs and included one throbbing, twisted vortex of agony in his left knee. But he heard a tentative sound, a slow groan that seemed to have been made by a dying animal, a rumbling stutter that only grew terrifying when he realized it was his own voice.

Aubry willed his hands to tense, and they dug into the mattress he lay on, tearing at cloth. It was dry, and that seemed wrong. Wet? What was wet? Water. He remembered water, and darkness. And . . . and Luis Ortega, dead at his feet.

Aubry felt his lips curl into a smile, and knew beyond question that he was alive.

His eyelashes fluttered and a line of dim light formed at the bottom edge of his darkness. He was in a room of some kind, alone—no, there was one figure seated by a rectangular door and he *felt*, rather than saw or heard, someone else in the room. Promise?

More than anything, he wanted to sit up and open his eyes, really examine the situation that he was in. But until he knew where he was, it would be smart to play unconscious.

From the way he felt, it would be his only advantage. There was nothing left in his muscles, and there didn't seem to be an inch of his body that wasn't either numb or aching.

There was movement in the room, and the sound of foot-steps. He closed his eyes and waited, flat on his back, as a

warm, calloused hand felt for his wrist and found his pulse. After a few seconds there was a sigh of relief, and the figure turned to Aubry's right, took a couple of steps, and knelt down. After a brief rustling sound, there was a more worried exhalation.

The whispers of sound had seemed genuinely concerned. Aubry decided to risk flexing his arms subtly. With great effort he tensed them, moved them like great leaden weights, but confirmed that there were no bonds holding him down.

He opened his eyes and looked to the right.

The room was unfurnished, except for two beds, a chair, and an overhead light.

On inspection, the overhead light seemed to be makeshift, wired up jerry-rig, with an electric cord stapled to the ceiling and the wall, trailing to the door. The beds were rude, Aubry's about twenty centimeters high, the other little more than a thick mat on the floor.

On it lay Promise. Her lips were swollen and purplish, and a bruise puffed out on the right side of her forehead. The plastiskin was largely dormant, but occasional, dim flashes of light wormed along in it like a slow-motion electric arc. She seemed deeply unconscious. A small gravity-fed IV dripped plasma into her arm.

He watched the slow rise and fall of her chest, and sighed contentedly.

"Awake?" The voice was young, even though the face Aubry focused on seemed old. It was a woman's voice, and once again he had the clear impression of caring from her.

He nodded, trying to raise his head. Swallowing made his throat feel as if it had been scrubbed out with a wire brush, and the room swam at his attempt to pull upright. The woman was across the room in three scurrying steps and her hand was under his head. "No," she whispered. "Don't try—not yet. Give yourself time."

He struggled against her for a moment, tears of frustration close to the surface.

"Shh . . ." Her face was very close. He could see that she wasn't old, but the circles under her eyes, the tension lines, and gray hairs had prematurely aged what had once been a lovely woman. There were still traces of beauty in her eyes, in the concern that lived, tangibly, in her voice. "Just rest, now. You're very strong, but whatever it is you've gone through

in the past few weeks has drained you. Your body needs time to recover."

Unable to do anything else, he nodded. "What about . . . her?" He tried to turn over onto his side, but again her hands were at his shoulders, limiting his range of movement.

"Your friend is . . . very ill. She needs medical attention. We may not be able to give it to her. We may decide to send her topside."

"What?" He could feel his strength ebbing again, the darkness swirling in from the periphery of his vision. "Where . . . where are we? What is . . . 'topside'?"

"Don't worry about that now." She wiped his brow with something moist. "You need to rest."

"No, wait." He was gasping it, and his hearing was flickering on him like a bad holo. "You can't send her to a hospital. They'll kill her. Please . . . you don't under . . . under—"

There was a moment when it felt as if he were swimming up through a pool of ink, the first glimmerings of light beginning to break through the surface. Then there was a sensation of pressure, of touch, and the light was gone again.

But there were dreams.

He dreamed that he sat in an empty room, on a wooden chair. The room was very dark, except for a halo of light which played along the length of one wall. A thin line, perpendicular to the floor, grew out of the wall, slowly tracing the outline of a door, which became solid and swung open.

There stood in the doorway a dead man.

From the wounds in his flesh to the maggots crawling in a shattered eyesocket, he was as dead as a man could be. His arms were pale orange ribbons of flesh dangling from twisted bones; and he stank. The smell was hideous—a bag of dead cats and human feces hung up in the sun to ripen; the smell of terminal gangrene, of festering sores and rivers of clotted blood.

The dead man crossed the room and stood over him.

*Who are you?* the apparition asked, cracked teeth showing through ruined lips. *You bring death and pain to my people. I know. I see. Tell me—who are you that I should not cast you out to die?*

I am Aubry Knight—

*That is your* name. *Who are* you?

I am a fighter. The best in the world—

*That is your* fantasy. *Who are you?*

I am a man who made enemies. Killed the one who tried to destroy me—

*That is your* story. *Who are you?*

A man!

*That is your* sex.

A human being, dammit!

*That is your species.*

I'm something that thinks, and hopes, and hurts.

*That is what you* do.

Well, then, dammit—who are you?

*I am nothing.*

Well, I'm not. I'm something. I'm somebody!

*Who is it that knows?*

I do.

*Who are you?*

I am . . . me.

*And what is that?*

I . . . don't have any words for it.

*Excellent.*

But that isn't anything!

*More precisely, it is nothing.*

But what is that?

*Firmly grasped, it is enough.*

Aubry tried to speak, but no more words would come. The dead man backed out of the room, shaking his head, teeth clamped in a death's-head leer as Aubry tried to stand and follow . . . backed out the door, which shut silently behind him. Which lost feature and depth. The edge of the outline disappeared, and once again the room was sealed shut.

The light faded to black, and Aubry knew nothing more.

Voices, and the sensation of air swallowed deep into his lungs. Realization: pain had receded, become a part of something distant and only dimly real. A feeling that balanced on the jagged edge between reality and dream. Aubry exhaled and forced his eyes open.

The young-old woman was in his room again. She was watching him, and he felt profoundly uncomfortable, wondering how long she had been there. He pushed himself to an upright position and glowered at her. "Who are you?" Aubry looked at the IV pouring nutrient into his left arm, and fought an urge to rip it out.

The room tilted, and with a savage act of will he righted it again. When he had, the woman was at his side and had seated herself, taking his hand gently. Her fingers were very warm. "You're much stronger now. Perhaps we can talk."

"Damned sure hope so. Where am I?"

"This is K-section, Los Angeles. Only about a half a kilometer from where you and your friend were found."

"K-section?" He pushed back in the bed until the cool of the wall was tingling against his shoulders.

"That's what it's called now. What Warrick calls it. We're near the old World Trade Center."

He shook his head. "Maybe I'm not hearing right." He glanced at the lower bed. Promise was still unconscious. The lights of her plastiskin crawled feebly.

"She looks . . ."

"Yes, it's severe."

Aubry thought for a few moments, trying to remember. "She was shot . . . I know that. . . ."

"We cared for that. It was more than just that. She's been bruised and cut, and septic water got into the wounds. She's an Exotic. Half of the skin on her body has been replaced with some kind of breathing silicon base. It's complicated our treatment of the infection. We need to cut sections of it away and clean her out. To do that, we'll need to take skin transplants from her right buttock and leg; she'll need massive antibiotics, blood, anticoagulants . . ." She raised her hands in defeat. "We just don't have the facilities here."

"Wait, let me think." He shook his head disgustedly, loosening the cobwebs. "I need to talk to the top man. Who's in charge here?"

"His name is Warrick. You don't need to see him—he's already seen you."

"We have to talk. This woman needs treatment and she can't be taken 'topside.' That would be the same as condemning her to death. There has to be another way." He looked at her curiously. "Who are you, anyway?"

"Mira. I'm in charge of the medical facilities. We set them up whenever we mine a new building."

"What? Oh, never mind. Listen. My name is . . . Shields. Aubry Shields. And we have to be able to work something out here."

"I don't think you understand, Aubry. We are willing to share—to a point. The investment in time and supplies *has* to

be a healthy one—or we cannot survive." She paused. "Suppose—just suppose I did try to treat her. That I brought in the proper tools and personnel. Would *you* be willing to pay for it?"

His thick brows beetled together. "How?"

"Scavenging, of course. There is a tremendous amount of wealth down here, under the ruins of the Maze. Convection heat destroyed some of it, but still—you'd be surprised."

"Valuables? What kind?"

"Underground bank vaults with money—paper, securities, gold, Service Marks. Security tunnels for the jewelry exchange, some of which lead to diamond caches. Canned food. Equipment. More than I can tell you in a few minutes."

"Well . . . damn, why do they just let it sit down there? How come everybody and their mother isn't down here, ripping it out of the ground?"

"Think about that, Aubry. Think about the structural damage the Quake left behind. The aftershocks alone were more powerful than *any* quake that hit California in the preceding hundred years. This entire area is a deathtrap. There is wealth to be had, but the cost is too high for anyone but a Scavenger."

"You mean the Government *lets* you come down here and take whatever you want?"

She laughed. "We have an unofficial franchise. Like I said—it's not profitable enough for any of the Conglomerates to care, and dangerous enough for the Government to leave it to us crazies."

"Scavenging. Why do *you* do it?"

"Because my brother is here." Her thin shoulders hunched in a shrug. "Because there's nothing for me topside. I don't have the skills needed to make it Corporate. I loathe the Maze, and I'm not ready for the work farms." She shuddered and seemed to shrink at the thought. "Doesn't leave me with a whole lot, does it?"

"I guess not. So you want me to join you—to pay for her treatment."

"It's an honest exchange, if she means enough for you to stay."

He looked at the still, vulnerable form of Promise. What *did* she mean to him? They had been partners in crime, and that was all. It wasn't much, but what else did he have? He had no career, nowhere to go. He was being sought as an escaped convict and as the killer of Luis Ortega, scion of the

most powerful criminal organization in the western hemisphere. Mira probably didn't realize it, but there was nothing in the world he would like so much as a place to hide and work, and think about the turns his life had taken. And decide if there was enough left of it to go on.

Stay, hell. They would have a bitch of a time throwing him back out onto the streets.

"All right," he said finally. "For her."

"No," Mira said. "It has to be for you."

"What's this crap? Why can't I just say yes?"

"Because if it's not for yourself, one day you'll quit, with nothing but resentment to show for your efforts. Our people will rely on you. Trust you with their lives. It has to be for you."

"That doesn't make sense."

"It doesn't have to. That's just the way it is."

Aubry's lips twisted in frustration. "There's somebody else who talks like that. I just can't quite remember where...."

"In a dream?"

Mira was smiling, laughing silently at him.

"Yeah, maybe—how would you know?"

"Like I said: Kevin has already seen you." She patted his hand. "Rest now. We'll do what we can for your friend, and we'll talk to you again in a few hours." She stood, crossing to the door.

"Wait—Mira. When am I going to meet this Warrick?"

"He'll be back in a couple of days, don't worry." Then she was gone.

Aubry turned over on his side and watched the slow rise and fall of Promise's chest. He wondered exactly where, and how badly her body had been hurt, wondered what she had done to her nervous system to create the violent shock of light that had bought them their escape.

And wondered why he cared. That, at least, was an easy question to answer. Hell, he had nothing else to care about.

# 10

---

# The Scavengers

"Banyon! I'm breathing soup down here. Why the hell can't you turn up the pump?"

Her voice came back to Aubry distorted by hollow echoes. "All right, Shields. Keep a lid on it. I've got my own problems up here—I've got to get air to you and three other tunnels."

Even with the light atop his textured plastic helmet, the tunnel was too dark for comfort. Although he knew that there was another worker around the next bend barely ten meters away, he felt cramped and isolated. He wiped his sopping face on his shirt and shifted position to take pressure off his aching knees. "Well, if you don't do something fast, you'll only have to worry about the other three."

He put his back against the wall opposite the ragged hole in the concrete. He had run into reinforced steel mesh and had spent the past two hours fighting with it. Though decades old, the strands still made a formidable barrier.

He tried not to look at the tunnel to his right: it was a pinched tube, blocked with collapsed chunks of ceiling and wall. Somewhere on the other side of the rubble were the bodies of the last crew of Scavengers who had tried to work the area.

Aubry breathed deeply, trying to compare his feelings now with the experiences at Death Valley.

Prison? God—*that* seemed an alien thought, and it couldn't have been more than two months since he broke out. It seemed a world and several lifetimes away. Impossibly, impassibly distant. Was there a difference? Both times the risk had been hideous, the conditions deplorable. Why wasn't this as bad as

Death Valley? He grinned to himself in the darkness, knowing the answer.

The air turned cooler, and he could hear the distant whine of the recycler pumping air down to him. Without it, he and the others would suffocate in minutes. The man to his left, invisible around the bend, sighed in relief. "Thanks Aubry," he yelled around the corner. "We need some canaries down here."

"Canaries?" Aubry grunted, hefting his pick and swinging it against the wall.

"Canaries. Birds, man. They used to use 'em in coal mines to tell when the air was going bad. The little buggers would just keel right over."

The pick tangled in a snarl of metal mesh, and Aubry jerked it free. "You're kidding."

"Nope."

He bent down to one knee, looking more carefully at the wall. "Where in the world do you dig up all of this crap, Peedja?"

The clang of pick against cement ceased, replaced with the sound of dragging feet. Peedja poked his head around the corner. "Same place I got my name, man. Books."

"How's that?"

"Last year I almost broke my neck hauling a set of Britannica out of a library. Encyclopedia. Peedja. You should try books some time, Aubry."

Knight felt a stab of irritation. "Nope," he said sourly. "I know everything in the world that I need to know. More."

Peedja shrugged and limped back around the corner, attacking the wall with renewed enthusiasm. "Is that right? I'll bet you don't even know what we're working in here." He grinned at Aubry's silence. "This is an electrical vault. It used to be a central cable connection. Held a transformer, too, but we already stripped that out. We're pretty close to the surface, but there's about half of a collapsed building over the manhole cover."

"Just what I needed to know. Now, back off, or I'll see if your sharp little head will get through this concrete faster than a dull pick."

"You wouldn't say that if I had both my legs."

"I'd say it if you had your legs, and two or three other people's besides."

Peedja laughed unconcernedly, and went back to his work. Aubry set the dull edge of his wire cutters against one of the strands, and heaved, taking satisfaction in the feel of his tendons bunching with effort.

When the last strand was severed, he snorted with relief and raised his pick again, swinging it with a grunt, trying to put every ounce of energy into the swing. There had to be a way. If he didn't have room to stretch his body, there had to be another way to get the exercise he craved. He had to do *something*. Anger solved nothing, and brought on waves of nausea.

He had to pause, waiting for the racking pains in his belly to cease.

He fed the embryonic surge of anger into the strokes, trying to see the wall as the face of Charteris, Death Valley's assistant warden. The first flash of anger, and dizziness overwhelmed him.

All right. Not that, then.

He had to find a feeling, the trailing thread of a feeling that was anger and fear and maybe some other things too, all wrapped up together in a package. Maybe he could *confuse* the response.

He felt the vibration travel back up his arm as the pick thundered into the concrete, driven by muscle and will and emotion.

In his mind, he *did* see Charteris leering through the mists of pain. Aubry envisioned the pick landing directly in the center of that grinning face, saw the grin dissolve in a welter of blood and shattered bone.

Aubry saw it dispassionately, from an emotional vantage point far distant from his usual level of involvement, and was pleased to feel no twitch of nausea.

The pick almost flew out of his hands as it penetrated his wall, and Aubry jumped in surprise. He bent down to peer at the hole he had created, then reeled back, overcome with the stench.

"Peedja! Put your filter on. I broke through over here, but there's somethin' real dead in there. Smells like stewed skunk-shit."

"Gotcha." Aubry heard the distant sound of Peedja struggling with his headstrap, as he slipped his own breathing filter into place.

The light from his helmet penetrated several meters into the dark, but it wasn't enough to see anything but swirling dust.

Even through the filters Aubry caught the smell of corruption, and knew that he was about to see something he wouldn't like.

Peedja rounded the corner, bringing the end of the airhose with him. The little man's dark eyes were bugged with admiration. "You're the first to break through, Aubry."

"And I'll be the first to *suffocate* if you don't get some air to me." He pulled his head out of the hole, and reeled back against the far wall, panting for air. When Peedja thrust the hose toward him, he grabbed it and sucked directly from the end, clearing the cobwebs from his brain.

"Are you all right?"

"Fine," Aubry said. "But I want one of the oxygen kits before I go into that hole."

"Fair enough. Here." Peedja unstrapped his personal kit and handed it over. "You made the hole. You get first salvage."

Aubry snorted and resisted a negative comment about the quality of the honor. It seemed to matter to Peedja, and the little man had done nothing to earn an insult.

He took off the air filter and strapped the rebreather on, sucking air from it harshly five times before the flow became sweet. He nodded to Peedja. "If anyone's stupid enough, send 'em in after me."

"Everybody. Aubry—" The big man paused and turned. "Don't touch anything—things are probably pretty unstable in there. It wouldn't be the first time that a roof has come down on a Scavenger's head."

"You've got it."

Wiggling through head first, there wasn't quite enough room for his shoulders. He growled, realizing as he did that the excitement was building inside him. He scooted back out and hefted the pick for another dozen strokes, smashing at the concrete and then pulling chunks of it free.

Another effort got him past his shoulders and the rebreather, and with a final push against a cold and grimy floor, his feet came free.

Even the stench had not prepared Aubry for what lay on the other side of the wall.

As Peedja had predicted, it was a basement. Collapsed beams blocked one side of it. He pulled a lightstick out of his backpack and beamed it down the other end, to a door with what looked like a pile of rags leaning against it. He took a step and stumbled, catching himself on the palm of his free hand.

He had tripped over a corpse, so badly decomposed in the dim light that he couldn't tell if it was male or female. He scrambled back from the heap, his chest suddenly twitching with fear, a surge of claustrophobia hammering at his senses, making him want to flee screaming out of the hole in the concrete.

Choking back the urge, he caught his breath. He let his lightstick beam crawl along the floor, passing three more bodies before it reached the door at the end of the corridor.

It was deeply grooved with scratches. The pile of rags at its base was another corpse, someone who had died trying to get through that door.

There was a scrabble of noise behind him, and Aubry turned, waving his hand towards the door. "This'll be our way in," he said gruffly. Now that his eyes had adjusted to the light, he could see two more bodies, painfully small ones.

Behind him, Peedja gave a low whistle, muffled by his mask. "Will you look at this?"

"Yeah." Dust and dehydration and insects had done a fine job of obscuring sex and identity, but Aubry could guess that one of the larger bodies was female, the other male.

"What happened here?"

"I can guess, Aubry. Sometime after the Firestorm and the Collapse, these people came down here—"

"Scavenging?"

"God only knows. Maybe just looking for a place to hide. They should have known better—the Government issued boo-coo directives about staying out of underground structures, but by that time a lot of people thought that everything the Government said was utter crap. So they came down here maybe to set up house. Who knows."

"And what happened?"

"Aftershock, man. Warped the jamb, and they couldn't get the door open. Their haven turns into an air-tight prison."

Aubry tried to imagine dying like that, hearing your children's whimpers in the dark....

Peedja gripped his arm. "Hey, mister. You're going to see a lot worse than this. Believe it."

"You just cheer a guy all to hell."

"That's what I'm here for." The little man's grimy face was tilted up to Aubry's and there was concern in his eyes.

"Well, we've gotten this far—what now?"

"We wait. Someone will bring tools, and we'll go on through.

Warrick has been notified, you can bank on that much. He should be here pretty soon."

"Good. I'm getting a little sick of hearing all this talk about someone I've never met." He turned his face back to the door, just keeping the corner of his eye on Peedja. "I'm almost beginning to wonder if the man's a myth, you know?"

Peedja grinned at him. "No myth," he said. After a moment's reflection he added, "But I'm not totally sure he's a man, either."

Aubry's face screwed up in irritation. "Now just what the hell do you mean by—?"

Banyon was crawling through the hole, dragging a bag of tools behind her. She was a squat, muscular redhead with a patch of hair and skin missing from the right side of her head, courtesy of a past cave-in.

She took a brief look at the pile of corpses and spat, just missing her own steel-tipped shoes. Then the flash of emotion vanished, and she was all business again. She eyed the door distastefully, and hoisted the bag over to it, becoming more businesslike every second.

"Firedoor," she said finally. "Old bastard. Steel over wood. Can't go through it, so I'm going to burst the hinges. Move this body."

They found a roll of carpeting and gently pushed the corpse off the steps into it, enfolding it neatly. As they did, Banyon rummaged around in the bag until she found the tool she sought, something that looked like a slender wedge attached to a crank. She spun the crank a few times, and the wedge opened into a pair of claws, so cleverly dovetailed that when joined they looked like a solid bar of metal.

She set the wedge into one of the hinges and worked it in as far as it would go, then took a hammer from her bag and began driving it into the slit. With every stroke, dust rained from the ceiling and puffed from the doorjamb.

When she finally had the wedge halfway in, she paused, and motioned to Aubry. "Here, muscles. You need to learn how to use one of these, and this is a perfect opportunity. I'm tired."

Aubry nodded and took the device, trying to find a good grip on the crank. It twisted easily in a clockwise direction, but he swiftly got resistance turning it the other way. It opened another quarter turn, and then stuck.

"Change the gear ratio," Banyon suggested.

Aubry inspected the device from top and bottom and found the gear switch, turning it to low. Then he leaned into the door and began to turn the crank. The door began to groan almost immediately, and he could see the claws separate as they ripped at the metal.

Encouraged, he set himself more firmly, found the angle from which he could move his arms smoothly, and turned until the hinges screamed out and one of the flaps of metal ripped free and stood away from the door.

He held the leverage device up to the light. "Nice little gimmick here."

"Not bad, tough guy. Now let's get the other hinges if you don't mind."

The other three hinges went swiftly, and Aubry stepped back as Peedja and Banyon slipped their crowbars into the jamb and set themselves, levering strongly. Aubry hid his smile as he admired the way Banyon used and conserved her strength— there wasn't a wasted twitch.

The door moved a fraction of an inch, then dust puffed out around the edges, and there was a sharp crack as the lock ripped free of the wood.

With a tortured sound, the door toppled out of the casing. Peedja scrambled out of the way, and Banyon pivoted smoothly as it fell past her shoulder. She grinned at Aubry. "Practice," she said.

The hallway beyond seemed to open out indefinitely, and Aubry felt his heartbeat speed up. He started to advance, and then turned to Banyon. "After you?"

"Yer full of it, Shields," she grinned, preceding him into the tunnel.

Smashed glass was everywhere, and fallen beams, and chunks of ceiling.

The glow of their three lightsticks probed out into the gloom like ghostly fingers, revealing bodies, shriveled and chewed, and trash of every description.

Peedja moved forward carefully, feet crunching glass as he walked. He cast his beam to the side and lit the remnants of a store window, the moldered manikins staring back at him with mindless smiles, posing with hands on hips for customers who didn't care any more.

"Jesus," Aubry breathed as his light found shop after shop. Some of the windows weren't broken. To his left there was a

meat shop of some kind. Insects had reduced the store's wares to shriveled husks, but he checked the door anyway, found it stiff with rust but unlocked.

As the gloom retreated before his torch, he saw rows and rows of dust-covered wrapped packages.

There was a rack of cans to his left, and he tiptoed through the trash and inspected one of them. The cover picture was of an artfully garnished, clove-studded ham. Aubry's mouth watered.

He looked back at the others, trudging through the dust and investigating the other stores, then slipped the can into the backpack. "Banyon!" He yelled. "Canned food in here!"

She appeared at the door almost instantly.

"Good." She rubbed her hands together, calculating.

"If you're not careful there, you're gonna smile."

"Never happened. Warrick should be here with a main crew in a few minutes. Leave this and let's get the rest of the place mapped out." She looked at him appraisingly. "You're pretty lucky, Shields. First week on, and you've bought into one of the biggest hauls ever. This is the Los Angeles Mall. Only the Multiplex is larger. Warrick will be happy."

"That thought lightens my load." He followed her out of the shop, down the remnants of a subterranean street that had once teemed with life. With shoppers, workers, perhaps craftsmen. He wondered what it had been like, the day that the Quake hit.

Behind them there was noise, as more Scavengers joined them, setting up portable lights and air pumps. The subterranean world was growing lighter, realer, the shadows pushed back as human life came again to the Los Angeles Mall.

He could see where there had been trees and decorations, and it was entirely too easy to think about what it must have been like, with the halls full of shoppers and Christmas cheer.

Then the Quake. December 23rd, two days before Christmas, and California got a present that had been long overdue, one that everyone expected and nobody wanted. Streets had split, ceilings shattered, tides rose to swamp the beach areas. And here, hundreds had died, been crushed or suffocated, hearts bursting with fear and awful knowledge, eyes dimming for the last time as the final darkness enfolded them.

"Merry Christmas," he muttered.

In the next storefront was a bank, and Aubry forced the

door open and poked around inside. There weren't any bodies to be seen, but a quick investigation proved that the money had been left in stacks at the tellers' windows.

He vaulted across the divider and looked down at the cob-webbed and mildewed stacks of money. He opened the drawers, the light from his helmet making fat sausage shadows of his fingers.

A hand fell on his shoulder.

He pivoted swiftly, not having heard the door open, having heard no footsteps. He felt a quick flare of panic at the thought of someone coming up behind him so quietly.

The man who spoke was large, and had been muscular once. His gaunt cheeks suggested many stretches of hard times, times when food was as precious as air. His eyes were light, and his hair was as pale as straw. The face was angular and strangely soft at the same time. He was about three centimeters shorter than Aubry.

"You're Warrick?" It wasn't really a question. Aubry felt something that was curiously like fear.

The man moved without a sound, almost floating. Knight stepped back as he approached.

Warrick nodded silently. "And you are Aubry Shields." Warrick lifted a hand torch, washing light into the dim, cob-webbed corners of the room. "Because of you, everything that I have done will be undone."

Aubry clamped down on sudden nausea, and pushed the anger away.

"What in the hell are you talking about?"

Warrick sighed, the movement exaggerated by his sloping shoulders. "Never mind. It will become clear enough later." He ignored Aubry's balled fists, and shone the pale circle of light around the room. "You'll find silver money in the vault. Perhaps a few items in the safe deposit boxes."

The massive vault door hung open. Warrick stalked over to it, carefully avoiding the fallen beams and shriveled corpses of customers who had been crushed beneath them. Out in the promenade, there were workers and lights and sound, and Aubry felt an urge to leave this strange man and go out to them, but quelled it.

Warrick slipped a pry bar into the slender lock protecting a security gate behind the vault door, and broke it with a flick of his wrist. Aubry whistled silent approval.

Aubry followed him in, watched Warrick sort through the scattered piles of money.

"What about this stuff?" he asked, sweeping a handful of it off the counter.

Warrick picked up a hundred, and held it to the light. "Food, gems, and tools are more useful. They can purchase Service Marks." The walls of the vault were lined with little locked boxes, and Warrick motioned Aubry to the left wall while he himself went to work on the right one.

The boxes weren't constructed to stand up to the kind of stress that an immensely strong man can apply with a crowbar, and they popped open, one at a time.

In the first one was a bundle of letters, and a slender necklace. Aubry held it up, noting the way that the gems split the pale light into a rainbow of color. The postmark on the letters was too faded to read, but he rifled through them before throwing them aside.

Warrick pushed his knapsack out behind him with a thrust of his heel. "Anything you find goes in there. Don't worry— everybody gets their share. Right now, though, you're earning medicine for your lady."

"Yeah." Aubry bounced the necklace in his hand once, then threw it in. The boxes yielded up their contents one after another, and almost half of them held some kind of wealth that could be traded for goods and medicine—coins, tiny gold bars, jewelry, a tiny packet of diamonds.

By the time they had been at it for forty-five minutes, the vault was almost completely cleaned out. Warrick hadn't said another word, just tirelessly worked at his side of the vault. Aubry deposited piece after piece in the bag, growing increasingly discomfited at his silent companion. Finally he turned and said, "Warrick, do you—?"

But the man was gone. Aubry snarled, the anger making a wave of nausea roll in his stomach. He gave up the anger, realizing that it was just a flash of transmuted fear, and kept working.

Strange man, he thought. Stayed just long enough to be sure that I understood the rules, then left.

"Now, what is there to stop me from pocketing some of this? Keeping it for myself? I'd be a real asshole to play by his rules just because he says to." He listened to his own voice, but couldn't convince himself. "Oh, to hell with it." He hoisted

the bag filled with jewels and coin, and trudged out of the vault.

Outside, the salvage operation was in full swing. Lights had been strung from what remained of the gnarled, dead trees, and the shops were systematically looted. Food seemed to be as highly prized as money, and as he dropped Warrick's pack into the center of the growing pile, he felt a flash of guilt.

As he did a hand gripped his shoulder from behind. At first he thought it was Warrick, and turned to speak to him. It was Banyon. Her eyes were aglow, and for a wild second he was startled to find himself thinking of her as attractive. "Good haul," she said happily. "Damned good."

He felt tired suddenly, and sat down to rest. "Yeah," he said, "lot of stuff here."

"Not just here. Warrick thinks we can get into another level, under this one. There's more than just the shop goods that you see. There are generator rooms, some with equipment that can be repaired. Or metal that can be salvaged. There's just no telling."

"What else?" He felt dizzy, and it was an effort to keep his eyes open. "Am I through, or do I go on working, or what?"

She looked at him carefully. "How are you?"

"A little light-headed, I guess."

"Yeah, I thought so. Listen, you may be King Kong, but you've got to get used to the air down here. I think that it's time you go back up." She paused. "Did you dump everything in the pile?"

"Uh . . . yeah. Everything."

Banyon's expression remained steady, but he could feel the coolness there, felt the change in attitude towards him.

"Uh, wait. I've got one more thing." He pulled out the ham and handed it over.

Her expression still didn't change, but he knew that she was relieved.

"You know," she said thoughtfully, "a lot of this canned stuff is still good. Tell you what—we'll test this, and if it is, we'll send it along to your ladyfriend. How's that?"

"Test it, huh?" He grinned.

"Absolutely." She stenciled his name on the side of the can with a grease pencil. "Botulism is nothing to sneeze at." She squeezed his shoulder.

"Now go on back to the upper levels. You probably need some rest."

He hated to admit it, but the throb in his temples, and the slow burning in his legs and back said that she was correct. "You've got that right," he said, grinning weakly. "Thanks, Banyon. When's my next shift?"

"As soon as you can get back. I'll leave that up to you." She paused, then added, "Let's see what you're made of."

"Yeah, well, right now I'm made out of tired." He shrugged his shoulders, trying to ease the pain in them, and trudged off.

The route back led him through the basement, the electrical vault, and a collapsed service tunnel.

The Scavengers got to it through a ventilation duct, or by another pedestrian tunnel that went the long way around, connecting through a broken wall in the main tunnel. He sighed, trying to make up his mind—did he want to take the long way, the way taken by the Scavenger technicians and their loads of equipment, or did he want the shortcut, and the probability of skinning a few hairs off his shoulder?

Shortcut. He squeezed up into the ventilation duct, and snaked along on hips and elbows for about thirty meters before reaching the spot where he had to flop over onto his side to make the corner.

There was a glowing red marker in the shaft when it came to a branch, and he took the right fork, crawled another three minutes, and came to a widened-out ventilation grille.

Aubry crawled past, then backed up into it, easing himself down until his toes touched the ground, wincing and cursing simultaneously as he realized that he had indeed skinned the living hell out of his elbow. Again.

The room was a warehouse, and the old man organizing the battered packages and tubs of merchandise barely looked up as Aubry entered. There was really an amazing variety of goods, gathered from all over the roughly square kilometer that the scavengers worked in central Los Angeles.

Nearby tubs were filled with scrap metal, pulled out of the walls of the nearby buildings, to be sold to the junk dealers who formed an interface between Maze and outside world.

This office building had been chosen for a base of operations because some of the machinery remained in working condition,

the freight elevators and lights restored to operation by the Scavenger technicians.

Aubry had taken one jerking, halting ride up in the reconditioned elevator, and preferred the stairs.

The Firestorm that had destroyed most of central L.A. had left four stories of this one building intact, except for minor smoke damage.

A hospital of sorts had been rigged up, with clean beds (sheets found God knows where) and even running water, perhaps the most ambitious addition to the "hospital."

The rooms were plain but very clean, and here in this area was the only place he could count on finding Scavengers who didn't look as if they had been rolled in grease and mud and left out to dry.

Promise looked asleep when he walked in, and he closed the door quietly, watching her, chewing the inside of his cheek as he tried to decide whether or not to wake her up.

Then she stirred, and opened her eyes, making the decision for him.

It took a few moments for her eyes to focus, but then they immediately became guarded.

"Knight," she said cautiously. Her plastiskin was turned off, and formed a milky-pale layer over her left side.

"How're you doing?" he said awkwardly.

"I feel—" Something almost surfaced then, bobbed once, and sank. She turned her head into the pillow and stared at the wall. "All right. Just all right."

He wished that he had something to bring her—flowers perhaps. Anything at all.

"Yeah, well—you look fine, just fine," he said lamely. He came up to the edge of the bed. "Do you mind—?"

"Would it matter?" The words were bitter.

He recoiled at her voice. "What do you think? Of course it would."

"Oh, go on." For the first time she made an effort to put the pieces of her face together, and a flash of her beauty crept through. "Please."

He sat, feeling the tired bedsprings creak under his weight. She peered out of the reconstructed plastic window of the "hospital" room, out at the twisted and ruined wreckage of a city. The street was bright with sunlight, but there was little sound out there, and no traffic or machine noises at all.

"Well," he said, "look at us. Both alive. I guess we never counted on that, did we?"

"Alive," she said slowly, wonderingly. "Am I? I've got nothing left. I can't go back to my life. I can't be seen in public. All I've got is charity from a damned bunch of tramps, and—" She closed her mouth, embarrassed and confused.

"And me?" he chuckled softly. "You don't 'have' me, Promise, and I don't have you. We've just bumped heads for a while, and until we can figure a way out of this, I think that we should try to get along."

She rolled over in the bed and looked at him appraisingly. "You're supporting me now, aren't you?" Her eyes were muddy.

"If—if I hadn't, they would have sent you to one of the topside hospitals. We both know how long you would have lasted."

"So you just pitched right in, is that right?"

"Yes, but—"

"I just want you to know," she said quietly, "that I pay my debts. In full." Her eyes met his, and he saw the weakness there, masked by a desperate facade of strength. "You just tell me what I owe, and I'll handle it."

"Listen." Aubry tried to keep his voice even, didn't succeed entirely. "You don't owe me anything. You helped me get away alive. You were hurt. I have this habit of sticking by the people who don't do me dirt—I'd do as much for a man or a dog."

"Thanks," she said, nodding her head slowly. "Just thanks a whole hell of a bunch." She turned back to look out at the street again.

There was no anger in Aubry, only a vast sadness, and he knew that he had been a fool to hope that she could fill his void with a word or a smile. "Listen, lady—what do you want from me? Should I have left you at Luis's? Or maybe let the Scavengers send you out to die? I mean, just what in the hell was I supposed to do?"

"I don't know." The words were soft enough, but there was a scream hidden in them. "Once, I thought I knew what was happening in my life, but now I'm flat on my back with no ideas about what I'm going to do. None."

"I don't—"

"Aubry, you have some kind of an idea what all of this is about. An idea of the world that the Ortegas live in, the violence

and the scheming and . . . and all of that. I wasn't ready for this
kind of thing. You had five years to think about revenge, and
what it might cost you. You fought your way out of prison,
and you fought your way into my life, and you fought your
way in and out of that damned house, and with your bare hands
you killed the man who'd hurt you. How wonderfully macho.
But me—" There was a catch in her voice, and now he was
sure that she was crying. "—I was living in my little world,
making do, dreaming that my life was stable and secure, even
if it wasn't exactly fairyland, and then suddenly, because I tried
to help someone, everything falls apart." She laughed, and it
was an ugly laugh. "Ain't that a burn? If I had just stuck to
my own game, I would have been fine. But I tried to do
something decent, and look at me. . . ."

"Look at what?"

*"Look* at me!" She screamed it now, and her eyes flared at
him with an awful light as she threw the sheets back. On her
side, a little above the hip, was a patch of slightly paler skin,
about three centimeters across, and roughly circular.

"Do you see me? Do you see this? Don't you realize what's
happened to me?"

He shrugged, feeling confused. "You've had a transplant.
You came out of it without being infected . . . they say that
you're going to be fine."

Her nostrils flared with anger. "Fine, am I? Watch this, Mr.
Knight." She closed her eyes and inhaled deeply and arched
her back, then exhaled with a slight tensing of her abdominal
muscles. The left side of her body began to glow, the colors
running in irregular ringlets, flowing around the restructured
area. The colors were muddy, not bright as they had once
been—except for her hair, which still flashed a brilliant blue
and red.

The inhalation ended, and she collapsed back into her pil-
low. She stared at him defiantly as she grabbed the covers and
pulled them back up over her naked body.

"My life has fallen apart, and it all started the day that I
met you." She turned back to the window and wiped the back
of her hand across her eyes. "All right, then, Knight. You've
seen me bleed, and you've seen me cry, and that's all you're
going to get out of me, dammit. You're nothing but a gutter-
rat, a lowdown tramp who thinks with his feet, and if you think
that you've got some kind of a hold on me, you've got another

thought coming. But don't worry—like I said, I pay my debts."

She seemed pitifully small and frail and afraid. Part of him wanted to grab her and shake her and scream loud enough that the part of her that was still unscarred and unfilled with hate would hear: *What in the bloody hell do you have to be sorry about? So, part of your body is different now. You're still more beautiful than any three women I've ever seen. And your life is ruined because you tried to do the Right Thing. Join the club honey—guess what, there are a few more of us out here who've had our brains beaten out with our own dreams.*

And in his imagination he said those things to her, and more. Angrier, viler things. And as he thought of them, the parasite in his stomach rose up, spitting acid into his throat and blurring his eyes.

He turned while he still could, squashing the thoughts and feelings until they were only warm ashes. Silently, he headed for the door. "Aubry?" He didn't turn around, but he did stop.

"Yeah?"

The voice was even smaller this time, a child's voice. "Thank you."

The hall outside was much dirtier than the room, and stocked with all of the Scavenger medical supplies that didn't need refrigeration.

Mira was there, sitting, watching him with inquisitive eyes, and a thin smile that was too warm to offend him.

He crossed his arms and leaned back against the wall, sighing.

Mira scratched the space behind her left ear, and stood, laying a hand on his shoulder. "How is she?"

He shook his head. "I think she'd be a lot better if I just went away and left her alone."

"Don't you believe it. That girl is fighting massive shock. Virtually everything in her life has changed, all in the course of a week. What do you think that would do to *you?*"

Aubry grew very still, very cold, and Mira flinched, wondering what memories she had ripped out of his past. Afraid to stop now, she stumbled on. "You're that girl's only bridge between her old world and her new one—this one. She needs you, and hates needing you—I'm not totally sure why."

"Yeah. Well, I'm just supposed to be made out of understanding, or what?" He paced up and down the hall, trembling, then pivoted on his heel. "What about me, huh? Just what in

the living hell about me? What am I supposed to use for feel-
ings? I'm not supposed to hurt, I'm not supposed to get tired,
I'm not even supposed to *dream*—"

His voice climbed and almost cracked. Mira's expression
was neutral, accepting, and somehow that made it worse.

"You couldn't understand," he said. "I was stupid to think
you could."

Then he turned and stalked away, his footsteps thundering
on the hallway floor.

She waited for a moment to be sure that he wasn't coming
back, then walked into the hospital room.

"You and Aubry have a little row?"

Promise was still looking out of the window at the ruined
buildings, ignoring the question. "What's it like out there?"

"Burned-out. Cold. Lonely. You know—a lot like it is in
here."

Promise glared at her. "Time for the sermonette?"

"Is that what you call it when someone tries to give you
some friendly advice?"

"No. That I call meddling."

Mira met her eyes, watched Promise's shift away nervously.
"If you're going to stay here with us, there are some things
you'll have to learn. One of them is that we need each other,
and every part of this family exists because the other parts take
care of what they're supposed to be doing. It doesn't work too
well when one part is sitting up feeling bad for herself, unless
she realizes that there's pain everywhere around her too."

"You're saying that he needs me?"

"Something like that."

"Why? Am I the only woman here?" She pulled the blankets
up to her chin, almost hiding behind them, and squeezed bunches
of the cloth between her fingers so tightly that her knuckles
whitened. "I'm damned tired of being needed. Being needed
is just the flip side of being royally screwed, you know that?"

"Is that what you think?"

"That's what I *know*, honey." She burrowed deeper into her
sheet, and hissed her breath out in a long, tired sigh. "That's
what I know. He doesn't need me, and I don't need him."

"You don't?"

Promise's voice was becoming sleepy. "I've got everything
I need."

Mira shook her head. "If you're all that you've got, I feel
sorry for you, because right now, you're not very much."

Promise sank into her sheets, her face full of pain and betrayal. She tried to find something to say, something bitter and clever, but it just wasn't there. Finally she said, in a very small voice, "I used to be."

Mira shook her head and left the room.

The shadows of the stubby buildings were lengthening in the twilight. Down in the street a few furtive shapes combed through the wreckage for the thousandth time. Mira watched them, feeling old, and tired. The figures moved with the halting shuffle-step that marked the deteriorated Thai-VI victim.

She wished there was something, anything, that she could do to help, to ease their suffering, even to quicken the inevitable; but there was nothing, and she didn't bother trying to find some ways to make the impossible possible.

Sometimes it just hurt, that was all.

"You bleed for them, Mira," Warrick said softly behind her.

She turned, smiling sadly. "Silly of me?"

"Silly perhaps, but very Mira." He reached out to trace the edge of a finger along her jawline, and the sadness welled into tears at the corners of her eyes. "How are our patients?"

"We're . . . going to lose Conners."

"The crushed chest. Yes, I know." He touched Mira's face, tracing a deep wrinkle line. "There's something else, isn't there?"

"It's really nothing. I don't want to concern you with it."

"Then it's Aubry, who lies about his name, and the woman Promise."

"Damn you, Kevin Warrick. I can't hide anything at all from you, can I?"

He took her hand and led her over to the side, sitting her down. He took her hand in his and placed it gently to his hollow cheek. "Now, tell me—what is it about them that troubles you?"

"It doesn't really make sense, but I feel that they're . . . dangerous somehow."

"Yes," he said sadly. "I feel . . . that they are in the grip of something they do not understand."

"What is it?"

"I don't know. The dreams come, and they go, and they leave bits and pieces of things for me to understand later. What do we know of these people? That they were running from something. Trouble with the law? That doesn't bother me.

There is something else. . . ." He pinched the bridge of his nose, and gazed out down the hall, his eyes filling with shadows. "I don't know. Not sure. What about their personal possessions?"

Mira got up heavily, fished in a series of boxes piled up near the supplies, and returned with a water-stained bodypouch. "Aubry was carrying this."

There was nothing in it but a few concentrated fuel bars, a micro-thin poncho, and a letter, which Warrick examined curiously. "I think I'll be rude," he said, and opened it. It was completely waterlogged, the ink smeared so that barely one word in three was fully legible. He chuckled to himself, and started to fold it back up again. Then he stopped, unfolded it, and looked closely at the watermark at the bottom. "Odd. . . ." He rubbed at it with his thumb, and it smeared. "Hmm . . . I wonder."

"Wonder what?"

"Do you know what this 'watermark' looks like? What it reminds me of? A spore print. A mushroom spore print. See how it used to be roughly symmetrical?"

Mira took the sheet of paper from him and held it up to the light. "Mmmm . . . you might be right." She shrugged. "And if it's true? We have plenty of mushrooms. Our farms hardly need any new strains to work with."

"No. . . ." He took the paper back from her, and crinkled it in his hands, thinking. "No, not *food* mushrooms. . . ."

Suddenly he seemed hollow, as if his mind had drifted somewhere far away, and when she touched his arm, it felt cold. "What is it?" she whispered, startled by his lack of response.

His face was glassy, emotionless, and when he spoke, it was as from a far-off place, somewhere that she could not follow. "This is the thing," he whispered. "This piece of paper is the danger."

Mira wanted to laugh, then saw the deadly seriousness in his face and backed off.

"I will take it to Emil. He will grow it for me."

"This thing, this sporeprint, is dangerous to us?"

"Yes," he whispered, "many will die."

"*Die?* Then destroy it!" She snatched at the paper, but his wrist turned in a movement like a butterfly's wings, and it fluttered out of the path of her hand.

"No, we have no right. It was meant to exist. It is more

important than any of my works. Certainly more important than my life."

"Kevin—"

He smiled down at her with bemused resignation. "What will be will be, Mira. My place in this drama is to give them a chance to grow."

She held out her hand for the sheet again. Calmly, he handed it to her. She studied it, the splotches and wet marks, then shook her head. "No. It's too contaminated. You'll grow twenty kinds of mold and fungus before you see anything of this strain. It can't work."

"It will work." He held out his hand for the sheet, and reluctantly, she handed it over to him.

He folded it and slipped it into his pocket. Then he kissed his sister gently on the forehead, turned, and left.

Mira watched him leave, hoping that he was wrong, that the mushrooms would not grow, or that if they did, they would be totally harmless.

It was not the first time she had hoped her brother was wrong. But she prayed that this time, for once, her wish would come true.

# 11

## "Love for Sale"

"Gibbs is late," Wu said, green eyes fixed uneasily on the empty chair.

Tomaso Ortega said nothing, pressing himself back into the command seat. It was his brother's chair, molded to fit a dancer's body, and too narrow for Tomaso's lumpy hips. But its arms contained all of the controls for the room's communication center; its hidden circuits allowed direct access to the highest priority information in the West Coast Family computer system.

There was something more to it, of course: the chair had belonged to Luis, and now it belonged to Tomaso. It would be a while before the need for physical comfort superseded the emotional attachment. A pale rectangle of starshine fell from the magnifying skylight overhead. It bleached the color from the men at the table, and Wu, for one, was the worse for it.

Wu—painfully thin Wu, whose incredibly precise posture saved him from being mistaken for an outpatient from a terminal ward. Wu's jade eyes oversaw the importation of heroin from China and South America, cocaine from Bolivia, and grubs from the vast Brazilian Coal Moth farms.

Across the table from him, to Tomaso's right, was Wu's complete opposite. Area Security Director Diego Mirabal was so massive that he scarcely seemed human. It wasn't merely the extreme thickness and definition of his musculature that gave that impression; it was his bones. They seemed thicker and broader than those of a normal man. Mirabal didn't flaunt

142

his size—his dark pullover and elbow-length cloak tended to decrease its impact. But it was utterly impossible to mistake the strength and control in every movement.

His sloping brow and the tight, wiry curls covering his head reinforced the image. He had few friends, used no drugs, took no women. In some ways he seemed to be part of a sidestream in human evolution, something that had been bred purely for physical intimidation.

Tomaso drummed his fingers, noting for the tenth time the two empty chairs at the far end of the table. As he did, his eyes flickered past Sims, and he noticed that the greenish-yellow hair was tinted blue. He cursed under his breath and fiddled with the control in his right armrest, correcting the color in the hologram. Sims, the communications man, was a cold point in the room. If Wu was nervous concern and Mirabal lazy anticipation, Sims gave off no emotion at all. He was a lean man with a thin face under a mop of dyed hair. His contacts ranged from the military to the inside of the federal penitentiaries, from Europe to Asia, and Luis had often boasted that Sims could acquire anything, given the time and money. Now he seemed like a humming motor in neutral gear, uncommitted, waiting for a purpose.

His image was pumped in from Santa Barbara, as theirs was beamed to him.

Mirabal's flat voice rumbled next to Tomaso. "It's a game," he said. "We know why Gibbs is stalling."

Tomaso nodded agreement and tapped Gibbs's code into the computer. A grid of the San Jose area appeared on a projection field in front of him. It disappeared and refocused twice, each time zeroing in on a smaller area until Tomaso was looking at the schematics of Gibbs's house. There was the blip—in the communications center.

The heartbeat was fast, but otherwise perfectly healthy. Tomaso opened his mouth to curse, and the air around one of the empty chairs began to sparkle as Gibbs came on line.

The master of the West Coast prostitution division smiled nervously.

"Greetings, Tomaso." The trace of a smile flickered out and died. "My condolences once again on the death of your brother. My report—"

"Shall wait until Margarete has joined us."

Gibbs opened his mouth and then closed it, gulping like a

beached fish. Almost on cue, the chair at the end of the table began to glimmer, and an image began to form.

Margarete was old. It seemed that her skin had been stretched and dried to a leatherlike texture that had no life in it at all. Even her small dark eyes were dead and unfocused. Although she appeared to be sitting up at the table, Tomaso had the impression that she was actually lying down, the image rotated to an upright position. When she spoke, her voice was an electronically augmented crackle.

"Tomaso," she said, ignoring the other men at the table. The voice was so flat that the *t* sound could easily have been mistaken for a *d*.

"Margarete. I trust that you are well?"

"An asinine question. What news of Luis's murderers?" She pronounced each separate syllable with painful care, as if her voice were the only firm tool remaining to her.

Tomaso looked into the sightless eyes, and nerved himself. It was like staring into total darkness, wondering if the next step would find firm ground, or a back-breaking fall. "Yes, Grandmother. We know that the assassins worked as a team, and that a woman was infiltrated into the social gathering held a week ago last Friday. She, in turn, assisted the man with his entry."

Margarete held up a skeletal finger. "What happened to your security?" She paused, sucking air. "I wish to know everything."

"Of course. Mirabal?"

The security chief closed his eyes and recited as if a tersely worded scroll were parading down the inside of his lids. "The woman's name is Promise. Exotic dancer; first known contact, Vegas in '12. Worked L.A. as a courtesan, first for the Gibbs agency, then as an Indy. The day before the assassination she rejoined the agency." He opened his eyes and fixed them upon an uneasy Gibbs. "Apparently, their screening process was inadequate."

"I can explain," Gibbs said nervously. Tomaso waved his hand sharply. "Don't interrupt, Victor. You'll have your chance to speak. Go on, Diego."

Mirabal continued as if he were a recording device clicked off "pause." "After she gained entrance to the house, she unraveled her purse, which was constructed of braided nylon. She then lowered the makeshift 'rope' out of the window." Mirabal almost allowed himself a smile there.

"It must have been very thin," Margarete mused. "The assassin must be an unusually powerful man. A man such as yourself, Diego?"

"No. Not a NewMan. A nullboxer. His name is Aubry Knight."

"Your voice says that you know this man."

For once Diego's machinelike concentration wavered, and he carefully subdued a smile. "I did, once. Years ago. Luis sent him to prison. He escaped recently."

"You are suggesting a revenge motive?"

Mirabal scratched a thick fingernail against the top of the table, leaving a mark in the hard plastic. "It would fit him."

Although blind, Margarete was facing Mirabal, scarred and cloudy eyes boring into him.

"Could this man plan all of these things?"

"He has intelligence, but has never learned to direct it. I find it more likely that the woman is using him."

"Why?"

"It seems she was peripherally involved with the last operation Luis established before his death. She was wanted for questioning. There may be an element of self-defense here."

Margarete's face twisted. "And this woman entered your household unchallenged?" In that instant Mirabal swore that her eyes were alive after all. He felt himself pressed back into his seat by the force behind them, and felt an alien emotion tickling his gut.

Tomaso filled in the gap. "The weekly parties were conducted at Luis's insistence. I told him over and over that we couldn't provide proper security, especially with the turn-over rate of the party girls. He assured me that the arrangements with Gibbs—" Here Tomaso tore his eyes away from Margarete and fixed them on the cringing man at the end of the table. "—were satisfactory. In my estimation, Mirabal discharged his duties with full competence."

The attention of the entire table turned to Gibbs, who seemed to wither before it like an insect caught in a torch flame. "It wasn't my fault," he bleated. "I'd known this woman for years, and—" He looked at Mirabal with venomous hatred. "I don't care what anybody says. Maybe this woman slipped past me, but how the hell did this man Knight get past your security, Mirabal?"

"I was going to ask you that, Gibbs. This seems to me like a very carefully planned operation. Knight is not a devious

man. The woman shows no evidence of technological capacity, and yet they defeated our security system. We don't know how, except that we can be sure that your agency was a weak link. Once she was in—" He paused and leaned forward, hands folded into a thick mat. "Once she was inside, with what we must assume was a sophisticated means to beat our code implants, she was within our defenses, and could do as she wished. I feel certain that our intensive investigation must begin with you."

Gibbs roared, his handsome face distorted with rage. "I'm not going to let you put this on me. Forget it. I don't need any of this—"

"Gibbs," Tomaso said softly. "I would appreciate it if you would make the trip down here. Just a few days. I feel that your presence might—expedite the investigation."

"To hell with you! I know what you want—"

"You are under contract, and you must know that all of our contracted employees are treated fairly—"

"I'm not under contract any longer—" he said, starting to reach forward. "I'm putting an end to this right now—"

"Victor—" There was nothing soft in Tomaso's voice; Gibbs stopped before he reached his control panel. "Do you realize how serious it is to cancel your contract without notice?"

"Do you realize I'm being set up by that ape of yours? I'm sure he'd love having me for one of his 'intensive investigation' sessions. I've seen his trick with the ribs. You listen to me. San Jose is *my* turf. You just try prying me loose from it—"

"I don't have to," Tomaso said.

Gibbs was trembling, even while making an heroic effort to remain calm. "What do you mean, you won't need to? Tomaso, I warn you—" Tomaso thumbed down the sound on the transmission until the man was ranting in silence.

Tomaso's voice had only a bare crackle of command in it, but it was enough to stop Gibbs in mid-syllable. "Are you certain that you have no interest in cooperating with this investigation?" Tomaso's fingers were already busy on the computer console built into the chair's right arm. QUERY. GIBBS DESTRUCT CODE.

The computer read the code back to Tomaso: GBBS-XX2573TRMN8. He paused for a moment before typing it back in.

"Very well," Tomaso said finally. "Would you raise your left arm please?" Gibbs shook his head, startled at the request,

but his arm started to rise. "Thank you," Tomaso said, and swiftly typed EXECUTE.

Gibbs had time to shape one silent syllable: "What—?"

The smoke and flash of light that blossomed four centimeters beneath the exposed armpit, the way Gibbs's body jerked sideways in his chair—both seemed to indicate that he had been shot with an explosive round. Gibbs's right hand flew to the gushing hole in his side. His mouth gaped in shock, more blood flowing from his nose and choking his throat. He blinked once, hard, and seemed to be trying to speak. Only one mouthed word made it past the pain: "*Implant*—" Then he fell, his body spasming with decreasing violence.

Sims's hand was feeling his own side, for once his emotions reaching the surface. "The implants. Do you mean that any of us—?"

"Tomaso!" Margarete's voice cracked like a whip in the room. "What is happening?"

"A traitor, Grandmother." He said, wiping the image from the room. "We have just eliminated a traitor."

Margarete sat back into her chair, the momentary surge of energy gone. "A traitor," she said, sightless eyes scanning the darkness, "and also a possible witness. Tomaso, I want you to find the killers. Bring them here, to Terra Buena."

"To the Island?"

"Yes. This is family business. You have temporary leadership of the West Coast until they are found, or until we are dissatisfied with your efforts to find them. Be swift, Tomaso. I want an answer, and quickly."

Tomaso opened his mouth to speak, but Margarete was already fading away.

There was silence in the room; then Wu cleared his throat. He seemed even paler, eyes still locked on the empty chair where Gibbs had been. "Your . . . brother had these bombs within the tracers all the time?" He turned to Tomaso accusingly. "And why do you show us now? Do you need to control us through fear?"

"No. As you said, this was my brother's idea. I will have no such need, and the transceivers will be removed immediately. If I cannot trust my officers without such methods, I cannot trust them at all. Things will be very different under Tomaso Ortega."

"Immediately. . . ." Mirabal said slowly, rubbing his side. "That would probably be best, yes."

Tomaso had a sudden chill as Mirabal's hooded eyes slid by him, almost as if the momentary contact were accidental. But there could be no mistaking the danger in them.

Could Mirabal really reach him, and kill him, even with a hole torn in his side? It wasn't an experiment he cared to conduct.

Sims was nodding to himself, as if confirming a private suspicion. "I'm finishing my business here," he said. "I'll be in the Palisades tomorrow. Have the surgeon standing by."

"Certainly. And Sims—?"

Tomaso kept his satisfied smile to himself, but it was easy to see that Sims was on the edge of panic. "Be prepared for a serious conversation. We need to find these people, and we need them quickly. Your contacts may lead where Mirabal's do not."

Sims was beginning to shake, and Tomaso knew he was eager to get off the line. He waved a dismissing hand, and the picture died.

Wu and Mirabal were both watching him. Wu looked on the verge of fainting. Mirabal's emotions were sealed under a wall of control so mountainous that Tomaso had the bizarre sensation of watching an explosion in extreme slow-motion.

"We can retire to the medical unit I have set up in the next room. And then, if you wish, you may join the party which should be commencing in an hour."

Wu and Mirabal left—one tiny and pale-skinned, the other enormous and dark. Do they hate me? Tomaso asked himself. No. Wu will regain control, and realize that I have released him. Mirabal, though . . . Who knew what really went on in that massive mind and body? Who truly wanted to know, as long as the animal dwelling in Mirabal's soul occasionally got the raw meat it needed. Who cared?

They might hate him for the moment, but it was really Luis they hated, Luis who had tricked them into carrying the seeds of death within their bodies. But now other seeds had been sown.

Seeds of trust.

Tomaso eased his bulk from the chair, stretching and yawning with a smile. He had time, and that was all he needed.

Almost . . .

The door opened to his thumbprint, and he stepped out into the hall. A smocked guard saluted as he passed.

He kicked his shoes off his feet as he approached Luis's bedchamber. Correction—*Tomaso's* bed chamber. The halls with their soft-glowing tapestries, the warm pile carpeting, the employees—all were his. Below him, he could hear the sound of preparations for the party.

But one very special guest should already have arrived.

The door to the bedroom loomed ahead, a massive panel of mahogany that seemed out of place with the rest of the decor. Luis had wanted it that way, had insisted on the appearance of solidity and old-world power. If not for the perfect hinges on which the door floated, it would have been monstrous to move; but with them it responded to a fingertouch.

"Luis," he said softly, shaking his head. Why did you have to be such a fool? A breath of sorrow shadowed his face for an instant.

Even though he had been in Luis's quarters many times, it was difficult to quell the sudden intake of breath, the wide-eyed appreciation for what his brother had created. The carpet fibers were light-conductive synthetic, and the illumination rose up through it in undulating waves of gold and silver. There was no music, but there was something soothing in the air, a pulsing hum which could be adjusted to bring sleep or excite sensuality.

The bed itself was a creation in shimmering white, raised four feet above the floor, a circular mattress mounted upon a layer-cake of carpeted, circular stairs.

A low snarl of anticipation rose in his throat. Behind the gleaming crystal wet bar stood a woman who watched him with huge, tear-filmed eyes as she poured herself a drink.

"So, Tomaso," Nadine said, her hands unsteady as he approached her. "I am here."

He stopped, eyes tracing her perfect face, the incredible fineness of her shoulder-length hair. In the room's dim, provocative light she seemed more a sculpture than a living woman.

"I didn't want to be here again. To see this place." She leaned back against the bar and took a sip of some concoction almost as golden as her skin. It seemed to calm her. "So, tell me what you want, and then let me go."

He stepped closer to her, and her eyes narrowed. "I'm not interested in that, Tomaso."

"I understand you better than you know, Nadine."

She brushed her hair back, laughing sourly. "What is that supposed to mean?"

"I understand that you didn't love my brother. That you never did. You loved his power."

"He was a *Man*," she said, and threw her cup into the sink. It shattered, shards of glass spraying out past the porcelain. Nadine brushed one off her arm, sucked at the shallow cut before looking up in anger. "The only real *man* I've ever known."

"Yes. You loved the tightness of his body, and the way he moved, and held you. That's what you told yourself. But you were lying."

She started to take another drink, then put the cut-crystal bottle back, glaring at him. "I don't need to listen to this kind of insult, Tomaso." Her brows beetled together. Even the lines they created were beautiful. "Why don't you get to the point?"

"All right then. The point is that you loved his power, his wealth. And that lives on in me."

"You? Isn't it a little soon for you to start propositioning his mistress?"

"Listen to me. Luis was a man, the living symbol of the Ortega dynasty. That, if anything, is what you loved." She stiffened, starting to turn away. "That is what *I* love, what I have given my entire life to. To revere a woman I haven't touched in ten years. To pay honor to a man who was dead before I reached puberty. To keep alive a tradition, a strength, which is more important than my own life—than anyone's life. Why do you think I would look down on you?"

"I'm going," Nadine said, the three syllables rolling off the perfect lips disdainfully.

She reached behind her, picking up her fur wrap and whipping it around her shoulders.

"Nadine!" he said as she walked to the door. "I can't give you Luis, but I can give you what he never would."

She paused, a barely perceptible break in stride, then continued on.

He felt as if his stomach were burning. Was he so little, and Luis so much? Were his hands, his soft hands, so repulsive when compared to the corded musculature of his brother? "I can give you what you always wanted."

She was at the door now. Why wouldn't she turn? Why wouldn't this woman even turn and look at him?

"I'll give you my name."

She stopped now, and he could virtually see her ears peel back and flatten against her head, like a bitch given the scent.

"You would not," she said flatly. But she had turned, and the turning put the lie to her words. "It would dishonor your family."

"My family is not just something out *there* somewhere, real and solid, with me some kind of emotionless puppet. *I* am my family. I can show them, make them respect me, care for my needs and wants." He stopped, and his voice grew steady. "And I want you. I've always wanted you, Nadine, from the first time I saw you, and knew that I could never have a woman such as you because I was only the Little Brother of Luis."

"You can buy women."

"I want you."

"You're trying to buy me."

"But not with money alone. Not with the things that any other man can give you. I can give you children who will be heirs to a kingdom. I can give you power and glory. I can give you love."

She stared into his face, thinking. Then, slowly, the door closed behind her, shutting with an oiled metallic click. "You don't have the strength to go against your family," she said. Her words were hard, but the first trace of warmth had crept into her voice.

"Don't decide now. Stay tonight. Stay—and watch the party. You may have changed your mind by the end of the evening." He walked up to her, felt the change in her body, heard the unasked question—*is he lying?*

"Stay here," he said. "Food will be brought to you. You can watch the party on the wall monitors." He paused, to insure that his next words would sink in. "I strongly suggest that you not come downstairs until the party is over." She stiffened slightly. "You may if you wish, but it might be safer for you if you didn't."

He turned then, and left the room.

Tomaso slipped into the guest bedroom.

The entire floor was soft, warm plastic, malleable throw pillows making up the remainder of the decor. Plastic hookah hoses pumped in smoke of varying compositions and intensities, according to the needs of the user. Tomaso walked carefully across the floor, rebalancing with each step as it sank under his feet. It gave a rasping squeak, almost a moan, with every footfall.

He picked up one of the hoses, and drew on it experimentally. Sweetish—that was the opium-hashish mix. He exhaled harshly, waiting for the instant of dizziness to pass.

There were faceted light-refraction crystals hanging from the glowing ceiling, fragmenting the illumination into a thousand patchworked rainbows. He removed a rectangular card from his vest pocket and spoke into it. "Tacumsi?"

It was a moment before the card vibrated in response. "Yes, sir. Would you like your blood pressure?"

"Pulse will do." Tomaso touched his forefinger to his wrist. "When ready."

"We've got seventy-seven."

"Excellent. Your voice is a little flat, however. I'll need a new comcard immediately. Are all systems in and operative?"

"We're waiting for the programmers to link up the last of the inputs." He paused. "If what you told us is correct, we'll need real-time dimensional biopsies on maybe eighty people. Tall order, Mr. Ortega."

"You can handle it."

"Well, we'll do our best."

"I'm counting on it. I want every single guest linked in and ready by eight forty-five."

"Yes, sir."

He slipped the card back into his pocket and looked around the room again. There was nothing, absolutely nothing for any of the guests to see or find, but the bedroom was as open as a glass cage. He grinned, a little trill of excitement ran through him at the thought.

At eight o'clock the guests began to arrive.

Their cars glided down the drive and coasted in on the restricted airspace, guided by beacons and landing lights. As the guests exited their vehicles, they were escorted through the first zone in groups of five or six, checked and rechecked. Many of them had been present the night of Luis's death, so there were no complaints.

Tomaso greeted them at the door, shaking hands, kissing cheeks or lingeringly offered lips. He distinctly remembered when the same women would barely speak to him. Now they managed to rub suggestively against him before entering the house. One half of him tried to smile while the other longed to spit in their faces.

By the time Tomaso escaped to the cool dryness of the

basement, his armpits were damp with perspiration, and he had a pounding headache. Damn! How did Luis do it? How could anyone deal with this madness without going insane? The requests for special food, drugs, and women. The separate eating quarters for those who preferred to keep their clothes on, those who preferred their entertainment in private, and those, like Tucker, the Congressman from San Francisco, whose streak of exhibitionism always drove him to perform his "specialty" in the center of the room. Tomaso hoped Tucker had brought his own vegetable oil this time.

He felt a familiar burning sensation in his stomach, and keyed his porta-doc to feed a few grams of antacid into his system. He paused, waiting for the slow fire to die down, listening to the sounds of the party above. Happy sounds. Laughing, singing—

"They don't miss me. Not at all." He whispered it, the sound of his own voice something alien and strange. He looked up at the top of the stair.

Below him there were other sounds, human and machine sounds, dim and muffled by a heavy steel door. He thumbprinted the lock, and the door hissed open for him.

The three technicians in the room stood to greet him. Tomaso shook hands with them warmly. Their palms seemed flatter, dryer, less sticky than the hands of the hoodlums and politicians who had gathered overhead to pick at the remains of dear dead Luis's empire.

On the flatscreen readout above his head, he could see into the living room, its singing tapestries moaning as his guests picked through their plates.

Steinbrenner, the quiet, stick figure of a woman who ran his computer analysis programs came up from behind, touching his arm timidly.

"Tomaso," she said in her whisper of a voice, "we'll have a variable display on the center screen. The left screen will provide a readout on whatever you throw center. The right screen will give us an average readout over the entirety of the participants in your—" There was an almost imperceptible pause before she said, "experiments." She said it haughtily, but Tomaso didn't let that bother him. Her apparent distaste had never interfered with any of the experiments she conducted. She brushed back a strand of sallow brown hair, and sniffed. She turned him around, and walked him to a holo stage, one similar to but smaller than the one in his brother's study. "Here

we have the most sophisticated tool. You will be able to call any particular . . . participant . . . up on the stage for a color-coded analysis. For instance—" she called back over her shoulder, to the large black man hunched over his console, "Tacumsi, give us a sample."

He nodded, his hands flying over the keys, and the center screen zoomed in on one couple, lounging on pillows and eating globules of spiced cheese. Tacumsi's voice was a bass rumble. "Here we are."

The holo stage flickered, and it was as if a shower of glitter had fallen through a battery of colored lights. The air above the stage was all stardust and kaleidoscoped hues, slowly taking shape as two human beings.

The reproduction was startlingly sharp. Tomaso leaned close, inspecting, satisfied.

"Give me blood pressure and alcohol content," he murmured.

"Easy, sir. One forty over sixty on the man; one thirty-five over fifty for the woman. Alcohol content—none, either one. Picking up some residual cannabinols, however. My guess is that they'll head for the hemp pretty soon."

"Follow them."

"Who are they?" Steinbrenner asked.

"The woman is Chyrmin Russell. She's the executive editor of a string of fashion magazines. An extremely valuable contact. She provides some of our best girls." He tried to imagine Steinbrenner's thin body sheered of its unattractive clothing, and failed. A damn good thing, he mused, that she was as intelligent as she was. If she had had to sell her ass for a living, she would have ended up in the work farms for sure.

"And the man?"

"I haven't the slightest idea. She finds her gigolos wherever she can, and drops them as soon as the gloss wears off. I don't think I've ever seen her without a hunk on her arm." He nodded thoughtfully. "And never the same hunk twice, either. Tacumsi, has anyone made it into the hemp room yet? Or the orgy room?"

Thick dark fingers played against silent rows of keys. A flat image, a group of three naked people twining in a rounded triangle. "Just these three."

Now Tomaso took his seat, gazing up at the flatscreen images. "All right. Stay with Russell and her stud. Find out what they're eating—cheese balls? Fine. Program the food processor

to add .1 gram of Cyloxibin to each ball. Same for the other food. Klause, I want you to calculate the average intake of the other food items, and begin spiking them so that each guest receives between .3 and two grams."

The conveyor belts running out of the automated kitchen never paused an instant, but now they were carrying drugged food, and the guests were downing it with gusto.

Tomaso chuckled grimly. Steinbrenner had the computer give her a temporary printout on magnetic film, and compared the sheet to notes in her private book.

"I've got Patricks's notes. Apparently, the drug can be taken orally or intravenously. Mixed with a carrying agent, it can be absorbed through the skin. I propose mixing dimethylsulfoxide into the lubricant creme in the orgy room, and combining that with a reduced Cyloxibin powder."

He looked at her face, trying to find a trace of emotion there, and saw none. "Do it."

"Sir—" Klause, the biochemist, began, not taking his eyes off the columns of figures growing on his screen, "did you have the time to examine my last report?"

"I haven't been clear enough to read anything lately."

"Well, preliminary reports indicate that the powder which was compressed to make the Cyloxibin tablets wasn't of ordinary chemical composition."

"No?" Tomaso frowned. "I remember reading the analysis. I have the formula. What do you mean?"

"Well, the tablets were composed of compressed spores and a neutral bonding agent. Millions of spores to a tablet."

"Spores?" Tomaso watched the screen again. Couples were beginning to drift up to the dancing areas. Conversation was quieting and another few people had made their way to the orgy room. "What kind of spores?"

"A fungus of some kind. Mushroom, probably."

"Huh." He hunched his shoulders. "Something from the psilocybin family, most probably. I want you to run a cross-check on the formula we got from Patricks. Make sure he didn't pull a fast one. If there is any variance at all, synthesize using the tablets as your basis. Start from scratch if you have to. Also—begin efforts to cultivate the fungus, whatever it is. I expect a complete wing of your lab converted to—whatever—growing mushrooms."

"Mycology."

"Fine. Steinbrenner, what about Russell?"

"I'm not sure I've seen anyone eat as many cheese balls at one sitting." Steinbrenner smiled uneasily. "And that brings her dosage to—2.4 grams. Five times the basic dosage. About two and a half times the dosage Patricks recommended."

"Do we have an estimation on toxicity?"

"LD50 for white rats was about two hundred eighty milligrams per kilogram of body weight. That comes out to about eighteen grams for an average adult."

"Fine. Start tapering off on the drug if your scans show that the guests are reaching minimum threshold levels. Some of them won't kick over; most will, and we'll probably end up with an overdose or two. Get the medivacs ready."

Tacumsi's controls had turned the screen into a patch-work of quasi-human figures, blotches of light, with each shimmering pattern carrying a different meaning to the trained eye. "Russell and friend," the big Black man rumbled. "They've both reached recommended maximum dosage."

The screen showed Chyrmin reclining against her pillow, hands wandering absently over the body of her companion, over his sinewy arms and neck. "Klause?"

"No change in metabolism yet. It's going to take at least twenty minutes for the drug to work its way into her system."

"I'm getting changes here," Steinbrenner barked. "Orgy room. Using the direct skin-absorption with crushed spores. Increase in breathing, pulse acceleration, and...pupil dilation."

Tomaso sneered. "How much of that can you attribute to the other drugs floating around? We've got marijuana, grubs, flamers, coke, alcohol, nicotine—"

Tacumsi hissed impatiently, watching the screen. By now there were nine couples, and two trois in varying stages of undress. "What we need is controls. I'm going to have the computer go back over the evening's tapes, and find the people who took no other drugs at all."

"Excellent," Tomaso said. "We'll want to know *exactly* what the others took, and in precisely what dosage. We'll want to check the synergisms. They may well be as interesting as the primary effects."

Then there was waiting: waiting for the last of the food to be consumed, for the drug to take hold, for the last-minute programs to be debugged and added to the computer burden. And when Tomaso finally smiled, his fleshy lips curling back

from his teeth in grim approval, the orgy room was full, and writhing with activity.

"All right," he said quietly, breathing gone shallow. "Let's have Chyrmin again."

The naked bodies of the magazine editor and her lover were projected full-size on the stage. The sweat seemed real enough to smell, and Tomaso walked up to the stand and watched closely, feeling the growing tautness in his own body as he heard their ragged moans.

"All right," he whispered, "let's have the absorption pattern." At the command of the console, their outline became a mass of red, blue lines within the mass tracing outward from the intestinal area, through the bloodstream, pooling in the brain.

"Coordination seems to have decreased, Mr. Ortega. We also have marked pupil dilation. . . ." Steinbrenner's voice had gone even colder than usual, and she was keeping her distance from the writhing red shapes. "A large portion of the drug has migrated to the lateral geniculate—"

"Drop the scan—let's have the image again." He hiked his chair up close to the stage and watched with clinical detachment. "Will you look at this? She's drooling." He pointed to a rivulet of saliva running from the corner of the woman's mouth, ignored as she pushed herself up onto the lap of her companion. Their naked bodies strained together in mindless rhythm. She began to shiver.

"We have an orgasm sequence beginning here, sir."

"How long since insertion?"

"Umm . . ." Tacumsi tickled his panel. "Four minutes, thirty one seconds. Thirty-four, thirty-five . . ."

"Fine. What about him?" He thumbed derisively at the male figure, bronzed and chiseled muscles beginning to gleam under a fine sheen of sweat.

"No. As a matter of fact, he hasn't reached the expected point in the male sexual cycle. My guess is that he—wait, let me cross-check drugs. My guess is the Cyloxibin is retarding his orgasm . . . slightly. It's nothing extreme. We have some excitation of brainwave activity, and from the expression on his face, I'd say there certainly isn't any decrease in pleasure."

Tomaso walked slowly around the figures as they sat on the stage, locked in passion. "Audio up a notch, please." The moans and animalistic sounds grew louder. "Try filtering this

mess down. I'm not hearing any words. Aren't they saying anything?"

Klause had come closer, shaking his head. "No. It's not uncommon to find a blocking of the speech centers during extreme excitation. Sex, especially, forces many people into non-verbal, non-temporal mode. Nothing unusual there."

"Wait. Wait—we're getting something." Steinbrenner's voice was excited, and her cheeks were beginning to flush.

Chyrmin seemed to be in pain. Her eyes rolled up into their sockets, and she gripped her partner's arms with fingernails that burrowed for blood.

"I'm getting an intense orgasm here. Look at the flush on the buttocks." She pointed to the heatrash of red splotches spreading up the back. "The same on her cheeks. I would say . . . hmm."

Her partner, who was resting back on his heels, with eyes closed, thrust up to meet her hips. "This," Steinbrenner said intensely, "is also interesting. The male seems to have entered a pre-ejaculatory orgasmic phase. Pseudo-orgasmic, perhaps—"

At last Chyrmin forced words out, but even with amplification and filtering they were largely unintelligible. They caught only one word, the name "Donny," repeated amid the jumble of sounds.

Tacumsi had left his computer, and the four of them stood around the stage, watching intensely as the couple began to spasm. There seemed to be no release for either of them, only a sexual tension that built up and up, until Donny's teeth were chattering and the blood flowed from the spot where he bit through his lips. Chyrmin moaned and lunged forward, licking the blood from his mouth hungrily, licking at the base of his neck where the perspiration pooled, then ravishing his lips in a savage, prolonged kiss.

They devoured each other, their sweat-slimed bodies twined painfully tight. Chyrmin's hands kneaded his back, biceps tensing as she tried to pull him deeper into her body.

Both were totally flushed, both in a rictus that seemed more pain than pleasure, and both broke that wet, clinging kiss at the same moment. Tomaso felt something electric brush his spine and his knees buckled. He grabbed at the top of the chair for support.

"Good Lord," Klause said fervently.

The couple had gone into convulsions, seemed not to be

conscious at all, their hips still jerking spasmodically as they tumbled over, tears streaming down their faces, eyes glassy, legs and arms locked together. They were panting into each other's mouths, chests heaving, and for an instant Tomaso's vision clouded, and he lost the contours, the two figures seeming to meld into one.

"Well," he said, trying to force a steadiness into his voice, "Donny is through for a while. Let's have a look at some of the other guests."

Tacumsi *tched,* glancing back at his computer at the arcing graph lines. "Let's have a deep scan on them." At his command their flesh seemed to melt away, and once again the stage was filled with a shifting mass of colors in rough human shape. "Look at this. Erectile sequence has already resumed."

"Well . . . Chyrmin was always one to pick a winner."

"Maybe. I'm not saying that it's the drug. I *am* saying that a level of excitation sufficient to re-engorge within such a short recovery time is . . . formidable." He shrugged, looking at the stage with thinly veiled curiosity. "I wonder . . ." he said, then was quiet again.

Tomaso watched him, and hid his own smile. I wonder what it feels like? That's what you were about to say, wasn't it? He looked around the room seeing the same unspoken question in Klause's face, and in Steinbrenner's.

"As I said. Let's move on." The field of view widened until they could see the rest of the orgy room. Tomaso gasped.

It was difficult to tell whether the guests were engaged in sex or mortal combat. There were exhausted, limp bodies everywhere, and the couples still engaged in intercourse seemed to be totally in a world of their own. The two trois had broken up, leaving two couples and two spare men. One man had found a woman partner, the other sat in a corner of the room, masturbating and crying disconsolately.

"Let's have the private bedrooms. Where's Wu?" Klause shook his head like a man coming out of a trance, and plodded back over to his console, talking to it in low tones. Steinbrenner continued to watch the projection field with an expression akin to shock on her face.

Tacumsi did a quick back trace on Wu, from the moment that the man had left the medical suite. "Got him. He's in the third guest bedroom."

"How many women does he have with him?"

"Just one. Just the one he came with tonight." Tacumsi

sounded more than a little surprised. "That doesn't sound like him. Let me check on something." He ran a swift side-program and added, "In fact, there's no one in the house who has remained in a trois. And there's damned little homosexuality." He scratched at his short crop of tight dark curls. "I'm not really sure what we have here."

"Neither am I," Steinbrenner whispered.

Klause had regained his composure. "I'm not sure either, but I have some theories." The three heads that automatically turned in his direction just seemed to irritate him. "No, I don't have any answers for you right now. I have about twenty million bits of information to boil down in the next few days, and I may have some answers for you then."

"And until then?" Tomaso felt like a school boy talking to his teacher, but at the moment there was nothing to be done about that: he was totally out of his depth.

"Until then, we finish recording the experiment. My readings show that some of the guests are coming out of it. Most of the others have long since entered their plateau stage. That suggests to me that the effective duration of the drug's primary effects is something in the neighborhood of three hours."

"Three hours. Good. That makes it more marketable. I think that we may have a recreational drug here. If it pans out—" His mind began spinning out the possibilities. "Yes—we'll need to work on subliminal marketing—"

Tacumsi shook his head thoughtfully. "Problems there. The harder we push, the faster legislation will move against us."

"This is a new drug, so it's still totally legal. I can tie up the control proceedings, stall the legislature for at least a year. By that time our distribution network can drop totally underground."

He squatted down, taking another look at Wu. The man looked as if he had spent six hours in a jacuzzi. His alabaster skin was flushed and hot, and there didn't seem to be a solid bone left in his body.

"Whatever it is that we have here," he said, something near reverence touching his voice, "I think that it's going to be worth all of our trouble."

"I might suggest that you wait a moment before you put a down payment on the moon." Klause's eyes were unfocused, looking through the bank of computer equipment. "I said that the *primary* effects last approximately three hours. Secondary and tertiary effects . . . I can't really say at all."

"Are you anticipating any?"

Klause chuckled darkly. "Not offhand, but wouldn't you be a bit surprised if a drug as powerful as this didn't have any after-effects at *all?*"

Tomaso looked at him coldly. "As long as it doesn't kill them, don't worry about it."

Klause seemed almost amused. "And if it *does* kill them, make sure it can't be traced back to the source, correct?"

"Dr. Klause, you definitely have a talent for this work." Tomaso shook his arms back into his coatsleeves, and sighed, taking one last look at the equipment and the holo stage. "I think," he said regretfully, "that I need to attend to my guests. Some of them may be functioning in a few moments, and I mustn't be a negligent host."

He nodded to the three of them. "Tacumsi? Steinbrenner? Klause? Excellent work, all three of you. I will expect your report on my screen within two days. Thank you."

He turned and fairly bounced from the room. Tacumsi watched him go, a storm cloud brewing in his eyes. "I don't know if any of you have noticed it, but our leader's personality seems to be going through a bit of a change."

"Oh?" Steinbrenner's lips were drawn into a knife-edge of disapproval. "And just what do you mean by that?"

Tacumsi looked at her, weighed her tone of voice against his urge to speak, and leavened the result with caution. "Just that he seems to be rising to the demands of his position more . . . rapidly than I had anticipated." He walked back to his console and slumped down into his chair. "That's really all." His voice was quiet now. *Best to just do your goddamn work*, he thought to himself. *And watch what you eat and drink from now on. Klause is right. There's something* damned *peculiar about this drug . . .*

After Tomaso helped the last of his guests through the front door, he sighed, shedding his dinner jacket and heading for the master bedroom. It was empty, but before he let disappointment tinge his mood, he checked the study.

Nadine was there. She was seated in his command chair, and she was watching the hall camera. He saw his own back as it disappeared into the study.

She watched him approach with something between fear and fascination in her eyes.

Tomaso smiled. "Was it a good show?"

Her eyes widened, and she started to say something caustic, then thought better of it. "Yes. Damned good." She stuck her empty glass underneath the dispenser to her right, and received a stream of amber fluid. By the ease of the motion, he knew that it had been repeated many times that evening.

Nadine leaned forward in her chair. "You know, I've played hostess to a *lot* of your brother's sordid little soirees. Maybe you forget that. Never—" She took another drink. There was one part of Tomaso's head that hated seeing her do this to herself, hated seeing her coolness and class disappear under the assault of alcohol. But there was another part that sensed the mood in the room, felt the shift in power between them, and knew that she was a little afraid of him. And gloried in it.

"I only took part with Luis. Except for him I stood back, and watched, and laughed. Well, Mr. Ortega, I was watching tonight, but I wasn't laughing. Not even a little bit. I don't know what it was that I saw tonight, but I don't ever want to see it again."

She waited for him to say something, an explanation or a denial, but he was silent, and watchful. She waited until the silence was stifling, then filled the void with her own voice.

"Something happened here, in this house, that I've never seen before, but I'll tell you what it reminded me of."

"All right. What?"

Her face grew younger and somehow older at the same time. "It was four years ago, right after the Quake. There were food shortages everywhere. Bad ones. I remember my father and brothers out hunting dogs." She shivered. "I was sixteen years old, and I don't suppose that I weighed much more than a hundred, a hundred and ten pounds. Well, there was a time when things got even worse than that—not long, maybe only a few days—but there just wasn't any food at all. There was murder in the streets, and I remember—well, I don't want to talk about that. The point is this—" She looked at him, and through him, and he felt extremely uncomfortable, wondering just what it was that she was seeing.

"The point is that the federal government finally got emergency funds into the state, and the food trucks arrived. It was awful. Armed state mercenaries protecting them were torn to pieces. Many people didn't get any food at all. My family, and some of the others in my building, were the fortunate ones. We got food, plenty of it, and we hoarded it, forming a coalition with the other families in our building, sort of a community

protection pact. We had ours, and to hell with everyone else. And for the next few days . . . for the next few days there was . . . I don't know. Call it a truce with death, maybe.

"I never saw or felt anything like that unnatural calm, that frantic peace—until tonight. It was something that made me want to scream. Everyone was happy—except that they were in pain."

"Pain?"

"Of a kind, yes. And fear. Fear that the peace would be over. Don't expect me to believe that you didn't feel it, down there in the basement, playing with your toys. Only, Tomaso— these people aren't toys. What you were playing with tonight was real. You were tearing their guts out, it was so real. I just hope that you know that. For your own good."

"My good?"

She shook her head. "You're playing the fool, and it doesn't work. I don't know exactly what you did tonight, but I don't mind telling you that it scares me."

"I'm sorry about that." He paused. "I think that you should go and sleep it off. I'll join you later."

She opened her mouth again, then closed it. Her face became a mask. "All right," she said, and drained her glass with one tremendous swig. She rose and walked to the door. Only then did she turn to face him again. "Tomaso, I hope—I *think*— that you are a man of honor. You made a promise to me. You promised to make me a part of your life, and not just another toy. If you meant that, then listen to me, please."

"Listen to what?" he said blandly.

"Whatever it is—stop now. While you can. Please."

They faced each other, and he marveled again at the perfection of her face and form, and took savage satisfaction in her fear. "Good night, Nadine," he said.

She nodded. "Good night, Tomaso."

Tomaso Ortega's car rose up from the oceanside, and his chauffeur pulled them off the guide strip and into the cross traffic of Santa Monica. Much of Los Angeles's business had shifted to the beaches after the Quake and Firestorm. Santa Monica was one of the most prosperous areas in Southern California, with some of the tallest buildings and cleanest streets.

Tomaso gazed up out of his window as they slipped through the streets toward their destination.

"You know," he said, smiling to himself, "you would think

that after that Quake they'd be a little more careful about erecting buildings as tall as these. Just asking for trouble."

"That's the kind of people we are, isn't it?"

He turned to see the expression on Nadine's face but she had already turned away. The temperature in the car dropped a notch.

Private police patrol vehicles checked their identification at two security points before they finally reached the garage of the five-story building that was their destination. The car glided in, stopping for another security check.

Two guards opened the doors for them, and Nadine exited first, pulling her wrap tight around her. "Where are we?"

"The building is registered as ChemSpec, Ltd. Luis never brought you here?"

"No, and I'm not sure I want to be here." She sniffed the air, her nostrils flaring slightly. "I'm not sure at all."

"Come on, now. I think you'll enjoy this." He was bouncing with enthusiasm, and Nadine tasted something sour that she swallowed. The guards led them to an elevator, where another guard—this one armed—saluted Tomaso smartly.

"I seem to remember," she said as they stepped into the lift, "that Luis didn't have quite so many guards working for him."

"Yes—and of course most of us are still wearing black armbands for dear, trusting Luis." He looked at her, curious. "By the way—where *is* yours?"

She looked down at her arm, and stiffened. "I mourn," she said. "It's just too easy to substitute symbols for feelings."

"Very good, Nadine." Tomaso watched her, watched the way she turned away from him, then dropped her eyes to the ground.

The doors opened on a green-lit hallway.

Steinbrenner met them there. Her thin, flat face was flushed with excitement. Her eyes flashed from Tomaso to Nadine with swiftly veiled hostility.

Possessive! Nadine realized with a jolt. She has her little secret, her little piece of techno-wizardry, and she doesn't want Tomaso to share it with any other woman. It's their baby. . . .

"So. I understand that you have something for me." Tomaso had adopted a somewhat fatherly air, and it was almost amusing to see this cold, homely little woman fall into the child role so easily. "If you called me all the way out here to show me some doped-up hamsters, I'm going to be rather irritated."

"No way. Follow me, Mr. Ortega."

The thin brunette trotted on ahead of them, and Nadine watched the way the woman's buttocks shifted under her lab smock. Tight, prim, and full of repressed energy.

The lab to which she guided them was almost bare. Klause was there, and Tacumsi, the computer specialist. There was a flatscreen projector and a screen at the far end of the room, and three vacant chairs.

Nadine let Tomaso hold the chair for her. "All right, Klause. What do you have for me?"

"Everything." The man's receding hairline had left an impassive expanse of forehead, but now it was crinkling in excitement.

Tomaso sat next to Nadine, taking her hand. "Everything? That could be quite a lot."

"I doubt you'll be disappointed. Tacumsi—?" Nadine thought that she had seen, and participated in, enough sex in its many forms that nothing she saw now could shock her. She was wrong. "As you can see from the color-coding here—" A lightpoint stabbed out, indicating part of a shifting color spectrum superimposed over the images. ". . . the threshold dose seems to be fairly constant—"

"Absorption pattern?" Here the pointer moved to the breasts of a girl who seemed barely into her teens.

"We have a tracer working here. Our pattern works a lot like this—" A young man arched his back, struggling to control his muscles, as a purplish stain began to glow in his body, beginning in his stomach region, spreading outward in tendrils which snaked through his circulatory system and reached up for his brain.

"Straight for the medulla oblongata, which, as you know, is the most primitive portion—"

"That might be an explanation for the psi phenomenon. We've got what looks like primitive telepathy—"

"—crazy. Increased sensitivity to body language at the *max*. The rest is just hallucination. It *has* to—"

A finger tapped Nadine on the shoulder, and she almost jumped from her seat. "Coffee?" The offending voice belonged to a young Oriental girl with a bright, inquisitive smile.

"—does absorption rate vary with age?"

"Metabolic changes vary with—"

"Cocaine seems to diminish the effects somewhat—"

"—Skin-popped?"

"Nobody at the party was into that—"

"Then, we'll have to find a volunteer—" (Grim laughter.)

Tomaso's expression suggested Christmas mornings and freshly unwrapped toys. His infectious eagerness made him seem years younger.

Nadine sank back into her chair, watching him, watching Steinbrenner, and Tacumsi, and Klause speak with calculating coolness about overdoses, probable addiction patterns, and more, and more, until the names and numbers and probabilities and suppose-this's and suppose-thats heaped up in her mind like a pile of nasty letters daring to be read aloud.

"I've done a voice scan on the party guests who've called in the past few days, and I would say that better than sixty percent of them are undergoing severe stress already. If the trend continues in anything like a direct progression—"

The voices were becoming indistinct, and Nadine's vision began to spin, the sour taste in her stomach rising to her mouth again and again, until she knew that if she didn't get out of the room, she was going to be ill.

She rose from her seat, bent over, and whispered in Tomaso's ear—"I have to go to the powder room. Will you excuse me?"

Steinbrenner watched her leave, and wasn't quite able to get the grin off her thin face by the time Tomaso turned back around. He glared at Steinbrenner and the grin shallowed a bit, but its ghost remained.

Out in the hall, Nadine felt the door hiss shut behind her. The air seemed cleaner, sweeter, away from the endless analysis of what should have been, well—

Sacred?

She almost laughed at herself, sinking down on one of the variable couches in the lobby, dropping her head down to her knees. Crazy. It was all so crazy. What was supposed to be sacred? Sex? What right did she have to say that, having parlayed sex into power and position, wealth and comfort, used it to manipulate Tomaso Ortega into marrying her? If that wasn't sheer prostitution, what in the world was? So, what right did she have to complain, or criticize?

None, perhaps, but still, she did. And meant it. There was something evil in what was going on in there.

What was it? What was the drug? She closed her eyes and tried to find the images, the words. The twisting bodies; the screams of pleasure; the maniacal focus of the eyes; the single-

minded driving motions; the begging; the expressions of glazed contentment . . .

They were talking about a *love* drug. She looked up with a start. That was *exactly* what they were talking about, and if that was what they had, why in the world was she so scared of it? What was so wrong about—?

She thought about the pleading voice of the publishing woman, Chyrmin Russell, begging for more of the drug. The need on her face had etched and drawn that flawless, photogenic skin until it seemed little more than flesh-colored plastic stretched over a skull. Tomaso had laughed and hung up the phone.

She remembered what Klause said just before she left: "We estimate a fifty percent addiction rate on the first application—"

"Love for Sale." The words of an old song, ancient before her mother was born, ran through her mind. Somehow she could see Tomaso standing on a street corner, holding a bucket of pills in one hand and a gas lantern in the other. "Looove for sale . . ." he crooned, turning to look at her, and his face was a death's-head. .

She jumped when a hand gripped her arm. "Come along," Tomaso said flatly, and escorted her to the elevator. Only when the doors shut did he make further comment. He looked at her with an expression that was more curious than angry. "You embarrassed me."

"Why? Because I had to go to the lady's room?" Her voice sounded weak, and she immediately wished that she could choke the words back and start over again.

"You don't think anyone believed that, do you? We all knew why you left—you were upset at what we were saying."

Back in the garage, the guards escorted them into the car. Tomaso was quiet, but the air between them had gone cold. She felt a need to reach out to him, say something, reestablish contact of some kind . . . any kind . . .

"I can't help it. I can't help being—"

He turned on her fiercely, eyes burning in his puffy face. "Dammit. You were my brother's woman for almost two years. What is this? You shared his life with him; what's wrong now? I mean, I'm not good enough, or what? Just what the hell is it?"

"Please, Tomaso—" She held up a hand, trying to collect her wits. "You have to understand."

"I don't have to understand a goddamn thing." The car rose
up out of the tunnel and headed for the CompWay again.
Tomaso watched the buildings whiz by, watched the people
walking and tubing to and from jobs. His voice, when he spoke
again, was a whisper. "I don't have to do a thing. They—"
He swept his hand out in a broad arc "—all the little people
out *there* had better watch out. Had better understand." He
pressed his face close to the bulletproof glass, fogging it with
his breath. "From today on, I own them. All of them." He
laughed, a nasty, predatory sound.

"What *I've* got, everyone will want. There has never, ever
been anything like this before."

She could feel the tautness in his body, knew that he was
aroused, that he would demand her, or someone, when they
got home, and that if she played her cards right, she could
undo the damage done by her carelessness.

She leaned against him, melting her body into his, kissing
his neck. "Tomaso, you have to understand. Luis never trusted
me to know about the Family business. I . . . just never saw that
side of it." He looked at her quizzically, and she pulled his
head down to her, until he was looking directly into her in-
credibly black eyes. "Can you forgive me?" She kissed him
hard then, tasting and feeling in the kiss that the power was
not yet entirely in his hands.

And perhaps, just perhaps, something could be done to
improve the situation even further . . .

After all, if he was so obsessed with his love drug, it was
only fair that he be one of the first to try it. . . .

# 12

## Out of Mind

Warrick drove the lead cart, and he wove his way through the dark, twisting maze of tunnels effortlessly. Aubry experimented with the throttle of the Scavenger go-buggie he was driving. It felt responsive, and if it weren't for the claustrophobia, the sour reek of corruption, and the sullen visage of the woman next to him in the cart, he would have found the trip enjoyable.

He glanced over at Promise. Her hair was bound back severely, and hadn't been clipped in a long time: the real hair was noticeably longer than the plastic filament.

She gritted her teeth as the cart hit a nasty bump, her bottom jarring clear of the seat and thumping back down again harshly. "Dammit," she snapped, "can't you drive any smoother than that? Just what's wrong with you, anyway?"

A couple of days earlier, he would have been upset at her outburst. A few bouts with nausea had helped him adjust.

"That bump wasn't me, lady. I've got news for you—this tunnel wasn't built for traffic. Be glad that these little scooters will fit down here at all—you might have had to walk."

She opened her mouth, then closed it again and sat with arms folded, seething.

Warrick's high, wavering voice floated back to them over the hum of the electric motors and the rumble of the hard rubber wheels on cement. "—tunnels go right through Area B, under City Hall. Nothing left up there but rubble—" He waved one of his thin arms up at the ceiling, "—thousand miles of these

tunnels. Sewers, storm drains, service and pedestrian tunnels, electrical conduits, even a subway."

Aubry's ears perked up. "Subway? Who are you kidding?"

One hand on the steering wheel of his cart, Warrick turned around. "No joke." His face darkened, and he seemed to be trying to remember something, finally shaking his head. Next to him on the front seat, Mira patted his arm and yelled back to them. "In the twentieth century there were two efforts to build subways in Los Angeles—both of them went broke. Neither of them were ever used for anything except filming movies."

"And now?"

"It's ours."

Warrick barely seemed to pay attention to his driving, although he guided the cart with uncanny precision. Every time that it looked as if he'd surely crash into one of the walls, he swerved smoothly around the corner, without so much as a ruffled eyelash. Mira didn't seem to be worried or impressed at all, taking her brother's odd driving style totally in stride.

"And they can keep it, too," Promise said. She scratched at the edge of her coveralls, wincing at the way they chafed.

"What's wrong?" Aubry asked. "Not used to working for a living?"

Her gaze was murderous. "Laugh on, Knight—"

"Shields," Aubry said softly.

"Listen, Shields, I know that hard labor is old hat to you." She sniffed, and sank her chin down onto her chest. "Some of us are used to earning our way a little more gently."

"A little exercise never hurt anyone."

She said nothing, just watched the walls of the tunnel curving endlessly ahead of them, and kept her thoughts to herself.

The air had a sour, dead smell to it, as though its only movement or circulation was caused by the passage of the electric carts. She had been assured by Warrick and the others that in time she would get used to it. Well, time was something that she had plenty of.

Warrick's cart hesitated as he chose the smaller of two branching tunnels and followed it down. Aubry wrenched at the wheel: the turn was sharper than most of the others, sharp enough to cause the supply wagon they towed to swing from side to side in protest. For an uneasy moment he thought that the cart was going to tip over: he felt his way into the balance

of the machine and compensated for the tilt, taking the turn safely.

He was profoundly grateful that Warrick had decided to take one of the storm drains, and not one of the sewage maintenance tunnels. Although the sewer had ruptured and dried long before, the walls and ceilings of those tunnels were caked with filth, and reeked hideously. Whenever it rained, more garbage washed down into the Scavenger area, and the smell never completely died.

Warrick pulled his cart over to a side and stopped it, the engine dying with a shudder.

He hopped out of the cart and trotted back to them. "All right, unload and come with me."

"This is it," Aubry said unnecessarily, and got out, pausing just an instant to listen to his own voice echoing up and down the tunnel. The light was dim, reflected back from the gently curved walls of the tunnel ahead.

Just before the tunnel curved, there was a breach in the tiled cement wall, opening up into darkness.

Warrick's step grew livelier as they went, until he was almost doing a jig.

"What's wrong with *him?*" Promise said sullenly, watching the way the thin, wild figure pranced at the entrance of the tunnel.

"Fleas?" Aubry shrugged. "Let's get the food unpacked, and go see for ourselves."

She didn't say anything else, waiting until Aubry had loaded his arms with the food and jugs of water intended for the workers on the other side of the hole. She hefted two small packages, sighed with disgust, and shifted the lot in her arms, finding room for another shoulderful.

She looked amazingly like an upright packhorse. "That's the girl." Aubry chuckled. "See there? Give yourself half a chance, and you'll fit in."

"I'd like about half a chance to break your neck," she gasped, staggering.

Mira had unpacked her own gear, and was first into the hole.

"That's a pretty big load, Promise," Aubry said. "You sure that you don't want to leave some of that for the next trip?"

"Listen, 'Shields'—you carry your load, and I'll carry mine."

"I can understand why you're having trouble."

She looked at him suspiciously. "And why is that?"

"You're used to carrying most of your loads on your stomach, aren't you?"

Warrick's laugh drowned out her retort. "Do you see why I keep you together? Surely you don't expect me to let the two of you pollute the rest of my workers."

"Most of your workers are at least marginally intelligent," Promise said doggedly, shifting her pack. There was a tiny stream of water trickling from somewhere, and her feet made sucking sounds as she slogged through the dark.

"I know my people," Warrick said. "Some of them are even as spoiled as you, Promise."

She gritted her teeth, but said nothing. "And some of them are as full of rage as Shields." He laughed. "Interesting thing, Aubry. I've dreamed of you. And when I did, I didn't see you as the shield, but as the man behind it. Does that make any sense to you?"

They walked on quietly for a few more feet. Mira took a turn, and the tunnel narrowed so that they had to walk single-file.

"Why don't you spit it out, Warrick? You don't think that's my name, do you?"

"I'm not interested in who you were. Just in what you do."

"You know, Warrick, I know what brought me down here, and I know what's keeping me down here. But what in the world keeps *you* here, Warrick? And the others?"

Warrick chuckled grimly. "Anything would be better than this, right, 'Shields'?"

"Yeah, something like that."

"Really? Because it's dark down here, and it smells bad, and you can hear things creeping out there in the dark, always just out of your torch's reach?"

"That's . . . what I was thinking, yeah."

"Then that's what it is for you, Aubry. For me, it's just—where I am. A place to fit in. Have you ever really wanted more than that?"

Promise laughed. "Yeah, that's right, Aubry. You crawled out of a hole just like this one, so why fight it?" She looked back over her shoulder for Warrick, and couldn't see him. "You can't say that about me, Warrick. I wasn't born in this cesspool. I don't belong here, and as soon as I can figure a way out, I'm going."

Again, the grim chuckle. "Aubry Shields was born into his prison. You weren't born into one, were you?"

"Of course not."

"So you wrapped yourself in a billboard. One that lights up on command and screams to the world that you're a somebody, trapped inside a nobody."

Promise cursed. "Why don't you stop—"

"—pretending I know so much about you?"

"And stop finishing my sentences. What is it with you?"

There was no reply. Promise waited until the silence grew unendurable, then turned, waiting for Warrick. His pale figure loomed up out of the darkness suddenly, stopping the instant before they would have collided.

She reached out and touched his arm. "Hey? Did you hear me?"

Warrick's skin was so cold he seemed dead. He stopped, and shook his head as though momentarily unaware of his surroundings. "I'm sorry—did you say something?"

Promise shook her head. "No. Nothing at all." She turned and continued into the dark, more confused than ever.

They passed another branching tunnel, and suddenly the ground felt smooth and well-worn. After the next turn there was a long straight way and another turn, with a jagged hole smashed in the wall at the corner. Light streamed through it. Mira whistled sharply.

There was an answering whistle, and a clattering sound as tools were put aside. A scruffy face poked out of the hole and whooped, "Supplies!" The face disappeared for a moment, then a leg poked through the barely man-sized entrance hole, moving with the delicate nimbleness of a long-legged spider.

Mira stopped the convoy, and the supplies were quickly scooped by a horde of Scavengers.

About half of them headed back down the tunnel toward the carts: Aubry wondered how in the world they would find their way through the maze of branching paths, then just shook his head and forgot it. Aubry followed Warrick into the hole, leaving Mira to dicker with one of the Scavengers over rations.

The room was piled high, stacked to the ceiling with dusty boxes and stacks of books. One stack was low enough for Aubry to take one off the top, and he did, mystified at Warrick's excitement.

He scratched his head. *"Dreaming and Memory."* He pro-

nounced the syllables distinctly.

Behind him, Promise clapped sarcastically. "Bravo. Better than I expected."

He shut the book with a loud snap and shrugged his massive shoulders. "So what, Warrick? Who are you going to trade this stuff to? Who wants it?"

Warrick turned to them, his eyes burning. "*I* want them," he said. "This is our wealth."

"Well, yippee shit. So what? Can't you get ahold of some cubes, some disks? Can't you set yourself up a compschool, or what?" He threw the book back on the stack. "So, who needs to read?"

Warrick looked at him with pity. "There's something of a fox-and-grapes attitude in that comment."

Aubry's eyes narrowed. "What in the hell are you talking about?"

"Exactly."

"Hey, man. Do you think I'm stupid, or what?"

Warrick pulled a book from one of the shorter stacks, leafing through its delicate pages with care. "You know, it isn't that you can't get information in electronic form, or microfilm, or disk, or cube, or any of the other forms—tape, holographic computer feed." He paused. "Tell me, Aubry—what's the similarity between all the modes of information storage I've just named?"

Aubry scratched his head. "They don't take up as much space as books, I guess."

"Yes, that's true enough—but as far as I'm concerned, the difference is that they all require an external power source." He cocked his head sideways, until he looked absurdly like a bird examining a piece of fruit. "Do you understand that that makes you dependent upon others?"

Promise ran her hand over the spines of a nearby stack, then shook her head. "Not cubes. There are plenty of solar-powered cube-readers. One sunny day a week, and you're set."

"True enough, but you are still dependent upon others to repair your viewer if it breaks down...the more advanced a technology, the more fragilely inter-dependent it is."

"So what?"

Warrick shrugged. "It just seems to me that the most valuable thing that any human has is the ability to educate himself, to find out about the world around him, to program his primary organ of perception—his brain. And that basic, inalienable

right should be as independent of external factors as possible. Once a book is printed and acquired, it's yours. Nothing else is needed except a pair of eyes and daylight. Individual books have lasted for hundreds of years—do you really think that you can say the same of your little viewers, or computers, or whatever? If you have a hundred libraries stored on cube, and your viewer breaks down, you have nothing. Give me an encyclopedia, and if it isn't totally destroyed by fire, I can dig it out, dry it off, piece it together, and still have *something* of value." His gaze became direct, and piercing. "There is nothing more important than directing the flow of information into your mind. It determines all—your attitudes, your actions, your life. You can rely upon the visual and audible media all you want—but they should be in *addition* to reading, not in place of it. If other forms replace reading, then your input is restricted, and much more dependent upon other people, who may or may not have your best interests at heart."

"So, that's the most important thing that you can think of in life? Reading?"

Warrick sighed. "You are being obstinate, my friend. You learn if you learn."

Aubry felt a tickle of anger and quashed it, pleased that he had recognized the symptom before the accompanying flash of nausea.

The first room had been enormous, and stacked with books. The second was smaller, but Aubry suddenly realized that it had once contained the racks and stacks now in the larger room. Much of the floor was still covered with shelves, but the books were water-logged, ruined. The walls were caked three meters high with filth and mud.

"What happened here?"

"Ruptured sewage pipes flooded the lower levels." Warrick led them to an old, mottled hallway that connected the room with further chambers. There were makeshift lights strung up along the ceiling and walls, and they provided a steady, frail illumination. "We've been reclaiming as much of this area as possible," he said as they walked. "This was the downtown branch of the public library. The top levels were destroyed, of course. We still need to clear out some of the connective tunnels, so that we can move the goods freely."

"Why in the world don't you just travel on the surface? Don't tell me you can't protect your people against the Spiders or the Maze gangs. A couple of guns . . ."

"You don't understand. We're not as helpless as you think—we've dealt with them before, and harshly, when necessary. You haven't seen our defenses. The Alpha-Alpha tunnels. . . ." He shrugged at Aubry's blank expression. "At any rate, fear isn't the reason."

"Then, why?" Aubry was genuinely puzzled.

"It's sort of an 'Out of sight, out of mind' situation."

"What in the world are you talking about?"

They exited through a wall, and after passing through a jerry-rigged tunnel shorn up by metal planks and wire, they were back in one of the storm drains.

"We won our franchise by default. Nobody else wants to work down here. The area is structurally unstable, and filled with memories of death. No one is interested in investing enough money to rebuild the area. So, the powers that be see us as hoboes scratching at a trash heap. If we keep a low enough profile, they'll ignore us a little longer. As soon as they realize we're making a decent profit working down here, the party is over."

"So you keep your head down."

"Exactly."

Promise ducked to avoid a hanging twist of pipe. "But you know that if you build anything worth having, they're going to take it away from you—doesn't that kill your urge to try?"

Warrick grinned at her. "Maybe it should . . . but it doesn't."

There was more sound up ahead, human sounds, the sounds of work and laughter.

And children. Promise realized with a start that she hadn't heard the high, sweet sound of a child's voice since she had awakened in the Scavenger hospital.

"Not all of our people work in the tunnels—" Warrick said. They passed through a set of firedoors.

It was like crossing the line between night and day. On the other side there was light, and warmth, and even the sound of music.

A low whistle of amazement escaped Aubry's lips as he walked to the edge of a railing and looked down.

There were three levels of an incredible complex that seemed to have been almost completely restored. The electric lights were not makeshift—they were mounted smartly, and fed with continuous power.

There were trees—real trees—grown in artificial light, one rising three stories high. Aubry was looking down a central

well of some kind, and could see what looked like shop doors and pedestrian walkways on the lower levels.

Promise looked around, mystified. "Where in the world are we?"

"This was the PanAngeles Multiplex," Mira said. She had slipped up next to her brother quietly. Warrick was staring down the central well, lost in his thoughts. "Twenty years ago, when it was first planned, it would have been the largest underground living complex in the western hemisphere. Schools, hospitals, shopping centers, entertainment, and a self-sustained air circulation system were all part of it."

"And then the Quake."

"The Quake. Downtown Los Angeles covered some of the most expensive real estate in the world, and in the 1960's and '70's it had become run-down. Property values were slipping. There was a major effort to clean the area up, to bring in investors—"

She led them to a clear glass tube set in one of the walls, where an elevator platform awaited them. "And the effort was working—this would have been a centerpiece, an attempt to dig down with special 'quake-proof' construction techniques and materials."

One of the levels slid by as they talked, and Promise could see the workers, sanding, and cleaning, and painting, the most polished restoration she had yet seen in the world beneath Los Angeles. And still, from somewhere far away, the sound of children laughing . . . singing?

"This area looks like it survived the Quake pretty well . . ." she began.

"Two hundred workers were trapped down here the day of the Quake. It wasn't the crumbling walls that killed them, as it was in so many of the other areas—"

"Then, what was it?" The level they were passing seemed to have been intended for offices, the rooms more like cubicles than stores or apartments. The giant trunk of the central tree was rising past them. Seen closer, she realized that it wasn't real at all but a sculpture, a tremendously complex wire-frame-and-plaster construct, and an unfinished one at that. Toward the bottom, whole sections of the tree were still bare wire, worn and dusty hollow innards exposed to her sight in the cavernous interior.

Still, it was magnificent, and she could only hold her breath in awe as they passed it.

"A fitting monument, don't you think?" Warrick said idly.

"Monument? To what?"

"To the man who built her. Was building her. Whatever." He shook his head, lost again.

"The designer was one of the men who suffocated here after the Quake," Mira said, stepping into the gap. She noted Aubry's skeptical expression. "The Firestorm, Aubry. When the surface burned, it sucked the air right out of the lower levels. They never stood a chance. The few of them who had oxygen equipment were killed by the heat. We scraped up bones that were welded to the floor."

The elevator came to a halt, and the plastic door slid open.

"You're wondering about our power, aren't you?" Warrick asked.

Aubry glared at him. "Well, yeah. It can't be City."

Warrick seemed energized as he led them along a pathway at the base of the tree sculpture. The sound of young voices was stronger, and the sound of work tools was far above and behind them.

"There are tanks of emergency fuel oil. We trade scavenged items for gasoline. And really—" He pointed to the lights, many of which were little more than sheets of glowing plastic. "—most of our lighting is extremely efficient. It doesn't take as much energy as you think, Aubry. We don't use it anywhere or anytime it isn't needed."

The first clean Scavengers that they had seen greeted Warrick and Mira, opening a pair of doors for the Scavenger leaders and their guests. They entered something that looked like an auditorium, through a lobby which still bore twisted and peeling posters featuring long-dead actors and actresses in romantic or heroic postures. Promise examined them carefully. When she turned, there was a crooked sort of semi-smile lighting up her face.

"I thought that you might like this place," Mira said. "This is where you two will be working for a while—as soon as the children are through."

"Children?"

"And the Others, yes. Go on in." She held another set of double doors for them, kissed her brother on the cheek, and walked off purposefully.

The auditorium had once held a three-hundred-sixty-degree holo stage, a circular central platform that might have spawned fantasies and tales of faroff lands, or stories of romance. Now

there was only a small crowd attending, and the presentation they were absorbed in was live, rather than filmed or taped.

It was a school of some kind, and most of the audience was between the ages of eight and fifteen, listening to a lecture on the underground transportation system beneath Los Angeles. The speaker was a small man, very pale and thin, who spoke with boundless enthusiasm for his subject.

It was Peedja, and he gestured broadly as he spoke, pointing to a blackboard which was covered with branching scribbles.

"—and petroleum are the most valuable items. Petroleum is scarce enough now that almost nobody uses it for fuel, only for manufacturing of plastics and medicines."

Peedja traced a line of the makeshift map set up on the stage. "This is section A, at Los Angeles and Third street. It shows a section of the storm drains used to ferry fuel to our dump. As you can see, the drainage system is ideal for travel in the dry months. During the rainy season, the branching tunnels have to be blocked off, sometimes totally. There have been a few times when that wasn't enough, and our quarters have been flooded, and that's when we pack everyone off to the outlands." The children were seated in one section of the circular theater, like a wedge of pie on a plate. They seemed to be moderately well dressed, even though it was easy to tell that much of their clothing was makeshift. They seemed bright and alert. One of them, a girl with her hair cut very short, raised her hand, and Peedja called on her.

"Yes, Daphnie?"

"Last year, we didn't have time to store all of our things before we had to move, and when we got back, a lot of my stuff was all yuckie. Isn't there any way to stop that?"

"We're working on it now. There's reconstruction going on, and we're re-routing some of the sewer pipes to carry the water to prearranged dumps. It can be reprocessed during the dry season. That way it will save us the trouble of trading for it, or trying to have it pumped in—"

Aubry motioned Warrick back outside. "Does everyone here have more than one job?"

"Most. Peedja loves to teach—he used to be a teacher before he lost his job, a low-status profession to begin with—he didn't have a lot of options. He got into debt, and couldn't get work. It would have been the Farms for him if we hadn't taken him in."

"What about you, Warrick?" Promise didn't seem chal-

lenging this time. "How in the world did you end up down here?"

"Long story," he said and turned away.

Aubry's large, calloused hand caught his arm. "Wait a minute. I've answered all of the questions you had about me—how about a few answers from you? You've built a hidden city down here, even though you know it can't last. You're proud of this family you have, even though you know they can be taken from you at any time. Just where are you coming from, man?"

Warrick's eyes shifted from one of them to the other. "You haven't answered all of my questions, 'Shields.' I haven't asked any." Warrick was perspiring, and Aubry could feel it under the cloth of the Scavenger leader's shirt, cold and sticky. "I have to go now. Wait for Peedja to finish—he'll give you your assignment." Then he walked away.

The class ended, and the children filed out. Some weren't children at all. There were teenagers, and even a pair of adults.

Peedja hailed them as he walked out. "Good to see you, Aubry. Is this your lady?"

Promise bristled. "I'm nobody's lady."

Peedja looked at both of them, and smiled. "Fine. Is this your woman?"

"This is Promise. She belongs to herself."

Peedja gave her an exaggerated bow. "I hope you're happy together."

Aubry choked back a snicker. "Listen. I'm getting pretty damned curious about Warrick. What is it with him?"

"Doesn't like to talk about himself, really. I got a little out of Mira, once."

"And what was that?"

"Warrick was one of the Mercenary Police before the Quake. Real hard bastard. Day of the Quake, he was chasing a suspect into the storm drain system. Quake hit, drain collapsed, trapped him. Scavengers found him, almost a week later. He should have been dead."

"Scavengers? I thought that Warrick *started* all of this."

"No. Scavengers have existed for . . . I don't know . . . maybe a century. They move into ruined neighborhoods, slums, anywhere nobody else wants to live or work, and reclaim. People have been doing it forever, but I guess they just started organizing during the Second Depression, in the eighties. Only real

rule is that nobody who wants to work is turned away. Nobody."

"And Warrick wanted to work?"

Peedja nodded, but looked away as he did.

Despite herself, Promise had become interested. "There's more, isn't there?"

"Yes, there's more. Warrick has brain damage. Oxygen deprivation, trauma . . . whatever. Something's wrong with his time sense. His body temperature is haywire." He shook his head. "There's more, but Mira won't talk about it."

"That's all you know?"

"Except that he came out of that experience totally different. Wouldn't go back to work for the M.P. Obsessed with the Quake, the sewers. I don't know, Aubry. I can't claim to understand him. But he's a leader, and a good man, and he's made homes for a lot of people who wouldn't have them otherwise." He smiled regretfully. "And that's everything I know."

"O.K., Peedja. I guess that's enough for now. Maybe it's more than I need."

"Why did you want to know? I get the feeling it's more than just curiosity."

"It's called 'knowing your enemy.'"

"He's not your enemy, Aubry."

"I like to be prepared."

The small man measured Aubry with his eyes. "If he's your enemy, Aubry, so am I. So are we all."

"That's the way it is?"

Peedja nodded.

"All right, then, forget it. Really—it was just habit, man."

Peedja seemed to hold his breath for a moment, then relaxed with a sigh. "All right, big fella."

"Thanks, Peedja. Now. What's this job he has for us?"

# 13

## Invitation to the Dance

"If this is what people call honest work, no wonder nobody's honest anymore," Promise gasped, straightening her back with a pain-filled grimace. She could feel every second of the four hours she had been on her knees. She groaned aloud, then returned to her work: scraping rust off the chromed metal of the holo stage.

Aubry laughed, although he couldn't hear exactly what she had said. He was hanging upside down in the rafters, jostling an ancient spotlight into position, screwing it down. He had crossed his ankles over one of the rafter beams and was enjoying himself more than he had in weeks. The spice of moderate danger made it more entertaining: a fall would fracture his arm, at least. "What are you complaining about now?"

Promise crossed her legs and looked up at him. "Aubry, the monkey-man."

"You were complaining about me?"

"Not really. *To* you, maybe."

"That's a step in the right direction." He unhooked his ankles, making a lazy flip to the floor. "Let's try this thing." Aubry went to the back of the auditorium, about twenty meters from the stage, and fiddled with the control box. A white cone of light leaped from the eye of the spot, engulfing the section of seats on the far side of the stage. "Not bad, huh?"

"Aim needs a little work."

"Got it." Aubry wiggled the toggles around, watching the spot respond sluggishly. Slowly, he brought it to bear on the stage, the hinges squealing in protest.

Promise humphed and got down on her knees again, scraping at the specks that marred the surface of the stage. She liked the work—it was much better than the tunnels, although it was no easier on her back. Perhaps Warrick had sensed that she was happy to be anywhere near a stage—that it brought back warm memories and made her feel more human.

It was easy to forget that her Plastiskin was ruined. She could still beckon the colors, still make the left side of her face blossom into light. No one would know, unless they saw her naked. And no one was going to see that. . . .

She raised her head, watching Aubry climbing back up into the rafters to install another light. He seemed almost as content as she, and that made her happy—there was less friction between them, and as long as Warrick insisted on the two of them working together, that was all for the best.

And he was happy—though she wasn't sure why. Perhaps it was that the work allowed him to be in one of the few truly spacious areas in the Scavenger world, allowing him to use his body more fully. Just in the past six days she had noticed a marked improvement in flexibility and balance as the amazing physical machine that was Aubry Knight took any opportunity to twist and turn, to leap and somersault, to stretch and stress his muscles in every conceivable direction.

On the other hand . . .

There was the way she caught him smiling at her sometimes, although he had never tried to press his point. The way his dark massive body radiated intensity at her. Whenever they happened to touch, he was gentle with her, and that very gentleness was disturbing because she knew that behind it was an urge to crush her to him, to cover her face with kisses, to . . .

She shook her head angrily. He was just a brutal, violent man to whom fate had joined her, and whom she no longer needed. Soon, she would find a way to get back to Oregon, and safety.

The light suddenly grew bright enough to be painful. "All right, Promise," Aubry called, a hint of amusement in his voice. "I want to loosen up this joint. Would you mind moving for me?"

She stood unsteadily, shielding her eyes, looking up into the rafters in an attempt to find him. She could only see the vaguest of outlines hanging there, bleached white by the glare of the lights. "What do you want?"

"Move for me. You know."

She licked her lips, his words triggering off something she didn't like. She gritted her teeth and walked slowly to the right, hands balled up into fists.

"Come on," he said gently. "There's an audience out here. You're on stage."

"I . . ."

"They came to see you. Just you. Unclench your fists. Raise your chin a little—be nice to the people."

"Aubry—"

"I'm not here. But the people are." He paused, and his voice was wheedling. "Come on, Promise. Just a little bit."

She swallowed hard, trying to deal with all of the warring emotions within her. Then, almost unbidden, her body began to move. The spotlight followed her as she did.

Promise took one halting step, and then another. She stopped and cursed herself, kicking off her workshoes. Her bare feet twitched at the touch of cold, smooth metal. She could feel every sanded blister, every slight depression, and she found her balance. She found herself humming a tune, something she couldn't recognize. The sound of it vibrated through her as if an entire orchestra were playing, as if a huge, adoring audience were clapping along enthusiastically.

And she danced. At first her body hated her for moving without a warm-up after so many injuries and so many weeks of disuse. She felt bones clicking into place, felt muscles protesting and stinging her with flashes of pain.

Once, just once her ankle started to turn under her, and she stopped, furious with herself, looked up into the light and opened her mouth, surprised to hear nothing come out.

Aubry spoke first, invisible behind the glare of light. "Go on," he said quietly, his voice carrying perfectly in the auditorium. "You're doing fine. Really."

She tried to find a negative answer, but couldn't. Her body was starved for movement. Once it started feeding, it refused to stop.

So she swayed her body in time and countertime to a rhythm that existed only in her memory. Guided by Aubry's inexperienced hand, the spotlight followed her like a clumsy partner, now brightness, now shadow, at first an irritation, then accepted in the flow of the dance.

Memories swarmed up out of the darkness. Memories of other dances and other audiences: Las Vegas, and the first few

months after Plastiskinning. The joy of being *special*, one of the few Exotics who believed in themselves and their craft enough to make their costumes part of their flesh. She was, then, more than a dancer. She was Dance itself.

She showed the hungry crowds things that they had never seen before, showed the movements she had learned from her Sisters in Coven, Oregon's feminist commune, a lifetime before—dances meant for women's eyes only, in celebration of life and fertility. But there were times when a small, still voice whispered to her that she was her own betrayer, whoring the only part of herself that was still pure.

She moved faster now, spinning, leaping to float back to earth, and her bones didn't click and her ankle didn't turn. As she remembered the good times, the heat poured outward from her chest until she felt herself to be composed not of flesh but of energy that flickered and leaped like an electric arc.

She tried to stay in that place, in that time, but could not, and the rest of the memories tumbled out unbidden, the harsh memories, the bad, condemning ones, and her eyes began to burn. When she opened them her sight was blurred, her limbs suddenly wooden. She wanted to stop, but the momentum carried her along.

She danced, now in shame, in a dark, cold place inside her that was beginning to expand like a bubble. Within that bubble glowed the faces of her strong and centered sisters, who mourned her as one dead for loving a man named Jamie.

Jamie. Friend, lover, agent, betrayer. . . .

*Go Exotic, Promise. That's the ticket. . . .*

*Listen to that crowd! They love you. I love you baby. . . .*

*. . . just temporary. Listen, there are too many Exotics on the market right now. . . .*

*Dammit, believe what you want. I invested that money. For both of us. If you want to get your skin out of hock, we will. Just give me some time. . . .*

*I'm sorry, but I'm not here right now. But if you'll leave your name and number—well, you know the routine. Get back to you doubletime, angel. . . .*

There was sound, the sound of soft footsteps approaching. She looked up, barely realizing that she had stopped dancing. She wiped her eyes, feeling the wetness on her hand with disgust.

"You were beautiful, Promise."

It was Jamie's face, Jamie's voice, although Jamie was

white and clean-featured and carried himself like royalty.

Jamie/Aubry's face wavered in her vision, half-smiling in that knowing, sexy way of his that always made her feel weak, that always convinced her that her sisters had lied, that there was nothing sweeter than lying in a man's arms, feeling his body, his hands . . .

"Promise? Are you—"

All right? Hell, no. Not now, not ever again.

Aubry was standing too close to her, and the urge to reach out and touch him was too strong.

She pushed him away, her fingertips burning at the contact. "Just get away from me, Aubry."

He was silent when she expected him to speak, impassive when she expected anger or sadness or mockery, or any of the other things that he had shown her in the past few weeks. But there was nothing, just the beginning of the gargoyle expression he had worn when she first met him.

"You don't have to be alone," he said quietly, "but if that's the way you want it—" He didn't finish the sentence, just turned and walked away. She watched him go, his head high, his muscular shoulders relaxed and moving smoothly in co-ordination with his steps. And she knew, perhaps for the first time, just how badly she was hurting him.

"Aubry—" she whispered.

He continued up the aisle and out the doors.

She spent the next hour polishing and repolishing. The auditorium was presentable now, ready for service as a schoolroom or showplace. She stepped down off the stage and walked backward to gain perspective, proud of the job she had done—*they* had done—wishing suddenly that Aubry were there to share it with her.

A large bony hand clasped her shoulder and she spun, anger and joy mingling in the same instant, arm raised to brush Aubry away.

"Very nice," Warrick said. He walked back up to the remote controls and turned the spotlight off, darkness immediately swallowing everything in his face except the jutting cheekbones and the gleam of his pale eyes.

She swallowed nervously, wondering if he wanted her to say something. "Aubry wants to be transferred away from you," he said finally. "I agreed. I have a change of duty for you, also. . . . You seem to be finished here. Please, follow me."

Still silent, she removed her smock, draped it over the back of a seat, and followed Warrick out of the room.

They took the elevator down another level, and as she saw the immense Christmas tree rising out of sight she finally spoke. "Where is he?"

"Aubry? Should I tell him that you asked?"

Pain. "N-no..."

"Then it wouldn't be fair to tell you, now would it?"

There was no light in the elevator. As they passed between floors, the cubical went totally dark. She could not remember ever feeling so alone.

The elevator bumped to a halt, and the doors sighed open.

Although the new room was large, it was by no means another level of the shopping complex. The ceiling was high, and she guessed that the room had once been used as a storage area. Now it was filled with row after row of hydroponic tanks, greenish algae floating in some of them, irradiated with sunlamps that cast a reflected greenish glow through the glass walls.

He barely glanced at them as he guided her past. "We can't get fresh vegetables through our contacts in the Maze, and the transportation lines to northern California are often cut. I believe in self-sufficiency, so we grow a micro-plankton, spirulina, down here on the basement level. You'll work here for a while."

She looked around in confusion at the tanks which sloshed ever so gently in response to their passing footsteps. "Why me? I don't know anything about this kind of stuff."

"I have a reason," he said.

They walked on past row after row, and finally some of the tanks were filled with rooted plants growing on crushed rock in nutrient broth. Some of them were common vegetables: onions, carrots, cabbages, and peas.

After she passed those, there were tanks filled with soil. A small man with an unhealthily pale complexion worked at one of them, pruning something, his tapered fingers straightening a bent stalk. His back was badly twisted, almost humped, and he was mumbling happily to himself as Warrick and Promise approached.

The small pale man clucked to himself for a moment, then looked up. "Kevin!" He looked at Promise with a speculative expression that she didn't find entirely comforting. "And this must be the young lady who brought us the spores."

"Spores?" Promise asked.

"Promise, this is Emil. You'll be working with him for the next few days."

"Shouldn't be longer than that, no not much longer at all." He walked away from them, wagging his head, still talking to himself, and evidently finding the conversation scintillating.

"You're not going to *leave* me down here with him, are you? I mean, I don't want to end up holding conversations with the little shrubs. . . ."

"Don't let Emil throw you—he's brilliant, he really is, and we're lucky to have him. He's one of the few people down here who could do better topside than he can here."

Promise finished it for him. "But he prefers living down here, right?" Warrick nodded and looked at her questioningly. "Never mind. I just guessed."

They followed Emil to the far end of the room, past a makeshift partition which shielded a row of four large tanks.

Somewhat to Promise's surprise, there were lights bathing the heads and stems of thousands of tiny mushrooms. Emil saw her surprise. "Oh, yes—some mushrooms use light as part of their growing cycle, just like other plants. We have these on a fourteen-hour light cycle, and they like it just fine. On the far side of that curtain—" He pointed down the row, and only then did Promise realize that the room was foreshortened by a heavy, curving sheet of cloth. "—we have the breeds that don't like light at all."

"Are all of these for food? Or medicine, or what?"

"Food," Warrick said.

"Except for the ones that you brought, young lady. Come over here." Flush against the far wall there was a sterile growing chamber, cobbled together out of wood and steel and glass. "Had a hell of a time growing your strain. We got penicillums and neospora and about eighty kinds of common airborne fungi and bacteria. But I finally managed to prune out something that I'd never seen before. The pattern of mycelial growth was fascinating—"

"My—what?" She was looking into the front glass plate of the growth chamber. There were glass dishes set in rows, something furry and reminiscent of thinnish cotton covering part of the surface. The petri dishes seemed to have been inoculated on successive days, because as her eyes traveled to the right, the cultures were more and more advanced. The "cotton" thinned

out and coiled itself into what looked like veins and capillaries, crawling along the surface of some clear gelatinous substance. Two plates down, the "veins" were condensed into puffy white nodes, and on a further one the nodes had darkened.

"Apparently this strain has difficulty fruiting on agar, so I provided it with a variety of mediums." Emil pointed at a series of jars in the case. "Rice, barley, soybeans, reduced woodchips, corn—all of it broken down under pressure to make it easier for the mycelium to catch hold."

"And?"

"It grows on everything. Once we licked the contamination problem, they just grew like crazy, even more easily than *Stropharia cubensis*, which it resembles in some ways."

"Stro-what-what?"

"*Cubensis*, genus *Stropharia*. Closely related to *Psilocybe*." Her expression was still blank. "Psilocybin mushrooms. One of the most potent natural psychoactives."

The mushrooms that she could see were short, with thick pale stalks and rounded caps. Some sprouted as individual mushrooms, but most of them grew in clumps, so thickly clustered together that they almost choked each other.

"And these are whatsacybin? What's this about me bringing them in?"

Warrick spoke now. "You remember the note in Aubry's bag?"

"Yes—the one from Maxine..." Was Max alive? Somehow she hadn't asked herself that question for weeks, but she hoped the answer was yes, that Cecil hadn't died for nothing.

"And do you remember an odd sort of marking on the paper?"

"Watermark? Sure. Maxie always went in for flash...."

"Not this time. It was a mushroom sporeprint, and we managed to grow the strain out. It's not psilocybin."

Despite herself, she leaned a little further forward to get a clearer look. "They're kind of cute, actually. They look like—" She broke off, startled at her own embarrassment.

"Yes, they are somewhat phallic," Warrick said dryly. "Do you remember what Maxine said in her note? 'Take it with someone you could love.' It was smeared with water, but still legible. Do you have any idea what that means?"

"No," she said quickly, too quickly, remembering that awful night in Cecil Kato's lab... the wonderment in his eyes as the

computer fed him its anlaysis of the drug.... Warrick was watching her closely, and she sensed that he knew she was lying. "No. I don't know what this is all about."

"I didn't think that you would. Having no preconceptions, you are the ideal person to assist Emil. You will be recording their growth patterns, experimenting with less expensive mediums." He paused. "Conducting ingestion experiments. It should be very interesting, don't you think?"

He laughed and Emil laughed with him. Promise felt disturbingly like a bug under glass.

Once the caps pushed their way out from under the soil, or the clumps of mycelia began to sprout in their growing mediums, the mushrooms grew with phenomenal speed.

"An inch a day—maybe more," Emil said soberly. "These grow at the same rate as the others in their family, but they never get taller than about three inches." He had his hands inside a makeshift glove-box, rubber flanges and seals completely shutting out dust and stray spores. "Do you see how thick the stems are? These *average* an inch and a half—about twice the thickness of *Stropharia*. Interesting. There's something else, also. We can get the mycelium to fruit but look at this." He wiggled a thin knife under the cap of a mushroom, wedged it up and cut a pie-shaped slice. "See? The spores are there, as pretty as you please, but for some reason the caps don't mature enough to rupture the veil." He shook his head in mock disgust. "More work, just more work." He grinned at her. "Wouldn't have it any other way, though, lady. Mighty interesting friends you have here. Yes, indeedy. Have half a mind to go topside, get in touch with some people I used to know who work for the state university...." He watched her out of the corner of his eye, noted the frightened expression on her face. "So Warrick was right—you do know more about these little devils than you're saying—and what you know about them doesn't make you happy at all. Not at all." He walked away, clucking to himself.

She slammed her hand down on one of the tank covers, watching the mushrooms within vibrate in response, fighting an urge to reach in and tear every last one of them up by their pale and fleshy roots.

Emil performed his toxicity tests on tunnel rats, grinding up the mushrooms and serving them with grain. The rats were

hungry enough to eat anything, especially the moist blue-tinged chunks of mushroom that he shoved into their cages daily.

Some of them grew weak and ulcerated from malnutrition, but when he added vitamins to their diet, none of them died. Not one. One was injured while attempting to masturbate against the bars of his cage, but aside from that the worst wounds were tiny abrasions gained by groggy rats bumping into their cage walls.

She held a third-generation lab rat for Emil to inject, then scratched it behind the ear and slipped it back into its individual cage. All the rats were in tiny wireframe individual cages. Promise was afraid that she knew what Emil was doing wrong.

"You're trembling," Warrick observed, suddenly close behind her. Promise tensed in surprise, barely subduing a startled flash of light.

Emil clucked in disconcertion, scratching his balding head. "Kevin, I know you're right when you say that there's something queer about this stuff, but I'll be burned if I can figure out what it is. As far as I can tell, it isn't any more toxic than ordinary edible mushrooms. Not quite as nutritious, perhaps. I've fed it to them in every way I can think of. I've injected the juice directly into their brains and stomachs. That killed some of them, to be sure, but you could kill them by injecting water or air, too. Actually, you'd kill a lot more of them." He sighed, stripped of his plastic gloves and threw them into the sink. "I'm going to be honest. . . ."

Warrick frowned, and his voice dropped in anger. "You tried them yourself."

Emil shrugged, the bare trace of an urchin grin on his round face. "Ultimately, Warrick, I am the only one who can make a decision about a thing like that. The choice was made—and the result is obvious: I survived."

Warrick leaned forward. "And what about your dreams?"

"They were extremely vivid, but difficult to remember. The immediate effect of the drug isn't remarkable. A buzz. Some slight sensation of warmth in the lower body. Some interruption of intellectual faculties—a tendency to have difficulty remembering minutiae or projecting future trends. Harmless—and pleasant. I'm afraid that that is all that there is."

Warrick rubbed the bridge of his nose, thinking. "No," he said finally. "There is something else here. I can feel it."

He turned to face Promise, and his expression was not pleasant. "You are lying to us."

"I—" She started to protest, but he cut her off with a wave of his large hand.

"No more lies. I won't ask you to tell me what you know. I *will* ask you to explain why you refuse to tell us the truth."

She moistened her lips. "I—" His eyes warned her not to lie. "I don't know, Warrick. I'm sorry." Despite the hold of his eyes, she turned and walked away, past the curtain, out of the room, her pace accelerating as she went, until she was at the elevator. Her heart was thundering in her chest, and her breathing was almost paralyzed with fear. She didn't want to look into her mind, to pry loose what she knew; and she wasn't sure why.

All that she knew was that she had an overwhelming urge to leave the growing chambers, leave the underground, take her chances on the surface....

She stood by the ancient elevator doors, one hand on the button without pressing it, feeling as if she were on fire.

What *did* she really know?

Maxine's note: "Take them with someone you could love." She tried to laugh. There wasn't anyone who fit that description in her life. Could never be, ever again. Aubry was too ignorant, too brutal, too...

She shook her head, trying not to think about him. What else? Cecil, Ornstein, Patricks, and Maxine.... No. Not Maxine (again, a tiny stab of fear ripped into her at the thought.) *Please Max. Be alive somewhere, and happy. Please. For me.*

Three people dead, at least. So, the drug was obviously valuable. New. Spectacularly different. Cecil's speculation: "Maybe if you take it with your sexual hormones pumping at full tilt?"

She hissed out a single harsh syllable and sagged against the wall. "So, why won't I talk? Because I'm afraid they'll kick me the hell out if they know how much trouble I am, that's why."

She felt as if she were floating as she turned and walked back to them. Without conscious prompting, her plastiskin was glowing again, a dim aura that hazed her vision.

She pushed aside the curtain and entered, looking from one man to the other. Neither of them had moved.

Warrick spoke slowly. "I do not mean to frighten you, Promise. But what we have here is nothing simple. And as long as it is an unknown quantity, it is dangerous in the extreme. Won't you help us?"

Hardly listening to her own words, she began to tell them everything that she knew.

Aubry's whole body ached, and that was the way he liked it. A good meal, an evening's rest in the room he shared with two other diggers, and an hour's slow stretching would drain the tension from his muscles and dissipate it into nothing. Tomorrow he would start with his mind a blank, a gray slate on which he might scribble the deeds of the day.

Today he had been with a mining crew, extracting condensed chunks of landfill from the acres at the periphery of downtown Los Angeles. There was a terrific amount of organic material in the old garbage dumps, and Warrick had the equipment needed to extract the energy from it. It was almost amusing to think of the wasted wealth beneath the skeleton of old L.A.

Almost. There was little which moved Aubry to amusement any more. Life had become the same trap that it was in Death Valley, and he had had about enough of it. Soon he would decide what to do, where to go, and then...

He opened the door of the converted basement, surprised not to hear coarse laughter and the never-accepted invitation to join in a game of cards or dice. There didn't seem to be anyone there at all. The single bulb in the ceiling, shining like an unfocused eye, reinforced the emptiness. "Wingnuts?" He swung his duffle onto the low cot he had called home for the past three weeks. "Foley? Where are—?" There was the sound of the door locking behind him. He turned, more curious than disturbed.

"Hello, Aubry," Promise said. She was wearing a cowled robe—one that looked hand-stitched, and her face was deep in its shadowed depths. Her plastiskin was glowing. "Your roommates are gone for the evening," she said simply.

He nodded, and sat on the edge of the cot, still watching her cautiously. "What do you want?"

"To talk."

"Talk?" He nodded, sitting back on the cot, hands folded behind his head. "All right. Talk."

She swallowed, trying to smile. "Aren't you going to invite me to sit down?" The smile that she managed was a little girl's.

They sat at opposite corners of the room, and there was no sound until Aubry cleared his throat. "You'll excuse me if I wash my shirt. It's gotten a little stiff."

"Cleanliness is next to . . ."

He stood and unbuttoned his shirt, and she recoiled a bit at the sight of him.

He seemed to be unconcerned with her reaction, stalking across the room to put the shirt into a plastic basin. The big tub of recycled water above the sink gave a gurgle as he uncorked it. A trickle of yellow, brackish liquid started out, quickly growing to a steady stream. He took a bar of hard soap and scrubbed at the shirt, all of his effort generating only a thin film of suds.

She watched him as he worked, watched the play of muscles across his back, and her nervousness increased. She looked away, scanning the room, and her eyes fell on an open book. There was a picture of a stalk of corn, and a couple of graph tables on the page opposite.

"The book," she said curiously, "is that yours?"

Aubry seemed embarrassed. "Yeah. Peedja loaned it to me. It's the 'C' volume of some encyclopedia or other. Kinda boring, really."

"Oh, yeah. I guess it would be. I'm glad to see you're . . ." Her voice trailed off.

When Aubry had finished with the shirt, he rinsed it out with another stream of the discolored water, then hung it up. He poured the water into a second keg, then sat back on his bunk and wrapped his long arms around his knees. "Well? You had something to say?"

She tried to speak, but couldn't force anything out.

"You said that my roommates weren't coming back. I didn't know that you had so much authority around here. You work pretty fast."

"Aubry . . ." she began.

"I can't hear you," he said flatly.

"Aubry," she repeated, louder this time, "I told Warrick everything. About you . . . the Ortegas, the drug. Everything I knew."

He was very still. "And?"

"He encouraged me to talk to you."

"About what?"

"I need to apologize to you, Aubry."

"For Warrick?"

"No. Just for me."

He raised his eyebrows. "Well. What brought *this* on?"

"Please. I don't think you can believe how hard this is for

me. I touch you, I hear you—but I see someone else, someone who hurt me badly."

"And who was that?"

She shook her head. "It doesn't matter now. What matters is—" Her eyes were burning again, and her hands were shaking. "What matters is that I've blamed you for things that weren't your fault, and I'm sorry."

Aubry nodded his head slowly. "All right. I can accept that. If that's helped you clear your conscience, you can go."

She turned away, lashed by his words. "Aubry, you have every right in the world to hate me—I haven't done anything to deserve better. But . . . but I think that you're stronger than that, and I don't think that you're out of strength yet." Her voice was very timid now. "And if you aren't, and you can extend a little of it to me, I can make things better between us."

He was silent, but somehow words were hanging in the air, as substantial as the heavy curtains in the mushroom farm. When he finally spoke, it was the heavy sound of an enforcement officer tossing a warrant onto a table. "Why?"

"Because I'm over my head, Aubry. I can't handle it any more. I can feel it eating at me. I've been alone for too long, and I spent too many of those years helping other people feel wanted."

She was crying now, choking on her tears. She ached with the urge to run. "I've had hundreds of men, Aubry, and each of them took just a little piece of me with him. Hardly enough to notice. Except for one; and he ripped my guts out."

"I wanted something, once," Aubry said, and his voice was suddenly unfamiliar. It seemed another man's voice—a younger man's. "Didn't do nothing but kill me. Save it, Promise. If you've got a shell that works, stay in it. There's nothing out there worth having."

She heard the hurt in his voice and knew that if she couldn't touch him, she would come apart inside. She stood, and crossed to him, sat at the edge of his mat and reached out for his hand. It seemed that he had retreated out of his body; it was so still, his hand so cool. But she held it anyway, held on for dear life, knowing that she could only say this once.

"Listen to me. I know what you feel." He turned his head from her and pulled his hand away. "No—I do. It's like there's you, locked inside your body, and your body is all that stands between you and this little child who's lonely. . . ." She took

his hand again, and this time he didn't pull away. "Lonely. And needs something, and doesn't know quite what it is. And so he's afraid to hope. And you feel locked inside.

"Aubry—I'm locked too. You don't understand how the plastiskin works. In order to master it, you have to develop a sensitivity to your body that is unreal. The most advanced biofeedback machines and hypnotic drugs couldn't cut the basic training to less than two months. I learned to isolate sensation. I learned—" She lowered her voice to a whisper. "I learned to *control* my feelings. I learned it so well that they shriveled up and hid in a little box in my head." She gripped his hand hard, as tightly as she could, trying to give him something to feel, even if it was only pain. "Aubry, I want out of the box."

The suspicion and hurt in Aubry's face submerged a bit, and Promise went on quickly. "Aubry, I want you to help me. If you will. If you would." She paused. "If it's not too late."

He seemed to roll her words over in his mind, weighing them. "No," he said, and she was surprised by the tremor in his voice. "It's too late for me, baby. I just don't have anything left. Maybe I should have died with Luis. That would have been best. I would have done what everybody said I couldn't do, and done it my way, in my time, and made it stick. Now all I've got to look forward to is running and hiding and maybe growing old down here in the sewers. You were right, Promise. I did come out of the gutter. I should really feel right at home here."

"I—"

He shushed her with a squeeze of her hand that stopped just short of the pain threshold. "No, baby. Just go away. I tried, you see? I tried to pretend that maybe my dream wasn't totally dead, that there was something good left in my life. But there just ain't, and that's all there is to it."

"No, Aubry. Don't say that. I'm the runner. You're the fighter. Don't give up on me—please."

He sighed massively. He looked as if he had carried hell on his shoulders for a thousand years. "Even the fighting was just another way of running. I'd hoped it would take me somewhere I hadn't been. What bullshit. I just ended up in one gutter after another. Sometimes it was a high-class gutter. Sometimes it was absolute piss. But a gutter is a gutter, and that seems to be where I belong—unless it's a sewer, and that's even lower."

"Aubry, what if I said that there was a way out? A way to

break through that?" Her hands shook as they searched in the pocket of her cowl, bringing out a glassine envelope holding two thick stubby shapes, the moisture from the mushrooms fogging the clear sides.

Aubry looked at them. "Jesus Christ. Are you talking about drugs now?" The small glimmer of hope that had been in his face died away, replaced by disgust. "No thanks. My body is all that I have, and I'm not screwing it up like that."

"No, you don't understand. We've been testing it for two weeks. It's less toxic than aspirin."

"Aspirin can kill you too, lady."

"Aubry . . . Aubry, listen to me. This is what everything was about. This is what Patricks and Ornstein died for. The reason Kato was killed." She was pleading now. "You saw how Cecil acted when he tried to analyze it—it just isn't like any other drug. Anywhere."

"I don't do drugs."

She threw the mushrooms down on the mattress and stood up, looking down on him with an expression that he couldn't read. "And when did you make that decision? When you were a kid, watching your friends fall apart around you? When you were a young man, with dreams of turning that body of yours into a empire? Well, you're not a kid anymore, and you're right, your dreams are dead. But you aren't, and I'm not, and I need something. Someone. I need you. You're the only decent man who ever wanted me, who cared about me. You worked for me when I was sick and couldn't take care of myself. And I don't have anything in the world I can give you except me, and I can't even give you that, because I cut that off a long time ago, in another life."

She dropped to her knees at the edge of the cot and reached out for his face, turning his head against token resistance until he was staring into her eyes. "Suppose that there was a chance— just a chance that this would work. That it would help us to find each other, help me to break down my barriers. Wouldn't it be worth it?"

He gritted his teeth, shaking his head slowly.

"You're lying," she said passionately. "You're as lonely as I am. I know it. I can feel it. And we can help each other past the hurt, but I just . . . I just need a little help." The tears, which had dried for a time, returned now. She held his head, burying her face against his chest. "I need help, Aubry. God, I need help. I never thought that I was going to get out of this box,

but maybe there's a way, and if there's any way at all, I've
got to take it. Aubry . . ." She looked at him, and for the fraction
of a second before he looked away, there was a spark there,
one that leaped the hollow between them. "Aubry . . . haven't
you been hurt enough to take the chance?"

He closed his eyes. His body was very still, almost as if he
had fallen asleep, or gone into a coma, or died—anything to
avoid her question. Finally he spoke. "All I have left," he said
slowly, "is my image of who I am. What I was—what I used
to be." He spread his hands helplessly. "That's all there is,
Promise, and you're asking me to give up a piece of that, and
I just can't do it. Not even for you."

"I'm not asking you to do it for me. I'm asking you to do
it for yourself. Both of us are trapped. I'm offering you a way
out."

"A way out." His laugh was harsh, but not loud. "God. I've
been thinking and praying, wondering if there isn't some way
out; and there just isn't one."

"Then what do you have to lose?"

He tried to be angry, but didn't have it left in him.

"Aubry—please."

He sat, shivering, and she thought that he wasn't going to
say anything at all. Then he buried his forehead against his
knees and sighed: "I'm just tired of hoping. . . ."

"Then give up the hope. Give up the image of yourself
you've been hanging on to. Be here, with me, right now.
Extend a little more of yourself to me—just a little. Let's see
what happens."

He swallowed hard. She could hear the effort rasping in his
throat. She reached out to stroke his stubbled cheek. He leaned
against her hand, eyes closed as gently as a baby's, and the
tension left his body like a passing wind.

"For years, I've had a dream," she said, holding his hand.
"I dreamed that there was someone, somewhere, who would
make love with me and not *at* me. That I would feel that, just
once. Just *once*. The way people do who trust each other. Who
know that there's going to be a tomorrow together. . . . To hell
with that—that there's been a *today*, Aubry, that today existed
at all."

"Today," he said sluggishly, as if he were already under
the influence of a narcotic.

"Today, Aubry—right now. It's all that we have."

She heard him swallow a lungful of air, pull it deeply into

his lungs, then exhale slowly, nodding. "All right—you're right. I've got little enough to lose." He finished the sigh. "Let's give it a shot."

Promise picked up the envelope where the two fleshy mushrooms waited patiently. She opened the slit with her thumb and pulled one of them out, looking at it, turning it around in her hand. She flared her nostrils, sniffing at it, catching no scent. She flicked her tongue at the underside of the cap. It was virtually tasteless.

She handed it to Aubry. He held it up in front of his eyes until it obscured his view of her face, until she seemed a woman's body with a mushroom's head. There was a slight aura of light around the curved edge of the mushroom. As he turned it in his hands, felt the texture, the subtle graining, he began to feel warmer, the last of his trepidation fading away. The broken stump of the plant was stained a slight blue, and he examined that, then nibbled at the end.

He chewed it slowly, making a face at her. "Definitely had better."

She smiled shyly. "That remains to be seen." She broke away a chunk of cap and put it into her mouth, chewing rapidly, swallowing with an obvious effort not to taste it. "I'm not sure I'd want to make a salad out of these."

He pulled the mushroom back from his lips for a moment, then made his decision and popped it into his mouth, chewing it down into mush, tasting it, trying to find the place in his mind where the taste wasn't unpleasant.

Then, a little at a time, he swallowed.

Having finished, he lay back again, watching her chew daintily at the remaining cap. "If you just go balls-to-the-wall and swallow it, you won't have anywhere near as much trouble."

"That's easy to say." She popped the rest of it into her mouth and downed it quickly. Then she folded her hands in her lap and gave him a sickly grin. "Well. Here we are. . . ."

"Looks that way, doesn't it?" He narrowed his eyes, and they smoldered hot enough to burn. "Well, if those were the hors d'oeuvres, where's the main course?"

Promise smoothed the cowl back from her head and reached out her hand to him. "I trust you, Aubry Knight. You have never hurt me, and you have never deserted me, even when it would have been the sanest thing to do. You are a man of honor, and kindness." She lowered her voice. "And you are my last hope."

He slowly, gradually, pulled her to him. Her stomach tightened reflexively, and she relaxed it. She felt her automatic, play-for-pay smile slip onto her face and she quelled it, facing him without artifice as a lonely, frightened woman who needed something she didn't completely understand.

He waited for her to relax, easing his grip, then smiled as she twined her fingers through his and pulled herself closer, until their faces were inches away in the room's dim light. He smelled of hard work and fatigue.

Aubry leaned forward and brushed her lips with his, rubbing his bristled chin against her softness.

He heard her breathing go shallow, heard her restrained gasp as his fingers stroked the robe down from her shoulders, as he traced a line on them with fingers strong enough to shatter concrete, gentle enough that all she felt was a trilling breath of excitement.

He sat back from her and gazed appraisingly. "I don't suppose that the drug has come on yet?"

"Then we'll just have to make do, won't we?"

Her fingers ran over his chest, over the hard flat muscles that thickened his midsection. She threw herself against him, pressing as hard as she could. "Aubry, hold me, Aubry—I'm just so damned scared."

"I know." His hands, those monstrously thick hands, stroked her hair, and his lips warmed the base of her neck.

They stayed like that for a time, then she felt his hands peel the robe back from her torso, her breasts falling into his hands like twin children begging to be loved. He nuzzled each of them, the warm undersides and the textured, stiffening tips, then raised his face to her, and they kissed.

That kiss was like two drowning people feeding each other air. Her fingernails, broken and untended for weeks now, raked his chest slowly. She arched her back, stifling the hysterical laughter that welled in her throat as his lips and tongue and teeth glided over her skin with absolute strength and softness.

She laughed, holding him, finding in that laughter something positive, knowing that her very ticklishness, the way her skin jumped at the touch of his bristles was a change, a small triumph over her own barriers.

She pulled back from him and stood up, shedding the robe, listening to it settle to the ground in a slow-motion flutter. And for the first time in her memory, the sight of his eyes on her body, the knowledge that she was stirring him carried no added

feeling of power. She felt unsure, insecure, wondering, hoping that everything would work, that this man, with his incredible, disorienting meld of strength and softness, this drug for which many had died and more would suffer . . . that somehow these things would combine to set her free of her prison.

She felt a queasy sensation in her stomach, a touch of something that bordered on nausea. He reached out to her and pulled her to him, burrowing his face into her stomach, kissing her navel, scratching her gently along the belly and inner thigh. She gasped, tangling her fingers in his hair as he played with her, turned her ticklish tremors into spirals of sensation that built and built, finally hammering savagely at the wall of her reserve. She felt the wall shudder, stretch—but not give way. The wave receded, leaving her covered in a light sheen of sweat.

He was breathing heavily now, his eyes even blacker than they had been, and his speech was slurred as he spoke. "There's something—it feels warm . . . and like someone is stroking the inside of my stomach with a feather."

"Hush," she said, her hand caressing the fasteners to his pants, feeling his excitement. She leaned forward to kiss him as she worked the buttons free of their loops, tasting her own saltiness on his lips. The room seemed to be tinted orange, and when she closed her eyes, his image was burned into the interior of her lids.

She pulled his pants off and lay next to him on the cot, running her hands over his body, trailing her fingernails down his stomach until she felt the blood rushing in him, felt him tremble as she left a trail of kisses down his chest and stomach.

The world was beginning to strobe, each individual act seeming to persist, each feeling, taste, or sensation lingering after its natural termination. She teased him artfully, losing herself in the moment, and for the first time in memory there was no separation between her thoughts and her actions.

And when he pulled her away, she found herself reluctant to let him go, that she wanted to continue giving. She clutched at him, crying again, knowing only that her skin felt hot, so very hot, that every touch burned, that her body was responding to him as it never had to any man, not even Jamie.

He laid her down on the couch. She thrust her hips up to meet him, pressing against him so tightly that her sense of identity ran like fluid, that she could no longer tell where her body stopped and his began.

She dug her hands into his back, trying desperately to pull him deeper into her, feeling as if she were a bottomless pit.

And, incredibly, he filled her, locked her in his arms so tightly that there was a flash of panic, a resurfacing of old fears. She pushed at him, wiggled, for a bare moment trying to escape, but he merely held her tighter and brought his lips down on hers. His tongue slid into her mouth like a rivulet of lava, burning away her fears. One at a time, she felt the muscles in her body relax as she gave in completely.

His face melted away as she looked at him, and she knew that she was totally in the grip of the mushroom, and there was no way off the ride except to see it to its end.

And as his flesh melted, hers did as well—melted until it seemed that their nervous systems mingled, that she could see herself through his eyes, feel herself through his fingers.

Then there was no Aubry Knight; there was only herself and herself, and a crazy funhouse of mirror-Promises, faces aglow with pleasure, stretching backward and forward into infinity. Then even that image vanished and there was nothing at all, just a darkness clouded with stars that pulsed and jumped rhythmically.

And from that darkness came a face, a younger face, the face of a small boy; and the face was hard and cold. She watched it harden, age, watched the hair grow wiry as he became a man, Aubry Knight. Then the face wasn't Aubry's, it was hers—then it *was* Aubry's—and then . . .

With each change, the feelings remained the same—the same sense of betrayal, alienation, the same protective mechanisms. But then those too were stripped away, and Promise—or what had been Promise—felt terror, naked and more starkly barren than she could ever imagine. She tried to think of her own name, but couldn't find it. She tried to find a face, but there was none, not even Aubry's. She opened her eyes—or thought she opened them, and fell deeper into the void.

No, wait. There was a flash in the darkness, a glowing pinpoint that grew as she watched it, watched the face that was half light and half death approach, watched it open its mouth to swallow her, heard her own scream of despair. . . .

She reached out with everything that there was in her, reached out to whatever comfort there might be in the darkness. Dropped all of the shields and barriers and stepped out over the edge in a mad attempt to escape the grinning jaws.

And something caught her. Something strong and soft

Someone calm and yet as terrified as she. And together, they waited, and the jaws circled, snapping, not grinning any longer, frustrated, finally howling off into the darkness.

And all was dark, and calm. And she said, "Aubry?"

There was no audible reply, no spoken words. Yet somehow she could see images, feel emotions, and knew what he was saying to her.

I'M HERE. I'LL ALWAYS BE HERE FOR YOU.

"Aubry—? I've waited so long to say it—"

HUSH. THERE'S NOTHING TO SAY.

But the light was boiling in her now, boiling up out of the locked box, consuming their world, consuming them both, and she knew that she had but a moment of sanity left.

"Aubry, God knows I don't deserve you—"

HUSH.

"But I love you."

And then the light was total, and neither of them knew anything but its warmth.

# 14

## The Hollow Woman

The carefully stacked logs had given off heat for hours now, and were finally surrendering to the ravages of fire. Red and white veins were etched deeply into the gnarled, ashy bark. Nadine sat close to the shimmering firescreen, snuggled deeply into her robe. She watched the leaping shadows as they flickered on the walls, and waited for the log pile to collapse.

She rolled back onto the rug, glancing over her shoulder at the clock, and wished that Tomaso would conclude his business and come to her. Nadine watched her reflection in the overhead mirror, proud of what she saw. "Nadine Orozco," she said, shaking her hair out into a dark crescent. "Could you love Tomaso Ortega?"

The question wouldn't have meant anything at all even a month earlier.

*Could I love Tomaso Ortega?*
*Yes—if he would love me.*

There was a scratching sound as the doorknob turned, and Nadine slipped her hand into the pocket of her robe, assuring herself that the tiny envelope of crushed powder was still there.

Tomaso chuckled from the doorway, "Nadine. I'm never sure whether I prefer you nude or just barely clothed."

"Clothed, I think," she said. "Most men prefer that. It gives them a greater sense of conquest."

Tomaso pulled off his jacket and flung it into a corner of the room, his eyes never leaving her. "I've had my conquests for the day. I'm not interested in winning you over and over again."

There were fatigue lines around his eyes. She kissed them.

204

"Come, lie down here. Give me a chance to work at the muscles in that back."

He sighed and rolled over onto his stomach. She worked her fingers in, and felt him exhale harshly. "What is it? I know that there's something wrong. Can I help?"

He shook his head. "It's not really something wrong. It's just going to be more expensive to synthesize the drug than we thought."

"Well..." He was beginning to work up a bit of a sweat now, and his shoulders were loosening. "I would think that you'd pass the cost difference along to your customers."

"It's not just that." His eyes were distant. "It's something that Steinbrenner said. At first we thought that the drug was a synthetic. It wasn't—it was composed of the spores of some kind of psychoactive mushroom we can't identify."

"Can't you grow them?"

He groaned. "A little lower. No. The spores are dead, deactivated. Whatever. We can't grow them. Analysis says that there are maybe twenty, twenty-five separate tryptamine derivatives in the drug. We don't know which are the vital factors. We're trying to duplicate it, but..." He reached back for her, fingers grazing a leg. "It's a mess. Ah, well, I'll let Klause work it out. What else am I paying him for?"

She kissed him gently at the back of the neck. "That's what I like to hear. I mean—I would hate to think that I've grown so old and ugly that I can't get your mind off business any more. That would be terrible."

"Disgraceful."

"Shameful."

He rolled over, and she sat astride him, unbuttoning his shirt to run her fingers along the smooth skin underneath.

He was watching her closely. "Well look at this. I put away my business face, and the first thing that you do is put yours on. Where are you now, Miss Orozco? What are you thinking about?"

"Us. Tomaso...let's have a drink, and end the day together."

"Sounds good. A little brandy, perhaps."

Not good. He wouldn't want much of the brandy, just barely enough to wet his mouth and fill his lungs with heat. "Tomaso—I have a special bottle I bought three days ago, after the last time that we made love."

"My lovemaking drives you to drink?" There wasn't even a trace of honest disappointment in his voice.

She knelt by his head and bent over, her skin glistening orange in the firelight, and kissed him moistly. "No. It makes me want to do something good for you. This is very good."

He groped up to kiss her, but she was gone, gone to the small refrigerator by the bedside, scooping out the bottle and rushing to the crystal wetbar in the corner of the room. She took out two chilled glasses and set them on the counter, humming to herself.

The winecork popped loudly, followed by the sound of gurgling liquid. Nadine spun around, her robe flowing out in a spiral, carrying a glass of dark fluid in each hand. Her eyes were twin mirrors that reflected the dying firelight as she walked to him.

The glasses, though brimming, never spilled a drop.

She knelt, crossing one golden leg over another, and ran her tongue around the inside edge of one of the glasses. She smiled and held it out to him.

He took it and saluted her gratefully, taking a sip. "There are potentials for Cyloxibin that no one has touched yet," he said. He took another sip and rolled it around on his tongue, savoring. "Steinbrenner *glows* when she talks about it. 'Enhanced sensitivity to physical stimuli,' she says. Increased alertness to body language; eye movement, heat, and pressure changes." He laughed. "It lowers the threshold of perception for all sensory input, especially pleasurable input. Apparently, it's that reduced threshold that accounts for the incidents of psi phenomenon. Steinbrenner has isolated twenty-four mild varieties of extrasensory activity, most of which have to do with what she calls a 'dissolution of ego boundries.' God, what an experience it must be."

Nadine was watching the fireplace, watching the flames chew at the logs. With a puffball of sparks, the pile collapsed. Glowing ashes bounced off the transparent firescreen. "Tomaso," she said carefully, "more than half of your men are already addicted. . . ."

"It hasn't impaired their intelligence or physical health. Don't worry about it."

"If it's so wonderful . . . why haven't you ever thought of . . . ?" the words evaded her. She took another sip of wine. "Have you ever tried the drug yourself?"

His body shook with laughter. "Of course not. As good as it is, there are drawbacks to everything, my dear. We have determined several personality types that would respond ...shall we say, unfavorably?"

She watched him drain the rest of the glass. "You're talking about really sick people, aren't you?"

"Psychopaths and sociopaths, of course." He grinned at her. "The person with the dark, killing secret in his soul. And, like myself, the person who needs to maintain control. Even this glass of wine was a mistake."

She froze. He laughed again, leaning up to kiss her. "It has lowered my defenses. I'm afraid that once again you're going to have your way with me."

They laughed, and she wondered if he noted her relief. His laugh seemed to her like the product of a musical instrument, something antique, carved from aged wood. She shivered, a ripple of sensation that felt almost like the stomach-knotting precursor of the dry heaves.

"What I want—" He paused, and she looked down into his eyes, suddenly alarmed at the size of his pupils. *My God! So quickly? Can it work as quickly as this?* He paused, confused by the lack of cohesion in his thoughts. "What I want..." He trailed off again. Puzzlement creased his features.

For an instant his face was calm, then he frowned. His muscles locked. With deliberate slowness he reached up and grasped her hands. "Something..."

"Relax, darling. I'll take care of everything." She stroked his head and kissed his browline tenderly, tactile fantasies twisting and twirling in her mind like a fall of autumn leaves.

At first he relaxed again, then he gripped at her. "Your pupils—" he muttered, his voice thick and slurry. "My God. What's happening? What have...?" His arm tipped over the cut crystal wine glass, and it tumbled in slow motion, shattering on the fireplace, shards of glass and drops of liquid spraying the air.

Color draining from his face in shock, Tomaso struggled to his feet. *"You drugged the wine!"* There was nothing of a question in his voice, only sadness, and...

*And what?*

*Enhanced sensitivity to physical stimuli. It lowers the threshold of perception for ...pleasurable input.*

*What about the threshold of resistance?*

Tomaso struggled up, face a battlefield of warring emotions. She grabbed his wrist. His skin was fever-hot. "Tomaso. I love you. Please."

"You don't understand—" His words were thick, slurred, but he had paused to speak them. She hitched up, pressed her head against his stomach, heard it rumbling with tension. Desperate, she stroked him, kissed him, afraid of what might happen if she let him go.

He took another step towards the door. "Tomaso," she gasped, "listen to me, just listen. You're strong. Stronger than any of the others. You have nothing to fear—it was for me, just for me. I wanted to be closer to you, to belong to you, to feel you more than I ever have before."

*What does he want to hear?*

"Please, Tomaso. I've never given you all of me. Now I can. Take it. Throw me away after, if you want; but please, just once. . . ."

She wasn't even sure she was making sense, but when he looked down at her, his eyes were vast and dark. He was trembling, sweating, out of control.

He sank down to his knees. Her hands were everywhere on him at once, coaxing, plying, laying him back on the floor, and finally mounting him with a vast rending sigh of relief.

She seemed to Tomaso a hollow woman, a bottomless pit. His body swelled in a frantic effort to fill her.

She gripped him on the rug in the firelight, moaning out her love, begging for forgiveness, the words soon giving way to inarticulate cries and the silent language of touch and taste and smell.

Her mouth was a boiling whirlpool. It seemed that he was being sucked into her from both ends, as if there was no end to her need, no way that anything or anyone human could give enough.

He tried to pull back, but when he did, she gripped him tighter, and he gave in to her embrace. He felt the ripple of her stomach muscles, the interplay of the sinews in her legs as they coiled around him, felt his skin melt away, until their flesh melded together, until gazing into her eyes was like looking into a mirror. He saw nothing but himself, being sucked deeper and deeper. The things that were Tomaso and the things that were Nadine rose bubbling to the surface of consciousness and intertwined.

Tomaso made little gasping sounds, trying again to twist away, to free her hands from their grip, but could not.

And he went mad. It was just a fragmented fear at first, then a torrent as he realized that every glimpse into her mind was being mirrored by a glance into his own. Every secret. . . .

He gathered the last of his strength and pushed—at her throat. He felt the pain, the agony as his fingers closed on her; he saw his own face turning purple, felt his fingernails tearing at his hands, raking his arms, searching for his eyes. He heard himself scream, the scream becoming a cry chopped off before its peak. He saw something that might have been Nadine roll her eyes back into her head, felt the last desperately dragged breath of air burning in his lungs, the red-tinged darkness swirling in from the peripheries of consciousness, the final, stifled scream of pain and betrayal, and love. . . .

"Mirabal," Tomaso said. His voice wavered before he managed to regain control. "I don't *care* how much it costs. I want him. I want *them*. This is a matter of family honor, and money doesn't enter into it at all. Do you understand me, or will it be necessary to find someone more tractable to fill your job?"

Mirabal watched his employer's holographic image warily, wondering how many of the small black tablets Tomaso had taken so far this week. "No, that won't be necessary. I hope you realize that we are attempting to follow up on old leads. You know how difficult—"

"Difficult! You want to talk to me about difficulty? See how you like running your section when the supply of cyloxibin runs out. *That* will give you a totally different perspective on the word *difficult*, I think."

Tomaso looked down the table at Wu—who turned away; at Sims; and finally at Margarete. His eyes were fierce, but Mirabal had no trouble deciphering the message in them.

*You're screwing up, Tomaso, and you know it. A little grandstanding for the* Grande Dame?

"Yes, sir." Mirabal didn't say, *And who asked you to addict them to that damned drug you miserable weakling?*

There was one new face at the table: Steinbrenner, the woman from Tomaso's technical section. She sat looking straight ahead, as if the slightest unplanned thought or movement might be disastrous.

"One tenth, Wu. Every month from now on, you will dis-

tribute ten percent of the remaining Cyloxibin, and that will be divided among the various dependencies."

Wu was silent, weighing the implications. "A tenth. ...Tomaso, surely you realize that that amount will not cover the addicts that you...that already exist. May I remind you that some of these people are quite powerful and influential. If we attempt to cut back on their supply, they can retaliate."

Tomaso cut him off. "Bullshit! None of them would dare do a thing. Look at yourself, Wu...."

For a moment, Wu's face tightened and Mirabal knew that he was gripping the armrest of his communications seat with crushing intensity. Wu was a strange one. His strength didn't lie in physical mass, or even in any conventional concept of intensity. Mirabal remembered the pleasure of watching Wu deal with a trio of federal spies. His frail hands appeared to move slowly, the stick-figure body barely torquing, moving more like a dancer than a fighter; but the three men were rendered into insensate pulp. Fascinating. And yet neither Wu's control, nor strength, nor even the vaunted Ortega blood in his veins could master the drug. Mirabal quelled his flutter of unease, and directed his attention back to the table.

"Look at yourself. You know what I did to you. Do you hate me?"

Wu moistened his lips. "I—don't waste my energy on unproductive emotions."

"Yes. Of course. For the sake of argument, let's assume that you did. You can imagine yourself in that role, can't you?"

"Most assuredly."

"Do you think for even a moment that you would do anything to interrupt the continuous flow of that drug?"

Wu paled, but remained silent. He dropped his head in shame and didn't answer. Finally he looked up at Margarete. "I have made a grave error," he said, "and wish only an opportunity to correct it." Margarete and Tomaso nodded at the same time.

"Tomaso," Margarete said carefully, "we know that this Cyloxibin can control minds. The sales figures are most impressive. It must be carefully considered."

Tomaso inclined his head gratefully.

"But Tomaso, where—where are your brother's killers?"

He swallowed hard. "As you will see, Grandmother, finding Aubry Knight and securing our supply of Cyloxibin have be-

come the same project. Steinbrenner?"

The small woman seemed to shrink even smaller in her chair, and she ran a fingernail nervously through the tight bun of brown hair at the back of her head. Her voice sounded as if something were pressing against her throat.

"We possess enough information now to make a guess at the missing pieces of the puzzle, ma'am." She triggered a video note scroll that didn't appear on her holo image. She coughed quietly, calming herself as if the information were a meditative *mantra*.

"First. The drug Cyloxibin was derived from an unknown form of psychoactive mushroom, probably genetically engineered. The active form of the drug would be the live spores or the flesh of the mushroom. There is some synergistic reaction of factors within the spores that we have not as yet been able to duplicate.

"Second. Luis believed that Cyloxibin was an easily synthesized synthetic organic. Patricks therefore misled him. Based on that deception, he convinced Luis to kill all of those connected with the original drug research project."

Mirabal interrupted calmly. "Most of the killings were routine, except for the death of Patricks himself, which was an information-retrieval operation. And one other—the death of the lab assistant, Ornstein. Under Patricks's supervision, it was made to look like a murder/suicide attempt. Maxine Black was allowed to live, as bait to pull in anyone else who had associated with her."

Steinbrenner smiled uneasily. "From this we can conclude that the Patricks-Ornstein connection was the most dangerous. The woman Promise was involved with the detoxification clinic, Maxine Black, and the death of Luis Ortega. We can assume that she holds the key to the entire puzzle." She looked up at Tomaso, eyes melting for approval. He smiled, very briefly, and then turned to Sims.

"Your report?"

The man's calm was no longer as steady as it had been. His eyes were haunted, and Mirabal watched them with caution. *Sims is addicted*, he said to himself. *Do not trust him.*

Sims couldn't meet Tomaso's eyes. "During the time that Aubry Knight was in Death Valley Maximum Security Penitentiary, he was implanted with a security scan device similar to that used by our organization.

"It couldn't have been activated, or he would never have been able to escape." He was sweating. "Nonetheless, the implant is there, and our communications satellite has been attempting to trace it. Either it is inoperative, or the transplant is shielded somehow. A few meters of concrete or steel would do it. We're still trying. If we succeed and the woman is still with him . . ." He shrugged.

"They're together," Tomaso said. "I know it. And she has the secret with her. I know—"

"You know, Tomaso? Or you hope?" Margarete's voice was cold. "This drug. Yes, very interesting. But it is nothing compared to the Family. Two murderers still walk the earth. Do not speak to me of drugs. You have lost perspective, grandson. What is money if the Family dies?"

"It . . . is well."

"It is well? When half of your own people are addicts? When assassins lurk in your own bedroom? Tomaso? That *is* what you said, isn't it? That the woman, Orozco, attempted to poison you?"

"Yes . . ."

"I want no more excuses. I want answers. In sixty days you will come here. To the Island. We must have a full meeting of the Family. Bring the drug, Tomaso. But more importantly—" She leaned forward until the edge of the table disappeared into her holographic image. "—I want Luis's killers. This is *my* family. It is more important than anything. Anything in the world. I hope that you understand me clearly."

"Yes . . . Grandmother."

She sank back down limply. "Good." Her voice was profoundly weary. "Good. I will rest now." Her image darkened and disappeared.

Tomaso composed himself. "Steinbrenner, you have work to do. You are excused." She nodded gratefully, and her image collapsed like a ruptured soap bubble.

When he turned to Wu, he caught a moment of interaction that disturbed him. Wu and Mirabal were watching each other, no expression on either face.

"Wu," he said sharply. "I want you to work with Steinbrenner. Surely, in all of your years, you have heard of some drug similar to this. Or one of your contacts must know who provided Patricks with breeding stock. I want to know. Anything. Anything at all."

Wu nodded, making a slight bow in his seat, and signed off. The others followed suit, leaving Tomaso alone in the conference room.

He adjusted the heat in the room: it always seemed to be out of whack—either too hot or too cold. He was sure that the meter was off, even though no one could find any error. With sweaty fingers, he pulled a bottle from his shirt pocket. He noted the dark moist rings spreading out from his armpits. They smelled more acrid than normal perspiration. He rattled the bottle in his hand, popping one tablet out into his palm.

He didn't need to take it. Really, he didn't. He hadn't heard the screams for hours now. Hours. Maybe if he just stayed busy, he wouldn't hear them.

Or see the faces.

Or feel the nails ripping furrows in his throat. Or smell the blood. Or taste the bile welling up in his throat as he gasped for air. Air. Oh, God. *There was no air!* He gripped at his throat, reddening. The ringing—at first a distant, keening, sour note—trebled into a scream, a mouth gibbering fear and betrayal.

He swallowed the pill. Instantly, the images, the sounds and smells and tastes, began to recede. Instantly. *It's all in your mind. The pill hasn't even dissolved yet.* But that was the voice of sanity, a still, faroff voice.

Tomaso Ortega sat on his throne, in the dark, and calmed himself, and plotted.

Wu shook his tablets out of their yellow tube, and watched them spin to a halt in his hand. Such small things, to command his life as they did. "Hurry up, darling," the woman on the bed whispered huskily.

He glanced at Dawn sidewise, wincing. What demon in hell had egged him to choose this woman that fateful night at Tomaso's? Her face, without makeup, was too thin and lacked character. Her eyes were too small and sharp, her lips hard. But he abhorred makeup and had insisted that she face him as herself, not a painted clown.

He had pondered that many times, on many nights, many days—but only when the drug was not coursing through his veins. Then it was different. Then he could forget the hundreds of men that she had known, her virtual illiteracy, her shrill laughter, and all of the superficial things he might have judged

her by, and saw only that she was capable of filling his cup,
if he let her come that close to him. And under the influence
of the drug, he had no choice.

His robe floated above the surface of the rug as he crossed
to her.

She had no appreciation of the things that he loved. The
seventh-century Silla tapestries on the walls of his bedroom
were dull things to her, no music, no history or pageantry in
them. Fine wines were wasted on her, as was talk of literature
or politics or business. There seemed no area of communication
save the bedroom; but what happened there was a mind-burning
experience.

If only he could find the strength, or the urge, to try the
drug with someone else. But every woman he saw had Dawn's
face, every breeze that blew through his fantasies carried Dawn's
perfume.

He felt the smoothness of her skin, and laughed to himself.
The drug had taught him one thing, something that he never
would have suspected: It is possible for anyone to love anyone.
You cannot hold a complete image of someone in your head,
even when you are looking at them. The selection of images
and impressions you hold of a person determines your opinion
of them. And when he thought of Dawn, his mind was pulled
inexorably to the desirable, irresistible, essential femaleness of
her. At least, as long as he had the drug. And without it, a
longing arose that paled all pleasures, that made life seem an
impossible burden, one best released as swiftly and painlessly
as possible.

He slipped the robe from his shoulders and lay down in the
bed next to her, her hands smoothing the care from his spindly
shoulders.

"Where are they, lover?" She licked her lips to a glistening
sheen. Even without the drug in his system, something within
him shivered in excitement.

*What if . . .?*

"Where is it?" Her lips were warm and intimate.

With all of the strength he had in him, Wu made up his
mind. His right hand dropped down to the floor, finding one
of his slippers by touch, and dropped the pills into it.

He looked into her face. "Do you love me?" he asked flatly.

She was confused for a moment, a dull cloud dampening
the glow that had been building a moment before. "Of course
I do. You know that. Now—where are they?" Her searching

movements were nervous, as if unsure of the game he was playing.

"We don't have any more pills now—" He felt her stiffen, withdrawing from him, and he almost gave up the game at that second, just forgot about anything but the moment, anything but the supreme happiness of lying with Dawn and feeling their bodies meld.

The hardness in her face broke through, a greasepaint mask emerging from shadow. "Baby, no. Don't play with me. You know I love you. I just need some help. Just a little help. There's nothing wrong with that."

"No. I just want to try something. This once." Her eyes were wet, and there was a catching sound in her throat. Wu kissed her on the shoulder. "Please? For me. I have to know something."

"And then?"

"And then we can have the drug." He paused, wondering whether to add the last thought, finally deciding yes, "If we need it."

Her mouth pursed with surprise. "You're not serious?"

"Do you want me to be?"

She tried to nod, but couldn't; tried to speak, but couldn't, and finally communicated in the only way she knew how, drawing him to her like a mother caressing a son, trying desperately to believe.

It was dark in the room, and Wu wanted to turn on the lights, to find the slipper under the bed, to take the pills. Wanted to, and his gut burned with the need. His eyes watered. The memory of other times, inhumanly intense experiences, pounded in his head.

He wanted the pills so badly that he could barely lie there in the bed, touching her body, feeling the clammy sweat on it, feeling her restless sleep.

Just barely.

The darkness he staggered through seemed tinged a sickly green. He fell against the door that connected his bedroom and study, his body turning around seemingly of its own volition. *Back. Take the pills. The pain will stop*—

No. He had to do it alone, just his will and his knowledge. And Dawn. He thumbprinted the lock and the door swung open slowly. He turned up the light very slightly, wincing. Withdrawal made his eyes painfully photosensitive.

In the precise center of the floor was a simple mat. Naked, he collapsed onto it gratefully. He sat with crossed legs and closed eyes.

From the swirling confusion in his mind, he called forth the image of the *Tai Chi* form. He often practiced this way, without movement, concentrating so deeply that his muscles twitched and the sweat rolled down from his head, his joints singing with the imagined strain. Slowly, slowly. More slowly than he ever had before, he pictured himself in the form, finding the *feeling* that would allow him to stay in the moment, intimately linked to each ritual movement. To ride the flow from the first inhalation, Rising Hands, through the subsequent cycles of contraction and expansion: *Catch the Bird's Tail, Carry Tiger to Mountain, Split the Horse,* and finally the gathering and centering of *Close the Tai Chi.* There was peace here, and strength.

His mind wavered, and for a moment he was out of the form, back in the bedroom, writhing with Dawn in the grip of Cyloxibin. He stopped breathing, held it until his lungs began to ache and he was pulled back to the immediacy of the moment.

He hurt. Sitting silently on the mat, only the faintest of glows illumining the room, Wu sank into the depths of the greatest pain of his life. Searing. Ripping.

Cleansing.

Wu sank deeper into the Void.

# 15

## Dark Within the Earth

*Nothing lasts forever,* Promise said to herself. *And the sweeter it is, the faster it rots.*

She watched Aubry drop his hard hat into a corner of the room they shared, then turned her back and finished undressing. Her work fatigues were matted with dust, and when she shook them the air clouded. Aubry glared at her.

"Why can't you do that outside? This place is filthy enough as it is."

"You're in a damn good position to do something about it, you know. There's a cleaning rag on the sink."

He muttered something that she couldn't hear and flopped down in the corner, covering his eyes with his hands, a sigh coursing the length of his frame like a ripple traveling through water.

"Do you want to eat here or go to the Communal?" she said finally. "It might be a good idea to give a nod to manners now and again. Warrick and the others—"

"Can go screw themselves." He sat up on the cot, his eyes shining. "What I care about is that there was a cave-in today, and we were just a little luckier than last week. Nobody got killed. I care about the fact that my nose filters don't work and that I'm tired of eating that algae slop, and—"

He looked at her with an expression on his face that baffled her attempt to define it. She slipped into her smock and walked over to him, standing, waiting for the inevitable words of blame or dissatisfaction. "Well? What is it this time? Are you going

217

to accuse me of humping Emil, or trading our rations for makeup, or primping too much, or not enough, or—?"

"No."

"Well then, what is it, Aubry? I mean, this time. As opposed to the last time, or the time before that. I want you to tell me, Mr. Knight, because I'm about as sick of your complaints as I am of you."

His voice was barely a whisper. "All I was going to say is that I'm tired to death of this. It just doesn't seem to be working."

"So you've noticed that, have you? Well, here. You want it to work? Do you?" She pulled her work smock out of the corner and dug into one of the pockets, pulling out two mushrooms.

She gripped them in her hand, squeezing her eyelids shut, breathing hard. "Here, damn you. Take it." She threw one to him, and he snatched it from the air with arms outstretched, as if it were a snake that he had to keep from biting him.

He glared at it, turning it over in his hand. He had to swallow twice before he could get the words out. "No. I can't handle any more of this."

She came a half-step closer and stood over him scornfully. "Poor Aubry. So used to his independence. So used to not needing anything but his own strength to get him through the day." She bent down until their faces were level. He hardly seemed to be the same man. His eyes were weak, watery, and he couldn't bring himself to meet her gaze. His muscles seemed to hang off his body in loose coils, as if his mind no longer controlled them. "Well, welcome to the real world."

"Just shut up," he growled.

"You think you're the only person in the world who's had his dreams smashed? Do you really think I came down to California and Nevada to become a whore? Is that what you think?"

"I don't think anything. Just get out of my face."

"No." Slowly, deliberately, Promise raised her hand to her mouth and bit off the head of the mushroom, chewing it slowly into mush. "No, Aubry. You wanted me, damn you. And God help me, you're all I've got."

Aubry watched her with eyes that bled. "Why? Why can't you love me without that? What is it that's so wrong about me?"

In the dim light of their shared room, Promise seemed not wholly human. The plastiskin side of her body was milky pale,

as though she didn't care enough to maintain the color properly. Her hair was a frazzled ruin, the right side chopped down crudely, with no concern for the overall effect. The muscles in her face had grown slack, and she seemed to have aged years in the past few months. "Everything's wrong." The toughness had left her face. He saw the ruin beneath it. "There's nothing left. And if you were any kind of man at all, you'd take the goddamn mushroom and help me." She rubbed at her nose, wiping a slick of wet from it as she chewed down the last of the mushroom.

He glared at the tiny pale thing in his hand, hating it, hating himself for needing it. He curled his hand into a fist, pressing hard, trying to feel the interplay of muscle and tendon that had come so easily to him before.

"Please, Aubry?" She smiled in a pitiful attempt at sensuality. "Please? I'm sorry I can't be anything for you without it. I'm sorry . . ."

He uncurled his fingers and let the damp crushed thing fall to the ground. Her eyes, dilated now, widened and she hissed at him. "You can't handle it, can you? *Damn* you, you scumbag. And damn me for ever having needed anything from you. You're no man at all. You're just a little boy who grew a lot of muscle to keep anyone from ever knowing what a sad, sick case you really are."

With a flickering movement of his hand, he slapped her. There was no body in it and barely any arm, just a whip of the hand, but her head snapped back and she gasped in shock, throwing thin arms in front of her face. She glared at him, wiping a trickle of blood from her mouth with the back of her hand. "So. I should have expected that. That's all you have to express yourself, isn't it? That's the only way, right? You're nothing. Do you know that? Nothing at all. You're getting fat and sloppy, big man, and that didn't even hurt." She stuck her jaw out at him. "Want to try again?"

There was murder in Aubry's face, suddenly turning to sickness as his stomach churned with acid. He fought to calm himself, swallowing a throatful of vomit, gasping at the edge of the cot. He looked down at the folds of flesh hanging at his belly, for the first time realizing how long it had been since he had done his exercises. Or run. Or done any of the things that had kept him alive in the long years of prison.

He looked up at her. "Yeah, maybe I am falling apart. But I'm not the only one. You better check your own face, baby.

There ain't a whole lot left of the glamor girl I met a while
back. And fat? Isn't that a little like the kettle calling the pot
bellied?"

She looked down and wrapped her hands around her mid-
section, turning and falling against the wall, sliding to the
ground. She said something that Aubry couldn't hear.

"What the hell are you mumbling about?"

She jerked her face around, and for the first time in weeks,
there was color in it, tiny rivulets of hue that crept, unsparkling,
into the pain-grooved valleys. "I said that at least I have a
reason."

"Do you, now?"

"Yes, damn your black ass."

"And what's that?"

She screamed it. "I'm pregnant!"

There was silence in the room, except for the sound of
labored breathing. Aubry stared.

Then: "What?"

"I said I'm carrying your baby."

"But—how in the—I thought—how could you—?"

"Because I'm a whore, right? How can a whore have a
baby, right? Why didn't I take care of it? Isn't that what you're
thinking?"

"Yeah. I guess something like that. Yeah."

She stripped the sleeve from her upper arm, exposing an
ugly, ragged scar, still visible even in the bad light of their
room. "I had a contraception implant. Good for a year at a
time."

A horrible suspicion froze the breath in his lungs. "And?"

"I cut it out about four months ago." She stood back up,
something hopelessly, helplessly bewildered and angry in her
body, her voice, her face. "After we started taking the mush-
rooms together."

"But . . . why?"

"I don't know. Because I was crazy, because I was doped
out of my mind." She dropped her eyes to the ground and her
voice turned quiet. "Because I found out that I wanted to have
your baby."

"Oh, my God. . . ." There was outrage in him, and crazy
laughter that rippled like a pool of swirling colored oils. He
rose from the cot and tried to embrace her. She pushed him
away.

"No! Don't—don't touch me." She shivered, watching him

out of the corner of her eyes. "I hate you." She was trembling harder now, in the grip of something she could no longer control. "I hate you, and I hate what's happened to my life, and I hate what you've done to me, and I hate myself for ever, ever wanting something so incredibly stupid."

"There's nothing stupid . . . nothing—"

"DON'T TOUCH ME!"

He reeled back, stricken by the venom in her voice, and staggered to his cot, squatting there, looking down between his knees at the twisted ruin of the mushroom. Slowly, hating himself for it every second, he reached down and picked it up, not even brushing the dirt from it before he put it into his mouth and began to chew.

The particles of grit tore at his gums.

The two of them lay close together in the darkness, Promise spoonlike against Aubry's back. She was crying, and had been ever since they had come to each other's arms.

"I'm sorry, I'm sorry . . ." she mumbled over and over, kissing him.

Aubry couldn't find his own feelings, lost totally in her, happy to escape from his own head, his own body, into a place the two of them had created together, into peace.

And Promise cried, and begged forgiveness. As she always did. And Aubry, deep in the grip of the drug, accepted wordlessly, for the moment forgetting that when the effect wore off, the cycle would begin again.

"What are we going to do?" She said it quietly, kissing his shoulder. She kneaded it, trying to find reassurance in his strength. His flesh seemed to have lost so much of its tone, as if he just didn't care any more.

"I don't know. As long as we love each other . . ." His voice trailed off. She didn't press him to complete the thought.

After a time Aubry rose from the mat, feeling around in the darkness for his pants, pulling them on with heavy grunting sounds.

"Where are you going?"

"I think maybe we had better put in an appearance at the Communal. Anyway, I'm hungry."

She moaned something indistinct and felt her belly, feeling the roundness that spoiled the contours of her once-perfect body. "Aubry, let's just stay here a little longer."

He flicked on the lights and looked back at her, wrapped

in soiled sheets, face gutted with tears and fatigue, muscles slack with exhaustion, hair a curly chopped jungle, filthy and ratted. The mother of his child. "The plastiskin," he muttered, "will it stretch enough for a baby?"

"It's more elastic than human skin," Promise said, trying to smile. "I knew an Exotic who put on thirty kilos while she had the plastic. Looked kind of funny, but it didn't hurt her."

Aubry nodded silently while he pulled on his clothes. "All right. I've got to get out of here for a while. I'm going to the Communal."

"Wait for me?" She rolled out of bed and clothed herself. He held the door for her as they exited.

Communal dining was held twice a day, morning and evening, in a converted storage room beneath what had once been the Los Angeles Civic Center. There was room for three hundred. The meals and furnishings were simple, but adequate to the needs of the hard-working Scavenger folk.

As the two of them wound their way through the tunnels leading to the dining hall, they heard laughter and the clink of dishes and glasses. A cold spot in Aubry's stomach began to warm at the thought of fellowship. Suddenly he wanted it desperately, and his pace quickened.

As they reached the door of the dining hall, the sound died. From under heavy lids, Aubry watched them watch him: a hundred pairs of eyes watched them. In the mirror running along the wall, the backs of a hundred heads turned as they approached.

Warrick spooned thick greenish stew from his bowl. He was the last to look at them, and his hazel eyes were expressionless. "Aubry, Promise. Join us. You're just in time for grace." He indicated two chairs near the head of the table, across from Mira. Aubry nodded sullenly, sitting.

The children bowed their heads slightly, followed by the adults. Warrick looked out over the table and said: "Life consumes life. Plants and animals die that we might grow. Here, dark within the earth, with no sun save our own understanding, let us acknowledge our humble place in the cycle of death and rebirth, giving love, killing only to survive, and when the time comes, rendering our own lives without fear, with thanks for the days we have known."

The children raised their heads and said, "Amen." After a

few moments the noise level in the room rose and there was conversation again.

One of the men on serving duty brought bowls to them. Aubry stirred it with a finger, licking the tip with a grunt of satisfaction.

Promise dipped into her bowl gingerly, swallowing her first spoonful with a grimace.

Aubry had taken about four spoonfuls when he realized that Warrick was watching him. He tried to ignore the attention, but failed miserably.

Finally he put his spoon down and looked up at Warrick, who was resting his chin on one bony fist.

"What is it?" Aubry said uncomfortably.

"Your hand is shaking, Knight."

"So what? I've been working hard. The air was bad today." He tried to interest himself in the gruel again, but failed.

"Yes. I know. It was bad for everyone who worked in R-sector. Are all of their hands shaking?"

A quick glance around the table told the story. There were many faces watching Aubry's conversation with Warrick, but none of them seemed as empty-eyed as the ghost who looked back at him from the mirror.

"I don't give a damn."

Warrick took another sip from his bowl and put it aside. "I know. In fact, you don't seem to care about anything any more, except your woman—"

"And what the hell is wrong with that?"

"You shouldn't interrupt, Knight." Warrick's voice was very soft. "Your woman, and your drug."

Aubry's hands clenched on his spoon, bending it.

"I have something you need to see," Warrick said.

Mira rose nervously and pulled a flatscreen video from her purse, extending its tripod. She set it facing Promise and Aubry, then inserted a rectangular plastic card.

"Yesterday," Mira said, "I was at Fair Market. Someone traded me this for a couple of carrots. I didn't know what was on it, but I . . ." She shrugged, and Warrick touched her shoulder comfortingly. "We had a lot of carrots, and there didn't seem to be any harm. It . . . well, you'll see." She brushed a finger over a flat, heat-sensitive membrane.

A syrupy male announcer's voice came on a moment before the picture. "Has *your* romance lost its pizzazz? Is sex the same

old boring grind week after week? Are you tired of orgies and one-night stands?

"Well, *now,* from the most prestigious hallucinogenics facility in the world comes *SX-1000,* the first significant advancement in sexual stimulation since the synthesizing of pheromones."

The screen was filled with pastels and slow-motion action. A teenaged couple were running through a field of poppies, moving more and more slowly, and aging as they grew nearer. Just before they touched, the screen froze. They appeared to be in their mid-sixties.

The scene segued to a rustling fire. "—or have the passions of the past died away, leaving only a yearning remembrance of what once was?" The same couple was seated on opposite sides of the room. He read his plastic newspaper while she played a sensory game, helmet and gloves blocking out the rest of the world. "Awaken those old desires. Stoke the flame of love with *SX-1000.* The miracle of this or any age, the magical potion sought throughout history, craved by kings and queens since the beginning of time. Not just another aphrodisiac, *SX-1000* makes your partner yours. Love can be yours after a lifetime of loneliness—"

Warrick reached out and flicked off the viewer. "You can imagine who is responsible for this."

Aubry was staring at the dead screen, an ugly thought piercing the confusion in his mind. "The Ortegas?"

"The Ortegas. I think that we know everything about that drug that we need to know."

"What—?"

"Look at yourselves and I won't need to waste my breath. The mushrooms must be destroyed."

Promise had stopped pretending to eat, dropping her spoon at the word *destroyed.*

"Knight, this is a very small community. We depend on each other for mutual survival. Once I saw you as a strong addition to my team and thought the two of you might work out well. For that and—" Mira squeezed his arm in caution. "—other reasons I let you stay. And I let the drug grow. But you aren't eating properly, you can't get along with your co-workers, you don't even bathe often enough. What has happened to the two of you is intolerable. The mushrooms are to be destroyed. Do you have anything to say?"

Now there was total silence in the room, every eye on them,

every face turned to see what Aubry's answer could possibly be. He felt numb, frightened, but a tiny voice within him said, *Good. Someone had to. Someone.*

But Promise's broken nails dug into his arm, and he winced as they drove deep, drawing blood.

"No, Aubry." He looked at her, barely recognizing the woman he had fallen in love with. Her flesh seemed shrunken and pale, ashy; her eyes were huge and glowing. "No, Aubry. You can't let him do that. You just can't. I—" She stood shakily, scanning the rows of Scavengers, trying to find support that wasn't there. She raised her voice. "I just can't make it without them." She ran her hands over her clothes, feeling the soil, for the first time fully conscious of the ruin she had become. "I know that I've fallen down a little. . . . Maybe we haven't been working as hard as we should, but we'll change. Honest to God, we will."

"I know you will," Warrick said quietly. "The decision has been made."

"*Aubry . . .*"

Aubry stood, tried to straighten out his frame, felt the kinks from too many hours stooped in nearly airless tunnels, heard his joints popping and creaking as he pulled himself erect. "Isn't there a vote? Don't we have any rights at all?"

"You have rights," Warrick said. "But so do the families who live here with me. So do their children. If they want to see the results of drug addiction, they can go topside and wander around in the Maze. We've tried to build something better for ourselves down here. It's all these people have, and I'll protect it in every way that I can. I should never have allowed you to begin taking the drug. This is the only way I know of undoing the damage."

Aubry's voice was so cracked with emotion that it was difficult to understand what he was saying, the words emerging as a dull croak. "I've had everything I ever wanted taken away from me, and now I have something—someone—even if I only have her when we're both freaked out of our minds. And now you want to—to take that away from me? *No!*"

"I can't take anything away from you that is truly real. If there is any hope, or any love between you, then it will remain after the drug is gone."

Aubry looked at Promise. She flinched away, horror stitched rudely across her face.

The message there was too clear to him, and he pulled away

from it as if shocked with a live wire. "No. I can't take that chance. Can't you understand?" He looked up and down the rows of faces. "Can't any of you understand?"

Silence. A few of them turned away.

Warrick faced him squarely. "None of them will go against the basic principles of our world, Knight. And none of them will go against me, so long as I am their leader."

"Well, then, dammit, maybe you shouldn't be their leader. Maybe you just shouldn't be some kind of high-handed dictator, pulling people's guts out to satisfy your injured sense of decency. Did you ever think of that?"

Two of the men at the head table started to rise, but Warrick restrained them with a wave of his hand. "And what do you propose, Knight?"

"Fight me." Aubry's hands had knotted into fists, the looseness in his arm muscles gone as he focused his gaze on the slender man at the head table. "Fight me, damn you, if you're any kind of man at all, give me a chance. Just a chance. I'll fight you any way you like. Any at all." Warrick sat back in his seat, watching Aubry with eyes that weighed carefully. "Do you think the weight difference is too much? Use a weapon. Anything you want." He was panting with desperation.

Warrick's pale eyes were hot, gleaming. "Aubry . . ."

"You used to be on the Mercenary Police. You had to learn how to fight. Use anything you want. Anything."

"You're making a mistake, Knight. I know what you were; but more importantly, I know who you *are*. And you don't know me at all."

"Save it. Don't hide behind your damn words. Fight me. Come on, Warrick. Fight me. Please. Come on."

Warrick templed his fingers meditatively. "You may be correct. I've been trying to reach you with words. Perhaps . . . perhaps I need to get your attention first." He stood. "Pull the tables back," he said. "We're going to need some space."

Warrick sat at one end of the cleared area, his eyes half-lidded. In his right hand was a twelve-centimeter section of pipe, capped at both ends.

Twenty meters away squatted Aubry Knight. He tried to stretch out the tendons and muscles in his legs, and felt kinks where once there had been liquid movement. He growled,

trying to fight past the pain, but gave up, realizing that he could hurt himself in the trying.

Joints crackled with disuse. Muscles burned as blood pumped into them. He swallowed air and pushed it down.

He looked over at Promise, who watched with her face frozen into something on the thin edge between hope and despair. He tried some simple gymnastic maneuvers, alarmed at how much agility and balance had been lost. No matter. He had more than enough left to handle this fossil.

He walked toward the center of the area. His gaze swept the Scavengers as they stood pressed back against the walls, holding their children, their wives, their security, while he fought for his. He would show them, dammit. He would show them something they would never forget.

"All right, Warrick. Come out and get your ass whipped."

Warrick smiled dreamily and rose. He took in Aubry's stance, the dirt in his clothes and hair, the half-focused gaze.

"You can't beat me, Aubry. Because all you see in front of you is your own fear."

Aubry snarled, dropping to the ground, his left leg scything around in a sweep. Even in his debilitated condition, the motion was so fast and fluid that the collected Scavengers gasped in shock. Warrick hopped up and back, barely fast enough as Aubry finished the full circle, drew his feet together in a crouching blur, and sprang into the air with uncanny lightness, left leg spearing out at the Scavenger leader's chest.

Warrick pivoted to the side barely in time. Aubry grimaced as his kneecap ran into the end of the short pipe, his own momentum providing the impact.

Like a scarecrow spinning in the wind, Warrick twisted behind Aubry, too close for the next spinning kick to land. Again, an electric jolt of pain shot up Aubry's leg as his calf collided with the pipe.

He landed just a hair out of balance, rolling to the side. He tried to spring up and felt the weakness in his lower leg, rolled again to stretch it out and relieve the cramp. He came back to his feet, adjusting his balance to compensate for the ache.

The instant he balanced he charged in, feinting a front-leg hook kick to the head, changing it to a kick to the ribs. He felt the pain as the pipe connected with his shin, but he had nicked Warrick this time. He gritted his teeth, bearing down. He fought to keep his emotions neutral as he launched a barrage of tech-

niques: elbows, backhands, hammerfists to the groin. Again
and again his weapons missed the skittering Warrick and be-
came targets for the steel-capped pipe. Aubry forced the pain
back and kept coming. He closed for a moment, grabbed one
of Warrick's spindly arms and spun for a hip throw. As he did,
the pipe slammed jarringly into his spine, destroying his bal-
ance. Aubry fell, legs jelly, but Warrick only half-managed to
ride it out and fell with him.

Aubry groped out, but Warrick wasn't there, and the frus-
tration became a surging wave that smashed against his wall
of control, bringing emotions to the surface.

Where was Warrick? Where was that— Aubry choked back
the thought, cursing.

"You fight with your feelings, don't you, Aubry?" Warrick
said. "If you can't feel, you can't fight."

The words triggered anger, and Aubry's control began to
crumble. He turned and caught Warrick coming up behind him,
whipping into a series of spinning leaps that drove the Scav-
enger leader back and back, too powerful to block, too broad
to angle away from.

Warrick didn't have time to get set, and Aubry's foot caught
him on the hip, spinning him, and he dropped, ducking under
a follow-up kick that would have broken his neck. He scrambled
back, and Aubry came after him, balance skewed, form and
technique sloppy, but still a juggernaut of destruction, a blur-
ring windmill of death, kicking, chopping, cursing out his rage.
He forced greater and greater speed into his limbs. Despite
Warrick's ghostly elusiveness, Aubry was nicking him again
and again now.

Warrick feinted high, then when Aubry took the bait with
a sidekick, moved back to strike the shin. Aubry didn't pull
the leg back straight—he hooked the heel around for a pun-
ishing kick to the jaw, and Warrick spit blood, falling to the
floor.

Aubry shook his head as if he were dizzy, and set himself
again. Warrick staggered to his feet. "Almost, boy," he said,
gasping for breath. "You almost got me to fight you on your
level. Fool thing to do. You never play the other man's game."

Screaming, Aubry leaped, changing directions in midair so
that Warrick's dodge took him almost directly into the path of
the true strike. Warrick ducked, but the kick grazed the top of
his head, snapping it back with a sickening concussive sound.

He staggered, dropping the pipe, blood drooling from nose and cuts under his eyes—

Aubry bent over and retched on the floor.

Almost regretfully, Warrick picked the short pipe back up. He kicked the back of Aubry's knee, driving him heavily to the floor.

"You're nothing without your feelings, are you?" Aubry tried to get up, but was caught in another spasm. Warrick struck him a sharp, jabbing blow precisely under the ear. Aubry hit the ground and lay there, quivering.

Promise screamed and tried to run to him, but the other Scavengers held her back.

Warrick looked at her, wiped the blood from his face with the back of his hand, and said, "Do you see? Do you understand yet? No, you don't, but it's time you learned."

Aubry raised a hand in feeble defense as Warrick grabbed his hair and pulled his head back. Aubry looked at him, face a running mask, weeping now, body shaking in impotent rage and fear, and Warrick hit him with everything he had. Aubry's head smashed to the floor and bounced once. Blood bubbled from his nose.

Warrick got down on one knee next to the prostrate man and turned him over onto his back.

"You can go now, Knight. You can leave us. Or you can stay here, because now you understand. And you can keep your drug if you want to—because now you can really see what it is. And what you have become."

Warrick rose and limped from the room. Mira's gaze was fixed on the prostrate Aubry. She started to go to him, but her brother shook his head in warning.

She and the other Scavengers followed Warrick out. Finally the room was silent, and empty except for Promise and Aubry.

Promise watched the last of them file out, then looked at Aubry. He seemed pitifully small now, sobbing his disgrace in the center of the floor, great chest struggling with the effort to breathe through a smashed nose.

She walked over to him and knelt down, laying her head on his chest. "Aubry. Oh, my God, Aubry." Somehow he found the strength to reach up and touch her hand. She took it without looking at him, smearing her face against his bloody shirt. "What's happened? What have we done to ourselves?"

She helped him up, wrapped his arm round her shoulders,

taking the crushing burden of his weight, and together they managed to drag themselves from the room.

Promise washed his wounds. The soap was rough, as were her ministrations, and it must have hurt abominably, but Aubry made no sound. He merely stared up at the ceiling with eyes that didn't want to see anything ever again.

"Oh, Aubry. . . ." It seemed as if she was cleansing a dead body, trying to comfort someone who was past caring. "Please, please understand. I never meant for any of this to happen." Her hands were shaking too much, and she had to stop.

She looked at him, just looked at him. His body would heal, but would his mind? What had happened to Aubry, so proud of himself, so proud of his skills, humbled and humiliated by an old man? He had nothing left now. Nothing at all.

And neither did she.

No more dreams of dancing. None of returning home to Oregon in triumph. Of laughing in their faces. *So you didn't think I could make it?*

Nothing. Nothing at all except each other and their ruptured memories . . . and a drug that had done more to them than either could have known or believed.

She dug into the pockets of her work fatigues and pulled out a handful of the mushrooms. Small and frail, their stems broken, bluish fringe dusting the edges of the breaks. So harmless-looking. The ache within her was almost more than she could stand, the urge to swallow one, to chew another up and push the pulp into Aubry's mouth, to have something to make the bridge for them. Something. Anything.

With a regret that bordered on the deathwish, she threw them into the room's small, stinking chemical toilet.

Feeling pain as if it were her own body, not his, that was covered with wounds, she took off her clothes and came to him, loving him, giving to him for hours until he was capable of responding, until his eyes came back to life, until his hands, however weak, clutched her desperately; and then they cried.

For the first time, truly alone.

Truly together.

# 16

## Warrior

Aubry Knight sat in an uncomfortable chair in an ill-lit storage room, listening to a small, strangely shaped man speculate on possibilities. He ran a finger over the roll of flesh at his stomach. It was still there, thick enough to feel when he walked, but the muscle beneath it was beginning to firm up. Warrick sat behind him, in shadow, listening without speaking.

"Are you feeling all right, Aubry? You still seem to be drifting." Emil leaned close, peering into Aubry's eyes with concern. "My hypnotic technique is a little rusty, so I may not have brought you all the way back."

"No, I'm fine." He wasn't, but he needed to hear what Emil had to say.

"You went through massive trauma in that prison, Aubry. Someone did a very precise conditioning job on you. One of the finest I've seen."

"I know," Aubry sighed. "But what I don't understand is why it seems to be so . . . so . . ." He fought for words. "It seems to work one time and not the next. Sometimes I'll just *think* about hurting somebody and I'll get sick. Other times—" He turned and looked at Warrick, who nodded silently. "—other times I can hold it together for a couple of minutes."

"And then there are the times when you performed perfectly. The thug at the drug clinic is easy to explain: you acted on reflex, before you could think about it. More difficult to understand was Luis Ortega. You had plenty of time to think about it, *feel* about it, and yet you were still able to do it."

Aubry stood, no longer comfortable staying still. "I can

231

remember waiting for Promise to throw the rope down to me. I felt angry, and eager—and sick."

The storage room was almost completely empty except for two facing chairs. Aubry paced from one end to the other, trying to dredge up some missing piece. "When I was climbing up the rope, I was concentrating on that. When I came in through the bathroom window, I started to feel sick again."

"Yes," Emil finished. "Until you actually entered the study. Then you were calm."

"Yes"

"And you remained lucid and in control until you finished killing Luis."

"Yeah, I guess so."

"How quickly did the sickness come back after that?"

"It took a while. It started almost immediately, but didn't hit strongly until I was out of the house."

"All right." Emil sat back in his chair with a squeak, watching Aubry. "I know the answer, even though it might not help. There was something in that house that broke through your conditioning. The conditioning may well have been structured to leave you a 'window' to operate through."

"Window?"

"Think about it. The administration at Death Valley wanted you as a . . . what do you call it? A tough guy, a ramrod. They wanted to break your will, and saw that your violent potential was tied in with your image of yourself, your need to protect your ego. So they tampered with it, made it impossible for you to get angry without becoming violently ill. But they didn't want to have to go through a lengthy reconditioning process once they broke you, so they left a window, a clear space in the conditioning, to operate through when a prearranged signal or stimulus occurred. This way, you would be completely under their control." He hitched his chair closer. "Now, Aubry—can you remember anything else about the house, anything that might not have come out already?"

Aubry closed his eyes, trying to remember any small loose end that might have crept through his awareness before. "Just the party noise and the smell of a lot of drugs in the air."

Emil looked at Warrick. "It could be anything, Kevin. Sight, sound . . . I might go so far as to think it was a smell. Some combination of aromas that was accidentally recreated that night." He stood. "I'm sorry."

"Thank you, Emil," Warrick said. The little man nodded

and left the room, his shuffling footsteps echoing in the cavernous room.

Aubry studied his fingernails, miserable. "Is that it, then? It's just gone?"

Warrick uncoiled from his seated position. "What's gone, Aubry?"

"My ability to fight."

"I don't think it's gone at all. What has been destroyed is your ability to motivate yourself with anger, with fear. Your *concept* of violence has been disturbed. Not your talent."

Aubry thought for a minute. "It's the same thing. Same result. I can't defend myself." He grinned ruefully. "I can't even take an old man."

"That's better," Warrick said. "Your sense of the absurd is still intact. Important. Important if we're going to help you."

"Help me . . . ? I don't even know why you're bothering, Warrick."

"Because I *am* an old man. Who are you?"

"Once," he said miserably, "I was a fighter. The best in the world."

"That was your *fantasy*. Who are you?"

Aubry hung his head, concentrating until it ached. "I am . . . me."

"And what is that?"

"I don't have any words for it."

"Excellent."

"What kind of crap is this? I tell you that I've lost any sense of who or what I am, and you say 'excellent'?"

"You said you were a fighter. A fighter is one who must fight to define himself."

"All right, I'll buy that."

"But I say you're more than that. I say you're a Warrior."

"Warrior, fighter, what's the difference?"

"A fighter must fight. A Warrior is *prepared to fight*. In time of peace, a fighter is an unused, unwanted death machine. A Warrior, in times of peace, is a farmer, a doctor. A leader. The actions are the same, but the *emotions* are unified."

Aubry held up his hand, cutting Warrick's next words off. "Then he . . . then . . ." He stalked across the room. "For God's sake . . . listen. I can't handle getting mad. But I *have* to fight, Warrick. It's all I know, and without it . . . I'm not worth very much."

"Then stop feeling anger, and just *feel*."

"Feel. Pull my emotions together. Man, I want so bad to see what you're saying, but I just don't *know*."

"Yes you do. You're a physical genius, Aubry. I couldn't begin to teach you about movement. But I can tell you that there are other ways to *feel* about movement, or about life. Don't ride the hate and fear. Those are just fragments of the real thing."

*The real thing*. An image played before Aubry's eyes—a slender figure twisting in the spotlight, lost in her own world; a flash of beauty in an ugly world, of light in the enveloping gloom.

"What are you thinking about?"

"Promise. In the auditorium." Aubry sank down on the floor, sighing. "I watched her, and I could feel something. Man, like I'd never felt it before. She moved for the pleasure of using her body. She was making love to herself up there, just letting her feeling out. And it didn't matter if there were a thousand people watching, or none at all."

"She belonged to herself?"

"Yes."

"And who do you belong to, when you use your body in hatred or fear?"

"I belong . . ." He opened his eyes, and they seemed clearer, and somehow lighter. A trace of moisture was running from the corner of one eye, welling up as he spoke. ". . . I belong to the thing I fear. To the person I hate."

"Excellent. Aubry Knight, I think that I can help you now."

Warrick bent down and picked up a two-meter wooden dowel. "You must *feel*, Aubry. Hate comes from the past, fear from the future. Pain and pleasure are *now*, and therefore their own trap. You have to bring the feelings together, blend them, and step away from time."

He swung the stick suddenly, and Aubry moved without thought, rolling away as it smacked against his back. Warrick followed him, swinging.

No matter where Aubry went—moving, dodging, blocking—the stick was there, striking his elbow, his ear, his fingers, with sharp jabbing blows.

Never did he hit back. Twice, in a daze of pain and fatigue, he grazed Warrick with spinning kicks. But they were perfectly controlled, and Warrick grinned at the scrapes.

Whenever Aubry faltered or slowed, the stick struck. He

felt the sickness hiss in his guts. "There is no violence here," Warrick said, "only motion and emotion."

And Warrick took him on. And on. Through every potential his body possessed. Past exhaustion and into a realm of light he had never known before. There was constant movement, constant pain and alertness, and finally a kind of ecstasy, a feeling of centering as they swirled around and around. Until it was difficult to say who chased whom, whether staff bruised body or body struck staff, until all thought and sensation melded together into the experience of Being.

Aubry woke with a start. Every muscle in his body ached, and it felt glorious. He sat up and saw Warrick crouched over him, grinning.

"Not bad at all, Aubry."

"What happened?" After a few seconds the room decided to stop spinning, and he tried to get up.

"No, rest a while yet."

"I want to keep going."

There was a touch of sadness in Warrick's eyes. "Yes," he said quietly. "You will. But for now, rest here and think."

"About what?"

"About who you are." Warrick stood, satisfied with what he saw in Aubry's eyes. "I'll be back for you later. No one will disturb you until then."

Aubry nodded, wiping his hand over his face. He was covered with little bruises and cuts, and ached abominably. But there was something alive inside him, something he had feared was dead. "Warrick," he called. "I don't know why you're doing all this for me—"

"You will," Warrick said quietly, and left.

Aubry stood, and breathed deeply. He was exhausted and in pain. He felt as if he could sleep for a week.

But in spite of it, he began to move, twisting and contorting, filling the air with the smell of his sweat and the sound of his tortured grunts. Moved until his hands and feet were a blur of sudden shifts and torques, his breath flaming in his throat.

For the sheer, painful pleasure of it.

"I want you with me, Knight. Any objections?" Warrick stood in the doorway of the cubicle that Aubry and Promise

hared. It was noticeably tidier and didn't smell of anything but soap and clean sweat.

Promise still slept, and Aubry kissed her cheek as he buttoned his shirt. "Be right with you."

He loaded his backpack and donned his work gloves. Warrick's eyes scanned the room, found the spot where several tiny droplets and a puddle of perspiration marked the spot where Aubry had done his morning exercise. He nodded.

Aubry caught it and grimaced. "Well, what in the hell are you gaping at?"

"Nothing at all. This way."

He followed Warrick out, down the narrow branching corridor that led to the main hall.

They exited the tunnel into the main artery. There were two electric tugs, each of them loaded with wire and scrap metal. The second tug was already manned. Warrick hopped into the nearest one and motioned Aubry into the adjacent seat. The cart shuddered into gear.

Aubry glanced at Warrick out of the corner of his eye. He seemed even gaunter, if possible, but his eyes burned fiercely. Every day for the past four weeks Warrick had driven him through a brutal workout session in which pain and pleasure, hatred and love somehow blended into pure feeling. Love? He stole another glimpse at the silent Warrick. What did he feel for this man who had given him so much, if not that?

Had given him so much, asking *what* in return? They rode on until they reached a spot where the wall had been broken out, a makeshift bridge fitted to connect the submerged building with an old storm drain. The corrugated metal bridge sagged under their weight, but didn't give. The storm drain ran with a trickle of muddy water.

What *did* he feel? What was happening to him? If he wasn't who he thought he was, then who the hell was he?

Warrick glanced over at the brooding Aubry. The cart hit a bump, and the scrap in the back rattled. "Stop trying to hide behind a label."

Aubry was watching the tunnel slip past. "I get up in the morning and I do my exercise, and I work, and I come home to my woman, and we share our day, and eat, and sleep. What is there in that?"

"Everything."

"*Will* you shut up? That doesn't make any sense at all."

"Does it have to?" Warrick laughed. Aubry was surprised

that there was no momentary flash of discomfort, no nausea. He sat back in his seat, smiling in the dark.

The storm drain took a long, gradual upward slant, but instead of opening up to daylight, it dead-ended in a makeshift wall composed of sheet metal. Warrick stopped the front car and got out gingerly. "How do you feel about going outside? Topside." He paused, sniffed the air. It was different, thinner than the air in the tunnels. Fresher. Aubry caught the urge, filling his lungs deeply.

"I've *got* to get out, man. I've been hiding in the dirt long enough."

Warrick nodded agreement. "The dirt's a good place to hide. It's not a bad place to grow, either. Ask a seed."

"Warrick, you have got to be the strangest son of a bitch I ever met in my life. Will you stop playing fortune cookie, and open the wall?"

The men from the rear car had moved up and were busy removing bolts from the false wall. They paused, and waited until they heard a light tapping sound from outside, then threw the last bolts and swung the door up on oiled hinges.

A gust of cold, deliciously fresh air blew into the tunnel. It was dark outside, still minutes before dawn would paint its glow along the eastern horizon. Mira stood in the opening, wearing a heavy coat, pinching the collar with gloved hands to keep out the frost. "Hurry up. Everything's clear."

The five of them hustled the carts out of the tunnel, onto the dry bed of a concrete river. Once they were out, the door was swung closed, and Aubry saw that from the outside the disguised door looked exactly like another section of concrete wall. He whistled in admiration.

"Very nice."

"Very necessary." Warrick motioned for Aubry to scoot over into the driver's seat. He himself swung around to check the cargo and lashings. Finally his narrowed eyes swept the banks of the concrete river bed, watching for the curious. Satisfied, he sat down again. "The tunnel we just came out of is too direct—it leads into the heart of our operation, and we'd rather not have everyone know about it."

"Makes sense." The lead cart bumped as it hit an inclining ramp, heading up out of the river bed. The first fingers of dawn were reaching up out of the east. "You said that you have some dealings with the gangs. What kind?"

"We get information and goods from them." Warrick grinned

238                          Steven Barnes

wolfishly. "Anything we can't get through legitimate channels
we get through illegitimate ones."

Aubry returned the grin. "Makin' do."

"Making do."

Mira ran up ahead and unshackled the metal gate that lay
across the exit from the river bed.

"Gate looks newer than the rest of the fence. That your
doing too?"

"Yes, but it's not supposed to look newer. Have to get that
fixed."

The headlights on the carts were dimmed the moment they
left the river. The streets were dark, but there was enough
illumination to steer by.

Most of the buildings were tattered ruins. Clothing hanging
in the windows showed Aubry that they were inhabited, despite
the yellow and red "condemned" signs emblazoned across their
doorways.

They cruised through the streets, a miniature convoy, elec-
tric engines purring low in mechanical throats. Here and there
were the first signs of wakefulness, a flickering light or two
in ground-floor windows, a shadowy movement in the mouth
of an alley.

"So, some of the gangs do favors for you. What's in it for
them?"

"Sometimes we have goods that they want. Or services."

A movement on a rooftop drew Aubry's attention for a
moment. He turned back to Warrick. "What kind of services?"

"I'm surprised you ask. You worked on one of our class-
rooms."

"Classrooms? What do you teach?"

"Just basics. Reading. Writing. The educational system has
broken down completely—unless you can afford to pay. How
much education do you have, Aubry?"

"Enough." He glared at the streets as they fanned past, drew
his collar tighter, feeling the chill. "Not much. Promise has a
hell of a lot more than me."

"But you're not at all stupid. Did you ever have the feeling
that you don't have as much control over your life as you'd
like?"

"Seems to me that we've had this conversation before."

"Is your answer the same?"

There was silence for about twenty seconds. Then, "No."

"And what's the difference?"

Aubry shrugged. "I'm not sure. I just know that there's this big thing inside me that feels empty, and I want to fill it."

"What with?"

"With everything, man. With the world." He paused, trying to find words. "There used to be something in my head, something that told me what I was, and what the world was, and what my place was."

"And that was important?"

"Hell, man, it was everything. I mean, all your power comes from knowing who you are."

There were one or two people on the street now, carrying bundles, headed in the same direction as the carts. They paid little attention.

"Definitions are just words, just labels. And once you label something, the label gets between you and the thing."

"How do you mean?"

"Say you found a lizard, all right? You put him in a jar, and slap on a big label that says 'lizard.' Only the label is so big that you can't see the lizard anymore."

Aubry looked pained. "You're driving me crazy. Four weeks ago you were telling me to call myself a Warrior. Now you say not to hide behind a label. Are you trying to make a fool of me, or what?"

"Labels are useful only if they're not vital. You mustn't *need* one, even if it reads 'toughest man in the world.'"

Aubry ground his face down into the palms of his hands, rocking his head from side to side. "I don't know, man. I just don't know. I hear what you say, and it makes sense. I can't say any of it is crap. But my head hurts when you talk. It feels like there's something *dying* inside me."

"Don't be afraid of dying. A Warrior lives with death, Aubry. Welcomes it as an ally. All other fears are just fragments of death, forms of unbecoming. A fighter clings to life, and therefore cannot win. A warrior treats life and death as the same thing, and therefore cannot lose."

Warrick turned out of the street and up into a cleared area where there were booths and music and sunlight. Aubry leaned back against his seat, a huge grin breaking out on his face like candles glowing at midnight. "Well, I'll be damned," he said.

Warrick laughed. "You never can tell."

Four Scavengers had arrived at the Fair Market before dawn, staking out a small booth. Aubry jumped out of the cart and

walked through the crowd to the spot, searching the faces around him, smelling, looking at the battered buildings ringing the square, feeling the *difference* in everything he saw, knowing that the difference was in him, only in him.

They set up the booth, handing out crafts made from bits of scrap metal, coils of wire trinkets, carved wood, painted mirrors, fresh vegetables from the hydroponics garden, and other items.

"Whatever we can't sell at a profit to our normal wholesalers," Warrick explained. "Bulk metals and wood, unwrought wire, salvageable machine parts—all of that goes to our regular buyer, who in turn is cleared by the state government. We free-market the rest of it."

A small man carrying a tool chest touched Aubry on the arm, and he looked down into a sallow, wizened face. The man couldn't possibly be as old as he seemed—no ambulatory human being could have been. Only his eyes were truly alive—his eyes and his mouth, which was empty except for the worn stumps of teeth. He looked like nothing so much as a smiling, bleached prune.

"Sir?" the oldster said timidly, "I don't have nothin' to trade but myself, but if you've got anything need's fixin', you can count on me."

Warrick glanced into the tool chest. "We don't turn away anyone who is willing to work. Come back at the end of the day."

The old man looked longingly at the oranges stacked in a corner of the basket. They were small, with patches of green on them and a slightly shriveled look, but in the old one's eyes they might have been globes of nectar. "It's been a long time," he said timidly. "Cain't even chew it, but if I could just suck the juice—" He smiled regretfully, already expecting a refusal, but Warrick caught his shoulder.

"I think we can advance you an orange."

The old man snatched the orange out of Warrick's hands with surprising speed and dug a dirty thumbnail into the skin, squeezing until juice welled out around the edges. He put it to his mouth and slurped as he walked away, juice running through his stubble.

"You can't just give the stuff away," Aubry said.

"Call it an investment."

Aubry snorted.

Trade went briskly. Few people had coin or Service Marks,

and dollars were next to useless, but some exchanged needed tools for fresh food or craft items, and a few more signed up to do specialized work in tunnels and inner chambers.

Warrick wandered off to check the other booths, leaving Aubry and Mira to conduct most of the business.

Drink vendors circulated through the crowd, hawking their wares as the day wore on and the sun warmed the air to the point that Aubry loosened the braided thongs that held shut the front of his shirt, reveling in the freedom.

A pretty young Hispanic woman eyed a pair of end tables that Aubry had dug out of a buried furniture shop and stripped and lacquered himself. They weren't pretty, but they were made of wood, and that, in the Maze, was rarer than virginity.

"Big man," she said, "what you asking for those?"

"What are you offering?"

She smiled suggestively at him, raising her skirt to expose a shapely calf. Aubry laughed regretfully. "Sorry, sugar. Got some of that at home. What else?"

She matched his smile. "Can't blame a girl for trying." Her purse was a thing of cloth and plastic, home-patched, and she turned slightly sideways to conceal her calculations. "Three Marks."

Aubry shook his head. "Spent that much just putting the things back together. Nine."

"Nine! *Hijo de la* . . . I give you five, and not a deci more."

"I can go as low as eight, and if you can't match that, you're walking away empty-handed."

"Listen—all I have is seven and a half. Honest." She batted huge black eyes at him. Aubry leaned forward to peer into her purse.

"You're sure about that?"

"God as my witness."

"Deal." Money and property were exchanged. She stacked the tables onto a small wire cart, and limped away.

Aubry elbowed Mira. "How about that?"

"Just a born merchant, aren't you."

"Must be in the blood."

"Certainly not in the eyes."

"What do you mean?"

"Watch the way she walks." The woman was disappearing into the crowd, the easy swing of her hips interrupted by a slight wobble.

"So she limps. So what?"

"So one of her legs is shorter than the other. Because she keeps her money in her shoe."

Aubry winced. "Oh."

"Don't worry about it. I only know because she pulled that game on my brother once."

"Old 'see all, know all'?"

"Still just a man." She chuckled, but there was something uncomfortable in her laughter. She looked around, as if checking to see if anyone was listening. "There's something you should know about him, Aubry," she said, then abruptly shut up as a familiar figure appeared at Aubry's elbow.

"Big man," the old repairman said, his face cautious.

"Hey, sorry, old timer. You'll have to wait."

"Not that. I think I can help you."

"This sounds like a con to me." Aubry put one huge hand over the bowl of fruit. "All right, let's hear it."

The little man drew closer, until Aubry could smell the cheap whiskey on his breath. He jerked a grimy thumb back towards the row of buildings bordering the north edge of the Plaza. "Look over at those buildings."

"All right. They're falling down on themselves. What else is new?"

"Now look just a little to your right. Don't move your head. Just your eyes. Down by the last stand in the row."

Impatient now, Aubry did so. "Damn it, man, I don't see—" But there was someone there, for just a moment—a figure in a ragged dark shirt, a figure which turned away too quickly, and then disappeared. Aubry felt a tickle of fear at the back of his head, but dismissed it swiftly. "What of it?"

"He's been watching you, big man. For maybe half an hour. I thought you should know."

"It's probably nothing. . . ." But Aubry knew he was lying, and gripped Mira's arm. "Listen—I can feel that there's something wrong here. I'm going to check out those buildings."

She brushed a strand of dark hair out of her eyes and nodded, her thin face drawn even thinner with worry. "All right, Aubry, but—take care. If there's something wrong, let us help."

Aubry stepped around from behind the stand, his gaze fixed on the spot where the man had disappeared. "I handle my own problems."

Her hand was a feather touch on his shoulder. "You're not alone anymore, Aubry. You have a family."

He nodded without agreeing, and slipped away into the

crowd. It parted before him like water, and he felt like a great predator as he moved.

He shouldered past a vendor hawking cooked rats in time to spy a black shirt disappearing into the north bank of crumbling offices. Aubry plunged through the crowd, breaking free from the sellers and buyers and thieves until he stood under the building with the cracked and ruined steps, the faded "condemned" stickers pasted over the door, all in once-garish reds and yellows, now totally ignored. There were shirts and pants hung out to dry along the windows of the upper stories. Aubry could smell sweat and human waste stewing inside.

He took a single backward glance at the market, but couldn't find Mira or the Scavenger stall, wondering vaguely why he felt the pang of their absence. He shook his head, growling, and entered the building.

There was a long straight hall ending in deep shadow, and a slanting staircase that went up to the second level. He paused, straining the air through his teeth, and calmed himself, trying to hear.

There was the background hubbub of the market and the distant sound of a baby crying. An argument, something about someone spending money on drugs. And the creak of a stair.

He glided towards the end of the hall almost noiselessly, trying to become one with the building, the trash-filled halls, the grimy doors, the piles of filth and scuttling rats.

He found an odd mental posture, one where Aubry Knight didn't exist at all, not enough of him to become a part of anything, and all that there was was the building, and the background noises, and the footsteps of . . .

Another creak, and Aubry forgot caution and ran, heard the tentative footsteps become frantic, pounding up the stairs. He swung around the railing in time to hear a squeak of terror and see a figure vanish up the next flight of stairs. Aubry took the steps three at a time, slowing only when he heard a crashing, splintering sound.

He rounded the corner, peering through the darkness to see a figure crouched on the stair, one leg driven through the rotting floor boards.

Aubry approached cautiously, testing each of the steps, careful not to place too much of his weight on any of them. The figure on the stair whimpered and tried to pull its leg out of the hole, and failing that, tried to edge as far away from Aubry as possible.

"What do you want from me?" Aubry's voice was like a dull knife pressing a throat. "Just what in the hell am I to you?"

"Honest, Knight—"

Aubry started at the sound of his name—and at the sound of the voice. It was a woman's voice, and, although unfamiliar, it made him pull back.

"Do I know you?"

She whimpered. "No, and I wish I'd never seen you. I ain't got nothing against you. I just needed the money."

"Money?" The tickle of alarm blossomed fully now, and even before she spoke, his mind was dropping guesses into place.

He stepped right up next to her, close enough to see the desperation and hard living in the lines of her face, the trembling of a battered nervous system. "Who's offering money for me?" *Ortega*.

"Ortegas," she said, and a great sigh went out of Aubry, a strange feeling of peace coming over him. So. He was right. "Five hundred Marks to anyone who finds you or the woman Promise."

"Are you working alone, or does someone else know you saw me?"

Her terror was pitifully obvious. She was a frail thing, couldn't have been much older than sixteen, with skin so clear it was nearly translucent, little veins in her face and hands showing through clearly. Her hair would probably have been blond if it ever renewed its acquaintance with soap and water. It was clear that she was considering a lie, wondering if it would do any good, but finally shook her head. "Nobody. I saw your picture at my sister's place. They're spreading it all over. Started about a month ago."

"Just a *month* ago? What kind of crap is that?" Without conscious thought, his hands had tightened on the collar of her jacket, and she gasped with pain. He cursed under his breath and loosened his grip.

"That's when the war started," she gasped, purpling.

"War? What war?"

"Jesus, don't you *know?* The top man's supposed to be cracking up, losing his grip. There's blood in the street, man. He's neglecting the gambling, the hookers . . . it's up for grabs." She swallowed hard. "W-What are you going to do with me?" The tone of her voice said that she had already formed an opinion about his plans. She was sweating, and even in the

foul air of the hallway, he could smell the rank dampness of it.

"That's a damn good question. I sure as hell can't leave you here." *What would Warrick think if I brought her back?* He bent to pull her leg out of the floorboards. *I guess there must be some kind of useful work we can put her to.*

But as his eyes left her hands, she slipped a slender knife from its place in her right boot and brought it down at his neck.

Aubry felt her body accelerate, and his combat brain took over. From sensitivity alone he knew the arc that her descending hand traveled, and his left hand blocked, grabbed, twisted, and his right hand formed a spear that lanced into her throat at a speed far beyond any conscious control.

There was a dull crunching sound and a look of shattered surprise on her face. She flew back, her head impacting with the chipped plaster. Aubry heard her arm break at the wrist and elbow. Her eyes stared wetly, and she tried to say something, but only coughed, a single dark droplet of blood sliding out of her mouth and down her cheek.

Aubry dropped her hand and stood back from her, horrified. He looked at his hand as if it were a stranger's.

The girl was limp, a last sigh trickling out of her lungs along with the bubble of blood. He backed further away.

"What happened?" Warrick asked.

Aubry started, then sighed. *Only Warrick.* The girl was a rag doll now. *They used her, like they'll use anyone, anything. I'm not the predator. They are. The whole rotten Family.* "The Ortegas. They're still after me."

Warrick nodded. "Wait here until dark. I'll send someone to bring you back. Did you have to kill her?"

Aubry could see how thin and frail she was, the way her cheekbones jutted through the skin. He felt sick and ashamed.

"Were you angry?"

"I wasn't anything. I felt, and I moved. My God. I never moved that fast in my life."

He closed his eyes, trying to find the center to the emotions that swirled in his head, and found it an instant before Warrick's large, cool hand clasped his shoulder. "Then feel no shame. Your body did what it was trained to do."

"I'm not just a body, dammit."

"I know that," Warrick said. "I've always known that. And now you're learning. Wait here. I'll send someone for you."

The Scavenger leader left the building, making no sound.

Aubry sat on the stair, looking at the limp body of the girl he had killed, and waited for darkness to fall.

Far away from Aubry, hundreds of miles above his head, a relay in a telecommunications satellite pulsed to life.

The satellite had been in service for thirteen years and was programmed to handle the needs of seventeen hundred separate customers tied into a master tracing network. It was what was called a "locator" satellite, with two antennas, each more than two kilometers long. One was oriented north-south, and the other east-west. Reception beams from this satellite and its brothers scanned the world, looking for the digital codes broadcast by tiny milliwatt radio transmitters belonging to its subscribers. Sometimes the transmitters were attached to packages being shipped. Sometimes they were implanted deep within valuable objects as anti-theft devices. And sometimes the tracers were implanted on or in persons to whom some organization attached special import.

The satellite picked up a signal it had been seeking for months now. One scanning beam located it north-south, the other east-west, and broadcast the location of the missing transmitter to a ground station in figures accurate to within twenty meters.

The ground computer took the information and passed it on to its transmitting station, which matched codes and relayed it to a receiving station in the basement of a house in the Pacific Palisades. The entire process had taken something in the neighborhood of three seconds.

Twelve minutes later, the information was brought to the attention of Diego Mirabal. He read it and made a call to Los Angeles City Engineering, Historical Topography division. He was on the line for the better part of an hour.

His next call was to Wu and was much briefer.

The little man was even paler than usual, but there was an almost beatific smile on his face. Mirabal looked at him carefully before speaking. "You are well," he said. It wasn't a question.

Wu nodded. "You have everything?"

"It's just research now." He paused. "Your final estimation of the drug?"

"It has given me all it can. I have expanded past it."

"And your organization?"

"Fifteen percent of my men have reduced their requests for the drug."

"Good. Operations begin in twelve hours."

He then took the message to a dark room, to a man with unfocused eyes and hands that were sticky to the touch. Mirabal quoted him the contents of the message and smiled as Tomaso Ortega cried with joy.

# 17

## Alpha-Alpha

A scream tore Mira Warrick from the depths of her dream. It was a heart-rending sound, one that she had heard with increasing frequency in the past few nights.

Groping in the dark, she found her nightgown and pulled it on, felt her way through the blackness into the connecting room, and finally to her brother's bedside. She blotted his face with her handkerchief, and his bony hand snapped up to grab her wrist.

"Who—?" He relaxed at the touch of her skin. "Mira." His forehead felt cold and sticky, and he was trembling. His blankets lay tumbled at his feet. She pulled them back to his chin.

"My head . . . oh, God . . ." His voice swirled away like dark fluid oozing down a drain.

"Do you need me?"

His grip on her hand grew painfully tight. She folded the blanket aside and ran her hands slowly over his body. She was relaxed, yet totally concentrated. "Your body is trying to heal itself," she said. "I can feel the heat. Especially around your head and kidneys."

"Just do what you can," he gasped.

She trailed her fingers along the contours of his body, sometimes not even touching him, feeling for the heat. When she found it she worked her fingers into the muscle groupings, caressed the nerves until the warmth evened out and there were no longer the frightening temperature differentials.

"I have to see," Warrick whispered, "have to know. So soon now, so little time."

"Is it time? Aubry and Promise are the ones?"

"Aubry is the one. He's strong enough. If only he can stop relying on his own power. Promise could help him. They need each other so badly. We all need them. There's so little time. . . ." Warrick shuddered and relaxed, and for a moment Mira thought that he was unconscious. Then he clenched his fists tightly. "It hurts. It hurts . . ."

"Shhh."

"Are . . . are the preparations made? Alpha-Alpha is our only real option. Will help—?"

"Kevin. Can't we just leave? Can't we start over again somewhere else?"

"No. It's here and now, or never."

Her brother's body was at peace now, lightly oiled with perspiration. His breathing was easy. "I can't go through it again, Kevin. I'm not a fighter. I never was."

"I've never asked you to betray yourself, Mira, and I won't now. But I can't betray *myself*, either. Somebody has to draw the line. There has to be somewhere people can go to start over. They've driven us into the sewers. Do we have to find somewhere lower than that?"

"Your mind is made up."

He nodded. "I'll be all right." He levered himself up on his elbows. "There's still work to do. You get some sleep." He switched on a dim light by his bedside and stared at her, through her, in the gloom, the woolly disarray of his hair a scarecrow's crown. His eyes shone. "Go ahead. I'll be all right."

Promise lay quietly. Her breathing was steady, eyes wide in the darkness as she watched Aubry exercise.

Long hours of stretching had reclaimed most of his old flexibility; but this was something different. He gasped, fighting to retain control of his breathing, to turn each tortured gasp into something slow and rhythmic.

Aubry kicked high with his right foot, leaped lightly, then turned so that the left foot glided smoothly through the same arc, pivoted again and again, kicking out each time, the only sound the swish of disturbed air and the quiet tap of his feet changing places on the ground. Again and again, until he was a blur, a human top. Then she could hear his breathing once more. Loud, but rhythmic. When he stopped swirling it was with impossible suddenness, and she gasped.

He turned at the sound and came to the bed, touching her arm. "You're awake?"

"I'm sorry if I disturbed you."

He leaned forward and kissed her. "No. Don't be. It was about you. About us."

She sat up, drawing the covers around her. "What are you talking about?"

He wiped his forehead with his tattered shirt, and sighed. "You know, I used to use working-out as a way to deal with the anger. But there's something else down there now. Something a lot more important. I don't know if I can say it right, but it's like—" He pulled her close, the warmth of her swollen belly against him. "You're all I've ever wanted, and I don't know how long I can have you."

She tried to shush him with a finger, but he brushed the hand away. "I'm not leaving you—"

"It's not up to us. The world doesn't give a damn what we feel or want. Only what we are, and what we do. All the time I spent rolling around in my anger didn't do me any good. Neither did all the time I spent giving you what I felt. Giving you love."

"What in the world are you talking about? That's all I ever wanted."

"No. Feelings aren't things. Unless they're attached to actions, they're just words. I want to give you more than words. More than feelings. I want to give you me."

"I don't know what to say."

He held her tightly, trying to memorize the feel of her body. "Listen to me. Something bad is coming, and I don't know exactly what it is, or when it's coming. But if I never have anything else in this world, I want you."

He kissed her again, longer this time. Then he reached over, turned on the light, and looked directly into Promise's eyes. "I want to marry you. Maybe it's just a ceremony, but I want it. I want to do anything that brings us closer. To let everyone know that we want everything between us that there can possibly be."

"Marry you...?" She turned away, laughing miserably. "Oh, God. I never thought I'd ever hear anyone say *that*. I never did. And it's not just a ceremony, Aubry. Where I...come from, it was all of the best things in life, but...but it had to be with honor, and I—I just *can't*."

"Why?"

"Because I have no honor, Aubry. I've violated everything I could have been, and I . . ." She held him tightly. "Let me have your child, Aubry. Stay with me for as long as you want. Let me stay with you for as long as I can. Maybe the rest of my life. But I—"

"Shut up, woman. We're going to do it, and it's going to be all right. Trust me."

"Oh, Aubry . . ."

"Promise, we don't have much time. Maybe not enough. But I had to get myself past the anger, to a place where I was clear. Only when I had done that could I see what I had to give. I'm just a man, Promise. A man who loves you. A man who's wasted the first half of his life and doesn't want to waste the rest of it. Who wants to build what he can, while he can. And who wants you with him, every step of the way."

Promise curled up into a ball on the bed, her tears wetting her breathing. But one of her hands reached out for his and grasped it tight.

There was a knock on the door. Aubry pressed her hand again and waited for her to arrange herself under the covers before opening the door.

Warrick was dressed in work fatigues, his gas mask slung at his belt. "Glad you're awake," he said flatly. "We have a cave-in in Q-section, near Sunset and Hill. If the wall gives in any further, we'll be working in a gas pocket."

Aubry nodded, stripping off his shirt, wiping his body with it to blot the sweat, then slipping into his fatigues. "My mask won't be much help. Filter's almost out. Got another cartridge?"

"None that fits your model. Peedja brought his mask, though—and he can work as outside man. Use his."

"Got it." He pulled on his shoes and jacket and ruffled Promise's disarrayed hair. "You think about that, hon."

And they were gone.

"Three of the support beams gave way in a supplemental tunnel. Ruptured one of the air lines." Warrick took a rest from fighting a reluctant block of concrete nearly the size of his own torso. "There may be a crew on the other side. . . . I can't find some of my people."

"Too many tunnels," Aubry gasped, heaving at a pipe. He

stopped to adjust the light on his helmet. "By the time you made sure that your missing people are really missing, they could be dead. Better to play it safe."

Warrick grinned. "That's the attitude." Aubry wrenched the pipe free and used it as a lever to help with the concrete block. "What is this area?"

"Used to be a storage garage for an antique gasmobile dealership. Top half of it is flooded with rainwater. Bottom level is dry. We've salvaged motors, converted them—you've seen the carts."

"Converted them to electric?"

"Or methane." Peedja wheeled in a flatbed cart, helping them load the rock onto it. "I don't like the air in here." He sniffed.

"You'll like it less if we're not careful," Warrick said. "A gasoline storage tank ruptured on the other side. This whole area could go up."

Peedja finished putting an expanding support beam into place and began clearing a new section of rubble. Aubry set his mind to the work and ignored him, his attention pulled back only by Peedja's scream of recognition.

"Over here! It looks like a foot!"

"Damned if it's not...." Two of the other men rushed forward, bending to the task.

It was already too late. The foot was twisted like a broken toy, totally limp.

"Aubry! We need help!"

"Be right there." There was only room for three to work at any one point, and Warrick stood back watching as they pried loose blocks of rubble, coughing in the resultant dust storm. Aubry clipped his gasmask loosely into place, bending to get his back into the movements.

He turned to Warrick, face grim. "This man is dead. I just hope we—"

That was as far as he got before the explosion. It was a rolling vibration that turned his whole body into a tuning fork. Smoke belched into the tunnel from the far end as a second shudder hit them and the tunnel behind Warrick collapsed. Aubry had a single glimpse of a flailing shape before he was lost under the stone and dust. Any human sounds were dwarfed by the screams of dying stone. Decades-old mortar gave way, and metal pipes exploded from their casings.

Then there was a bright flash of pain, and everything went black.

Aubry coughed dust out of his lungs and rolled over. There was only the dimmest glimmer of light, and when he groped toward it, he discovered that it was his shock helmet, the tiny bulb atop it still glowing feebly. He pulled it to him and put it on. "Warrick?" There was no answer. By moving, he discovered that one of the support beams had collapsed atop him, felt it pressing against his side, and tasted blood in his mouth. Everything else seemed numb. *How badly am I hurt?* With a terrific heave, he shoved the hollow metal support away, listening to the clang reverberate in the confined space. He dragged himself to a sitting position and checked his legs, finding no obvious damage.

On hands and knees, he crawled around the center of the opening, finding one body, and then another. The first was much too obviously dead, her head crushed by a falling rock. The second he almost left for dead, blood on the face and white bone showing through at the ribs; but Peedja was alive, and groaned to prove it. Aubry peeled Peedja's eyelid back and flashed a light into it. After a moment's hesitation the pupil began to contract. Aubry grunted in satisfaction. "Stay alive, teacher."

There was a rustling sound behind him. He crawled back to find Warrick dragging himself out of the debris. Aubry tried to help, but the Scavenger leader pushed him away with an unsteady hand. He lay there on the ground for a moment, eyes wide and staring into the dark, then coughed and pulled himself over to Peedja.

"Warrick?" the little man rasped.

The Scavenger leader said nothing, watching Aubry examine their safe-pocket for possible exits. There were none, both ends of the narrow tube pinched by giant fingers.

"Warrick?" The voice was weaker this time.

"Rest yourself, Peedja. Help will come."

Peedja nodded without speaking and closed his eyes again. Aubry stripped the jacket off the dead woman and rolled it into a pillow. "He may have a neck fracture," Warrick said. "Just give me enough thickness to pad his head." He unfolded the roll until it was only three centimeters thick, slipped it under Peedja's head, and left him there. "Concussion, at least. If we

try to tunnel out, we can only be sure of burning up whatever oxygen is in this pocket. We'll wait for help from the outside."

"The explosion," Aubry said. "That wasn't the gas pocket."

"No." Warrick folded his legs, leaning back against a wall. "It wasn't."

Aubry lifted the faceplate of his mask. "I do smell gas, though."

"The tunnel has shifted again, and it's leaking. Let's just hope they don't cut their way through with a torch, eh?"

Peedja's breathing had become regular. Aubry stopped watching over him, coming to squat at Warrick's side. Warrick's chest heaved with the same slow regularity as Peedja's.

*Try not to waste air,* Aubry decided, and sat, crossing his legs, and tried to relax. "I just wish I knew what was happening out there."

"You already know," Warrick said. "That's why you're scared."

"You know, I still have a hell of a time figuring out whether or not you're crazy."

"Stop worrying," Warrick said without opening his eyes. "You already know the answer to that, too."

"Well if I'm so goddamn smart, how come I'm confused all the time?"

"Exactly."

"What?"

"Time. You still believe in time. Just let it go. When time loses its meaning, past and future get a bit muddled."

Aubry gritted his teeth in the dark and settled down, making up his mind to try to relax.

No, dammit, he wouldn't *try*. He would just *do it*.

Emil barely looked up from his hydroponic tank when the first explosion shook the complex. "Eh?" He examined a leaf for rot, then tucked it back under the light. "Did you drop something, Promise?"

"No—" She was already starting towards the curtains. "And if anybody did, it was an awfully big something, I'll tell you that." There was a second explosion, louder this time, shaking the room so that a row of vials flopped over and slid free with a crash.

At that Emil sprang up. "Burn it! Can't they ever stop their damned tunneling?"

"I don't remember Warrick talking about opening new tun-

nels." Her heart began to triphammer as she remembered the expression on Warrick's face, the sober decision of Aubry's plea. "Something is wrong, Emil."

"Yes, yes, I should say so. The least they could do is to warn me ahead of time so I could lash my equipment down." He stopped, changing his thought in midflight. "Now why would they be blasting so close to the living quarters, Promise? Promise?" He looked around the lab, waddling towards the front to part the curtains just in time to see her disappear out the door.

The screaming was so distant and so faint that at first she thought she was hearing things. Then there was the unmistakeable sound of a gunshot, followed by quiet.

With a curiosity that bordered on the hypnotic, she walked down the railway tunnel in the direction of the sounds. Her mind was buzzing with questions, questions that hushed even the rising wave of fear within her. Was it an accident? Or—?

It was then that she saw the first thin tendril of gas. It crept along the floor, heavy as syrup, boiling up when it hit an obstruction, flowing down the gradient of the ancient tunnel. It was a patch of light against the dark, but when she shone her flashlight into it, it sparkled venomous green.

She was frozen by the sight, frozen until the edge of the mist was only ten meters away. She felt her belly tighten. Her hand went automatically to the spot and felt the weight of the life within.

Promise turned and ran. Behind her, the sound of a radio crackled in the fog.

"Emil!" she screamed as she reached the lab. "We're under attack. You've got to—" She turned and looked over her shoulder. The fog was moving more swiftly now, and if she stayed to warn him, she would be caught. She took a halting step in, then turned and ran. Her first reponsibility was to the unborn child within her.

She ran, feeling heavier and more awkward than she ever had in her life. She ran along the deserted railway tunnel, tripping over the remains of the ties.

Heads poked out of the various cubbyholes. Some of the Scavengers were already out, and she warned them, "Gas! Get your masks!"

By now the entire area was in an uproar, and the sounds of gunshots were like strings of firecrackers punctuated with

echoing screams. She hurried through a branching tunnel—
and saw more gas coming in from the other direction. This
time, walking in the cloud, she saw shadowy human forms.

Backtracking quickly, she found the passage that connected
the rail tunnel to a narrow serviceway. Her stomach muscles
were sore and pulled, and she was exhausted. But she kept
going until she smelled clean air on the other side.

There was screaming, and a pair of Scavenger women ran
down the tunnel towards her, both carrying guns. She was too
breathless to say anything but, "Gas!" They paused just long
enough to fasten down their masks, then disappeared around
the turn.

When Promise reached her room she searched Aubry's and
her own things quickly, finding the gas mask he had left behind.
"The filter is bad," she muttered, looking at it carefully, "but
if it gives me any time at all . . ." She smoothed down her hair
and pressed the mask on, fixing the velcro fasteners at the
back.

The mask was musty. Its faceplate was clouded, obscuring
her vision. She tore it off, polished the shatterproof plastic on
her shirt, then donned it again quickly.

How much time was there? What was happening? *Where
was Aubry?* The question stabbed into her like a white-hot
needle, and she almost panicked. Then she was calm again,
and searched the cubical for a weapon. There didn't seem to
be anything there at all—no guns or knives; but there was a
length of pipe by the bedside, one which Aubry used to exercise
his wrists. She hefted it—it was massively heavy, but she could
carry it, and it was much better than nothing.

There was a sound behind her and she swiveled around,
club at the ready. With a knee-buckling wave of relief, she
recognized Mira. "Thank goodness." They hugged fiercely,
and Promise fought the urge to kiss Mira's gas mask. "Where's
Aubry?"

"With Kevin. Almost a kilometer from here, and I don't
know what's happening on that end." Through the mask, her
voice was badly muffled. "Come on—we have to move."

Without another word, Promise followed her into the fog.

They moved away from the creeping green, carefully at
first, past the dry living quarters and into the main feed tunnel
where rainwater still trickled through the muck. Several other
Scavengers, mostly women and children, waited for them there.

Mira looked at Promise's belly, judging the swell. "No problem running?"

"Try me."

"All right. We're getting out of here, and we have to stop as many of the intruders as we can. If we can split them up enough, our security groups should be able to fight back. Everyone has to do their part."

"What's ours?"

"Bait. They don't seem to be shooting people on sight. Yet. So we can expose ourselves, then duck out through Alpha-Alpha."

"I thought that tunnel was dangerous."

Mira managed a weak smile. "It is—but not to us. Just follow me *precisely* and everything will be all right."

Some of the others didn't have gas masks; they wore handkerchiefs wrapped around their mouths . . . and frightened expressions.

The green mist came boiling up out of the tunnel behind them. They ran.

A gunshot *pinged* at their feet. Gasping for breath, Promise heard frustrated yelling behind her. As they passed a cross tunnel there was another shot, and a tendril of gas wafted out to caress the face of one of the unmasked runners, a boy of twelve. He stumbled, but was jerked erect by his mother who supported him until he collapsed. With a scream, she dropped to his side, and tried to drag him with her. The mist caught up with her as well.

Promise didn't see what became of them, but within sixty seconds she heard another gunshot.

Spurred on by fear, for her life and for the helpless life within her, she kept up with the others, ignoring the pain in her stomach muscles. One hand held her belly, attempting to quell the terrible sloshing sensation; her breath rasped loudly in the mask.

More gas poured out of a side tunnel, swallowing them, and now they were running in a fog bank.

"This way!" Mira gasped, and led them into Alpha-Alpha, tearing aside a couple of warning boards as she did so. The mist cleared out of the tunnel, and the five Scavengers examined each other like survivors of a blitzkrieg.

"All right. We have to stick to the left side of the tunnel for about fifty feet, then stay in the middle between the tracks,

and then the right side from then on. I lead. I need someone
to take up the rear."

Two of the others were children, a pale blond boy and an
older girl with hard flat features. Tears fogged their faceplates.
The only adult male dragged his leg painfully, and looked
weaker than Promise felt. "All right," she said, "what do you
want me to do?"

"Let them see you, then disappear around the bend as quickly
as you can. You have to stay ahead of them."

She nodded. "It'll be easier if they're using that damned
fog."

"They will. This has all been planned too carefully." Mira
laid a dirty hand on Promise's shoulder. "Don't be too brave.
And move as quickly as you can. Remember, you're running
for two."

Promise tried to smile. "I'll be fine."

"All right. Let's get going." Mira took the lead again, pull-
ing along the two children, who had ceased crying and had
become silent as stone, tiny gargoyles who looked back into
the fog with eyes that hated.

Promise pressed herself into the wall and waited until the
fog began to seep into the tunnel—the lovely green fog, with
the dim lights flickering inside. It swirled aside to reveal a
glimpse of an invader. He wore a clear, wraparound face filter
with lines running to a flat rectangle of a backpack. The muzzle
of his rifle probed the mist in front of him, and he walked with
a carefully measured tread.

Her mouth curled into a snarl and she bent, searching the
ground with one hand until she found a chunk of rock. She
stayed against the wall, out of sight, until he was almost up
on her, then she heaved the rock, bouncing it squarely off his
head.

He sagged, groaning, and fell to one knee. By the time that
the second man had moved up to help him, Promise was gone,
moving swiftly along the left wall.

There were shouts and curses behind her, and the sound of
running feet. She bumped into the wall for the third time, and
fought an urge to defy her instructions and run pell-mell down
the center of the tunnel.

The glimpse of a trip-wire, anchored two feet from the left
wall and slanting upward to join the right, cured her of the
urge.

A bullet ricocheted off the tunnel wall.

She disappeared around the bend, almost too far away to hear the trip-wire snap and the quick *swish* of air. There were two groans. . . .

Grinning, she ran on, almost bumping into the boy. They began to move along the center track.

There was a small explosion behind them, then the whine of shrapnel slicing through the air. For the first time, Promise felt a trickle of hope. *How many other death-tunnels are there?* Suddenly, it didn't matter. That was for the other Scavengers to deal with. Right now, her job was here.

She waved the boy on ahead. "No," he whispered. "I want to fight too." She grabbed his shoulders and spun him around, adding a slap on the behind for emphasis.

Groans of pain and cursing wafted from behind the green mist that crept towards her. In spite of her fear, she smiled. "A few morale problems?"

Footsteps echoed through the fog. She waited until the first booted leg emerged, then ran.

There was a grinding crash, and an entire section of the tunnel gave way behind her. Stunned, she turned around in time to see flailing arms and legs disappearing into the maw of a crevasse. There was a flash of light and a roar as they hit bottom, followed by plumes of black and brown smoke.

She ran on until she reached the rest of the group.

"I heard," Mira said. She tried to put enthusiasm into her words, but her eyes were haunted. "Good work. Now listen— we're close to an escape route, but this is the dangerous part. I want you to take the children on through. I've got to go back and try to find Kevin. Can you do that?"

"You bet your ass."

"More to the point"—she tousled the hair of the youngest child—"I'm betting theirs."

Promise nodded soberly and hugged Mira, turning to continue her journey along the right wall. Mira disappeared into the fog.

Explosions and gun flashes split the darkness, but she didn't dare turn back. More gas belched out of a cross-tunnel ahead. As the four of them reached it, a man emerged. He turned to face them, and seemed as surprised as she, hesitating a decisive moment before bringing his gun to bear.

Promise swung her pipe in a shoulder-wrenching arc, hitting

him squarely in the head. There was a splintering sound followed by a soft squish as the man collapsed. A blast of light pierced the fog and a muffled scream of "Halt!"

Promise skidded to a stop just the other side of the crosstunnel and crouched, waiting until the running feet were almost atop her before swinging the pipe at foot level, catching the man at the ankles. He went down in a tangle. She straddled him and hammered the pipe into his head twice before someone hit her from behind. She went down screaming, tripping across the sprawled body of her victim. The body cushioned her fall, but the other man's hands were at her throat. She fought savagely, kneeing, scratching uselessly against the heavy khaki of his coat.

Her air suddenly turned sour. *God! My gas mask is going dead!*

She had no strength left to stop him, and sobbed in frustration as the stubbled face behind the clear mask snarled in triumph, eyes lit with recognition.

Those eyes widened further, in shock, then dulled as the grip at her faceplate was released. The man went limp and was rolled off her by the children.

Promise felt numb, her air quality deteriorating rapidly. She gripped her faceplate with fingers that felt thick and clumsy as the children helped her to her feet.

The thin man waved them on. "The exit!" he whispered, gesturing at a line of rungs rising up out of the mist to the ceiling. He went up first, dragging a bleeding leg, every rung clear torture. When he got to the top he bumped his head against the sealed grate, and grunted.

He felt around on the underside of the grate and finally found the latch, pulling it free with a rusty, crackling sound. His fingers slipped and he cursed, for an instant trying to suck the wounds through his faceplate, then rubbing them against his shirt. He worked his fingers into the grate again and heaved.

The grate creaked free, and he lifted it out. He climbed up to shoulder level, then called back down, "Clear!" He disappeared as if lifted on a breath of wind.

The youngest of the children went next. When the oldest boy tried to force Promise to follow, she shook her head no, even though her head was buzzing and the left side of her body seemed dead. He glanced at her in concern, but she gasped, "Get *up* there!" and gave him a shove.

There were voices drifting in from the fog, and Promise

gritted her teeth, waiting until the boy's feet had passed her head before beginning to climb.

Her right hand was terribly weak, almost unusable, and her awkward weight made it even worse, but she kept going. She levered herself up a foot, then rested for a second by wedging her elbow in the rung. Then another step; and another. The spinning in her head became worse, and she knew that she was going to be violently ill. Her vision darkened, green mists slowly gathering, and with the last bit of strength she pulled herself up another rung and hung there, gasping, nothing left, feeling her fingers and mind losing their grip. . . .

And a hand reached down from above, clamping onto her wrist with a strength as implacable as a steel grapnel, hauling her up effortlessly. She almost blacked out with relief. "Aubry . . . ?"

"I'm afraid not," Diego Mirabal grinned. "But I'm very glad to see that you're alive."

The grate slammed shut beneath her.

# 18

## Endgame

Aubry Knight and Kevin Warrick sat in the darkness, sharing a space that was closer to death than life. Aubry was breathing more slowly by the minute, and had been for the past hour.

There was darkness beyond the absence of light in this place, and to sink deeper was to risk both body and mind. But the downward course was slowly taking control, whispering to him of the endless peace on the far side of the wall.

He tottered on the brink. A sound—perhaps a touch—from the man next to him drew him back, and there he remained. Without a name, without a past, without thoughts of a future, in a darkness that seemed in some impossible way to be the brightest light imaginable.

Aubry and Warrick sat side by side, their breathing slowing as they edged towards death.

It was just a scratching sound at first, not enough to pull Aubry from the depth of his trance. Only when a block of stone shifted, causing smaller blocks to fall from their places, did his eyelids even flutter.

*Leave me alone,* Aubry thought from the place that was very near death. But next to him, Warrick began to quicken his breathing, and Aubry, joined to him in some way he could not even begin to understand, hastened his own.

Aubry's chest spasmed, and he pulled in a shuddering breath, sucked it in and coughed it out, each jolt of the cough kicking him further and further out of his trance.

"Kevin! Hold on...." It was Mira's voice, frightened and

determined at the same time.

Aubry opened his eyes resentfully. *Why did you bring me back?* His fingertips ran up his face, smudging dust and sweat, and flicked on his helmet light, the dim illumination wavering like a single candle in the darkness.

He saw the wall of collapsed rubble break down and the first filthy head poke its way out of the debris. A probing spotlight filled the darkness, blinding him.

Warrick's eyes were still closed, although his breathing was now close to normal. "Mira?"

"Thank God!" Mira wiggled the rest of the way through the hole. Aubry could hear others behind her, clearing the tunnel. She checked her brother first, then Aubry. "We're under attack. The basic defense plans are in effect, but we need you, Kevin." She turned to Aubry, who was beginning to uncoil from his lotus. "And you, Aubry. More than anything else, we need you now."

He nodded, feeling death recede patiently. "Where are they? What are they using?" Warrick asked the questions while his eyes were still closed, although they were just beginning to tremble.

"Everywhere. Coming in from the surface and from the peripheral tunnels. They're using some kind of paralytic gas. They're *killing* people."

Warrick's eyes opened. "Tell our people to fall back to the Multiplex. We'll make our stand there." His entire body shivered as he woke up. "Aubry?"

"Where's Promise?"

"I sent her up topside."

"All right then, let's go." Behind his mask, his eyes were focused and calm.

On all fours, they crawled out of the enclosure, dragging the still-unconscious Peedja with them.

The fog was dense enough to mask sound and hide Aubry Knight and Warrick as they crouched in the tunnel.

"If our people are going to make it to the Mall, we'll have to clear the way for them."

Aubry nodded, his face impassive except for the faint curve of a smile on his lips. His thoughts seemed distant. Warrick gripped an iron bar two meters long.

There was a sound in the fog, and four shapes outlined

themselves. Aubry flicked his fingers at the two on the right, and Warrick nodded. Moving silently, Aubry slipped away.

There was a moment in which nothing happened, and then one of the men was swept violently to the floor, back onto his head. The other fell forward. Warrick saw a flash of legs as Aubry caught him in a kind of scissoring sweep, one leg in front and one behind. There was a slithery blur of motion, then Aubry was riding the man's back, his fingers ripping at the facemask.

Warrick was already charging forward, catching one of the men before he could turn, shattering his shoulder. He shifted grips and swung again, staving in the man's side. He bounced the end off the ribs and flowed into a short jab to the faceplate of the fourth soldier as he swung his rifle up. The man choked, panicking, and clawed at his throat and eyes, sinking to the ground.

Aubry was already gone.

Warrick trotted along after him, eyes straining to catch a form in the swirling green mist, and almost stumbled over a body. He caught his balance just in time and bent closer to examine it. There were actually two bodies. The one on top lay twisted with a broken spine. The other's faceplate had been totally shattered, shards of plastiglass driven deep into face and eyes.

He ran faster now, barely avoiding three more bodies before he caught up with Aubry. Warrick saw a flash of leg as it traveled in an impossibly elongated and fluid arc, then heard the impact as its instep met the side of a jaw neatly. The head jolted sideways as the neck snapped.

Aubry was a mammoth figure crouching among the fallen. Warrick called to him. Aubry turned so quickly that it seemed magical, as if he had flowed through himself. "We'd be more efficient if we split up. I'll take a branching tunnel and meet you at the Multiplex. Make sure to pass the word."

"You got it," Aubry said, and then disappeared into the fog.

There had been no anger in Aubry, Warrick noted approvingly. Nothing except cold purpose and survival. That was the finest beginning he could hope for.

Aubry wrenched a rifle from the quivering hand of an Ortega soldier and tried to work it. He squeezed off a short burst, then it jammed. He worked the cartridge release and depressed the trigger again, satisfied.

A man's scream from up ahead electrified him into action. Four soldiers were dragging a Scavenger family out of a hidey-hole. A second scream was cut short by the clubbing descent of a gun butt. The soldier raised his weapon for another stroke, but a burst of explosive slugs from Aubry's rifle sprayed red mist into the green.

The gun jammed again, and Aubry threw it. It missed the other soldiers but made them move frantically, spoiling their aim. Aubry rolled twice and was among them. He drop-kicked the first one into the second, the two of them going back against the wall in a tangle. The third man reversed his grip on the rifle and swung it, the butt clipping Aubry's shoulder. Aubry went with the momentum like a revolving door, his leg whipping up and around with a spinning heel that smashed the soldier's head into the wall. As he finished the spin he planted his weight and shifted sideways, driving a stiff sidekick into one of the men trying to stand up: bones cracked. The other wiggled out of the way, pulling a knife.

Aubry set himself, then felt arms pinioning him from behind. The knife man lunged in. Aubry tried to kick, and the man holding his arms bounced him, destroying his balance. Aubry entwined the grappler's legs with his own and whipped his hips to the side as the knife sliced along his stomach. He crashed to the ground, butt landing squarely on the man's bladder. He arched his back and snapped up to his feet.

The knife man lunged again. Aubry pivoted sideways and caught the arm, then reversed directions, dropping to one knee. The knife man screamed as he flipped backwards, landing on his shoulders. Aubury disarmed him and sliced his throat, dispatching the other soldier a moment later.

A woman and an older boy watched Aubry rise to his feet, something between shocked horror and relief on their faces. "Warrick said for everyone to head for the Multiplex." They stood frozen for a moment, and Aubry shouted, *"Move it!"*

The boy hugged his mother and stepped over to Aubry. "I want to come with you."

Aubry looked at the boy. He was about seventeen and seemed to be strongly built. "All right—I guess we'd better make this a caravan. Grab one of the guns, if you can operate it." Aubry picked one up and threw it to the boy. "And take point with me. The others stay back."

The woman snarled and kicked the corpse of one of the soldiers. She pulled the pistol from his belt, handing it to her

younger child. She took the belt knife for herself. "This fight belongs to all of us, Knight."

He examined her soberly. Her face was pale and lined, but her eyes were as cold as ice. "All right, then. Spread out. Stay with the kid. Junior, up here with me."

They made it another fifty or sixty meters before they saw another group of shadows. The older boy dropped to his knees and prepared to fire. Aubry tapped him on the shoulder. "Wait just a minute—let's make sure that we're not killing friends."

He waited another second, growing increasingly tense, then recognized the makeshift clothing. "Scavengers!"

"Is that you, Knight?"

"You got it. Warrick says to make it to the Multiplex."

That added three more to the group, including two fighting men, both with guns.

The next trio of soldiers were outnumbered and neutralized before they could respond effectively.

When the echoes died down, Aubry examined the bodies and stripped them. As he did he heard the faint buzz of a radio, drew closer and realized that the receiver was mounted on the inside of the dead men's facemasks. He twisted off the built-in microphone, and donned it, careful to hold his breath and shut his eyes during the transfer. When it was in place he flushed it out with a short blast of oxygen and opened his eyes.

"*. . . bravo team leader, we are encountering resistance in north quarter; request you send backup—*"

Aubry smiled grimly. "Let's get out of here and head for the Multiplex."

The Multiplex was eerily still, a pall of green fog hanging over everything, wreathing the enormous Christmas tree in lethal holly. Warrick clapped Aubry on the shoulder as he brought his people in. "Good job. We've got places to hide here. If they try to collapse the whole thing on us, we have two dozen ways out. We need to set up some kind of a line of defense, though."

"I'd like to know what the hell they want."

"They want you."

Aubry looked at the rows of the paralyzed and the wounded, and the tired, beaten gas-masked faces of the others who stood, guns and knives and makeshift clubs in hand, waiting for instructions. "It isn't worth it, Warrick. I can't let you do this for me. If all they want is me, then let's just give me to them."

"We take care of our own."

"But I'm not one of you." Aubry caught himself in mid-sentence and shook his head. "All right, then—how do we play it?"

"Close. We have to wait for them to hit us. They aren't the U.S. Militia—there has to be a limit to their manpower. No matter what kind of maps they have of this area, we know it better. If we're overwhelmed, we split up and seven group leaders will lead the evacuations, out through the death tunnels. We've already cut into them pretty badly—let's wait and see what happens."

Aubry watched Warrick's men creeping about the upper levels, planting booby-traps. As they retreated downward they used equipment or merchandise of any kind to create blockades. "I don't like this," Warrick muttered. "I'd rather have high ground. The only clear openings are at the top, and that's where they'll come from. We'll do the best we can before we split off."

Mira settled in between Warrick and Aubry, head hanging with exhaustion. "This is crazy," she said, "but it's always been crazy, from the very beginning."

"I think you'd better stay with the wounded, Mira," Warrick said soberly.

"No, Kevin. I'd rather be here, with you. I . . . I think I can handle a rifle." Aubry rubbed her shoulder with a strong hand and she smiled weakly, kissing him on the cheek.

Aubry settled back, cradling his rifle in his arms, not thinking of how things might turn out or of what had been, but thinking of Promise, hoping that she was well, and thinking of their child safe within her womb, wondering idly if she was thinking of him. It didn't matter, as long as she was safe.

The first crackle of sound came into his headphones. *"Moving into Multiplex area. Expect heavy resistance. Request permission to use high explosives."*

Aubry tensed, then relaxed when he heard the reply. *"No. Not under any circumstances. We want Knight alive—"* That was reassuring. Aubry almost smiled before he heard the second part of it. *"—but if we can't get him, at least we have the woman."*

It felt as if someone had taken an electric cable and attached it to his groin. He rose to his knees, peering up through the splintered plaster branches of the Christmas tree, his entire body shaking. He felt Warrick's strong wiry hand on his shoulder.

"Whoa, Aubry—don't expose yourself."

"They've got Promise, damn it."

"Alive?" Mira asked.

*We have the woman.*

"Yes, alive."

"Then you can't do her any good by getting yourself killed. If she's alive, they're keeping her alive for a reason."

"Me. They want me, for killing Luis."

"Are you sure that's all they want?" she said, almost under her breath.

"What else?"

"The mushrooms. They've triggered a whole chain of death. Don't be surprised if the chain hasn't ended yet."

"Jesus Christ. All of this for a handful of mushrooms? I can't—"

There was a shattering explosion that wreathed the entire top level of the Multiplex in flame. A smoking body arced out of the top level and fell, twitching, to the bottom, its scream chopped short by the impact.

Warrick plucked a rifle off the ground and handed it to Mira. He clicked his own safety off. "They're here," he said blandly.

A quick burst of weapon fire gouged furrows in the wall above their heads, and Aubry could see the crouching soldiers along the rail of the first level high above them. He squeezed off three shots, missed, then placed the weapon on automatic and emptied his clip, ripping sparks out of the railing and finally hitting one of the men. Around him, the other Scavengers were returning the fire.

There was some kind of work being done up on the first level: Aubry could see a box being lashed to the wall. At first he thought it was a weapon. Then the men fastening it disappeared, and the box spoke. "Scavengers. Lay down your weapons. There is no escape. All we want is the man Knight and the drug which is rightfully ours. We have no quarrel with you. Scavengers—"

"That's interesting," Warrick said as he raised his rifle, "but we have a quarrel with you now." His bullets crawled along the wall and into the speaker, shattering it into spinning bits of metal and plastic.

The Scavengers were moving out now, creeping behind the railings of the fourth and third levels.

A grenade exploded near the top, and plaster chunks rained down on them. Aubry wiped his faceplate clean as another flash shook the complex. A door splintered open behind them, and Aubry whirled just in time to see Ortega soldiers pour through, firing at the group of Scavengers around him. Two screamed in pain, hands clawing for the bulletholes.

Aubry flipped on, emptying his clip into the thick of them. He picked up the corpse of the nearest Scavenger and held it in front of him as he charged. He felt the body shudder as two slugs slammed into it. The explosive rounds had little penetration, although they did massive surface damage.

He heard Mira's cover fire during the four steps it took to reach the soldiers, and then he was there, too close for any of them to use their guns as anything but clubs. There were six of them. He hit them without thought or concern, three going down under the force of his charge alone. He felt a rifle butt graze his head, and he rolled one of the soldiers on top of him so that the next stroke cracked the wrong skull.

There was no thought, only a blur of feeling; there was pain and pressure, and the sound of blows given and received. He had a sensation of weight and heat, intense heat, but his mind was far away, in darkness, as his body strove. One moment he seemed insubstantial, a wisp of vapor, a snake wriggling too quickly to be grasped, the next as solid as an iron bar, breaking bones and delivering crushing strikes at impossibly short range.

He was covered with soldiers. Scavengers rushed to him, pulling the men away and off into smaller knots of conflict. Aubry shook off the remaining man and stood. He was cut and bruised, and a crack in his faceplate leaked air.

Mira squeezed her eyes shut and clubbed a man down. Aubry ripped off the soldier's faceplate and donned it quickly, adjusting the plastic straps above his ears. Mira stared in shock as he turned to her. His eyes were glassy, and held something beyond anger or fear or anything else Mira had ever seen, something so feral and powerfully human that it was frightening and beautiful in the same instant.

Then Warrick's voice behind them broke the spell. "Problems," he called, voice muffled by the facemask. "Some of the soldiers are wearing different gear. It looks like full-body armor."

Aubry still had the last man by the throat. The soldier clawed

at his hand, eyes bulging and veins standing out grotesquely on his forehead. Aubry smashed the man's head into the wall and tossed him aside. "What does that mean?"

"I don't know. Maybe nerve gas."

Mira gripped Aubry's arm. "Our facemasks will be useless. We've got to retreat."

Aubry shielded his eyes as a phosphorus grenade exploded against the trunk of the tree, wrapping the branches in crawling light.

"It's time to go," Warrick said calmly.

"All right. To where?"

"Back up toward Q-area. We can make a stand on the far side. That gas is heavier than air, and the storm drain is an uphill gradient. It should help."

Aubry nodded. "Let's get moving, then." There was the sickening thud of more explosions, duller explosions, and light orange smoke curled out. Warrick watched it uneasily, and began to edge backwards.

There were ten Scavengers left on the fifth level, and Warrick gathered them up and hustled them out the broken door. Behind them, the Christmas tree was a mass of flames and showering sparks. Gunfire and explosions echoed in the Mall, and wherever the orange smoke drifted, unarmored fighters collapsed.

Mira watched the progress of the smoke, horrified. "We don't even have a chance to clear out the upper levels."

"They want me alive, if possible," Aubry said. "That must be knockout gas. Stronger than the green, but no deadlier. Later, though, they can go around and cut throats."

"There's got to be something we can do," she said sadly.

Warrick watched a branch sag on the tree and fall, blazing, to the ground. "Don't worry," he said. "There is."

They retreated through a service tunnel into a storm drain. Its bottom was slick with rain-washed sewage. A few Scavengers lay facedown in the muck, and it took every ounce of control Aubry had to keep his emotions in neutral, to keep them from straying into anger or fear. That would only sap him, weaken him. There would be revenge, but he couldn't dwell on it or take pleasure in it.

Mira and one of the men brought up the rear, and Aubry could hear their weapons bark intermittently. He hoped that they were firing at shadows, that the enemy wasn't that close behind them. He could run faster; in fact, he would welcome

the chance to use his body so freely. But beside him, Warrick was trembling, his eyes staring glassily, and his mouth was open as he heaved with soul-deep fatigue.

Behind them, ten or twelve Scavengers, frightened, determined, trotted wearily along, carrying whatever captured or makeshift weapons they had been able to put their hands on.

A gas grenade exploded in front of them—but it was the green gas. Aubry fired into it, and then charged. He collided with one figure and struck from reflex, gratified to hear bone crack. He felt another man go down at his side as Warrick tore into him. There was a brief struggle in the murk, grappling shadowy figures, the other Scavengers beside him, each lost in his own death struggle.

From the corner of his eye, Aubry saw a woman armed only with a knife attack a fully armored soldier. She actually managed to work the blade into his neck baffles before he clubbed her in the ribs with the butt of her gun, felling her with a downstroke.

Suddenly Warrick was between them, hands twisting the gun barrel up to the ceiling. As the two fighters stood locked together, a blade flashed from the rear and Warrick took a knife in the back.

Aubry was there instantly, shattering the knifeman's arm and driving the barrel of the rifle through an armored facemask.

He dropped beside Warrick; checked the knife wound, and grimaced. In a hospital, or even with decent medical care, Warrick would pull through. But in the midst of a war zone, there was nothing to be done.

Mira knelt beside them, running her hands over the wound. She was matted with sweat and dirt. "No! Kevin—"

Aubry gathered Warrick up in his arms. He had never noticed it before, but the Scavenger leader seemed as light as a breath of air.

"You can't carry me—"

"The hell I can't," Aubry growled. "Like you said, we take care of our own."

Warrick closed his eyes and pawed at his wound with a crimsoned hand.

The nine remaining Scavengers trotted on until they could hear the sound of pursuit behind them and felt the dull explosion of gas grenades. The floor grew steeper, and more difficult to climb, but at least the gas tended to flow back down. The walls began to narrow as they reached the spot where the branching

tunnel had caved in on Aubry and Warrick. Aubry slowed, waving the others on. Mira watched her brother with disbelieving eyes, the blood draining from her face.

Aubry spoke sharply. "What's up ahead?"

She gulped, and tried not to look at her brother. "It keeps getting narrower in here. It used to lead back to the surface, but we walled it up. This is it, Aubry—there's no more room."

"Then we'll make our stand here, dammit."

Warrick's eyes opened. "No—Aubry. There's another way. We're under the spot where we first found you and Promise. Do you remember? Do you understand what that means?"

Aubry looked at him and thought, nodding his head. "It might work." He checked his rifle, saw that there were still two rounds left in it. "I can do it."

"This is my play," Warrick gasped.

"Warrick—"

His eyes lit up, and for that moment there was no weakness in them. "Don't sass me, boy. You still have to find Promise."

Aubry set him down gingerly, and Warrick almost buckled with pain. "This is mine, Aubry. The rest is up to you now. These people need someone as strong as you—if you'll have them." He winced, feeling the wound. "You could have a home here if you want it." He reached out, took the rifle from Aubry's hand, and nodded to him. He turned to Mira. "You're everything you need to be, Mira." She held him tightly, staining the front of her shirt with his blood. "I love you so much."

"Kevin—"

"Help him, Mira. Help them both." He turned and wobbled back to the ragged hole that led to the caved-in tunnel.

"What is he going to do?" Mira said, walking shakily away from the opening, her eyes wide.

"There's a gas leak," Aubry said quietly. "The rifle is loaded with explosive bullets."

Mira began to cry, and Aubry took her by the hand and dragged her up the tunnel, up the steadily increasing gradient. Aubry packed them back when they reached the walled-up end. The eight of them were filthy, tired, wounded. Aubry squatted on his haunches, rifle pointed at the bend of the drain, waiting. Beside him Mira sobbed, and he reached out an arm and encircled her shoulder. She huddled against him, the others huddled around him, and they waited.

Waited until they heard the sound of cautious footsteps, until he knew that the soldiers were gathering, perhaps two

dozen or more of them concentrating for the kill. They lobbed more of the gas ahead of them, and the canisters burst yellow. This gas seemed lighter, and spilled out towards them, flowing smoothly and venomously, creeping further, until it was only meters away, until Aubry could feel his feet growing numb—

There was a gunshot, the sound of an explosive cartridge triggering, and then a second small explosion—

And then a monstrous roar as the thousands of cubic meters of vaporized gasoline exploded. The wall of the tunnel burst out, and the soldiers disappeared in a flash of flame, mortar, and powdered brick. The breath was slammed from Aubry's lungs and he was crushed against Mira, hanging onto consciousness with the barest wisps of strength. The flash of heat was horrifying, killing, and Aubry felt the cloth singeing against his skin—

The restraining wall of the underground parking garage gave way.

The fireball vanished in torrential water and sludge, paper and wood, live rats and rusted pieces of automobile. It flooded the tunnel, and Aubry braced himself, pressed back against the sucking current that plucked at him, lapping against the faceplate of his mask, then washing away down the tunnel, taking with it the charred and blasted corpses of the soldiers.

A second tide rose and fell, and again Aubry turned his head away, glad that the radio in his mask was deadened by the water, the screams of the dying and wounded lost to him.

There was the sound of a third wall breaking, and the entire tunnel seemed to collapse, debris raining down on all of them, water and flame filling his universe for an eternal instant. Then the tide swept out, almost pulling him with it, and there was quiet.

# 19

---

## Old Friends

The hydroponics lab was a shambles. Mira found Aubry sitting on the floor next to the small, bloodstained corpse of Emil.

"All of this because of me," he said dully. "He just tried to help me. All of you. You only . . ." He fell silent, touching the corpse with strange gentleness.

Mira said nothing, but sat beside him. She wasn't trembling, but Aubry knew that only the most fragile of mental barriers stood between Warrick's sister and utter hysteria.

"How many Scavengers are dead, Mira?"

"We're—still counting. Over a hundred." She moved her lips as if they were shot full of Novocaine. "About that many wounded."

Aubry's head sank into his hands.

Quietly, she said, "My brother knew that this was going to happen."

"You can't expect me to believe that. How would any sane man—?"

"I don't expect you to believe anything."

Aubry waved his hands vaguely. "What's so worth fighting for down here?" He took her shoulders fiercely, shook her, and pulled her until their faces were only a breath apart. "Tell me, Mira. I want to know. I don't think you can understand how badly I need to know. What could possibly be worth all of this?"

She seemed even plainer than usual, face grooved with fatigue and streaked with rivulets of dried muddy sweat. It sank

274

until she was looking at the floor. "He knew he was dying, Aubry. He carried a time bomb in his head since he was trapped in the cave-in, years ago. He just wanted to build something that was real."

"What? This is all dead." He pushed her away, hard. "Warrick died for nothing."

"No, Aubry. Kevin didn't fight to protect people, or things. Not even for his own life. He died to protect an idea: that your life isn't based on your past. Only on what you are at the moment. On your *becoming*."

When he looked at her, there were tears streaming down his cheeks; his eyes were those of an automaton.

"There *is* something in you, Aubry, and even you haven't found all of it yet. You're so much more than you were when you came to us. You and Promise both. Kevin knew he was dying—but hoped you might be strong enough to carry on."

He seemed to look through her. "I'm going to kill him, Mira. I'm going to find Tomaso and kill him. No matter what it costs me."

"It's bigger than death, Aubry."

"You're wrong," he said, his voice utterly chill. "Nothing is bigger than death."

Aubry stood, and walked slowly past the wrecked tables, through the heavy curtain. Mira followed him, limping to favor a bandaged knee.

There, still intact, were the mushrooms.

"Jesus. Not even looking for the drug. Just for me. Just for Promise."

He picked three of them. "This will get me into *Casa Ortega*. Promise is there."

"What will they do with her?"

"They'll probably send a finger a day until they get their damned mushrooms. That's their style. What's yours? Do you call the police?"

Mira shook her head. "Too many of us would go to the Camps. To prison. And when they saw what we'd built . . . no. We have to handle it ourselves." She took his hand. "Aubry— don't just give up."

"Don't try to stop me."

"I won't. But there's a way that will buy you more time." She walked over to the row of cabinets against the wall and searched them until she found what she was looking for. "Here,"

she said, handing it to him. "The sporeprint. They can grow mushrooms from this."

He looked at it suspiciously. "What the hell's the difference?"

"It will take them about three weeks to isolate the strain and produce mushrooms."

"So?"

"They'll keep the both of you alive until they're sure they have what they want. It will give you time to think. To find a way out." She came to him and took his face in her hands. "To finish discovering who you are. Their trap is set to catch the old Aubry. Don't play into their hands. Don't be what you *were*. Be who you *are*."

He fumbled the mushrooms out of his pocket, holding them up to the light. "What should we do with these? One part of me says to destroy them, that the world would be better off. The other part says that if they're going to exist at all, that they should grow wild, everywhere. I don't know, Mira. I just don't know."

"Come back and lead us, Aubry—then you can tell me what to do." She threw her arms around him, kissing him hard on the mouth. "That's for you," she said. "You're going to need more, but it's all I have."

He pushed her away, holding her at arm's length. "I'm going to find my woman," Aubry said, "and I'm going to kill Tomaso, and then I'm coming back."

Without another word, he was gone.

All of the lights were on him, and the glare was so bright he was nearly blinded. The lights overlapped in searing pools. He stood in the middle, dead still, hands raised as the armed men swarmed out to take him.

Aubry listened to the wind whipping the waves under the cliff. He could taste the salt foam and the icy mist numbed him, even this far to the front of *Casa Ortega*. There were eight men guarding him, and from the look on their faces, it was clear they wanted eight more. None came closer than five paces, and none lowered their weapons from the ready.

They waited. After what seemed like an hour, a huge figure approached. He was as tall as Aubry, but thicker through the chest and legs. He broke through the ring of guards, pistol in hand, but came no closer than the others.

"Aubry," he said.

"Diego. It's been a long time."

"It has. Hell of a fight your people put up." He smiled, searching Aubry's face. "I'm sorry it had to be like this. I assume that you came to make a deal."

"Bargain," Aubry said.

"The mushrooms?"

Aubry nodded silently.

Mirabal drew a little closer, cocking his massive head sideways. "For a woman, Aubry? You must know that *you're* dead. It's not in my hands. In fact"—he lowered his voice—"it's not in Tomaso's either." His eyes met Aubry's squarely. "In fact, things have been out of Tomaso's control for quite a while now."

He squeezed the trigger of his handgun. There was a dull report, and Aubry felt a stinging pain in his ribs, then a spreading numbness. He tried to move, but the chill moved far more quickly, until he collapsed on the wet gravel outside *Casa Ortega*.

His first waking sensation was one of hardness. His cheek lay against the bare metal floor of a cell. As awareness expanded outwards, he realized that he was naked, bound hand and foot. He struggled to an upright position, and leaned back against the bare wall of the cell. A glaring lightsquare burned in the ceiling.

His hands were bound behind him, but he could see his feet, and they were tied with the unbreakable plastic straps he had grown to hate in prison. Human flesh and bone would give way long before the bonds.

He was struggling with them when the door to the cell opened and Diego Mirabal entered. He looked at Aubry, then at the torn skin around his ankles. "I knew you'd fight. What else is there for men like us?"

Aubry glared at him. "You've done pretty good for yourself, Diego. I didn't expect you to still be with the Ortegas. Not after what they did to Walker."

A cloud passed behind Mirabal's eyes. "He was a fool. I told him he could never kill you."

"Did you know that they taped it?" The cloud darkened. "Yes, they did. I killed him, sure. But the Ortegas set him up and taped it—and watched about a hundred replays of him kicking around on the sand."

Mirabal's eyes were distant now.

"Diego," Aubry said, "he died for your sins."

Mirabal finally managed to smile. "That was really rather subtle, Aubry. I'm surprised."

"I'm telling you the truth."

"Homophobe Luis? No doubt. Well, he paid the price of his machinations, didn't he? I happen to know that Tomaso tried to talk him out of it. And it's Tomaso I serve now."

"You never served anyone but yourself."

He nodded soberly. "And I usually get what I want. Except for you." He reached out and touched the straps at Aubry's ankle. "I wish I could loosen these for you. I really do."

He stood. "One last thing, Aubry. The rest of these fools I can understand. But you . . . you're a *man*. The drug. Is it really that good?"

"Better."

Mirabal smiled. "I'm tempted to try it, Aubry. But there's almost no one I'd want to try it with. Do you know what I mean? Tomaso is obsessed. He thinks that that poison is the key to the kingdom. So, I have to get it out of you. I hope you won't make things too hard."

"We were friends once, Diego. I think that if you gave your word to me, you'd try to keep it. Will you do what you can for Promise?"

He shrugged. "What I can. But it had better be the real thing."

"It is."

"All right then—where are they?"

"Destroyed."

Mirabal started forward, his hand brushing aside his light coat to rest on the gun butt beneath. "What? You deliberately—"

"No, no," Aubry said hastily. "There was an explosion. The mushrooms were flooded out. Destroyed."

"Then what exactly do you have?"

"The original sporeprint. With it, Tomaso can grow his own from scratch."

"Yes." The hand came back away from his gun. "I can see that. All right. Tell me where it is."

"There's a streetlight about a kilometer north of here. Behind it, there's an envelope under a rock. It's there."

"All right. I'll check. I hope you're telling the truth, Aubry." He rapped twice on the door. As it swung open, he said, "If

you are, I'll try to make your death a good one. Maybe you and I can do a one-on-one."

"I . . . could go for that."

Mirabal nodded thoughtfully, then slammed the door shut behind him. Aubry closed his eyes, resting against the wall.

He wondered where Promise was.

He wondered when he would die.

And he wondered how he would kill Tomaso.

The light in the cell was turned on and off irregularly, and Aubry had no way of knowing exactly how much time passed. It seemed like weeks, but could only have been days. Surely they fed him at least once a day. From the taste of the paste they gave him, it seemed to be some kind of high-nutrition concentrate. At least they weren't trying to starve him to death. His stomach felt drawn and he could taste the acid on his breath, but he didn't weaken much except for the ache in his wrists. He believed that the paste was sometimes drugged. Sometimes he fell into deep sleep, and when he woke the bonds on his feet and ankles were shifted slightly, and his limbs didn't hurt as much.

He withdrew into the space that Warrick had shown him, a place where time and pain and hatred and memory and expectation all merged into a single point, a point where total weakness and total strength were the same, where all color and sound converged. And there he stayed.

Waiting.

Promise stood in the opened doorway, framed in light.

She walked in without being pushed, her face drawn, a bruise above her right cheek. Her eyes were ringed darkly, and her belly seemed more swollen than when he saw her last.

She fell to her knees beside him, cradling his head in her lap. She didn't cry, for which he was grateful. She wore a simple smock, and he was profoundly glad that they had not humiliated her by stripping her naked.

Gently, she kissed his cheek. "Aubry. You idiot." Their eyes met, and hers wavered as she looked away, the milky plastic on the left side of her body shifting delicately into pink and then blue, the patterns of color breaking up, swirling with each breath. "We're going to die," she said.

He nodded. "Together."

They curled together as closely as possible.

*If only we were alone. If I could tell what I feel without it being recorded and analyzed by Tomaso and his freaks.*

The silence lasted a long time, and he watched the lights play on her skin, swirling around the damaged portions where the color bled out and dulled.

Just in holding each other there was more peace than he had known for a long time. More peace than any time since...

He closed his eyes and relaxed into another world. At first it seemed to be the timeless place that Warrick had given him, and then the world of the drug, where there seemed to be nothing but *is*. Then the two merged into a world of feeling.

It was dark, utterly dark there, but he sensed that he wasn't alone. He followed a spectral voice that whispered his name.

AUBRY.

PROMISE.

He was already touching her, but now there was a different kind of touch, a different kind of joining.

I'M HERE, PROMISE.

THEN IT'S TRUE? I'M NOT CRAZY? GOD. I FELT SO MANY THINGS, FOR SO LONG—

He opened his eyes and met hers. They were terribly frightened and in need of reassurance. He nodded his head and whispered, "Yes."

She almost fainted against him.

WHAT IS IT? WHY CAN I HEAR YOUR THOUGHTS? I DON'T UNDERSTAND, AUBRY.

IT'S NOT TO UNDERSTAND. JUST TO HAVE AND TO SHARE.

BUT I'VE HEARD THE ORTEGAS TALKING ABOUT THE DRUG. NONE OF THEM HAVE HAD ANYTHING THIS POWERFUL HAPPEN TO THEM.

IT'S NOT JUST THE DRUG. THE DRUG ONLY RELEASES WHAT'S INSIDE YOU. MAKES YOU SENSITIVE TO YOUR TRUTH. NOW WE SEE THAT WE'RE TWO PARTS OF SOMETHING BIGGER...FEEL THAT WE'RE NOT QUITE WHOLE WITHOUT EACH OTHER. I THINK...I THINK THAT MAYBE THAT'S WHAT LOVE REALLY IS.

WHAT DO WE DO, AUBRY? WHAT IS THERE TO DO? I DON'T WANT TO GAIN SO MUCH JUST TO LOSE YOU LIKE THIS.

WE HAVE TO WAIT, PROMISE. WAIT AND SEE. WE HAVE TO STOP LOOKING AT THE PIECES AND START UNDERSTANDING THE...

He struggled for the right thought, and before the word was formed, she had it.

TOTALITY, AUBRY. WHOLENESS. She held him tightly. AS

LONG AS I'M WITH YOU, I CAN BE STRONG. YOU'RE MY WHOLE-
NESS.

He touched her belly, warm and full. Doubt seemed to
belong to another universe and time, not a part of anything he
understood or cared about.

AND YOU ARE MINE.

Tomaso Ortega sat in his command chair, his hands shaking,
his eyes unfocused. He was looking through the wall in front
of him, seeing a panorama of faces, hearing sounds, feeling
fingernails shearing through his flesh. A woman's screams, the
smell of her sweat and musk, the terrified clasp of her body—
all were upon him. The empty container at his feet spoke of
the impotence of the compressed Cyloxibin spores.

He didn't move when the door eased open and Steinbrenner
walked in. She looked at Ortega as if he were someone she
barely knew, someone she feared and pitied. There was nothing
there of the confident man who had taken over his dead broth-
er's organization a year before. His mouth hung slack, his
eyelids drooped. Except for the occasional flashes of pain and
fear that racked his body, he might have been mistaken for a
corpse.

She stepped closer to him and held out her hand. In it was
a glass vial. He looked at it dully. "What . . . is that?"

"Cyloxibin," she said, and stepped back a pace as the whole
of his attention focused on her.

"So quickly?"

"I knew that it was important, so we didn't wait until the
spores reached the fruiting stage. The mycelium, the infant
stage of the mushroom, contains the active drug. I condensed
it and tested it. It's the real thing."

He stood, stepping down from the chair, and took it from
her. He twisted the capsule open and spilled the two tablets
out into his hand, the touch of them in his palm seeming to
quiet the shaking. He swallowed one down dry, without water,
then looked at her questioningly. "Just one," she said. "This
is fresh and much more powerful than the compressed form."

He fought the urge to swallow the second tablet, staggering
back to his chair, collapsing there. Steinbrenner watched for a
moment, then left the room.

He groaned, his entire body burning with need, making little
animal sounds, twitching. At last the feeling of warmth started
in his stomach, a sensation that changed to hot and cold flashes

and from that to a dry mouth and a constricted throat. Tomaso sighed with relief, his muscles growing flaccid.

Time passed. He was lost inside himself, but the warmth dissipated all of his pain, brought him back to balance.

And beyond. The warmth gave way to cold, and that to a numbness that chilled his soul, all of the voices and feeling and needs swept away, blown out like the bottom of an overfilled basket.

He opened his eyes and smiled a smile that was hard and arctic. He bent over and touched the communicator switch. "Send Steinbrenner in," he said flatly.

The first thing that Steinbrenner noticed when she came back through the door was the breathing. It was dry and raspy and seemed to come from everywhere at once.

"Mr. Ortega?"

The room was in shadows, most of the light from the ceiling turned out. A thin strip of illumination crisscrossed the floor. "Tomaso?"

His chair was empty. When she touched it it was still damp with perspiration. She looked around the room nervously.

She pinpointed the sound of the breathing. Tomaso was crouched in the corner of the room, his head down, staring at the floor. He looked up at her, and his eyes shone like huge glassy spheres.

"Steinbrenner. . . ." She tried to take a step backward, but couldn't. She watched him rise like a snake uncoiling from its nest, and felt her panic swirling away into those eyes.

*The eyes!*

They were a lover's eyes, vast and moist and wanting. They were fixed and hot, engulfing and deadly cold, and there was no way that she could tear herself away from them.

He came to her and held out his hand, held it directly under her mouth, and his hands weren't trembling at all, although they were perspiring freely. In the middle of it was the other tablet, the tablet containing just 500 milligrams of dried mycelium.

It stuck to his palm as she lifted it free. Her flesh burned at the slight contact. She stumbled back away from him.

"I know you want me," he said, eyes gouging into her. "This is your chance. Take it."

She whimpered, tried to say no, but there was just no strength. She could smell him, feel him. When she closed her eyes she

could see him. He seemed to have expanded past the limits of his body. She choked on her panic, trapped.

Slowly, she raised her hand to her mouth and swallowed.

Tomaso Ortega took her hand, and together they sank to the floor.

She heard her clothing being ripped away from her body. The tile against her back was scaldingly cold. And a moment later she felt something that was beyond sanity, or pain, or anything else she had ever known. . . .

Magnificent. . . .

Tomaso marveled, stretching. Still in the grip of the drug, he felt every interplay of sinew. Every thought sent nerve impulses racing like flame along a fuse. His body was magnificent, his mind extraordinary. How strange that it had taken a tiny black tablet to show him just how godlike he was.

Next to him, Steinbrenner quivered, naked on the floor. He turned to her, and she dropped her eyes, trying to press her face against him. She was pale, trembling, shattered.

She tried to reach her lips to him, and he laughed, slapping her. "Never," he hissed. "Unless I tell you. Do you understand?" Her eyes were wide and glassy with need. He could feel the heat from her, and reached out, grazing his palms along her body, barely touching her. A sob caught in her throat.

He grinned viciously. "Now get dressed and get out."

Diego Mirabal stood near the open cell door, his expression flat.

Aubry and Promise lay huddled at the far end of the cell. Aubry looked from Mirabal to the doorway and back again, the questions written clearly on his face.

A smaller figure, moving with terrible slowness, entered.

Aubry sat up straight. "Tomaso." He looked up and down Ortega's frame, stopping for a moment at his eyes, subduing a slight chill at the way he looked at Promise.

"I hope you're comfortable," Tomaso said, unsmiling. "I have to keep you alive for a while longer."

"I'm going to kill you, Tomaso."

"Yes," he said, and the slightest bit of dull life crept into his eyes. "I'm sure you think I have much to answer for. Patricks. Kato. Black."

Promise stiffened.

"Is that a surprise?" Tomaso said, too politely. "I'm sorry. I thought you knew she was dead. At any rate, you may get your chance for revenge if you answer my questions exactly." He waited for Aubry to reply. "All right, Knight. What do you know about the drug?"

"Less than you do. I didn't even know we'd been carrying it around with us."

"Did you take it?" He looked at Promise's head nestled tightly against Aubry's naked frame, and laughed nastily. "Yes, obviously you did. And even you . . ." He bent down closer, as closely as he dared. Mirabal saw Aubry's toes tense and put a restraining hand on Tomaso's shoulder, pulling him back.

"Diego thinks so much of you. Considers you so damned strong. You don't know what real strength is, Knight."

"And you do?"

"Yes. You've given me the world. I just wanted to thank you."

"It won't work, Tomaso. They won't stay hooked forever."

"You're referring to the rather interesting built-in tolerance. Yes. I've seen. The stronger you are, the sooner you can throw it off. But give me three months, Knight. Three months in which a man or woman is totally at my mercy. In three months people can die, Knight. Laws can be changed. Stocks and bonds and Marks can change hands, and power can shift. How does that old song go? 'All you need is love.' I've always liked that."

"So I've done you a big favor," Aubry said sullenly. "What about Promise? Are you going to let her go?"

"Of course not. Didn't you know?" He turned and grinned at Mirabal. "Diego did ask about it, but there's a somewhat more important need for the both of you."

He turned back to the door, Mirabal leaving first.

"What need?" Aubry yelled. "Damn it, what now?"

"My grandmother wants to meet you," he said.

Neither of them slept. Promise cradled his head, wishing that she could confort him. She touched him gently, his bruises and wounds, and the many indignities his body had taken in the years since her friend Maxine had sent him to prison.

"What are you doing?" he said, watching her run her hands over his body, touching the light ridge of a scar.

"Just memorizing you," she whispered. "Death will be here soon. Certainly for you, perhaps for both of us. I just want to know you the best way I can, to remember everything about

you. In case I live. In case I live to have our child, and one day I want to tell her what her father was like."

"Her?" He wiggled to an upright position. "That's a boy for sure. Too big for a girl."

"Silly male. It's a girl. A mother knows."

"I put it there. It's a boy."

"All right, I give in—but only because you're bigger than me." She traced the light line of a scar on his leg. "Does this still hurt?"

"No, not many of them do, except for the ones I got with the Scavengers last week. Or the week before—" The whole thing seemed so misty and far away. "Whenever that was."

"Good, I'm glad."

She lay her head down on his hip.

"Couple of them itch a little. Not much, though."

"Let me scratch it for you. Where?"

"Over my ribs for one. About three cim from the end of your nose."

"Where?"

"There. Right where you have your hand."

She looked closer, almost giving up before she saw a very faint line etched into his skin, along the grain of the muscle. "That? It doesn't look like much."

"No, it doesn't. But it itches sometimes."

She put her fingers to either side of it and tugged gently. "It certainly seems to be completely healed. When did you get it?"

"In prison. I don't know what happened. It was one of the times they used the sound on me." He winced at the memory. "I went under, puking up my guts. When I woke up I was sore all over, and I had that scar." He shrugged. "Must have cut myself."

She nodded, fingering it. As she did, the lights went out. She felt it again, something nagging at the back of her mind. Finally she gave up trying to remember, and settled her head down against the warmth of his hip. "I guess so," she said, closing her eyes. "I guess that's what you did."

# 20

## The Tribunal

The skimmer came in from the east, flying out from Ecuador's *Golfo de Guayaquil*. At no time did it travel more than thirty meters above the surface of the Pacific. Still ahead were San Salvador, Santa Cruz, Isabela, San Cristobal, and the rest of the *Archipelago de Colon*, also known as the Galápagos Islands. And somewhere to the north of San Cristobal was the island renamed Terra Buena.

Promise could hear the ocean distinctly now, and knew that the skimmer was dropping. Sound was the only reference she had: there were no windows in the compartment where she and Aubry were kept. It was a bare-walled prison, stripped to the floor panels and gleaming alloy walls. Aubry was still nude, bound hand and foot. Far from making him seem helpless, nakedness emphasized the quality of his musculature. With all of his scars and bruises, he seemed like a demon of war, coiled in quiet anticipation.

They were anchored on opposing walls, but if she stretched out her leg she could almost touch his, could come within a centimeter of him and could feel what he felt.

The images came to her: a maelstrom of incredible destructiveness, somehow in complete accord with nature. She felt as if she were fighting through the winds, torn and pitted by the memories and negative emotions swept along in the tide. Then Aubry exhaled, stretching his body out to the limit, and they touched. Violence and destruction surrounded them, but she was in the eye of the storm now and nothing could harm her.

Experimentally, she drew back from him, and tried to find the same place of Oneness. It had to be there. *It's not just the*

*drug. It only releases what's inside you.* . . . If that was true, then she owned the power, if she could only tap it.

Where did she find the greatest peace, the greatest harmony? She retreated back and back into herself, to the times when she danced, her emotions and movements one being. She remembered her teacher back in Oregon, Sister Teresa, one of the Sisters of Mary, the parthenogenic sect which produced a third of the children in the communes.

Sister Teresa was balding and lame. She walked with a cane, or, more frequently, with the help of one of her students. Yet she taught them to dance.

"Dance is like improvisational jazz, Promise," she had said in her surprisingly strong and clear voice. "It's alive. It's now. There's no time for a retake. You blow the note, and it's gone. You make the move, and it's made. No regrets. No past or future. Just now. . . ."

Peace was there. And where else? In the Plastiskin. The damnable, beautiful plastiskin. Her prison, custom-made to order. Sign of her utter foolishness and her total control. *Relax. Feel the heat dancing in your skin. Isolate it, tickle the thermoelectric sensors. Watch the colors form.*

And she was at peace again, and Aubry was in her mind.

The skimmer bounced as it settled down against the waves and rocked as it was guided in to the shore. She could hear the movement in the front cabins. She spoke silently to Aubry.

THIS IS THE ISLAND?

HOME OF THE ORTEGAS. MARGARETE. BE STILL.

The compartment door clicked open, and Tomaso entered. Mirabal had a hand discreetly under Tomaso's arm, helping him to stand.

Tomaso carried a small green box which he aimed like a gun at Aubry. Tomaso wasn't bluffing—of that Aubry was sure. But exactly what was the box? What would it trigger?

"You don't look too good, Tomaso."

"You'll look a lot worse if you try something, Knight. And your woman, too." He seemed shrunken, withered, as if he had swallowed something alive and hungry.

*It's not just the drug,* Promise and Aubry thought.

Guards untied Aubry's feet and put on his pants. His feet were rebound and his hands untied to allow him to put on a shirt. Then his hands went behind his back again and his feet were released.

Tomaso's forehead was damp. His voice quavered. "One wrong move. Just one, and the woman dies."

Promise was unhooked from the wall and her hands bound in front of her. She contrived to stumble against Mirabal as they were escorted out. He caught her with effortless strength and set her forward again. "Watch your step."

She caught a flash of something, but what was it? It was too quick, and she wasn't relaxed enough.

What could she say for sure? He was incredibly powerful—perhaps as strong as Aubry. Professional. No interest in her as a woman. Probably no interest in women at all. But there was something else that eluded her. She had to sink deeper.

Something . . .

The two of them were moved out into the front of the skimmer, past empty rows of double seats. Promise looked at the controls hopefully, finally shaking her head in disappointment. The maze of switches and dials was far beyond anything she could hope to master.

Tomaso waited in the cabin as Mirabal escorted them out to the gangplank and down to the dock. He looked out of the side window. On a calm, silver-blue sea floated two other skimmers, a hydrofoil, a seaplane, and a helicopter. He slipped the transmitter into his pocket and followed the others down the gangplank.

No time to waste.

The Family was waiting.

They traveled in two jeeps, Mirabal in the front with Promise and Tomaso, Aubry in the back with four of Tomaso's bodyguards and the diminutive Wu. It was almost a kilometer from the dock to the house.

It had been so long since she had smelled the wind or perspired cleanly in the sun. Promise felt everything more keenly. The sunshine, the sight of small drab birds picking through the rocks, the lizards scurrying for shade.

"Beautiful," Promise breathed wistfully, gazing at the elaborate cactus garden growing to either side of the road. It was a maze of thorns and spiny leaves and incongruously delicate red and white flowers. Some of the desert had been reclaimed, irrigation and soil-enhancement nurturing stands of trees and rows of flowers beyond the cactus. The tang of citrus blossoms wafted on the morning breeze, and she savored it.

"Margarete loves plants." Mirabal grinned. "Anything that grows. Isn't that right, Tomaso?" Tomaso said nothing, staring up along the road. Mirabal laughed quietly. "Lemon and orange groves are on the other side of the island. Along the road here, and spreading around the house, we have a natural defensive barrier, her cactus garden. Cereus, strawberry hedgehog, there . . . prickly pear, agave." He pointed out a cactus that was nearly a tree, great serrated leaves surrounding a main stem twenty feet high, crested with flowers. "You might like the agave. I suspect that Margarete has a special attachment to it. It takes fifty to sixty years to mature, then sends up its flowers—but in flowering, it dies, restarting the cycle of birth and life."

"The mother giving her life for her children. I can understand that," Promise said in a very still voice. "I would."

"So would Margarete, if she could."

Tomaso turned around and glared. "That's enough, Diego."

There was a house up ahead. It was a single-story dwelling, but covered more ground space than *Casa Ortega*. It looked old, repatched and rebuilt many times over the years. The flat roof was curved red tile, the walls white clay, or cement textured to look like clay. There were two enormous windows facing the road. The glass was tinted blue with sunshield, and its frilled white curtains rustled as the caravan approached.

The gravel road gave way to concrete, a huge red circle of cleared ground before the front door. There were already three jeeps parked on the circle, and their driver pulled up next to the last in the row.

Promise smiled at Mirabal and extended her bound hands to him in an exaggeratedly formal gesture.

He took them, helping her from the jeep with a grin. "You almost seem to be enjoying yourself," he said.

Her smile remained stable, but she was deep within. Her plastiskin began to sparkle, and he held her hand a moment longer before drawing it away and wiping his palm on his trousers. "No wonder Aubry likes you." He left her to speak to one of the guards at the front of the house. Tomaso joined him, and stayed behind when Mirabal returned a moment later.

She closed her eyes. *Wu. Who is Wu? Luis. Explosive tracer. Tomaso. Security setup. What is on his mind?*

Aubry was standing next to her, and brushed her arm.

WHAT IS IT?

NOT SURE. NOT YET. THINGS AREN'T QUITE AS THEY SEEM. . . .

The muzzle of a rifle prodded her back, hard. "Move along."

Mirabal's enormous hand snapped out, catching the guard around the neck, pulling him close. "Let's be polite, shall we?" Face purpling, the guard bobbed his head. When he finally wrenched himself away, there were dark red bruises on his throat.

They were taken to a side door which opened directly into an elevator. The guard with the rifle remained outside, and one with a shock prod took his place. The elevator began to drop.

"Where are we going?"

"The shelter." Mirabal glanced from Promise to Aubry, as if trying to answer a silently posed question. "Bomb shelter, really. Food, water, and filtered air. The Ortega clan could fall back here and keep forty people alive for three months. Reinforced concrete and steel walls—strong enough to keep just about anything out... or in." The door slid open. "End of the line, Aubry."

There were four holding cells. Promise was pushed into the first one. Aubry looked in after her, his broad, dark face neutral. His mind called to her so loudly that it pierced the growing distance.

IT'S NOT OVER YET—

The sound of the door slamming behind her was an awful, hollow ring, and she slid down the wall until she was sitting on the floor. She looked at her bound wrists, trying not to cry.

Aubry was taken to the next cell. It was metal on the outside, the inside coated with shock-absorbing plastic. He battered his clenched fists against it a few times in simulated anger, then gave up.

He settled down to the floor and crossed his legs, closing his eyes. He frowned and moved against the wall, looking within himself for the space that Warrick had given him.

PROMISE?

There was no answer, but he knew she was nearby by the way he tingled. He scooted around until he found the spot that felt warmest. They were still too far apart for words, but soft images came to him, and he sighed, slipping deeper into his trance, and waited.

Aubry was roused from his meditation by a voice. It was a woman's voice, old beyond reason, and amplified electronically. "On your feet, Mr. Knight."

He stood slowly. "Margarete. I'm honored."

There was silence for a long moment, then: "You killed my grandson, Mr. Knight?"

"Yes."

"For reasons of revenge?"

"You should understand that. Isn't that what this is all about?"

"No questions, Mr. Knight. Was this your idea and yours alone?"

Surely they knew everything he did. It would be pointless to lie. "My idea. Promise helped, but she had no choice."

"Revenge. And protection. And this is all?"

"What else is there?"

"Profit, Mr. Knight." Her voice was sad and thoughtful. "There is always profit."

"Not this time. I hope it makes a difference."

"Not for you, but perhaps for the woman." The heaviness of her breathing said that she needed rest between sentences. "It is your child she carries?"

"Yes."

"You will cooperate fully with us. I can offer you a painless death, and the opportunity for your woman to give birth. The child is blameless and will not be harmed."

"I understand."

"You surprise me, Mr. Knight. You are not the animal I was led to expect."

"We all change."

"Yes...." There was something in the invisible voice that he couldn't identify. "All of us do, in time." There was a clicking sound, and the speaker went dead.

Aubry thought for a moment, then said: "Margarete—may I see your face? A condemned man should know the face of his judge."

After a few seconds there was another click, and the entire wall wavered and turned transparent. Tomaso stood there with a pair of quietly erect, graying men with leathery skin. Between them was a wheeled vehicle that hugged the ground, a vaguely egg-shaped plastic bubble. It was equipped with oxygen filters and a blood recycler. Within was a water mattress, and upon it was what had once been a woman.

There couldn't have been much of her left: certainly not legs; the egg was too short for that. Aubry could see one feeble arm, the skin as pale and soft as cotton. The other arm seemed a stump. The chest was sunken to the point where Aubry could detect no breathing. A voice box nestled against her throat

supplied her words, and a tongue sensor gave her control of her environment. The face was a withered mask, her eyes clouded and dead.

Aubry held his breath and walked slowly up to the front wall of the cell, looking down at her. His face betrayed no emotion. "Your sons?"

"Grandsons, Mr. Knight. My sons are both dead. Tomaso is actually my great-grandson." Her breath hissed and whistled with each intake, and she was visibly in pain.

"They need you badly, don't they?"

"Someone must be Law. Without law, there would be war between the families. Someone must be Justice, regardless of the cost."

"Aren't you . . . tired?"

"You don't know what tired is, young man. I should have died twenty years ago, but still I live. I have no kidneys, no liver, and still I live. My heart has been replaced twice, my eyes once." She paused. A sucking, whistling sound came through the walls. "And still I live."

Aubry shook his head in wonderment. "Why?"

"Honor, Knight. My husband and I started the Family, over seventy years ago. We created it—but now my husband is gone, and I am Law. There must be Law, do you not see?"

"I . . . think I can understand that." He paused. "What now?"

"Now, you wait. Until tonight." The wall began to cloud.

"And then?"

"Goodbye, Mr. Knight."

The wall went blank.

Tomaso Ortega smiled vastly, walking alongside Margarete's bubble as it wheeled down the main corridor of the security block. She paused as one of her grandsons opened the two-centimeter-thick steel door. "I trust you are pleased, Grandmother. You and the Family are all that I live for."

She managed to twist her neck a little to peer up at him. "I know that that is true, Tomasito. That is why I gave you your chance."

Beyond the door was an elevator. She purred into it. As soon as they stepped on, it began to rise.

"What of your organization, Tomasito? There has been much disruption. War. You are on the edge of bankruptcy. Much of this can be traced to your actions. Yours, Tomaso. What do you think of this?"

He shook his head impatiently. "Confusion, Grandmother. After Luis's death there were many things to be decided, worked through. The drug."

"Yes, the drug. The last of Luis's projects."

His eyes tightened. "My project, Grandmother. Luis never saw what I see. We are heading into a new age. Bribery, blackmail—such devices are things of the past. Why control minds, when you can control hearts?"

"You have lost many employees. There have been deaths. This had nothing directly to do with the drug?"

"No," he said easily. "Nothing at all."

She looked at him until the doors opened, then dropped her chin back onto her withered chest, closing her eyes.

Promise was awake and on her feet before the wall cleared to transparency. The guard outside looked at her coldly and said: "Stand clear of the door," then unsealed it. He stood back from the door and gestured her out.

"I haven't eaten anything in almost a day—"

"You won't need it."

She waited in the hall as they let Aubry out of his cell, his hands still shackled tightly behind his back. Two guards watched him at all times, and two more waited at the end of the corridor, shock prods humming at the ready.

Aubry shook his head as he emerged from the cell. His hair was matted and tangled, and his skin was sticky with four days of unwashed sweat. He was covered with cuts and scratches. Promise thought that he was the most beautiful thing she had ever seen in her life. She leaned against him, cupping his chin in her cuffed hands.

WHO IS WU?

HEAD OF THE NARCOTICS ARM. RELATIVE OF MARGARETE. WHY?

THE IMPLANT. WAS IT TOO EASY FOR YOU TO—?

Guards pushed the two of them apart and through the door. Escorted, they walked through a hall lined with doors with dark labels stenciled in Spanish and English. "Food," "Recycling," "Danger: Power Room." Aubry filed all of the separate labels under "bomb shelter" in his mind and tried to sort through his jumbled impressions.

Wu. Mirabal. The itch in his side. Tomaso. Too easy? Death Valley.

Death Valley?

What was too easy about Death Valley?

A gleaming metal hall lay in front of him, and for all of its polish, it seemed like another corridor in Death Valley. God. So long ago.

*Too easy?*

The door at the opposite end opened, and they were in an enormous, high-ceilinged room shaped like an isosceles triangle. Temporary bleachers had been set up along each of the equal walls. A three-meter restraining fence marked off a cleared space in the center of the room.

The seats were empty. Most of the room was darkened, but in the cleared floor space a single spotlight cast a circle of illumination. They were pushed into it at prod-point.

The doors at the sides opened, and rows of men and women filed in: the Ortegas. The grandchildren, and great-grandchildren, cousins and blood relatives of Margarete, brought together from their homes and empires the world over to make a life-and-death decision, a decision too important to be made over the ordinary communications lines. They ranged in skin tone and racial features from African to European.

From the anonymity of darkness they examined Promise and Aubry, judged them, prepared to pass sentence. A low murmur of conversation ran through the room, interrupted only when the last seat was filled.

A door opened to the side, and Margarete's party entered. There was absolute silence as the egg wheeled in, followed by a medical attendant, Tomaso, and a short, slender figure Aubry recognized as Wu.

They waited until the low conversational buzz in the room died down, waited until Aubry could feel the thread of nervous perspiration trickle from his armpit and feel the weight of almost certain death pressing at his mind, clouding his reason, separating his desperately maintained calm into fragments of fear, hatred, and anger. Promise leaned against him, and in her touch he found strength and centering.

"Good evening," Margarete said gravely. "It is sad that it takes such unpleasantness to gather our family together. That is often the way of life. We must determine the nature of the event that took place on February 19, 2022."

Her voice was much stronger than it had been earlier. This was her Family, and before them she would show no weakness.

"Aubry Knight and the woman known as Promise, you are here to bear witness to the events of that night. You will tell

us everything that you know. Omit nothing. The slightest variation from the truth will be severely punished."

Aubry spoke carefully as he recounted the events: the formulation of the plan, his climb up the rope, and Luis's death.

As he spoke, he made a special effort to feel out towards them.

*If only I could hear them. Touch them. What are they thinking?*

Beside him, Promise stiffened.

AUBRY. I KNOW WHAT IT WAS THAT BOTHERED ME. MIRABAL IS IN LEAGUE WITH WU.

WHY? WHAT DO THEY WANT?

"Continue, Mr. Knight."

Aubry looked up at them, and for the first time, his half-formed thoughts began to coalesce. He went on, and as he did, felt Promise probing his mind for pieces of information.

*Ignore the pieces. What is the larger picture?*

Aubry stopped talking. The escape from Death Valley. Too easy. *Casa Ortega.* Too easy.

*"You are here to bear witness ..."*

*"There was something in that house that broke through your conditioning...."*

"Mr. Knight? Have you finished?"

He couldn't find the words anymore, and it was Promise who spoke. "He's finished, because you already know the truth. This is a farce. You already know that Tomaso set Luis up to be killed."

Tomaso came upright in his seat, then stood slowly. *"What did you say?"*

"I said that they know, Tomaso. You thought you were bringing us here? You poor fool. They suckered you into coming here so that they could pass judgement on *you.* That's what all of this is about.

"We're not on trial, Tomaso. We're *witnesses.* We were just tools. You programmed Aubry. You set him loose from Death Valley. You made sure he could get in to kill your brother. You gave him one of your damned implants in his side. It had to be. There was no other way for anyone to get past the defense screen—"

"Lies!" Tomaso pointed an accusing finger. It trembled. "Lying *bitch!*" He pulled a gun from his coat, aiming at her head.

Aubry dropped to the ground instantly, cutting Promise's

feet out from under her, angling so that she fell atop his cushioning body. The bullet struck sparks against the far wall. Margarete's attendant grabbed at the gun frantically.

"No guns, Tomaso." Margarete tried to raise her head from its cushion. "This is my home, and I will have no guns within it. You will release that weapon at once."

"Check Aubry!" Promise gasped. "Check the implant! Find out who gave it to him at the prison, how they knew the security code that was used at *Casa Ortega!*"

"Lies!" Tomaso screamed again, and there was another gunshot. The attendant staggered back from him and fell against the curved bubble of Margarete's egg, leaving a dark stain.

Tomaso had lost all control, the smoking gun in his hand twitching as he turned to Margarete. "Grandmother." His round face sagged as if the facial muscles had been severed with a scalpel. "These are l-lies." Margarete's face was cold, and from the corners of the room, guards were moving to intercept him, shock prods whining. He waved them away with the point of his pistol. "And . . . and even if they were true, it would only have been for the Family. The Family is everything to me. You know that." He screamed it. "You *know that!*"

One of her grandsons grabbed him from behind. Wu sat impassively, watching as the two struggled, as Tomaso broke free with a desperate wrench and clubbed the man down.

The men and women in the room were clearing the tiers frantically, heading for the doors which had opened for them on all sides.

Tomaso aimed the pistol through the plastic bubble, directly at Margarete's head. "Get back, all of you." His voice was too high, cracking, and his body was racked with tremors. "I don't want this. I don't want any of this. I only did it for the Family. He was ruining the business. He was killing his best employees, squandering money——" He wheeled and fired, catching an approaching guard in the shoulder. The man flopped back, groaning. Tomaso had the gun pointed back at the bubble in an instant.

Margarete's face was frozen in contempt and shame as Tomaso pleaded. "He had hold of a new drug, the strongest, most valuable——"

There was a series of clicks. Guards had dropped to their knees, rifle barrels pinioning Tomaso.

"No!" Margarete screamed. "He is mine. His blood must not be spilled. Whoever kills him, dies."

Tomaso looked around him, backing away from her. "Just let me go. I just want—" He shot at one of the guards, who ducked away. Tomaso ran and fired twice more, clearing the corridor before disappearing along it.

Margarete turned her face to the side, tears spilling from her eyes. "It's my fault," she said softly, unaware that the sound of her voice was amplified and carried to all ears.

Wu leaned close to her. "Margarete. He will never leave the island alive. The guards, the others—they have heard your words, but one will shoot, and no one will remember who."

"Then what? What can I do? My family is all there is. All I have."

"What if I can bring him back?" Wu asked carefully, eyes glittering. "What if I can save him?"

She turned to him, her dead eyes staring through him. "Anything. Anything you want."

He stood, and pulled out a security card. "Diego," he said clearly. "Move your people into position. Apprehend Tomaso." His eyes widened, and he looked around the room. "Knight," he whispered. "Knight and the woman. They are gone. . . ."

Aubry and Promise hid in a storage room off a darkened corridor, listening to the sound of running feet. There was gunfire and screaming upstairs, but that was too far away for them to think about. She laid her cheek against him.

HOW MANY MEN DOES TOMASO HAVE?

I'M NOT SURE. MIRABAL AND WU HAVE TURNED AGAINST HIM. MIRABAL WILL PROBABLY TRY TO GET WU PUT IN AS THE NEW HEAD OF WEST COAST. HE'S FAMILY. ANY SECURITY MEN TOMASO BROUGHT WITH HIM MAY GO EITHER WAY. MOST OF THE OTHER FAMILY WOULD HAVE BEEN AGAINST HIM ANYWAY, BUT POINTING THE GUN AT MARGARETE CINCHED IT. HE'S DEAD. AND SO ARE WE, IF WE CAN'T GET OFF THE ISLAND.

BUT HOW?

Feet were approaching. Aubry opened the door a crack and waited until he saw that there were only two of them before he made up his mind. As they passed he exploded out, attacking from behind. A kick to the back of the knee drove one to the floor before he could even begin to turn. The other got halfway around and was met by a spinning thrust kick just under the right floating rib, damaging bone and liver.

Tied hands threw Aubry's balance off badly. He lost a step in covering the distance between them, and the first man had

time to get his gun up before Aubry landed on them with both feet. The gun fired in a hiss of compressed gas, and the flaming sting of a needle gouged a furrow through his cheek.

He spit blood and dropped to his knees, dizzy. "Margarete said no guns," he said in disgust. "Here. Prop him up." Promise helped Aubry wrap his legs around the man's trunk and arms. She cupped the guard's face in her hands, and relaxed.

*Nothing at first, just a rolling blackness, clouds of ink in water....*

The man twitched into consciousness, and Promise held his jaw and mouth as he struggled.

In the background, the dull sound of an alarm buzzer rang through the walls.

Now there were images from the terrified guard, and she concentrated, sorting them out. *The layout of the island: the house, and its three levels: bomb shelter, guest quarters, house proper. Outside: stands of trees, gardens. A solar still. Communications shack?*

NO. WE COULDN'T GET ANYONE HERE IN TIME. WE NEED TRANSPORTATION.

THEY'LL BE WATCHING THE DOCKS, AUBRY, AND I CAN'T FLY ONE OF THOSE MASS-TRANSPORT SKIMMERS. CAN YOU?

NO. BUT THERE HAS TO BE SOMETHING. SOMETHING.

They coiled around the guard tightly, joining, pulling images and sensations from him and sorting through them carefully.

*Medical emergency.*

It was the briefest flash of memory, months old. An image, broadening out into a sudden shadow play. The sound of klaxons and running feet. Guards and medical personnel clearing the way; an unconscious Margarete wheeling through the halls of her house, the egg on automatic. Doors sighed open before her, and the egg slid out into the open air, down a gleaming track, where a three-seat transport skimmer waited. It eased into the side of the craft, and the two medical attendants hurried into their places, monitoring her life functions with care.

Without any prodding from the attendants, the gleaming wedge lifted on its fans, finally washing the ground below with burning air as it flashed towards the mainland.

HOSPITAL. Excitement ripped through Promise's thoughts like live steam. AUTOMATIC MEDICAL TRANSPORT, SET TO RIDE IN ON A HOMING BEACON. IN CASE OF LIFE-SUPPORT FAILURE, MARGARETE'S EGG AUTOMATICALLY HEADS FOR THE TRANSPORT.

WHERE?

They pulled a final image: a nearby corridor and a set of colored buttons, triggered in sequence. Then the guard bit Promise's hand, and when she jerked it away, began to scream. Aubry bore down savagely with his legs, and felt the ribs splinter.

She helped him up, in the touch continuing to trade with him all that they had pulled from the guard. She took the needle rifle and shifted it around in her hands until she could cradle it comfortably despite her bound wrists. They turned and moved off down the corridor.

Aubry could feel his contact with the guard dissolving, and fought to stay in the same space. *I've been here before. I've been this way. I know this hall,* he told himself over and over as the images slipped away.

He stopped at a crossway and concentrated fiercely. There were feet approaching from the other direction, pattering distantly. Promise pulled at his arm.

AUBRY—NOT THAT WAY.

But he was staring, muscles straining as he forced himself in the direction of the footsteps.

IT'S THIS WAY, PROMISE. WE HAVE TO HURRY.

Halfway down the hall was a steel door. At its side was a vertical row of colored buttons. Aubry closed his eyes and visualized the image of the sequence.

*Blue, red, green.* He fought to move his bound hands into position to push the buttons, but couldn't. Promise covered the corridor with the rifle as the footsteps and voices grew nearer.

She looked at him in desperation and set the rifle on end against the wall, punching at the buttons.

*Blue, red, green, blue—*

With a clatter, the rifle slid down the wall and hit the floor. There was a clamor of voices, and the footsteps broke into a run as the door slid open. Promise snatched at the rifle, but Aubry shouldered her into the elevator as the men came around the corner. He jabbed his elbow into the "Close door" button as the guards came into view. Bullets and needles spattered against sheet steel.

He scanned the buttons quickly. "Second from the top. 'Medical Emergency.'" Promise punched it, and the elevator began to move.

Aubry collapsed aginst the wall, sucking air. The sound of rifle butts banging against the doors disappeared beneath them

as the lift rose. His gaze swept Promise, and she smiled. "You're a mess," he said gently.

She nodded, brushing at her hair self-consciously. "Didn't use to be."

"I know, baby." He looked up at the floor indicator. "Promise—"

"Don't say it, Aubry," she whispered. "We're almost clear, aren't we?"

He nodded, and their eyes locked, sharing the lie. "We sure are."

The elevator stopped. Then the doors opened to the outside of the house. It was dusk. Firelight from the direction of the docks made the cactus shadows dance on the ground. Gleaming steel rails led to the tiny medic skimmer.

Between them and the skimmer were Mirabal, Wu, and two of Mirabal's men, pointing a rifle and pistol unwaveringly at Promise and Aubry.

Mirabal blinked. "Step out, Aubry. Please. You surprise me—you really do. I had no idea you knew this house well enough to end up here. I had expected Tomaso. Please—"

They stepped out slowly, faces neutral, hope dying within them.

"What's the fire?" Aubry asked.

"Some of Tomaso's idiots. A few of the others who sided with him. Distractions. Trying to help him get away. They'll all be dead soon, and we'll find him. I want him alive."

Promise leaned against Aubry.

I'M GOING TO DO IT, AUBRY. DISTRACT THEM. ANYTHING.

Mirabal was still talking. "Aubry, you know, I rather hope that you can give me a reason to keep you alive."

"So you can fight me or screw me?"

"It doesn't really matter, does it?" He smiled, showing even white teeth. "You can fool other people, but not me."

Aubry was silent. He felt Promise's weight against him as she went limp.

Wu was very still. "Diego," he said firmly, "this man is dangerous. Best to kill him now."

Aubry looked past them into the darkness, and smiled sourly. "Your move, Tomaso."

One of the guards turned his head slightly, and missed the buildup as Promise exhaled harshly, tensing her muscles and sending a charge into her Plastiskin that built from quiescence

to full output in just over one second. The flash of light was like a silent thermite explosion, and even with his eyes shut against the glare, Aubry still saw the veins in his lids outlined in blazing crimson.

He was moving before the flare died, and hit the ground, rolling up off his shoulder. The guard fired blindly.

Aubry ignored the pain of his cruelly mashed hands and arched his body out straight. His feet lanced out at the end of his roll and smashed into the guard perfectly, sending him cannoning into the second guard, both rifle and handgun discharging, one with a hiss, the other with an explosive flash. Promise screamed.

The kicked guard dropped instantly, shooting at point-blank range. The second man rolled into the surrounding cactus, screaming as the spines bit into him. One hand covered his eyes, the other clawed at his side. Aubry took a chance and ignored him, pivoting back toward Wu.

It had been three seconds since the flash.

Mirabal was still shaking his head. Wu was already groping out and Aubry kicked sharply once with his left, intending to bounce back from the little man and go straight into Mirabal.

But the incredible happened. Blinded, Wu evaded the kick, swirling behind it to lash up at Aubry's groin. Aubry felt the move rather than saw it, tightening the arc of his circle so that he completed it faster, dropping his foot down to block with his shin. He rammed forward with his shoulder, but again Wu wasn't there. Something hit him between the shoulder blades with the impact of a sledgehammer and his left leg was swept out from under him.

Aubry twisted desperately as he went down, turning the fall into a partial somersault, whipping his right leg back to kick up over his shoulder. It was a free-fall maneuver, almost impossible to predict or counter. He felt the muscles tearing with the strain, but his foot connected solidly at the impossible angle, and Wu dropped, unconscious.

Six seconds had elapsed.

Aubry limped up, breathing heavily, and turned barely in time to meet the charge of Diego Mirabal.

The man's shoulder took him in the stomach, driving what breath remained from his lungs. They went down, Aubry's head barely missing a stand of cactus, Diego's arms locked around him, pinioning him tightly.

Pain exploded in Aubry's body, and in that moment the sickening realization of Diego Mirabal's superior strength hit home with the impact of a grenade.

He felt a rib go. Mirabal reared his head back, grinning. Aubry slammed forward, butting Mirabal in the face with all of the strength in his neck and shoulders. He distinctly felt Mirabal's nose break. The man grunted, but the hold didn't slacken at all.

He butted again and felt teeth go. Mirabal *smiled*.

*My God—he* likes *the pain*.

Panic poured over Aubry like a sheet of lava. A chilling voice in the back of his mind whispered *Give up. . . . You can't beat him*.

*No. I can't—so why am I trying to?*

Aubry hunched his chin down on his chest, and with the greatest effort of will of his life, relaxed. In that moment, his feelings stretched out beyond his skin, penetrated into Mirabal as if the two of them shared one body. Life and death, pain and ecstasy, Mirabal and Knight. One.

Mirabal felt Aubry's resistance drop to nothing, below nothing, and for a hideous second, he had the sensation that what he held wasn't a human being but a construct of his own mind. He felt the pain of his own crushing embrace, felt ribs giving way. Sudden fear gnawing at him, he drew back, bloody mouth open in shock.

Aubry's legs jackknifed up and he got a knee into Mirabal, and then a foot, screaming as he heaved. Mirabal tumbled back, shaking the ground with his impact.

Aubry fought onto his side and concentrated, bringing his wrists down to his hips, ignoring the pain as he fought them past, as the plastic bond cut into his wrists, slicing the skin away. He ground his teeth together as his wrists slipped over his hip, and he feverishly passed his legs through them as Mirabal rolled up and oriented himself, smiling as he saw Aubry's bound hands come around to the front.

Mirabal swallowed, the grin becoming feral in its hunger. "I knew you'd be good, Aubry." His voice was low, husky.

He charged, face masked with blood, eyes burning, great hands outstretched. Aubry joined with him for a moment, felt the movement, felt the dance, then parted when a knee driven into the ribs bounced him out.

Without thought, without hesitation, he rejoined, and again

there was the slithering blur of movement. Suddenly he was outside Mirabal's grasping arms. His clenched fists hammered the side of Diego's head, the meaty edge of a hand striking directly over the eardrum, the concussive force rupturing an eardrum.

Mirabal hit the ground and rolled. This time he didn't pause even a second but sprang up, taking Aubry's kick, taking the clubbing hands, eating it all and smiling through the hideous, mashed face.

*I can't stop him. I can't stop him—*

Then don't try.

He smashed Mirabal's forehead with his palms and grabbed a handful of hair. Then he went down and rolled back, thrusting up with his feet into Mirabal's stomach, releasing the hair as he pushed. Mirabal's body flew up and back over Aubry's head, landing with a rustle.

Aubry heaved for breath. Ohmigod. *He landed on his feet. On his feet. I have to get up—*

Fear, and anger, and the sickness returned. His gut spasmed, and he rolled to his knees, all of his carefully conditioned responses lost in a flood of nausea.

All Mirabal had to do was take him. There was nothing left.

From the corner of his eye he saw Promise, lying horribly still on the ground. Fear jolted through the dizziness, through the pain, and he forced himself to rise on rubbery legs.

Then he just stared.

Mirabal was hanging upside down, suspended on the arms and barrels of the cactus patch. He had smashed through several plants, covering himself in needles, his body finally coming to rest on the leaves of an agave. In the darkness, the spines rose up from his torso like quills. His body heaved, trying to work its way free.

There was still some light in his eyes. His expression mingled pain with a strange, almost childlike sense of wonder. "I knew . . ." he managed to whisper before the words choked in his mouth. His eyes slid closed, and he was still.

It had been a minute and ten seconds since the flash.

Aubry hobbled over to Promise. She was bleeding from her side and unconscious, but still breathing. He pulled her gently toward the medic skimmer, gasping every step of the way.

"D-don't move, Knight." The voice was painfully weak, desperately tinny. Tomaso emerged from the shadows, looking

at Mirabal's body in amazement, eyes wide. He pointed the green box at Aubry, and every instinct screamed that it was something to fear.

"I'd k-kill you now, but they'd hear and come. Not much t-time." His clothes were ragged, his skin scarred where the cactus spines had torn him.

The voices were closer now, and Aubry could hear the elevator thrumming in its shaft. No more time. No one was leaving the island. Best to just finish his business with Tomaso and end life complete. "Been hiding in the cactus patch, Tomaso?"

*There was fear in the air, and Aubry could feel it more strongly than from any of the others. Why? Because Tomaso was a Cyloxibin addict. His sickness vibrated in every word, every movement. His nerves were open to the air, burning with need, with fear, his body devouring him with adrenaline. He's near the edge. If only—*

Aubry let his feelings penetrate into Promise, to a place where time slowed and stopped, past the pain and the stupor, to the tiny glowing place that was her essence.

TWICE, DARLING. TWICE YOU'VE SAVED US BY FOCUSING EVERYTHING THAT YOU ARE INTO A MOMENT SO INTENSE IT DROVE YOU FROM CONSCIOUSNESS. SHOW ME. LET ME FEEL IT. I CAN DO IT, I KNOW, IF ONLY YOU CAN SHOW ME.

Pictures and voices flooded into his mind.

*Audience and artist. One. Promise and Aubry. One. Mirabal and Aubry. One. Life and death, pain and pleasure. . . .*

Tomaso and Aubry.

Tomaso watched Aubry stand, and his finger trembled on the button. There was no anger, nothing fearsome, not even pity on Aubry's face. It seemed to balloon, floating across the ground towards him with killing slowness. Tomaso's finger strove to push the button, but couldn't.

With each approaching step, the sense of connection grew clearer, the sense of *oneness*. Something in Tomaso broke, and he began to sob. He fell to his knees, the transmitter tumbling from a limp hand.

"It's all wrong. Everything's gone wrong. Please. I'm so sorry. Please . . ."

Gently, lovingly, Aubry gathered Tomaso in his arms and stood, turning to face the elevator as the doors opened and Margarete wheeled out with her guards.

Tomaso cringed, his arms wrapped around Aubry's neck. Aubry shushed him and looked at Margarete with eyes that accepted everything.

"Margarete," he said softly. "I think that we should talk."

# Epilogue

"She lost the baby."

Aubry watched Promise through the glass observation window. He leaned against it, fogging it with his breath. The need to touch her was almost more than he could bear. Finally he straightened, leaning on the jointed support rods within his bandage. His side still itched from the removal of the transmitter. "But she's alive."

"Yes," Margarete said, her face pale beneath the curve of the plastic bubble. "And still fertile."

"And Tomaso?"

"His body is alive." She steered the bubble to the end of the corridor. A door opened into a laboratory gleaming with chrome and crystal. Beside her, her attendant paced slowly.

"What are you, Knight? You bleed. You hurt. You kill more efficiently than anything human. And yet—"

She swiveled the egg around until it faced a rack of glass plates. In two of them were budding mushrooms, just the bare beginnings of growth. "These. These can create men such as you?"

"I don't know," Aubry said softly. He reached out and touched one of them, stroking the cap. "There's nothing in me that isn't human. Maybe I'm just luckier than most."

"After what you've been through, you can say that?" She looked up at him wonderingly, a terribly ancient woman whose eyes searched the darkness for answers. Her tongue probed the controls by her mouth, and there was a hiss as the seal on her egg broke.

Her attendant leaped forward, horrified. "Margarete! The air—"

"Get away," she snapped. "Back. There is something. . . ."

Aubry crouched by the egg.

"Touch me," she said.

He reached out, fingers brushing the aged skin as gently as a puff of air. He felt her weakness, and she tapped his strength as the spark leaped between them.

His knees sagged as the depth of her pain flooded through him. He bottomed out, no strength or reserves at all to sustain him, and let go.

And suddenly there was power. Not his, but his to use, not a part of him, but washing through him like a river of warmth and comfort. Its embrace was more than ecstasy, but less than completion.

When he opened his eyes a long time later, Margarete was crying. She raised her head from the pillow. "My God," she said. She was trembling but found the strength to grasp his hand tightly.

They stayed together for a time. When Aubry moved away from her, she smiled.

"Once," she said, voice shaken. "I could see what was good. What was good was the survival of my family at any cost. Any cost. I had my dream, and you can see the price that they have paid. They are bound together by greed and hatred, Mr. Knight. Not love. I've been so very afraid to admit that I was wrong, that I didn't know the truth any more. But now I see my way out, and for that I thank you. You are a good man, Aubry Knight."

She was crying again, and there was a spot of color in her cheeks. The attendant started forward. "No. It's over now. Nothing in the world could stop my children from growing this drug. And distributing it. Because they don't know what it will do to them. They will make the same mistake that Tomaso did, and see only the profit in such a drug." Her eyes met his directly, and for the first time he felt her power. Although she was blind, it seemed that she could see through him, through any lies or artifice. "They do not know that you will distribute the drug, will see that it is available free of charge to those who want love in their lives. *You* will see that the spores are distributed, that my children cannot hoard this wealth. The mushrooms belong to mankind, Mr. Knight. Love is the only

thing that can destroy my family without bloodshed. It is their only hope to begin again."

"I think I understand," Aubry said, glad that she knew it was the truth.

"Good. It is good." She sighed deeply, and seemed to shrink back against her sheets. "My attendants are faithful to me, and will give you safe passage from the island." Margarete paused, panting for air. "You have given me my death. It is a fair trade to give you your life."

"A fair trade," he murmured.

"Leave me now," she said, even the electronic amplification of her voice insufficient to mask the fatigue. "I must rest. Good luck to you, Mr. Knight."

Aubry stood watching her for another second, then turned and left, returning to his own bed.

Promise lay back in her seat, her head turned so that she could see the island recede beneath her. There was still pain, and she knew that her body would take time to heal. She squeezed Aubry's hand as tightly as she could and felt his warmth spreading through her. He leaned over to kiss her.

"Is it really over, Aubry?" Her voice was softer than he had ever heard it.

"Nothing's over. There are the Scavengers. They need us. And we have to start growing the mushrooms."

"You're sure?" she whispered.

He nodded.

She took his hand and laid it on her stomach. "I feel empty," she said.

"I know." He tried to say more but the words choked and he held her tightly, feeling her shake.

She pulled his head around until he looked into her eyes. As clearly as she could, Promise said: "Aubry, I'm empty but I'm alive. And I'm not alone."

He nodded, closed his eyes, and held her. He could feel the steady purring of the skimmer engines in his bones, warming him towards sleep.

At least they had each other, and hope, and time. Or, if need be, timelessness.

# Acknowledgments

There are so many people who participated in the production of this book that it may not be possible to thank them all. Be that as it may, the author feels obligated to try.

First of all, Toni Young, who believed in the project and never let me forget my obligations.

Steve Sanders, Danny Inosanto, Rex Kimball, and Hawkins Cheung, my primary sources of information and inspiration concerning the martial arts. And Gordon Lewis and Jim Green, my training partners, who have helped me accept my gifts and limitations.

Larry Niven, who understands quite keenly the distinction between a handout and a hand up. I owe him a debt that can only be paid in excellence.

Pam Reuben and Mary Mason, who provided criticism, technical information, and concerned feedback.

Eleanor Wood, my agent, a charming and ruthless lady. Glad you're on my side.

Susan Allison, who saw the potential, and Beth Meacham, who went above and beyond, and trusted a young writer enough to give him the space to breathe and grow.

Peter O'Donnell, creator of *Modesty Blaise*, who writes the best action sequences in the world.

Otis Allred, Pat Connell, Arthur Cover, Harlan Ellison, Frank Gasperik, Elizabeth Oaks, Karen Willson, Patric Young, and the Los Angeles Department of Public Works.

Gordon R. Dickson, who told me to go for it.

And to all of the family, friends, fans, pros, and others who
believed in me or, conversely, *didn't* believe in me, and thereby
motivated me to excel . . .

Bless you all.

—Steven Barnes

# THE BEST IN SCIENCE FICTION

| | | |
|---|---|---|
| ☐ 54989-9 | STARFIRE by Paul Preuss | $3.95 |
| ☐ 54990-2 | | Canada $4.95 |
| ☐ 54281-9 | DIVINE ENDURANCE by Gwyneth Jones | $3.95 |
| ☐ 54282-7 | | Canada $4.95 |
| ☐ 55696-8 | THE LANGUAGES OF PAO by Jack Vance | $3.95 |
| ☐ 55697-6 | | Canada $4.95 |
| ☐ 54892-2 | THE THIRTEENTH MAJESTRAL by Hayford Peirce | $3.95 |
| ☐ 54893-0 | | Canada $4.95 |
| ☐ 55425-6 | THE CRYSTAL EMPIRE by L. Neil Smith | $4.50 |
| ☐ 55426-4 | | Canada $5.50 |
| ☐ 53133-7 | THE EDGE OF TOMORROW by Isaac Asimov | $3.95 |
| ☐ 53134-5 | | Canada $4.95 |
| ☐ 55800-6 | FIRECHILD by Jack Williamson | $3.95 |
| ☐ 55801-4 | | Canada $4.95 |
| ☐ 54592-3 | TERRY'S UNIVERSE ed. by Beth Meacham | $3.50 |
| ☐ 54593-1 | | Canada $4.50 |
| ☐ 53355-0 | ENDER'S GAME by Orson Scott Card | $3.95 |
| ☐ 53356-9 | | Canada $4.95 |
| ☐ 55413-2 | HERITAGE OF FLIGHT by Susan Shwartz | $3.95 |
| ☐ 55414-0 | | Canada $4.95 |

---

Buy them at your local bookstore or use this handy coupon:
Clip and mail this page with your order.

Publishers Book and Audio Mailing Service
P.O. Box 120159, Staten Island, NY 10312-0004

Please send me the book(s) I have checked above. I am enclosing $_____
(please add $1.25 for the first book, and $.25 for each additional book to
cover postage and handling. Send check or money order only—no CODs.)

Name _____

Address _____

City _____ State/Zip _____

Please allow six weeks for delivery. Prices subject to change without notice.

# THE TOR DOUBLES

Two complete short science fiction novels in one volume!

☐ 53362-3   A MEETING WITH MEDUSA by Arthur C. Clarke and   $2.95
    55967-3   GREEN MARS by Kim Stanley Robinson   Canada $3.95

☐ 55971-1   HARDFOUGHT by Greg Bear and   $2.95
    55951-7   CASCADE POINT by Timothy Zahn   Canada $3.95

☐ 55952-5   BORN WITH THE DEAD by Robert Silverberg and   $2.95
    55953-3   THE SALIVA TREE by Brian W. Aldiss   Canada $3.95

☐ 55956-8   TANGO CHARLIE AND FOXTROT ROMEO   $2.95
    55957-6   by John Varley and   Canada $3.95
            THE STAR PIT by Samuel R. Delany

☐ 55958-4   NO TRUCE WITH KINGS by Poul Anderson and   $2.95
    55954-1   SHIP OF SHADOWS by Fritz Leiber   Canada $3.95

☐ 55963-0   ENEMY MINE by Barry B. Longyear and   $2.95
    54302-5   ANOTHER ORPHAN by John Kessel   Canada $3.95

☐ 54554-0   SCREWTOP by Vonda N. McIntyre and   $2.95
    55959-2   THE GIRL WHO WAS PLUGGED IN   Canada $3.95
            by James Tiptree, Jr.